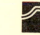

VENETIAN COLOUR

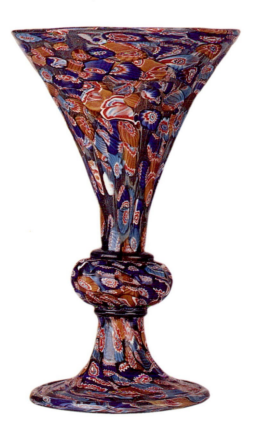

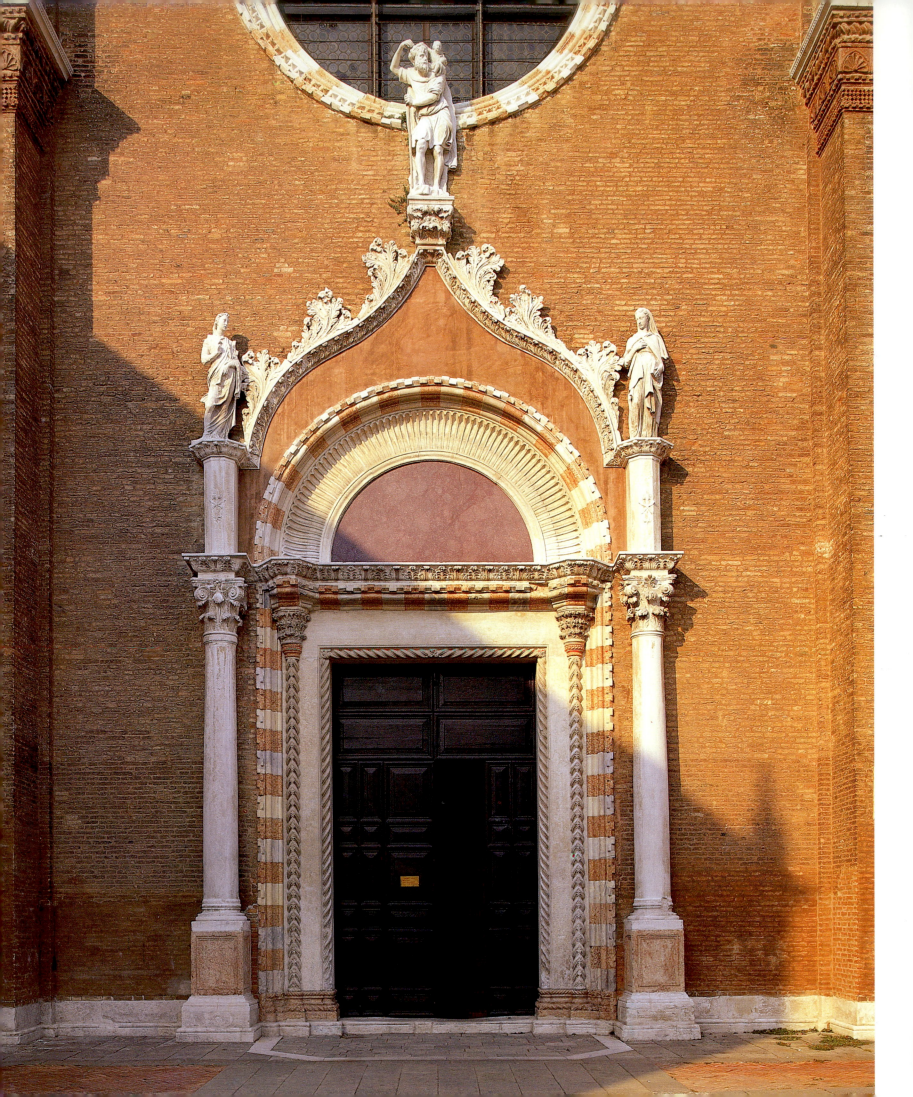

VENETIAN COLOUR

MARBLE, MOSAIC, PAINTING AND GLASS 1250–1550

PAUL HILLS

YALE UNIVERSITY PRESS
NEW HAVEN & LONDON

PUBLISHED WITH THE ASSISTANCE OF THE GETTY GRANT PROGRAM

The author thanks
The Lila Wallace Reader's Digest Publications Subsidy at Villa I Tatti
for its grant towards the cost of the photographs

Designed by Gillian Malpass

Printed in Singapore

Library of Congress Cataloging-in-Publication Data

Hills, Paul.
Venetian colour: marble, mosaic, and glass, 1250–1550/Paul Hills.
p. cm.
Includes bibliographical references and index.
ISBN 0-300-08135-9 (cloth: alk. paper)
1. Art, Gothic – Italy – Venice.
2. Art, Renaissance – Italy – Venice.
3. Color in art. I. Title.
N6921.V5H56 1999
701'.85'094531 – dc21 99-20880
CIP

A catalogue record for this book is available from
The British Library

Page i Venetian goblet in *millefiori* glass (*c.*1500). London, British Museum

Frontispiece Portal of the Madonna dell'Orto (mid-fifteenth century).

For Vivien Lovell

CONTENTS

facing page Giovanni Bellini, detail of fig. 160.

PREFACE

Venetian colour has exerted a potent influence on European art since the sixteenth century. Painters as diverse as Rubens, Velázquez, Turner and Delacroix achieved mastery of colour by absorbing the lessons of the Venetians. John Ruskin's praise of the stones of Venice left its mark on the polychromy of nineteenth-century architecture. Well known as these influences may be, art historical writing continues to stress the dominance of 'Cartesian perspective' and to underplay the role of colour in Western art since the Renaissance. In part this stems from attention being focused too much on colour in pictorial representation, too little on colour in architecture and the social world.

To understand the value of colour in Venice it is necessary to look more widely than at the history of painting. By including mosaic, building materials, table-glass and textiles in the inquiry it is possible to comprehend the value-systems of the mercantile Republic. In Venetian luxury manufactures colour is substantial rather than mimetic. Similarly in the poly-chrome fabric of Venetian buildings, colour constructs, decorates and signals difference and distinction. Chromatic value inheres in material and pattern – colour builds a world before it imitates one. Therefore the opening chapters of this book consider first the environment and fabric of the city – the sedimentation and *bricolage* of precious colours within a unique site and a mercantile society.

The time-frame of the book, 1250–1550, has been chosen to reveal patterns of repetition and reinforcement in optical and social discrimination. Some of the marbles and mosaics discussed date from before 1250, a few of the paintings to after 1550. In the light of this *longue durée* the *disegno–colore* debate turns out to be relatively insignificant. Discussions by Aretino and

Dolce are addressed in the last chapter, but readers who expect art history to revolve around re-examinations of canonical texts will be disappointed. Larger historical developments deserve attention. In particular I argue (in chapters 7 and 9) that the establishment of Venice as the capital of European printing is crucial to understanding the colourism of Giovanni Bellini and Titian. In establishing the self-sufficiency of monochrome media of representation early modern print culture also set in train a reassessment of the function of colour.

Murano glass, the most celebrated luxury produced in the lagoon, has long been underestimated in art history. Chapter 5 examines its place within Venetian material culture and suggests that the innovations of the glassmakers revealed to fifteenth-century Venetian painters new possibilities in transparency and hue. Giovanni Bellini is the key figure here. Chapter 6 examines his pigments and his shift from a predominantly tempera to a predominantly oil medium in the light of recent conservation reports. Chapter 7 considers more discursively how Bellini's light and colour related to the needs and beliefs of Venetian society. In the penultimate chapter the focus shifts to the dress of the patriciate, to their ability to discriminate dyes and textiles and to negotiate sumptuary regulations. These factors informed Titian's choices as a portraitist and shaped the cognitive skills of his patrician patrons. The triumph of tonal painting, with Titian as its most accomplished practitioner, is the central theme of the final chapter.

★ ★ ★

This book is the result of dwelling in Venice for nearly three months a year for over twenty years. I was able

to do this thanks to my duties teaching Warwick University's term-long programme in Venice. The inception of that programme was due to the imagination of Sir John Hale, its continued success to the care of Michael Mallett. My understanding of the Renaissance has benefited from long association with Warwick historians – Humfrey Butters, Martin Lowry and Michael Knapton. I am grateful to all my colleagues in Art History at Warwick, especially to Julian Gardner, to Anthea Callen for her enthusiasm for painting, and to Michael Rosenthal for his inspiration when we taught together in Venice. Two friends in Philosophy, Andrew Benjamin and David Wood, enlarged my vision.

As always I have learnt from conversations with painters, particularly Edmund Fairfax-Lucy, Christopher Couch and Antoni Malinowski. John Gage has answered my queries with his incomparable learning and wit. To Jill Dunkerton, Peter Mack and Jane Bridgeman I am indebted for reading chapters and suggesting improvements. Only I am to blame for errors that remain.

My research was begun during a year as fellow at Villa I Tatti, the Harvard University Center for Italian Renaissance Studies. I thank the Director, Walter Kaiser, and all the librarians and staff for making that such a fruitful time. In 1995 the Victoria and Albert Museum kindly invited me to deliver the Sylvia Lennie England Lecture; this brought me into contact with the Department of Ceramics and Glass, where Reino Liefkes generously shared his expertise. Also in 1995, I rehearsed my ideas in lectures as Benjamin Sonnenberg Visiting Professor at the Institute of Fine Arts in New York. I am grateful to the Institute for that invitation, to the graduates for their response, to Clare Hills-Nova for help in the library, and to Jonathan Alexander for his welcome.

I thank the Lila Wallace-Reader's Digest Publications Subsidy at Villa I Tatti for a generous grant towards the cost of the plates. Maureen Bourne, Alan Watson and Sarah Quill helped to obtain photographs. John Unrau kindly lent his transparencies of the interior of San Marco photographed by natural light. Angus Mill undertook photography in Venice. At Yale University Press I am grateful to Sally Nicholls for her picture-research, to Celia Jones for her copy-editing, and above all to Gillian Malpass for her insight into the complexities of this project. At home Matthew's humour helps keep things in proportion, and Vivien – even in black – fills life with colour: without them my canvas would never have been complete.

facing page Giovanni Bellini, detail of fig. 148.

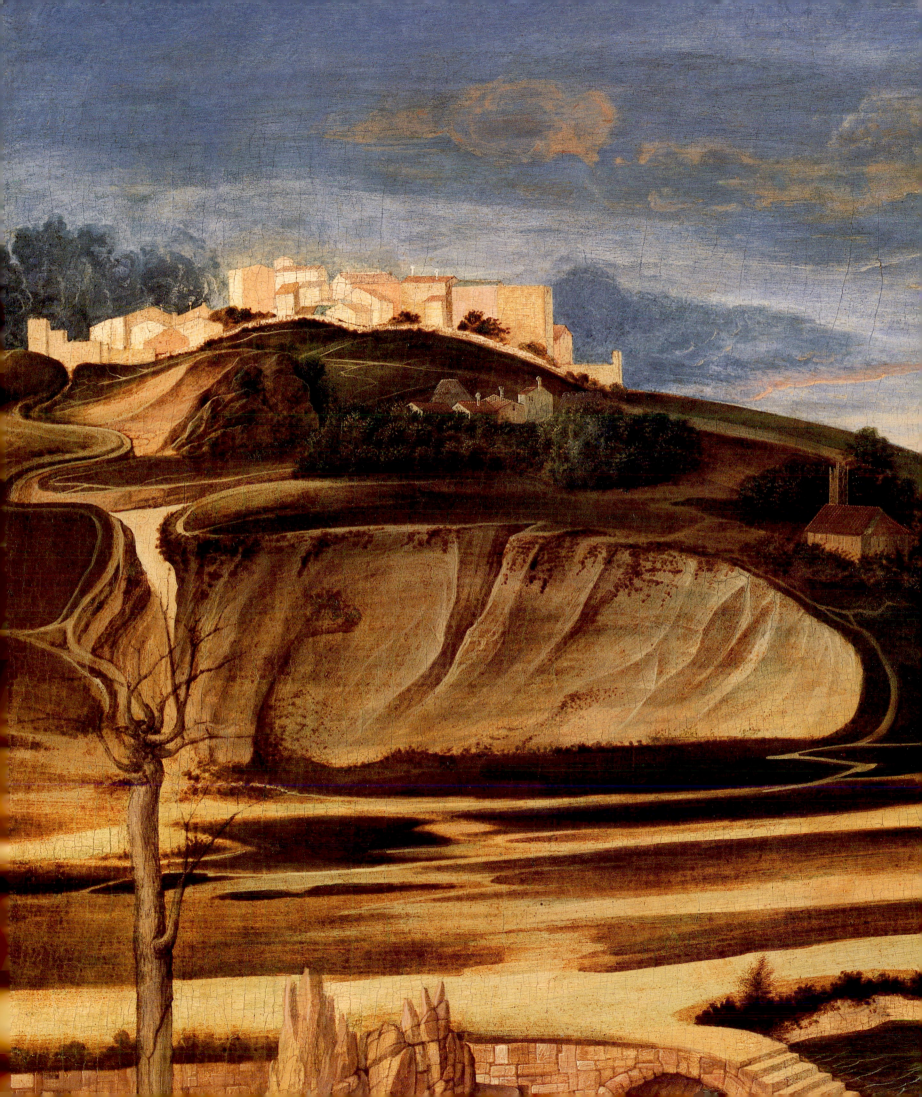

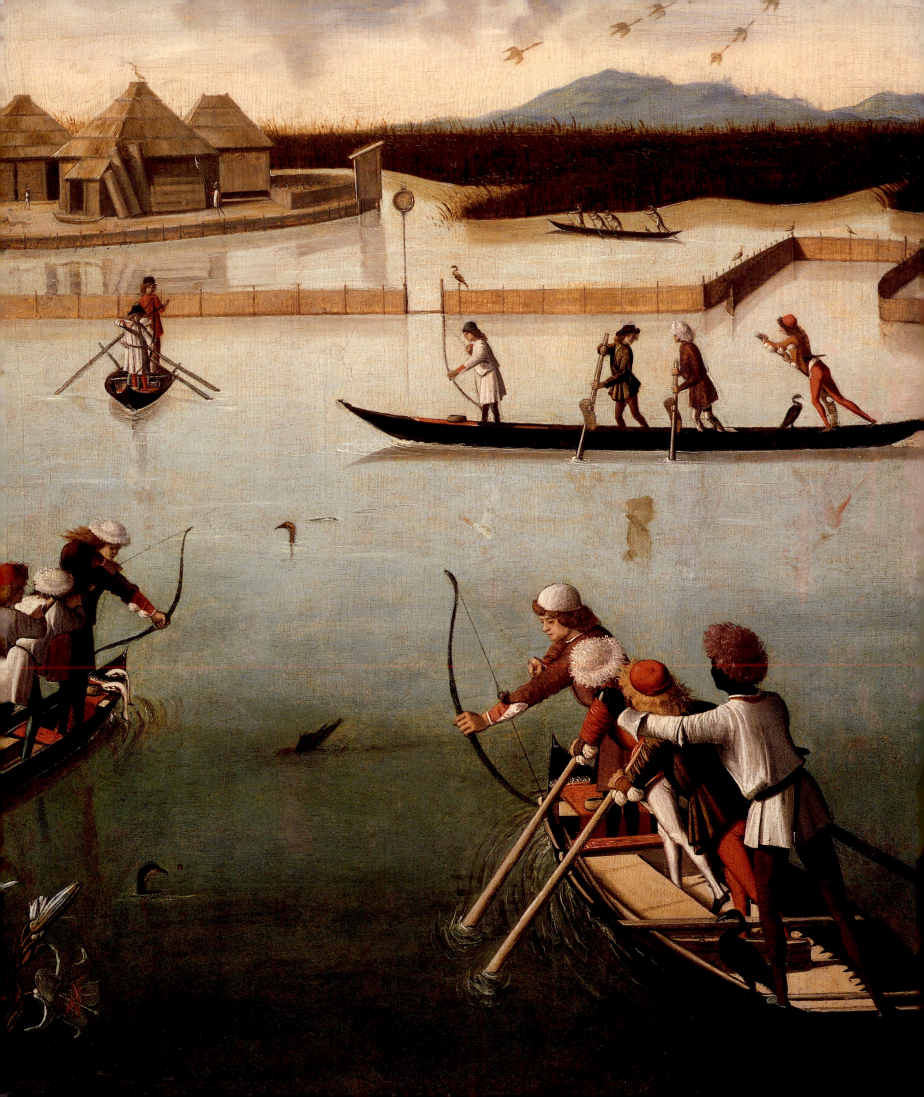

LIVING ON A LAGOON

Redefining the natural

The site of the city of Venice, in the middle of a lagoon, affords unusual commerce between the organic and the man-made (figs 2 and 3). Demarcations between the natural and the artificial are not easily drawn. The arteries of the city, its canals, follow the meanders of the tidal channels of the lagoon. 'It is two miles from terra firma', wrote an Irish visitor in 1323, 'and its streets are one-third paved in brick and two-thirds made of navigable streams, through which the sea ebbs and flows continuously without respite' (fig. 4).[1] In a city without walls, palaces of marble and glass are raised on mudbanks. All the materials for building, for shelter and its ornamentation, have to be fetched from afar. At a distance from terra firma, ideas of the natural and the normal are redefined, and what seems miraculous made real.

Whereas the traveller approaching Siena will see here and there fields of richly coloured earth which prepare the eye for the sheer warmth of the brick walls and tiled roofs of the city, in Venice there can be no relation perceived between land and the materials of the city. The materials of Venetian building are brought from a distance, detached from their origins. Isolated by its blue belt of water, there is a necessary uprooting of materials, and a fresh bringing together. The houses of the Venetians, in all their colours, do not seem to grow from the ground, for neither their bricks nor their tiles share the colour of a visibly sustaining earth, and their stones and marbles cannot be checked against the tone and texture of any neighbouring cliff or exposed bed of rock (figs 5, 6 and 7). In such a setting all the materials of shelter and the ornaments of display acquire new distinction. In its unique location Venice, cut off

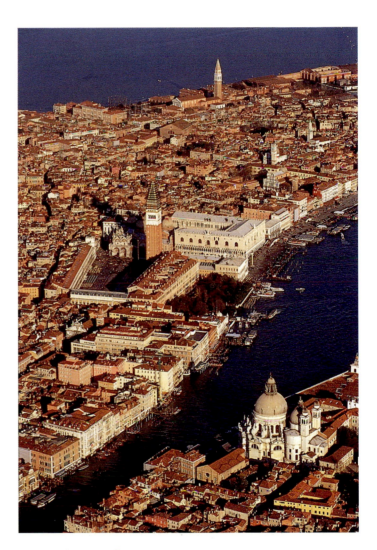

2 Aerial view of Venice with San Marco.

1 Carpaccio, detail of fig. 17.

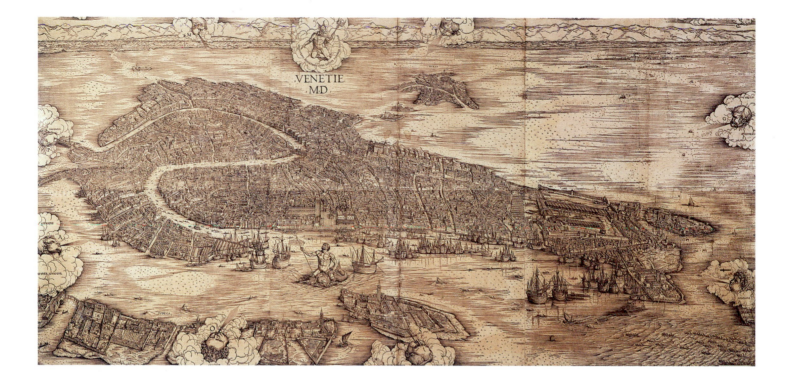

3 *(above)* Jacopo de
Barbari, *View of Venice*
(1500). Woodcut from
six blocks, 139 × 282 cm.

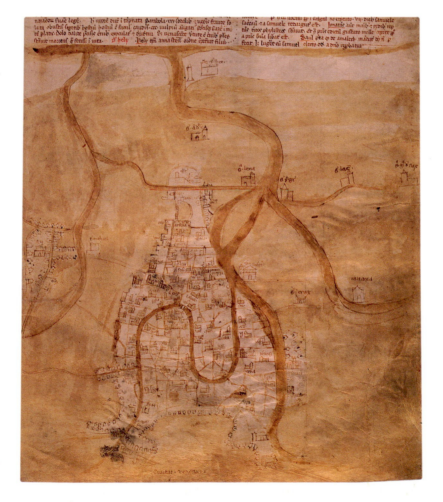

4 Plan of Venice
(*c.*1346) in the *Cronaca
Magna*, Venice, Biblioteca
Nazionale Marciana.

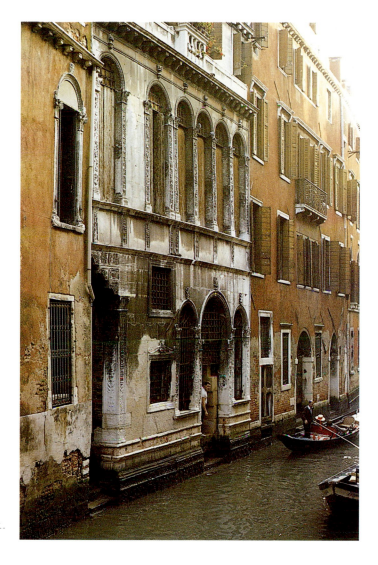

5 and 6 *(above)* Ca' Gussoni
(end of fifteenth century),
attributed to Pietro
Lombardo, and detail.

7 Pattern of red and
yellow bricks on façade of
the former Church of San
Zaccaria (*c.*1400).

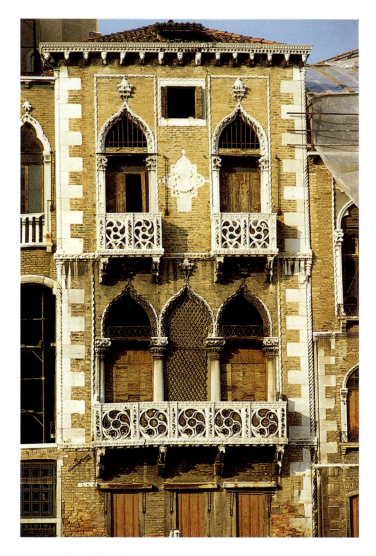

8 Detail of façade of Ca' Contarini-Fasan (second half of fifteenth century).

from the earth, invited celestial comparison: the reaction of the Irish visitor of 1323 anticipates many a later eulogy: 'it is completely set in the sea, yet by the name of its beauty and the merit of its elegance it could be set between the star Arcturus and the shining Pleiades.'[2]

That something so fragile should endure is a source of wonder, a theme that takes us back to the earliest written testimony, the description of the Venetians in AD 523 by Cassiodorus, the praetorian prefect of King Theodoric the Ostrogoth: 'For you live like sea birds, with your homes dispersed, like the Cyclades, across the surface of the water. The solidity of the earth on which they rest is secured only by osier and wattle; yet you do not hesitate to oppose so frail a bulwark to the wildness of the sea.'[3] By the end of the Middle Ages the frail bulwark had been strengthened with brick and stone, the wondrous fragility now become an ornament, transposed into the delicate tracery of Gothic palaces (fig. 8).

Intimidation by display

In the Venetian marking of territory, display replaced defence: the primary function, shelter, was overtaken by a secondary function, ostentation. Intimidation by display is a theme which will recur in many contexts in this exploration of Venetian colour. To visitors accustomed to heavily walled cities and towns, Venice's lack of fortification, together with its flaunting of riches, appeared amazing. They assumed that the lagoon acted as a defence: as Felix Fabri, a Dominican friar from Ulm who passed through Venice in 1483, remarked, the city 'has the ocean for a pavement, the straits of the sea for a wall, the sky for a roof'.[4] To the Venetians themselves, especially those of the Renaissance, who constructed myths of divine foundation and miraculous preservation, the idea that water took the place of walls was common coin.[5] An inscription by the Magistrato alle Acque of 1553, puts it succinctly: 'Venice, founded at God's command among the waves, surrounded by water, protected by walls of water. Whoever dares to despoil this asset of the community shall be no less severely punished than he who damages the walls of this native city. This edict shall stand for all time.'[6]

In fact the celebrated openness of Venetian architecture, especially of the palaces, was in part born of necessity. Building on unstable mudbanks, the Venetians needed to keep the superstructure of their buildings light; walls were thinner than elsewhere, and vaulting in stone almost unknown. In a city where space was at a premium – urban expansion was limited – even palaces tended to be built abutting one another. On the Grand Canal, the most desirable address for patricians, palaces support one another like books on a shelf, their façades the narrow spines facing the waterfront (fig. 9). Windows had to be generously clustered in long arcades on the façades to admit light into the depth of the buildings (fig. 10).

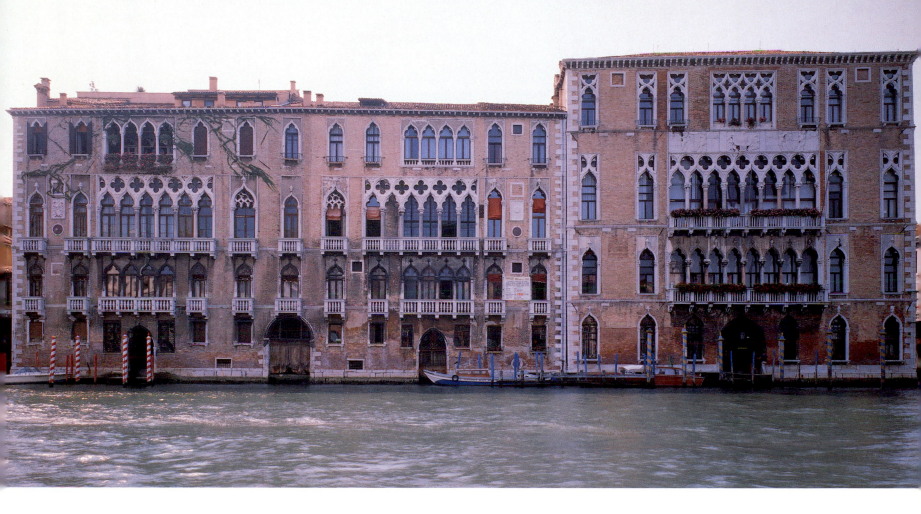

9 *(above)* Grand Canal with Ca' Giustinian (double palace of second half of fifteenth century) and Ca' Foscari (begun 1452).

10 Plans of Ca' Giustinian and Ca' Foscari.

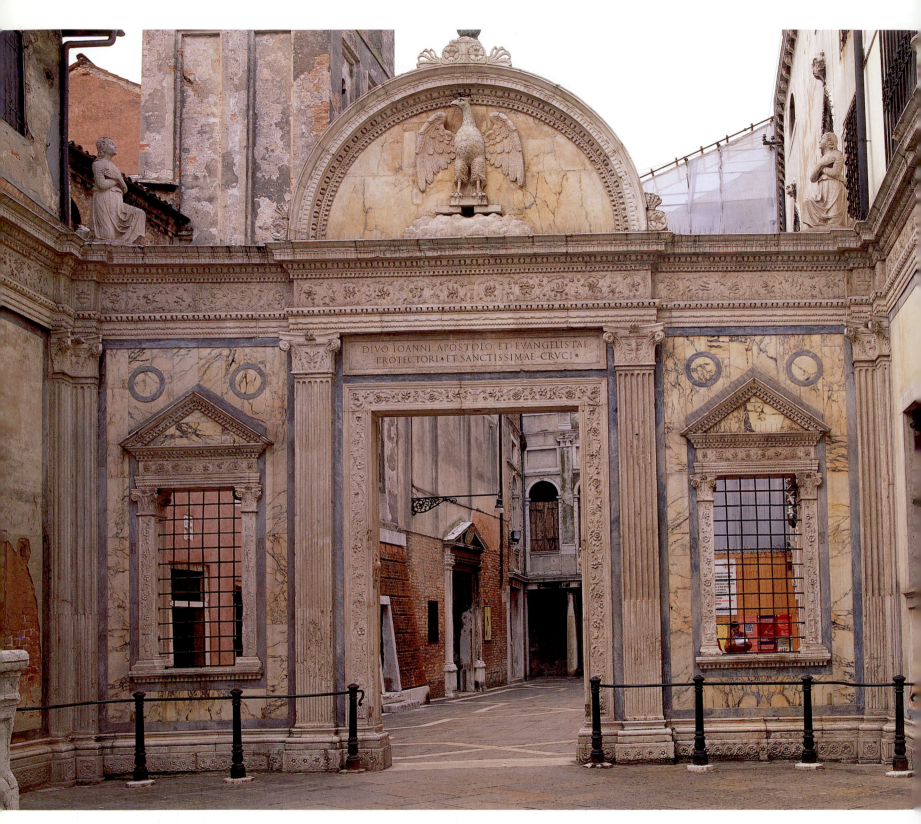

11 Forecourt of Scuola Grande di San Giovanni Evangelista (1478–81), attributed to Pietro Lombardo.

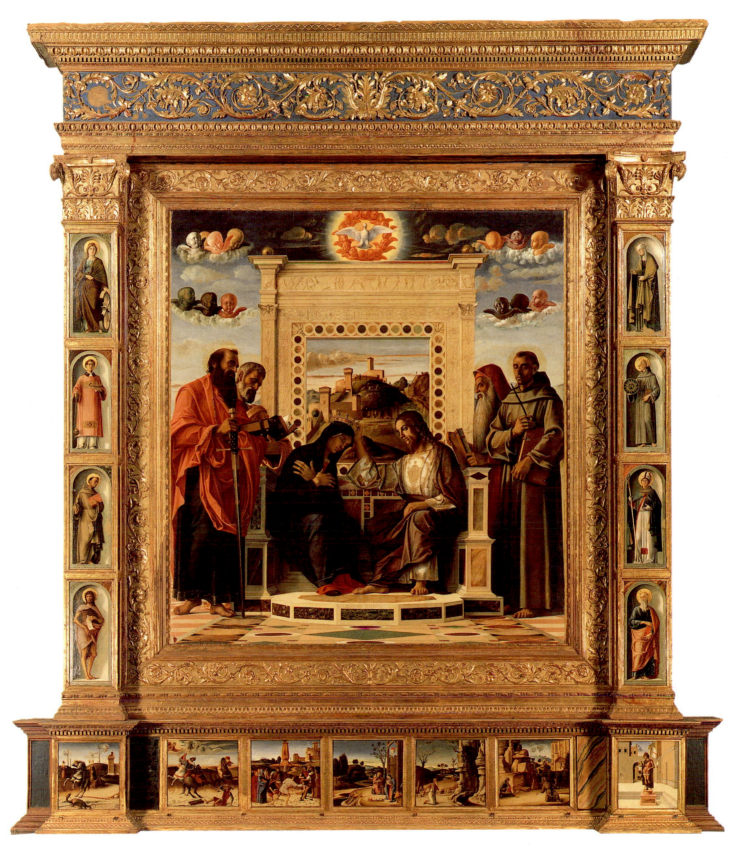

12 Giovanni Bellini, *Coronation of the Virgin* (*c.*1471–4). Central panel, 262 × 240 cm. Pesaro, Museo Civico.

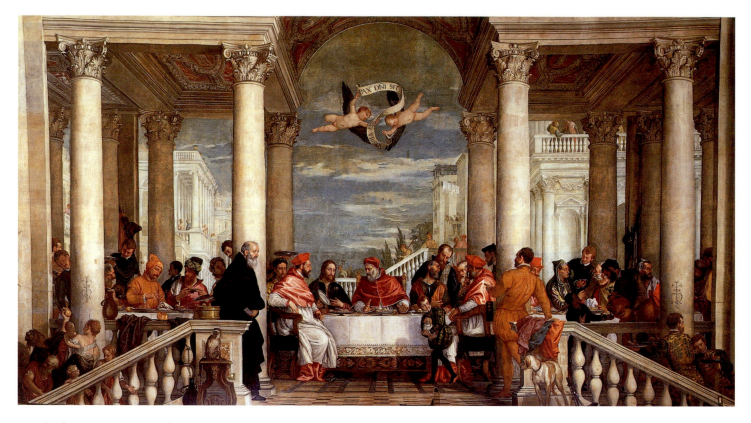

13 Paolo Veronese, *Feast of Saint Gregory* (1572). Canvas, 477 × 862 cm. Vicenza, Monte Berico.

Dispensing with fortification (and fortification in the late Middle Ages was often more symbolic than functional) licensed playfulness in denoting inside and outside. Walls often turn out to be merely a screen, as at the entrance to the forecourt of the Scuola Grande di San Giovanni Evangelista (fig. 11). For the Venetian painters windows, doorways or other apertures were not necessarily passages from light to darkness or darkness to light: the same is true of the 'window' in the throne of Giovanni Bellini's *Coronation of the Virgin* at Pesaro (fig. 12). Contemplating a feast scene by Veronese (fig. 13), which spills over terraces and stairs, any ultramontane, cold-climate distinction between colour and light of interior and exterior must be revised. Flow between inside and out is characteristic of Venetian living. The scenographic sense was nurtured by daily events of passage. The palaces of the Venetian merchant-patricians served as domicile and warehouse: goods arrived by boat at the watergate, were unloaded, stored on the ground floor and then frequently shipped off again;

while from the living quarters on the floors above balconies provided vantage points where the women, normally confined to the house, could emerge to enjoy the sun, the air and the spectacle of the canal. As Francesco Sansovino commented in his sixteenth-century guidebook to the city, 'Outside the windows it is their custom to project balconies surrounded by columns; little more than waist-high these are very convenient in summer for taking the cool air'.[7] Traffic of this kind – sometimes slow and lingering – between inside and out is not to be found in quite this manner in other Italian cities.

★ ★ ★

Tidelines, reflections and trading spaces

On a lagoon, boundaries are not rigid, tides raise and lower, ever so slowly, the demarcation between water and building: in no other city is the base-line from which architecture rises so variable. The physical environment, its textures and colours, is as sensitive as a barometer to changes in the weather. After a storm the waters of the canals and the lagoon are aerated, they lose their transparency, they turn jade green, opaque and crested with white. Then the vigour of the waters, the currents of the lagoon, are revealed as the prows of boats cleave the dense colour, ploughing a momentary furrow of jade veined salt white. Such colour is endless, abundant, unfathomable, imbued with latent energies. On the lagoon, colour manifests itself by turns as a phenomenon adhering to surface, or spreading into a film, or filling a volume.[8] It may bound, may veil or may defy limit and definition, opening to the abyss and chasm of space. Venetians as a maritime people needed to keep a weather-eye open to their changeful environment: their exploration of colour begins with this dwelling amongst the waters of lagoon and canal.

On clear days the water appears glassy, reflecting either the blue sky or the ochres, peach and rust reds of plastered walls. The surface is laced with small ovals, interlocking, rocking, molten, mercurial, shimmering in their alternation of brilliant sky blue and intense hues of orange (fig. 14). Such colour is like a substantial film, elastic and glossy, adhering to the surface, moving with the undulations of the waters yet nowhere revealing its depths. A gust of wind, or the disturbance caused by a passing gondola, will fracture and sub-divide the kaleidoscope without introducing any moderation, blending or muddying of hue. No city built on land can offer so brilliant and so strange an intermingling and intensifying of the colour of the sky and the colour of the buildings on the surface of its thoroughfares. What is above is reflected in what lies below, the brightness of the water may outshine the brightness of the sky, upsetting the normal sense of hierarchy from height to depth, of lightness above and darkness below.

Studies of perception reveal that in our bodily relation to an environment manifold visual and other stimuli are correlated, and that, typically, organisms orientate by an unconscious co-ordination of the pull of gravity with the normal experience that light falls from above. In Venice such co-ordination is frequently thrown into suspense or inverted by mirroring in water. For the lagoon-dweller what James Gibson calls the 'affordances' of the environment – what furnishes shelter, or sustenance – differ from those on land.[9] A special set of affordances creates its own patterns of attention and constructions of meaning. Travel by boat reawakens awareness of balance that on terra firma is readily taken for granted (here is one source of those figures by Tintoretto that wheel and tip in balletic postures) (fig. 15).

The setting of the city amidst water also involved attitudes to space and colour that are historically specific, more mental than retinal but in turn informing vision.[10] The city as an agglomeration of buildings, the communal homestead, is compact, absolutely limited by water, yet this same water extends seamlessly through to the great spaces of the Republic's maritime empire. In Carpaccio's monumental canvas the *Lion of Saint Mark* (fig. 16), commissioned for a government office, the stepping of the lion on to the shore alludes to Venice's claim to its mainland conquests, while the ships with billowing sail heading toward the horizon indicate its trading dominion. Land, in any terrain but the desert, is necessarily varied, differentiated, whereas water like air has a quality, universal and homogenous, that readily proposes to the imagination a peculiar sense at once of unlimited extent and of tangible connection

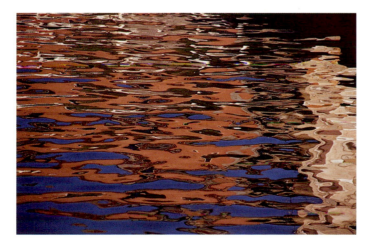

14 Reflections on a Venetian canal.

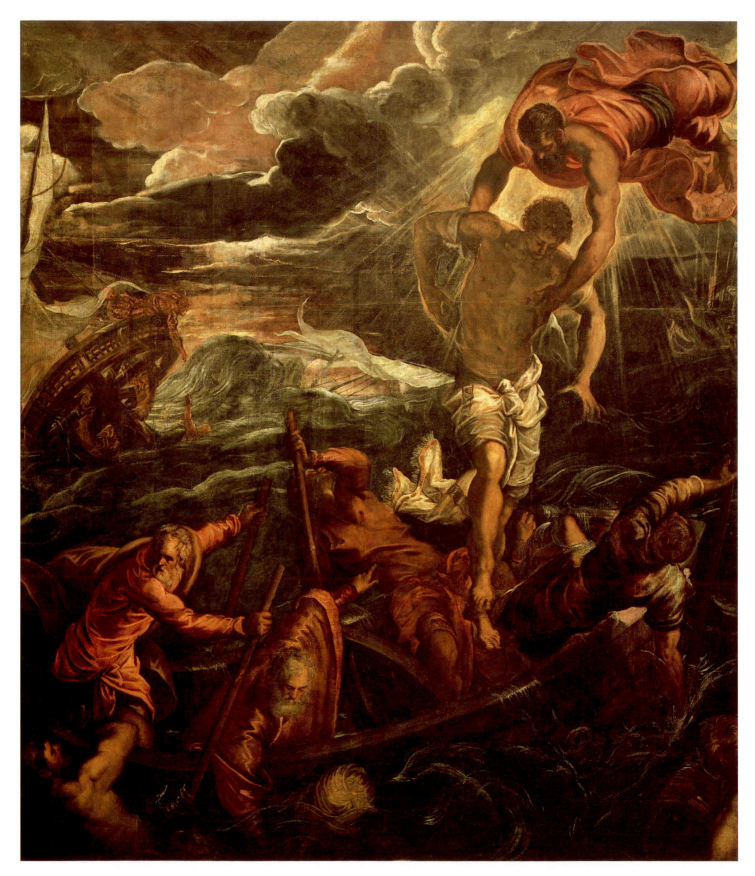

15 Jacopo Tintoretto, *Saint Mark rescuing the Saracen* (1562–6). Canvas, 398 × 337 cm. Venice, Accademia.

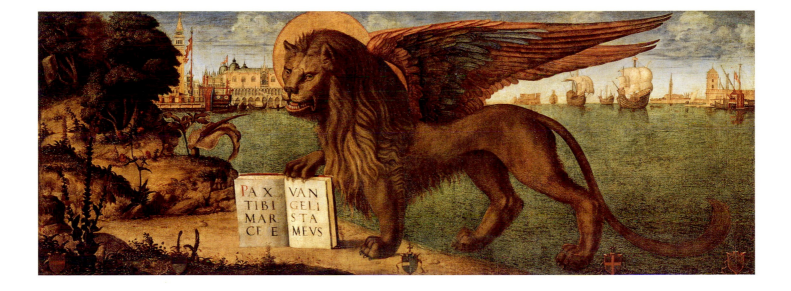

between the distant and the near. For water itself moves, travels, carries along and is borne along, prompting images of journeying that transcend the movement of persons or the centrality of the individual subject. Landlocked Florence would be the home of Brunelleschian linear perspective centred on the unmoving observer, whereas the seafaring Venetians would eventually feel more at ease with representations that allow for a moving eye and for a translucent medium between figures that itself seems mobile. Normal divisions between subject and object are washed away, the boundaries flooded. To the Venetian patrician, the lapping of water at the walls of his palace placed his domicile in touch with the keel's way, and reminded him of the sea-borne traffic that was carried to and fro over the horizon, moving between the visible and the out-of-sight. The space of the settlement, the city, the home of a closed élite class – which until the later fifteenth century was largely without landed estates – was dense, confined and intricate. The surrounding lagoon provided open spaces for recreation, hunting duck and fishing, as is shown in Carpaccio's *Duck-shooting in the Lagoon* (fig. 17). Beyond this lay the vaster spaces of commercial exchange in the Mediterranean and the Orient.[11] Between this density of the centre, and the over-the-horizon sources of wealth, lay a gap to be traversed – a degree of emptiness, if never a void. Under the brush of Giovanni Bellini in his maturity, and following him the painters of the

16 Vittore Carpaccio, *Lion of Saint Mark* (1516). Canvas, 130 × 368 cm. Venice, Palazzo Ducale.

17 Vittore Carpaccio, *Duck-shooting in the Lagoon* (*c.*1495). Panel, 75.4 × 63.8 cm. Los Angeles, J. Paul Getty Museum.

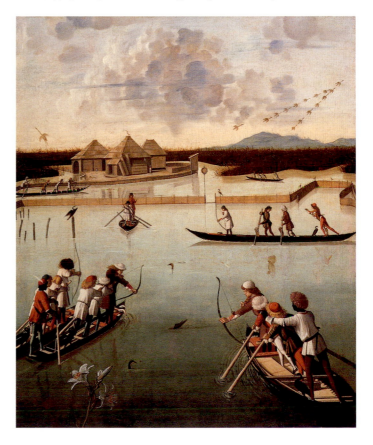

18 Giovanni Bellini, *Sacred Allegory* (c.1490). Panel, 73 × 119 cm. Florence, Uffizi.

sixteenth century, this gap, this breathing space, becomes apprehended in painterly terms as the envelope of air that gently touches the figures, illumines their colours, softens their contours (fig. 18).

The social space at the centre of the commercial network was limited by the extent of the higher mud-banks. In the city itself the surplus that resulted from successful trading or − as on the Fourth Crusade in 1204 − from looting, could rarely be spent on increasing the scale of buildings or the size of the public spaces between them. The Venetians could not emulate the ambition of the Sienese when they embarked on doubling the size of their cathedral in the early trecento.[12]

Encrustation and perforation

Venetians of necessity came to prefer preciousness of material and richness of colour to grandeur of scale. Florence is the city of stone, Venice of encrustation. Florentine blocks of stone convey weight (fig. 19), Venetian coloured veneers suggest lightness; and where Florence proclaims strength, Venice parades wealth. In Venice imported marbles are cut into fine slabs and attached to the brick core of the façades, or colour is spread over brick in the form of plaster finishes: neither can be cut into deeply, so surfaces appear planar yet fretted with shadow (figs 20 and 21).

Accompanying this style of encrustation and thin-wall architecture is a distinctive fenestration. In the late Gothic period traceries viewed from outside punctuate with darkness, or viewed from within perforate with light; a contrast accentuated by the brilliance of light concentrated in the canals. This perforation by bright

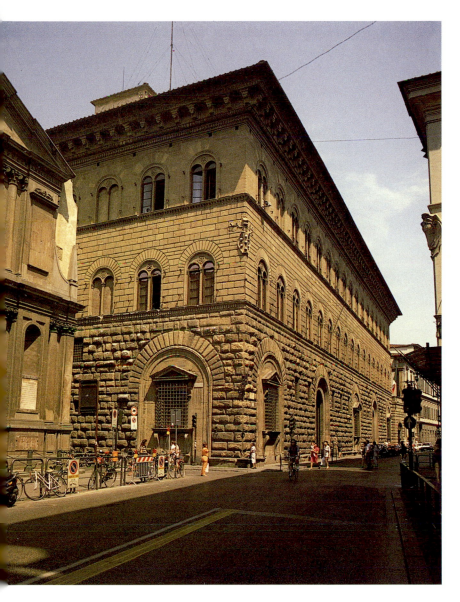

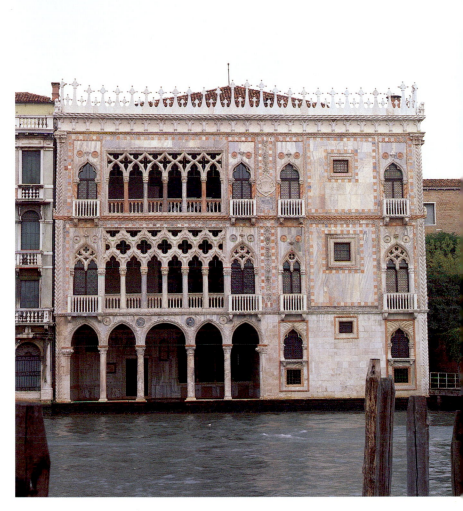

19 Palazzo Medici, Florence (begun 1444), by Michelozzo di Bartolomeo.

20 Façade of Ca' d'Oro (1422–33).

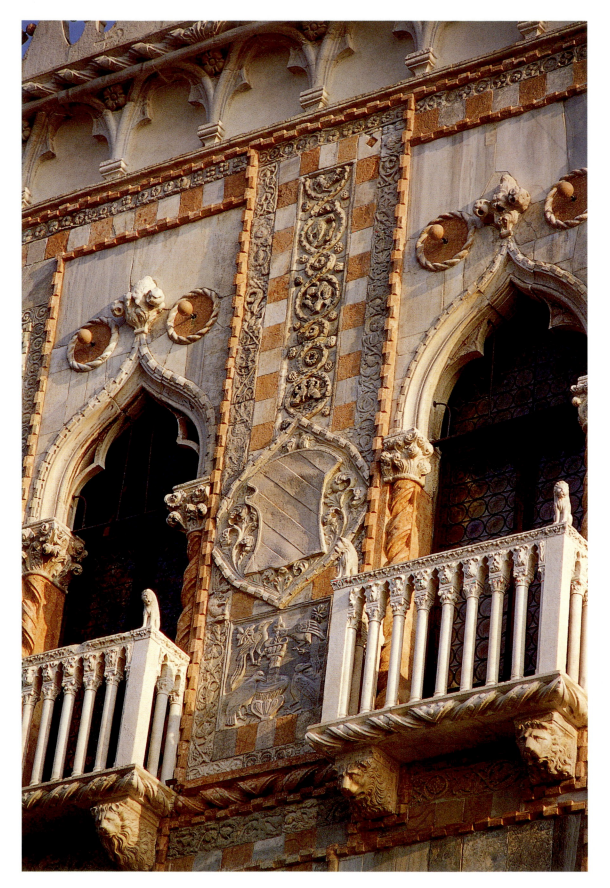

21 Detail of the second storey of the façade of Ca' d'Oro, with the Contarini arms (1422–33, incorporating earlier reliefs).

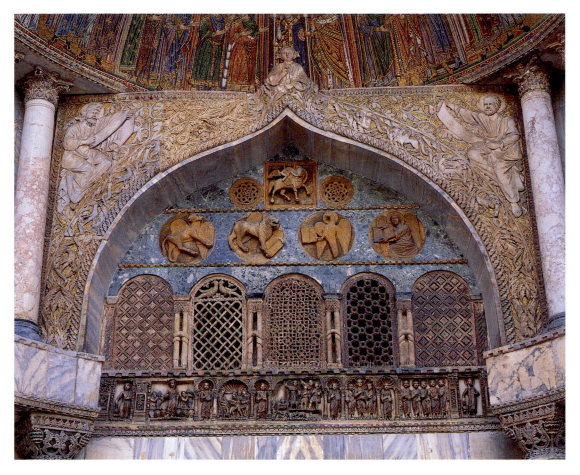

22 Detail of Porta di Sant' Alipio on the west front of San Marco (twelfth to thirteenth centuries, incorporating earlier carvings).

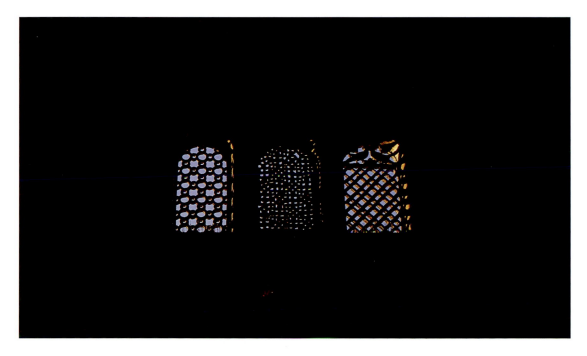

23 View from inside Porta di Sant'Alipio, transennae in silhouette.

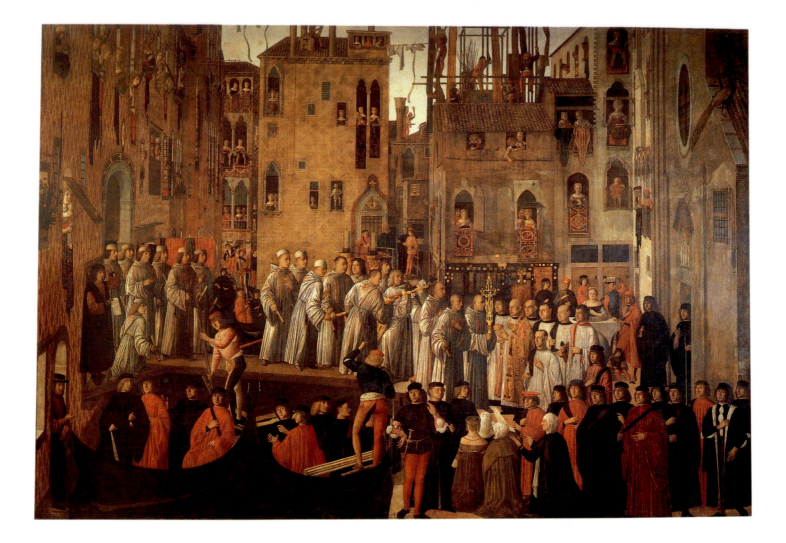

light, so important to the development of *contre-jour* – and hence to the relationship between colour and light – has its roots in the Byzantine and Early Christian system of fenestration by transennae, that is unglazed screens or lattices in marble. Transennae, such as are to be found on the façade of San Marco in the left-hand portal, the Porta di Sant'Alipio (fig. 22), when viewed from within turn the flow of light into a pattern of bright light isolated by a mesh of darkness (fig. 23). Strangely, rather than rupturing the surface, transennae, by virtue of the tightness of their grids, which are necessary to prevent undue penetration by the elements or by birds, are absorbed within the planarity of the wall. Perforation becomes pattern; the brightest light and deepest dark nudge one another within the confines of their geometry. (Centuries later Charles Rennie Mack-

intosh, and, even closer to our own time, Carlo Scarpa, adapted such lattices of light and darkness to create geometric order in their architecture.)

To the coloured veneers, the encrustation of marble, was added on festival days the furnishing of carpets hung from balconies, as can be seen in the narrative canvases of Gentile Bellini, Vittore Carpaccio and Giovanni Mansueti (fig. 24). When Petrarch lived in Venice, varicoloured awnings were draped over a temporary dais outside San Marco to provide protection from the sun.[13] Rich colours in soft textiles overlay the hardness of marble; and the eye of the Venetian painters and their public became attuned to fine degrees of hardness and softness, of fixity and pliancy, as when silken textiles move in a current of air but marbles stand fast.

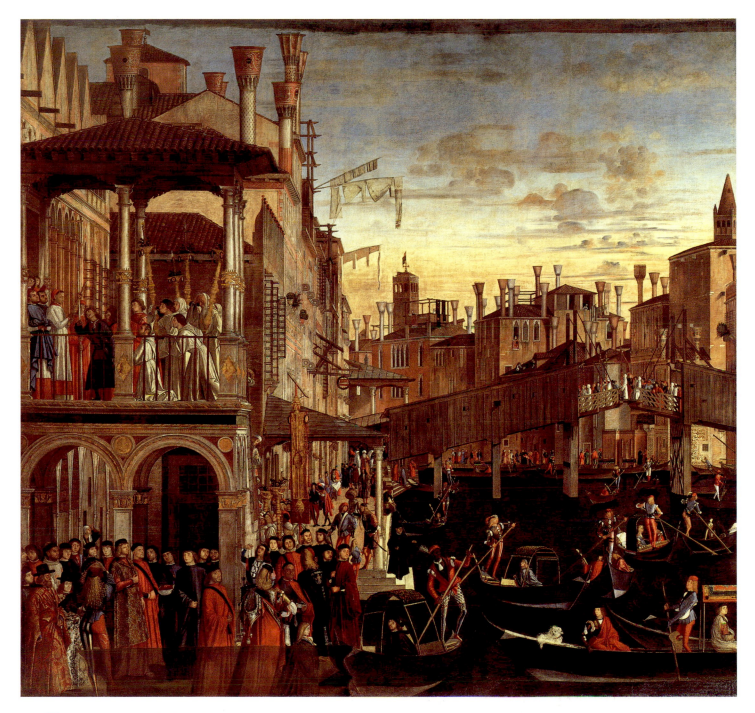

25 Vittore Carpaccio, *Healing of the Possessed Man* (1494). Canvas, 365 × 389. Venice, Accademia.

24 *(facing page)* Giovanni Mansueti, *Miracle of the Bridge at San Lio* (1494). Canvas, 318 × 458 cm. Venice, Accademia.

Public display of private possessions, the ritual turning outwards of what was kept within, reinforced collective ties. Over time, the connection between surpassing beauty, material value and belief in sacred destiny was forged: for the Venetian ruling class their communal wealth was a sign of God's favour. Marc' Antonio Sabellico, historian to the Republic writing in the late fifteenth century, had the priest at the solemn foundation of the city declare: 'When in days to come we attempt great things, grant us prosperity! Now we kneel before a poor altar; but if our vows are not made in vain, a hundred temples, O God, of gold and marble shall arise to Thee.'[14]

Spectacle that answers the gaze

Ways of seeing reflect ways of being seen, for vision is socially constituted in a two-way process of giving and receiving. The more self-conscious a society, the more interactive the seeing/being seen becomes. Within the social networks of negotiation and exchange, shared vision, or what might be called the communal habits of attention, engenders its systems of signs and reciprocal acknowledgements. The Republic of Venice invited its inhabitants and visitors to experience it as spectacle, heightening the sense of the world as something that seems to look back, to return the gaze, to mirror and enhance consciousness.[15] Venetian festivals, whatever the propaganda of their staging, kindled participation. Writing from Venice in 1364, just after the Cretan rebellion had been quashed, Petrarch caught the mood of intense urban self-awareness in his eyewitness account of the festivities in Piazza San Marco: 'Under our eyes the swarming, well-mannered offspring of the flourishing city augmented the joy of the festival. The general gaiety was reflected and redoubled by one's recognition of it in one's neighbour's face.'[16] For the inhabitant such a confirmation of belonging was reassuring; for the visitor it was exhilarating. For the painter, the sense that the spectacle looks back – answers vision – would allow a new match to emerge between a perceived reality and the structures of representation in paint on canvas (fig. 25). And once represented, the visual world would never look quite the same again.

How does colour enter the social formation of seeing and being seen? Does colour play any role in the subject's sense of being at home within his social space? Paradoxically, given the variety of spectral hues and the wide range of secondary and tertiary colours, of tints and gradations of hue, colour has a universalizing power based in part upon cultural and linguistic tendencies to classify it in broad families. This universalizing power of colour is reinforced by the atmospheric effects of illumination and ambient light. Illumination that is warm or cool will establish affinity amongst the lights and another affinity among the shadows, and such affinities will cut across the entities that line and shape may separate. Such patterning by chromatic light diverts attention from the practical actions of grasping or handling, towards a more distant, more leisurely, less consumer-oriented appreciation of the visual. It is nothing less than a reorientation of the person, a lifting of the subject away from the immediacy, urgent and physical, of touching or eating. The contentment, the promise that all is right with the world, that all belongs together, which is produced by certain qualities of illumination, such as a radiant sky near to sundown, is a common experience.[17] By harmonies of colour the painter extends such a promise and thereby reinforces myths of political serenity amongst city and citizens. Venice, through its setting and its politics, creates a unique relation between the subject – as citizen-inhabitant and viewer – and the object viewed – the city, the work of art. Colour plays a role in this special subjectivity, operating at a subliminal level of shared experience of the climate and atmosphere of the lagoon (which in pictorial terms harmonizes colour by interweaving reflections, by softening and blending) and at the conscious level of ensign in clothes, in flags and even in the carpets hung from the balconies.

Colour is worn and manipulated, as well as seen, and every subject, as well as every person viewed, possesses colour, is born into colour, through pigmentation of skin, of eyes and hair. Of course there is no beginning to this story, no original moment of unprejudiced response to colour. In Renaissance Venice, to an unusual degree, thanks to its production of mirrors (see chapter 5), as well as its production of portraits, this interaction of seeing and being seen extends to the individual person, but attitudes to the colour of the person are

social before they are individual. In the environment of the lagoon, in which colour is unusually unstable, the demarcation between the natural and the cultural can be shifted, and will be shifted, with little fear of detection. The famed beauty of Venice as city readily embraces Venice as congregation of bodies, thus the beautiful women of Venice were frequently paraded as tokens of its wealth and refinement when foreigners visited. Few would have objected to the fact that the hair of these women was frequently dyed – blonde, ash or auburn – for this was but one refinement that Venetians could perform upon nature.

Encountering difference

How did the sensibilities, the cognitive skills, the prejudices, the hierarchies of values of the inhabitants of Renaissance Venice develop? Over time systems of trade and modes of manufacture influence habits of perception, systems of values and styles of living. Medieval and Renaissance Venice was pre-eminently an entrepôt, a centre of exchange between the Orient and Europe: already in 1404 Giovanni Conversino da Ravenna described it as an international emporium.[18] As a place of meeting between Orient and Occident, home to many foreign communities, comparatively safe ghetto for Jews, staging post for pilgrims to the Holy Land, trading post for German and Netherlandish merchants, Venice was a city which made men aware of identity and difference. It seems appropriate that the twelfth-century mosaics of the Pentecost dome of San Marco include an unusually complete set of the nations to whom the Apostles spoke in tongues. Sixteen nations, a pair of figures representing each, fill the spaces between the windows at the base of the dome. The Egyptians (fig. 26) are rendered as dark-skinned Moors, which, as Otto Demus pointed out, shows 'that there was no ethnographic basis for the choice of types and costumes', but nevertheless indicates a typically Venetian 'pseudo-realism' in marking difference between nations.[19] In fact heterogeneity in Venice was far from random: variations in colour, whether in the pigmentation of skin, in costume or in merchandise, could be judged and interpreted. Magistracies, political organizations, guild regulations and social divisions ensured a

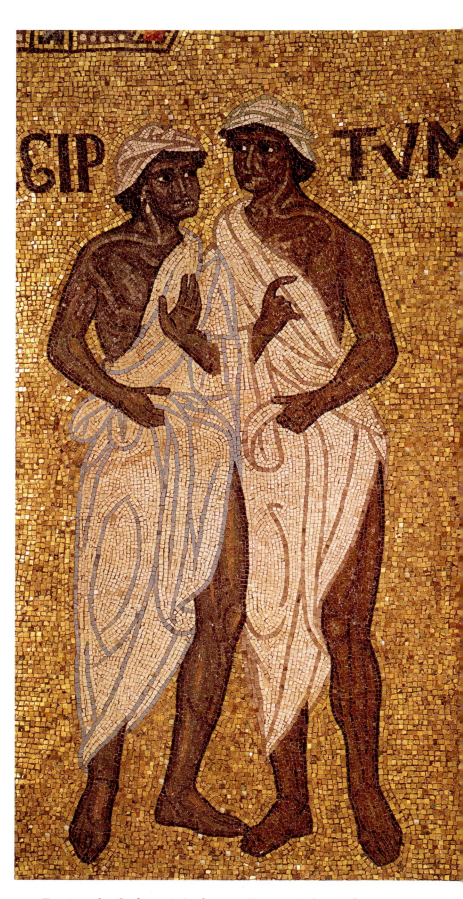

26 *Egyptians*, detail of mosaic in the west (Pentecost) dome of San Marco (first half of twelfth century).

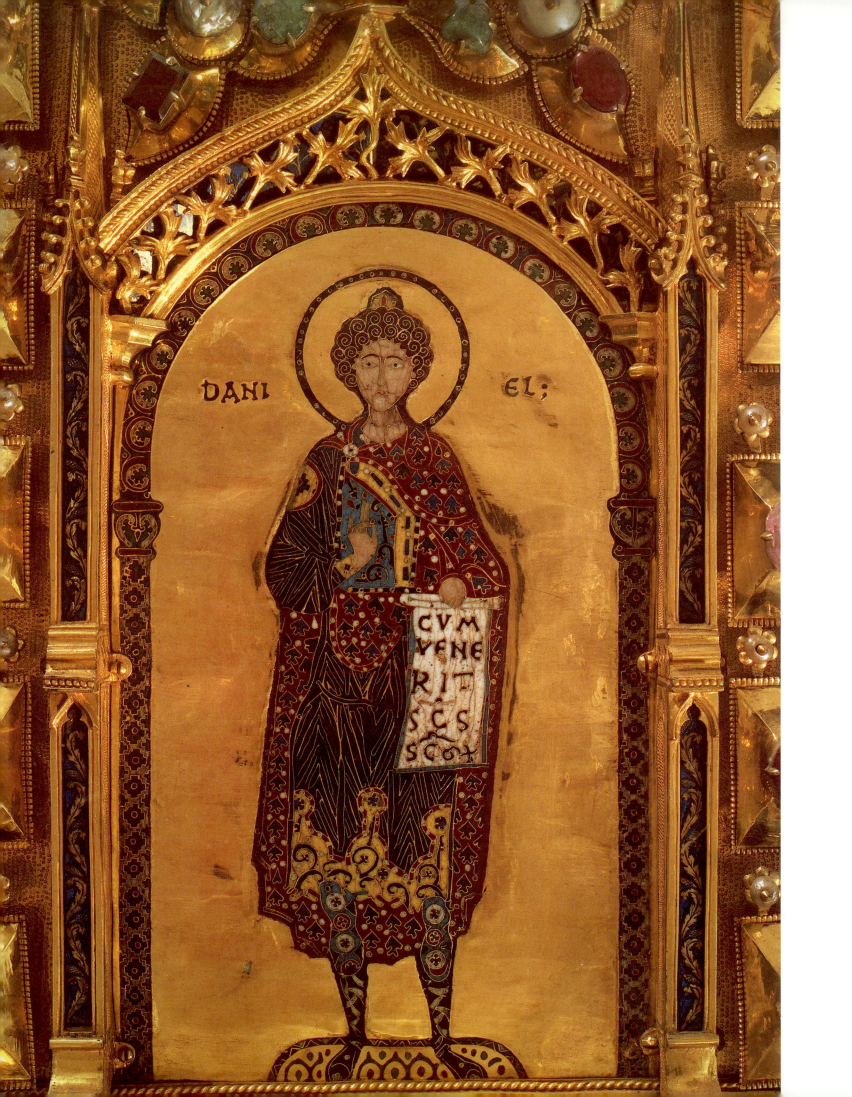

structure in which men could negotiate, agree deals, know the rules. Above all it was a city where exchange values would predominate over use values; a city where the mechanisms of money, banking and trade separate manufacturing from consuming. In Venice, a site where not just building materials but diverse objects, especially luxuries worth transporting half way round the known world, were set apart from their origins, mercantile and aesthetic attitudes grew up together. Colour as gratuitous will be valued here.

Counterfeit and accumulation

As traders and dealers, bringing manifold wares – textiles, ceramics, marbles – to the city, Venetians were precocious in nurturing the collector's mentality. As early as the mid-fourteenth century Oliviero Forzetta came from nearby Treviso to Venice to buy antiquities, including cameos, coins, gems and statues.[20] By the end of the fifteenth century the trade in antiquities was flourishing. Now the collector, like the merchant, does not necessarily buy something so that he can use it for the purpose for which it was originally made. The coins the antiquarian buys have value but are no longer common currency; the significance an antique cameo held for a Renaissance collector differs from that which it held for its first wearer; in this slippage between original meaning, or original use, and later appreciation the aesthetic attitude finds a place to grow.

With works of such value passing through their hands it is not surprising that Venetians should have developed their own imitations and counterfeits. In a tightly limited site the products of labour, and the social relations they involve, accumulate as works (including works of art), and these artefacts in turn become incorporated into lasting habitats, the vital deposits that constitute the visible city. As Henri Lefebvre put it, 'In the case of Venice . . . the surplus labour and the social surplus production were not only realized but for the most part expanded on the spot'.[21] In Venice the instrumentality of the world of manufacture, of labour and technique – the varied acts of doing in the lagoon city – became correlated to seeing and feeling, for what a society does with its hands conditions what it perceives with its eyes. The skill of Venetian artisans in luxury production was evident from the start of the thirteenth century when, for example, they so successfully imitated the filigree goldsmith work of earlier Mosan and Rhenish models that they established an export market to northern Europe. Venetian counterfeits, in a sense, usurped their original models. *Opus venetum ad filum*, as the Venetian goldsmiths' filigree was called, became famous.[22] When the Pala d'Oro of San Marco was remodelled in the fourteenth century the Byzantine enamels were framed in Venetian filigree (fig. 27) in a remarkable fusion of Byzantine and Western styles.

Artefacts, the products of labour, both embody and displace social relations. In positing that what a society does with its hands affects what it esteems with its eyes, it must be recognized that the artisans were not usually those who traded, appropriated or ultimately enjoyed the products of labour. But in medieval and Renaissance Venice the sedimentation of artefacts within the city worked to disguise their origin in labour and to absorb them into communal pride and property. This chapter has touched on how the geography of Venice contributed to this by blurring the distinction between art and nature: equally important was the role of civic piety as focused by one building, the state church of San Marco, where marbles and mosaics were absorbed into a kaleidoscope of colours and lights. In Venice Christian devotion is framed and coloured by the visual experience of San Marco: in the emergence of a Venetian aesthetic the mercantile and the religious are entwined.

27 San Marco, detail of Pala d'Oro with blue enamel and filigree, Venetian goldsmiths' work of 1342, framing earlier enamels of Byzantine origin.

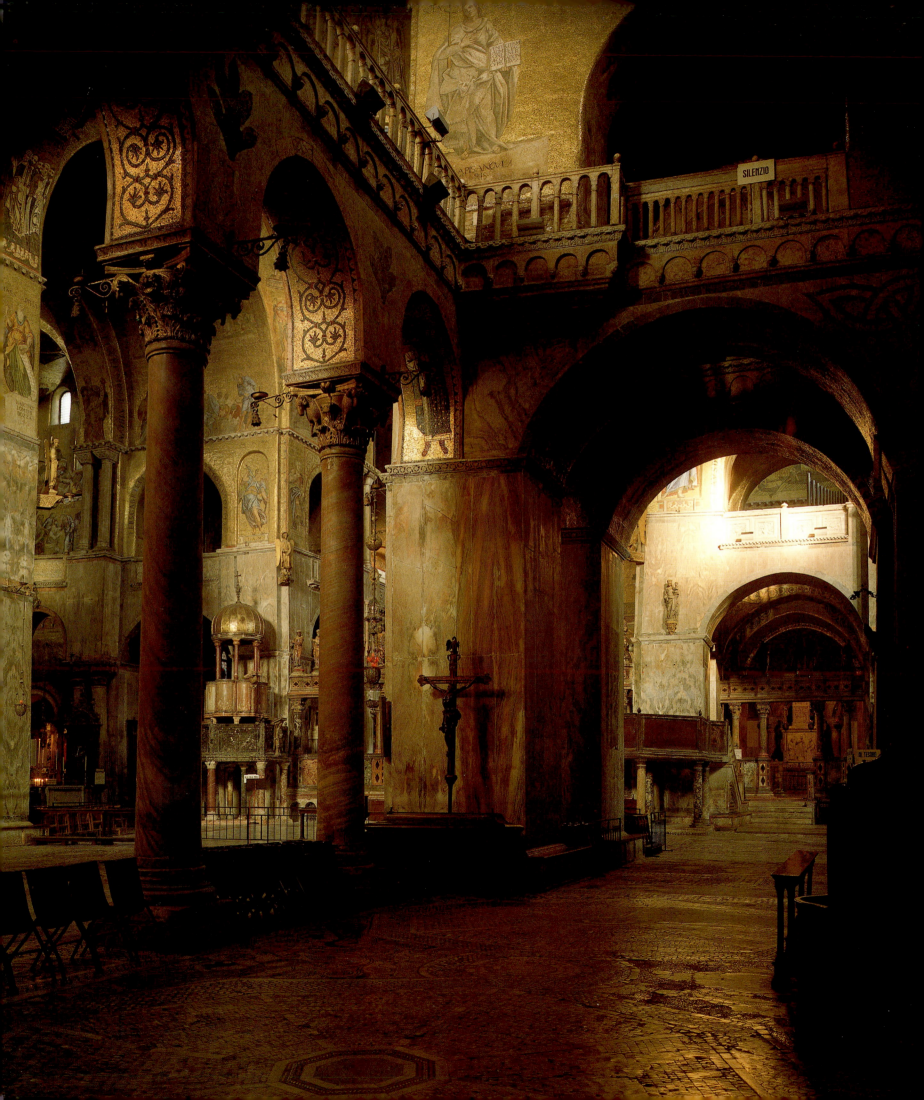

SAN MARCO: MARBLES AND MOSAICS

'The jewels of the Signoria'

The prime focus of Venetian communal pride was the chapel of the doge, the shrine to one of the four evangelists, the state church of San Marco (fig. 29). In this building the alliance between material value and beauty as spiritual power that underlies Venetian attitudes to colour was solemnly and splendidly manifested. Spoils were set up here. In 1204 the Venetians were diverted from the proper task of the Fourth Crusade by the tempting wealth of Constantinople. They sacked the city and brought back a treasure-trove of plunder, including gold, marbles and works of art.[1] Precious smaller items kept in the treasury of San Marco, strongly built between the church and the Palazzo Ducale, were described by the Renaissance historian and diarist Marin Sanudo as the 'jewels of the Signoria' (fig. 30).[2] The jewels (*zoie*) 'are shown', he wrote, 'to visiting lords or ambassadors, and on the eve and feast day of the Ascension and the eve and feast day of St Mark some of them are displayed for ornament upon the altar of St Mark's'. Thus the mercantile state salved its conscience, elevating loot into relics, and riches into a sign of God's favour. Sanudo's account reveals the easy coexistence of sacred and civic functions; to show a jewel for ornament, *per adornamento*, becomes as powerful as displaying the bone of a saint. The English pilgrim Sir Richard Guylforde, who passed through Venice in 1506, treated relics and jewels in the same breath: 'There be also in the churche of seynt Marke many grete relyques and jewelle. There is a great chales of fyne gold of curious werke, set with many precious stones, whiche is in heyght .iij. quarters of a yerde; it is to large to use at masse, but they use it in adhornynge the aulter at pryncypall tymes, and in theyr processyon on Corpus Xpi day . . .'[3]

So the liturgical function of a chalice in the Mass is usurped by its use for adornment or display. Following hard on Guylforde's description of chalice and candlesticks, he marvels at the crowns, pectorals and a rich cap with which every doge is crowned, 'the pryce of all whiche . . . is inestymable, for they be full set with precyous stones of the gretest valoure that may be'.

Like the collection of jewels of the Venetian Signoria, colour in San Marco is often a fortuitous result of sedimentation, not of planning. Saracenic, oriental and Western sources are interwoven in a visual bricolage. As in the Byzantine models that influenced the design of San Marco, notably the church of Holy Apostles in Constantinople as well as Hagia Sophia, the building presents an amalgam of precious materials, which forms

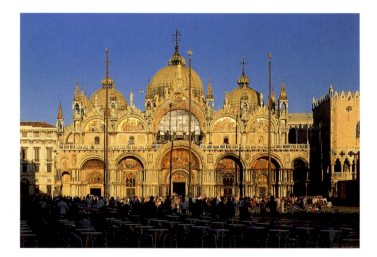

29 San Marco, general view of the west front.

28 San Marco, view of interior.

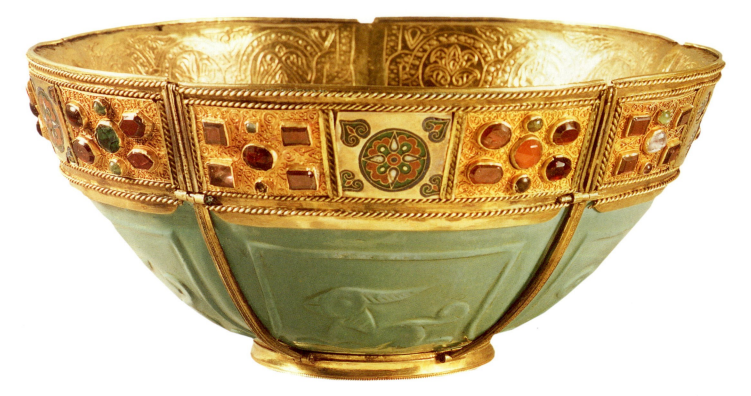

30 Turquoise glass bowl. Glass made in Iran or Iraq, ninth–tenth centuries; enamel, Byzantine, eleventh century; metalwork, tenth and (?) fifteenth centuries. Diameter 18.6 cm. Venice, Treasury of San Marco.

its own visual continuum in which pictorial elements are embedded and sometimes overwhelmed.[4] Few frames organize attention into sequential compartments, and colours are not marshalled according to the hierarchy of narrative – *historia* – and its communicative priorities. Colour, gold and marbles all function as display; they are brought together *per adornamento*.

The portico

It is more for adornment than structural necessity that the lower storey of the west front of San Marco is hedged with a double tier of columns (figs 32 and 33).[5] Set close against the marble revetment of the walls, yet fully in the round, these ranks of columns moving in and out of the recesses of the porticoes create a colourful chiaroscuro. Ruskin observed the nuanced polychromy of cylindrical shafts set close against planar revetment (fig. 31):

When there is much vacant space left behind a pillar, the shade against which it is relieved is comparatively indefinite, the eye passes by the shaft, and penetrates into the vacancy. But when a broad surface of wall is brought near the shaft, its own shadow is, in almost every effect of sunshine, so sharp and dark as to throw out its colours with the highest possible brilliancy; if there be no sunshine, the wall veil is subdued and varied by the most subtle gradations of delicate half shadow, hardly less advantageous to the shaft which it relieves . . . I do not know anything whatsoever in the whole compass of European architecture I have seen, which can for a moment be compared with the quaint shadow and delicate colour, like that of Rembrandt and Paul Veronese united, which the sun brings out as his rays move from porch to porch along the St. Mark's façade.[6]

Around the central portico, in the spandrels and upper row of columns, the resemblance is closer to

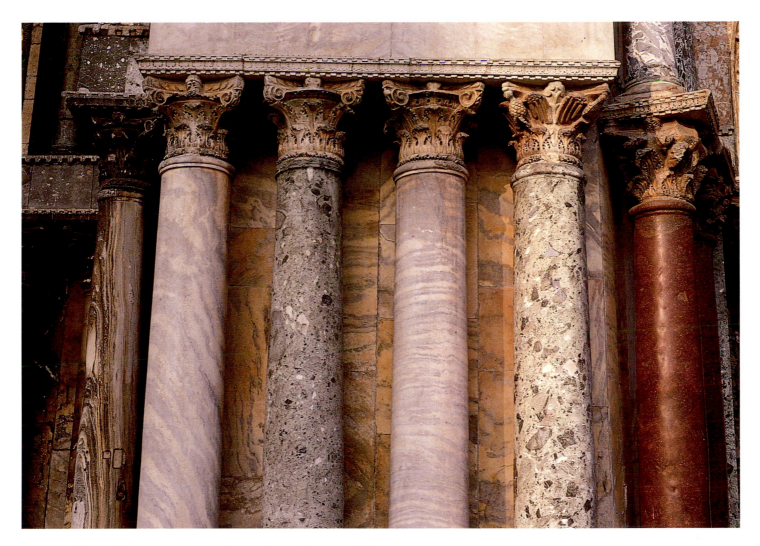

31 San Marco, Greek veined and other marble columns to left of the central portico.

Veronese's colour than to Rembrandt's (figs 34 and 35). Whether spread flat on revetments or curving on shafts, the patterns in marble mitigate the advances and recessions of architectural form. Mottling in skeins of greys and whites infiltrates the colours and tempers the shadows cast by architectural relief. The carved ornament is likely to have been gilded and polychromed as early as the thirteenth century, and appears to have been renewed in 1493–4, just before· Gentile Bellini's completed the *Procession in the Piazza San Marco* (figs 36 and 37). Analysis during the recent cleaning of the carvings on the arches shows that the marble of the reliefs was originally coated with a preparatory bole or underlay of burnt ochre and then covered with leaf gilding. This

typically Byzantine technique was applied extensively over figures and backgrounds, and integrated with a restricted polychromy for flesh and hair. Some backgrounds bear traces of original blue in varying tones made of azurite mixed with lead white. The fifteenth-century intervention reinforced the colouring, probably to affirm the peculiar splendour and 'Venetianness' of the state church: backgrounds were generally repainted, sometimes thickly, with azurite; the fields of the carved panels were painted red with a mixture of cinnabar and a little red ochre; touches of red lake were applied in the manner of the panel painter to add glowing depth. The regilding of the 1490s was more fiery than the original, for it was applied either over an orange

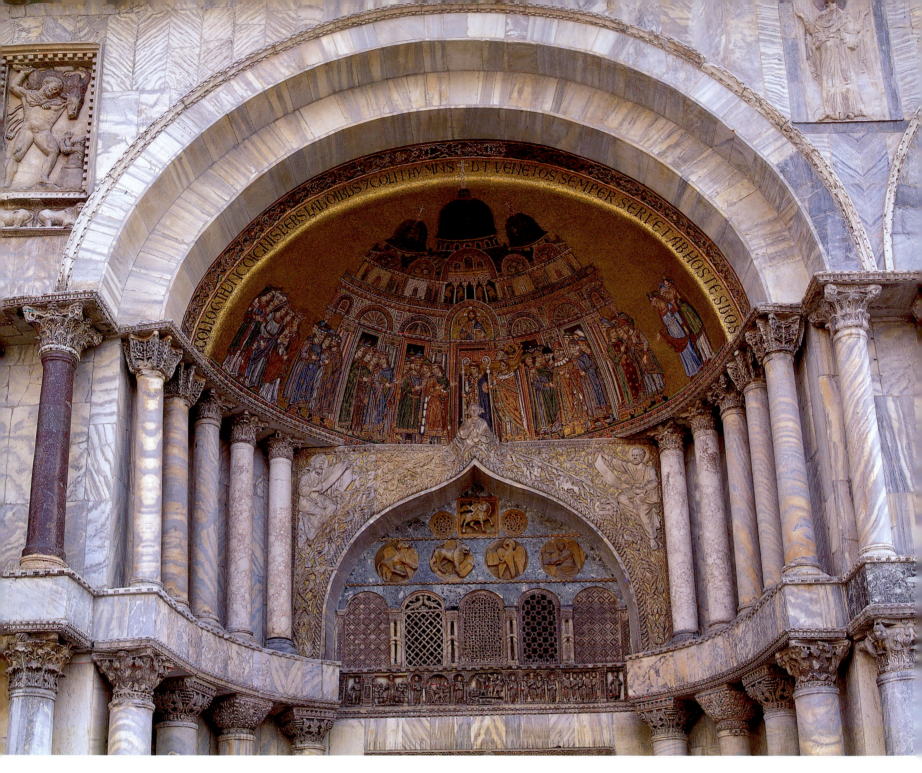

32 San Marco, Porta di Sant'Alipio, with flanking columns (twelfth to early thirteenth centuries).

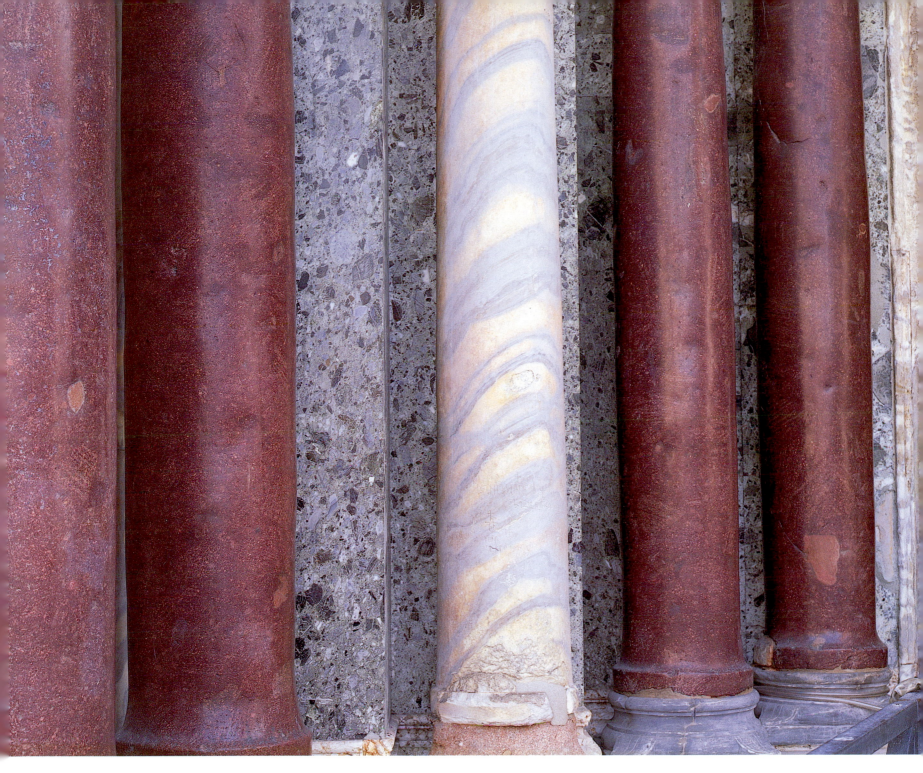

33 San Marco, porphyry and Greek veined marble columns against *verde antico* around central portico of San Marco (twelfth to early thirteenth centuries using earlier materials).

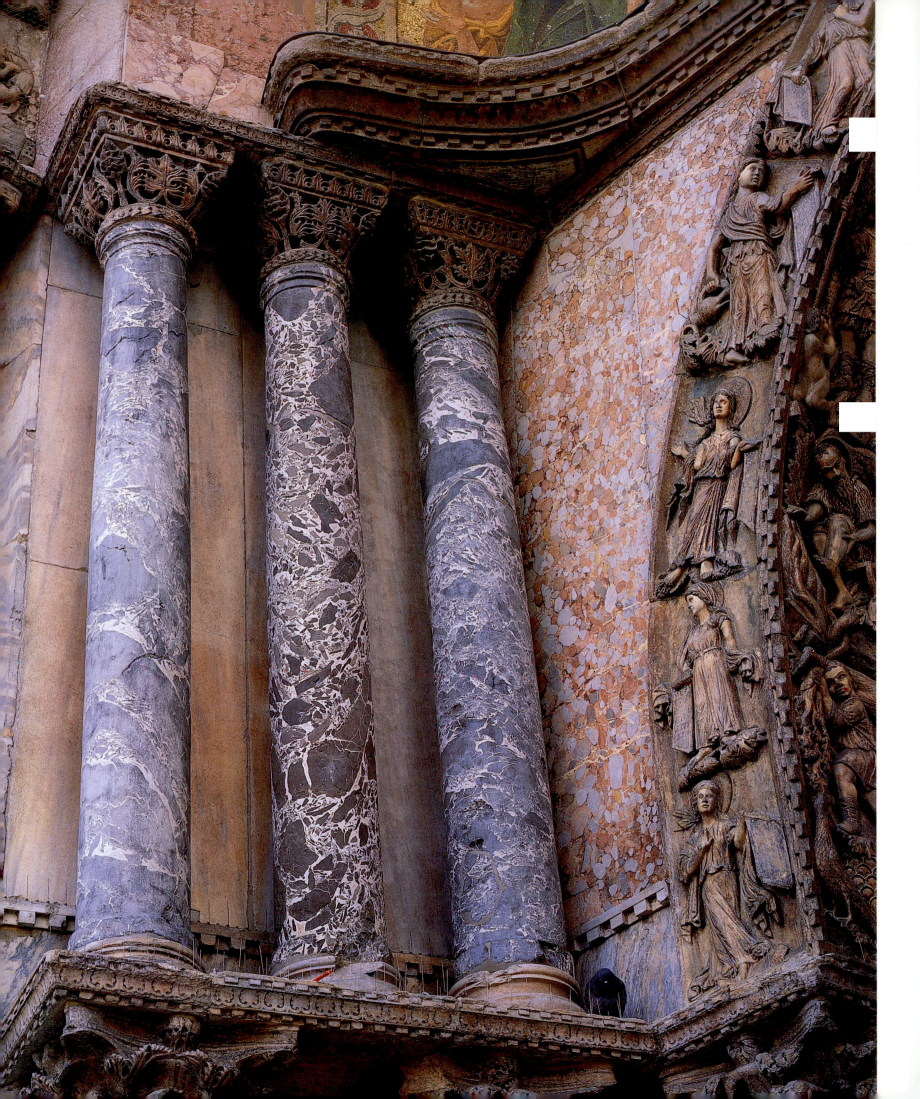

35 Paolo Veronese, *Hermes, Herse and Aglauros* (*c.*1580). Canvas, 232.4 × 173 cm. Cambridge, Fitzwilliam Museum.

34 *(facing page)* San Marco, central portico, upper tier of columns.

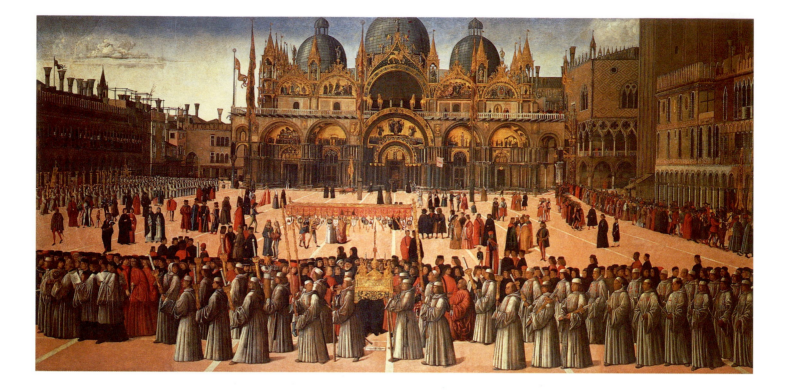

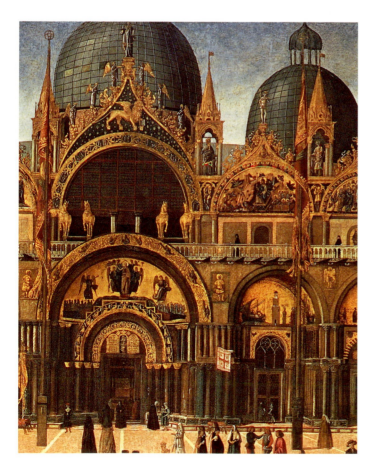

36 Gentile Bellini, *Procession in Piazza San Marco* (1496). Canvas 367 × 745 cm. Venice, Accademia.

37 *(left)* Gentile Bellini, detail of fig. 36, showing the central portico of San Marco.

preparation of minium with some lead white, or – less extensively – over red bole.[7]

By 1300 widespread gilding of sculptural ornament, notably capitals, confounded the shadows, transforming chiaroscuro into an interlocking jigsaw of negative and positive shapes. Lower down, around the doorway, colourful greys give way to the solemn tones of porphyry columns set against facings of green breccias and *verde antico* (fig. 39).[8] Such a contrast of purple maroon against dark green will reappear in the paintings of Giovanni Bellini (fig. 38).

38 *(facing page left)* Giovanni Bellini, detail of fig. 18.

39 *(facing page right)* San Marco, porphyry and Greek veined marble columns against *verde antico* around the central portico.

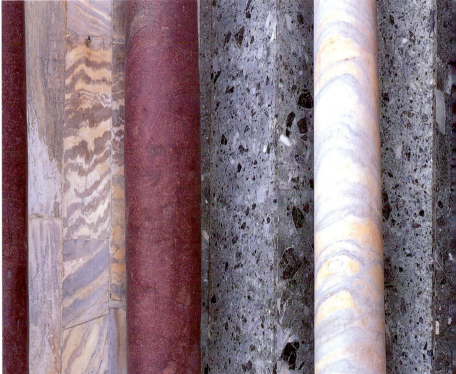

The pavement

To pass from the brightness of Piazza San Marco, through the comparative darkness of the atrium, into the greater dimness of the main vessel of the church is an optical experience described in one of John Ruskin's set pieces (figs 40 and 41). He evoked the impression of the interior upon first entering:

> It is lost in still deeper twilight, to which the eye must be accustomed for some moments before the form of the building can be traced; and then there opens before us a vast cave, hewn out into the form of a Cross, and divided into shadowy aisles by many pillars. Round the domes of its roof the light enters only through narrow apertures like large stars; and

40 San Marco, nave from the south aisle looking towards the entrance.

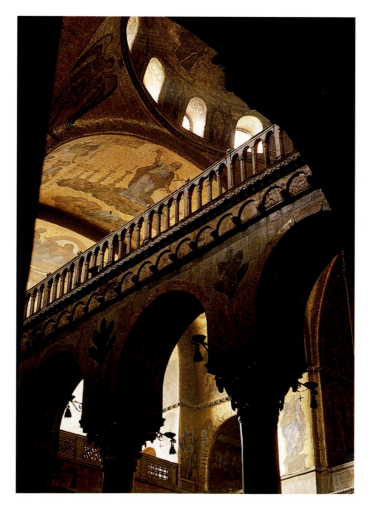

here and there a ray or two from some far-away casement wanders into the darkness, and casts a narrow phosphoric stream upon the waves of marble that heave and fall in a thousand colours along the floor. What else there is of light there is from torches, or silver lamps, burning ceaselessly in the recesses of the chapels; the roof sheeted with gold, and the polished walls covered with alabaster, give back at every curve and angle some feeble gleaming to the flames; and the glories round the heads of the sculptured saints flash upon us as we pass them, and sink again into gloom.[9]

In this twilight it is hard to tell where changes in colour end and effects of illumination begin. Subdued hues blend into shifting tones of gold, brown, dull rose, purple and grey. Only on the colours in the marbles on the pavement is there sharper definition, a reassuring resistance and support given by the manifold geometric interlocking of chequers, triangles, diamonds and lozenges (fig. 42). This floor has been remade over the centuries; the floor in Santa Maria e Donato in Murano, also of the early to mid-twelfth century, has been less drastically restored, so by taking them together some observations may be made.[10]

In common with nearly all medieval pavements the governing principle of design is essentially tonal: marbles are graded according to their place on a light–dark scale and distributed in the pattern that draws attention to the linear junctions between each slab or tessera of marble. Whether the units are the larger cut marbles for *opus sectile* or the predominantly black and white smaller tesserae for *opus tessellatum* and the sinuous or 'wormlike' *opus vermiculatum*, their cutting is sharp and regular (figs 43 and 44). Variation of hue enriches this linear geometry without obscuring it. Many patterns, especially the circular ones, are constructed with a 'field' of pale grey marble rhythmically interspersed by the 'figure' of coloured marbles of many different types, all of which are, to varying degrees, darker than the pale grey. Figure and field may interchange, tonal contrast remains.

In the sections of polychrome infill, two of the most esteemed and adamantine marbles of antiquity, purple and green porphyry (the latter now called serpentine), are paired in symmetry or alternation. Such regular

41 Interior of San Marco from the west door.

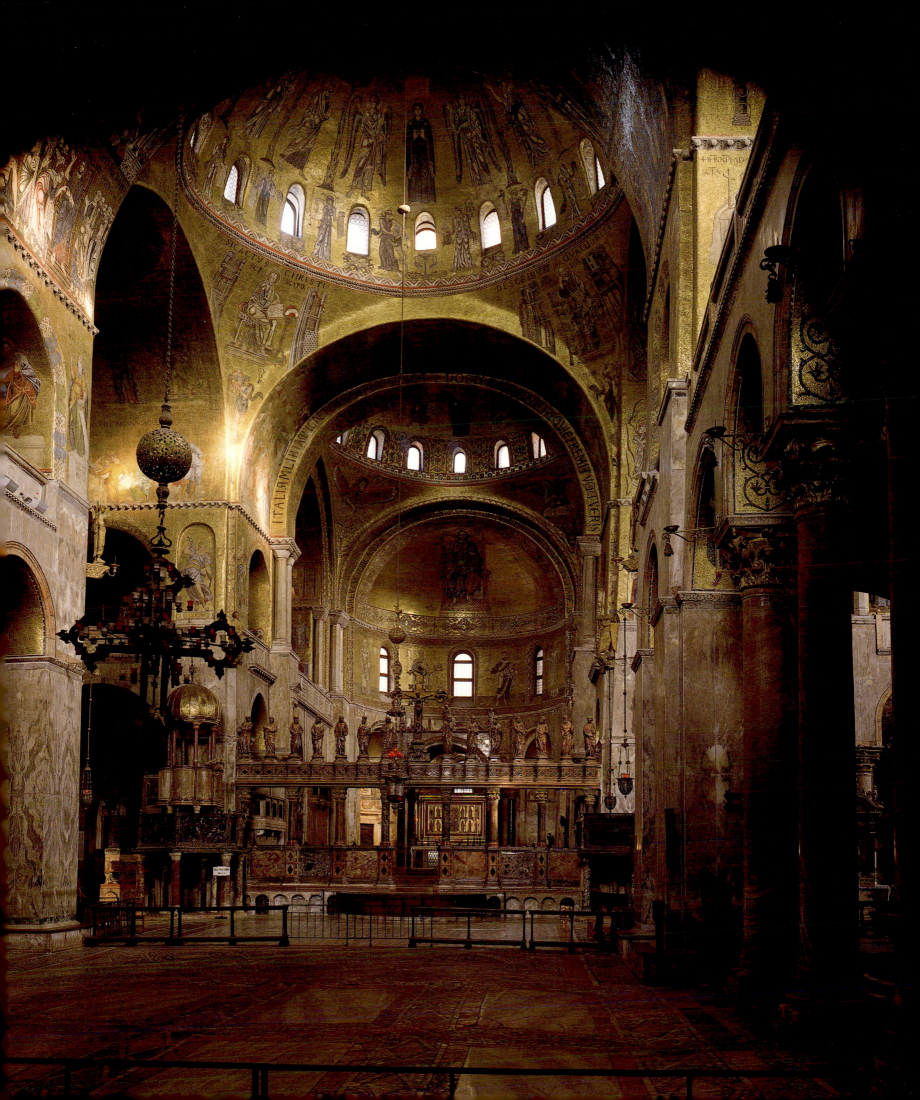

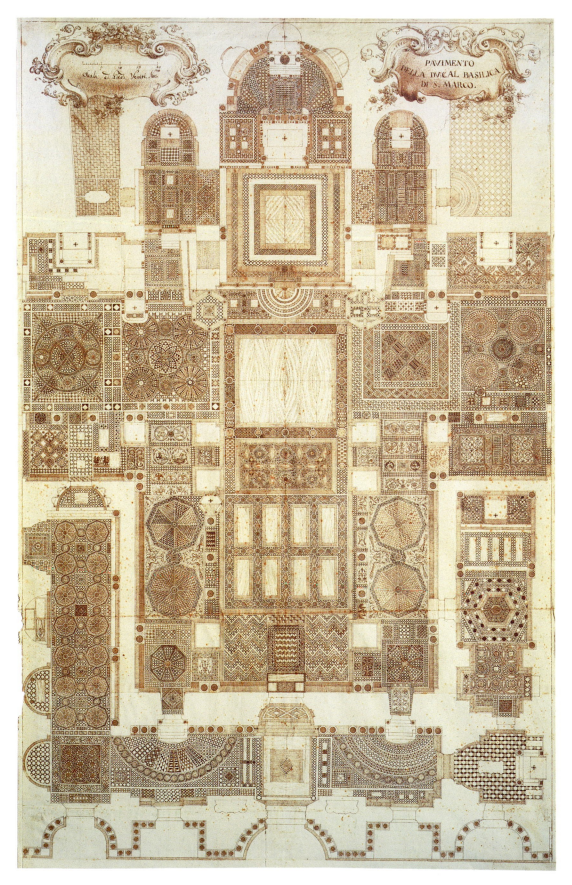

42 San Marco, plan of the pavement drawn by Antonio Visentini (1750). Venice, Museo Correr.

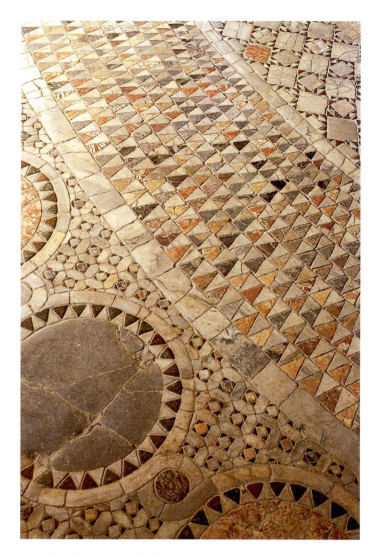

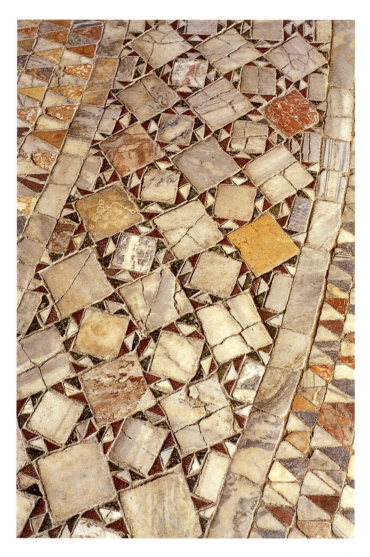

43 San Marco, detail of floor with interlaced circles.

44 San Marco, detail of floor with *opus Alexandrinum* (twelfth century, restored).

juxtaposition of porphyry and serpentine is typical of *opus sectile* floors, such as those made by the Cosmati in Rome; in San Marco it reiterates the contrast of purple-maroon and dark green announced around the portico.

The floor combines influences from the Byzantine east and Latin west. The compositions centred on interlaced circles derive from Byzantine models; the animals and foliage (fig. 45), the only figurative elements, as well as the geometric infill sections are closer to Western models. The coupling of the two entails alternations between polychrome areas, normally in the larger *opus sectile*, and areas that are predominantly black and white

with some red, normally in the denser mesh of dice-like cubes of *opus tessellatum*. Descended ultimately from the black-and-white floors of the Romans, the white fields of the *opus tessellatum* – minutely criss-crossed by the greyer mortar – engender the vibrancy of white light, against which animals, birds and foliage are virtually silhouetted. Quite often some black and white chequerwork is included within the area of figure creating an effect of diaphanous cells through which the light of the ground shines.

The conjunction between the two scales of mesh in *opus sectile* and *opus tessellatum* is highly characteristic of Venetian twelfth-century floor design. Today the best

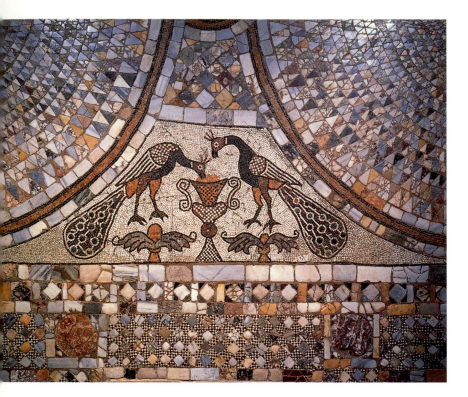

preserved examples are to be seen in Santa Maria e Donato, the cathedral of Murano. Tiny chequers alternating with little flags of grey marble fracture the light and set up oscillation in the depth of field. Perceptually a fascinating shift occurs: whereas the little flags of *opus sectile* – predominantly in grey marble from Proconnesos on the island of Marmara – read as marble, the finer mesh of black and white reads almost as an effect of illumination. Within the compass of a single floor, colour is perceived as in one place inhering in marble, while in another it is effaced by the brilliant interchange of light and dark. In *opus sectile* marble is seen as marble; in *opus tessellatum* it may be read as an effect of light.

Not until the sixteenth century when Venetians began to exploit impastoed lead white in oil on canvas, were such brilliant oppositions of black and white achieved in painting. Titian discovered the value of *contre-jour* and how it allies surface and depth by the juxtaposition of lightness and darkness (fig. 46).

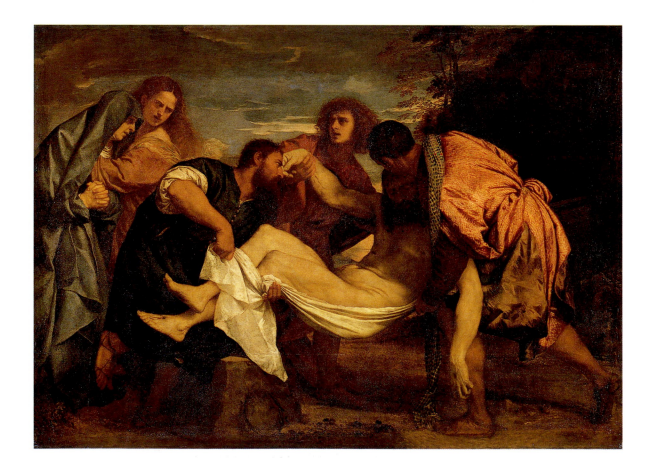

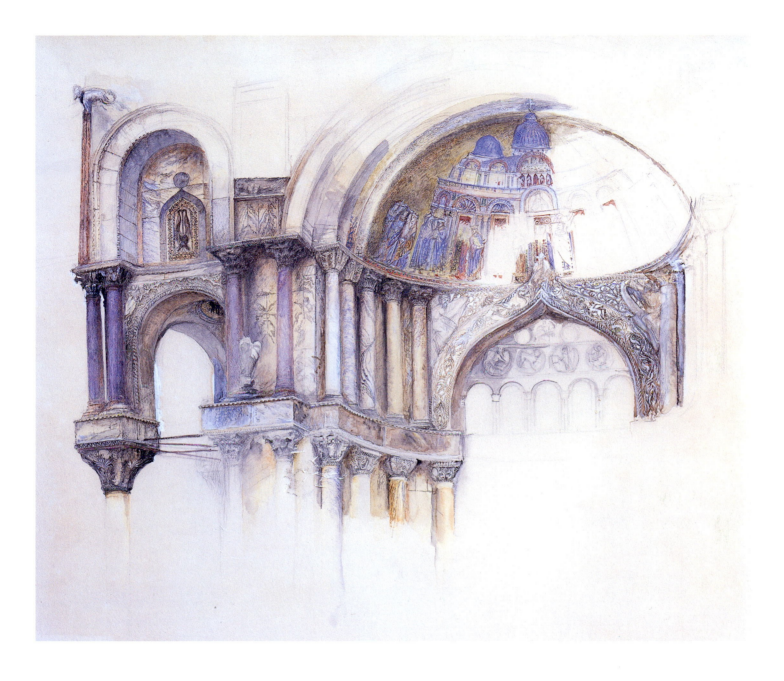

47 John Ruskin, *Northwest Portico and Part of the First Porch of Saint Mark's* (1877). Pencil and watercolour heightened with white on paper, 64.8 × 76.8 cm. The Ruskin Foundation (Ruskin Library, University of Lancaster).

45 *(facing page top)* Santa Maria e Donato, Murano, floor with peacocks at the fountain and chequer in *opus tessellatum* (twelfth century).

46 *(facing page bottom)* Titian, *Entombment of Christ* (c.1520). Canvas, 148 × 212 cm. Paris, Louvre.

Another comparison with the floor may be drawn. Ruskin rightly observed that dentil moulding is very widely used on the façade of San Marco, and he traced instances where one could just make out that the forward face of the dentils were gilded and the recesses between them painted in dark blue (fig. 47). Such regular alternation of a rectangle of splendid gold and recess of shadowy blue on a scale of little over a finger-tip's width lent a special micro-rhythm to the architecture. It is the heart-beat – light/dark, light/dark, gold/blue, gold/blue – throbbing endlessly, its

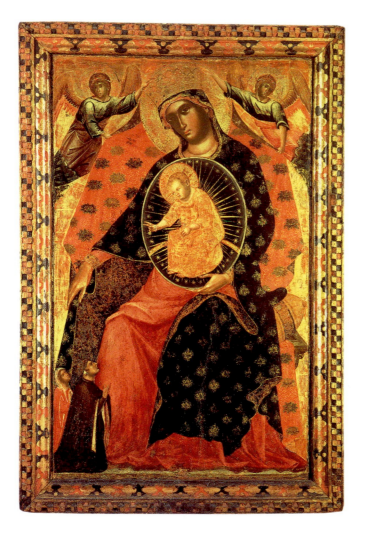

sandy breccias, were more randomly interspersed (figs 49–52). Their veins and salami-like markings are bigger, more bulging and vary from piece to piece. Such markings, mottles, freckles and speckles, introduce organic gradation into the geometric order of colour and tone.

In most of the marbles on the floor each sample consists of one hue rather than a rainbow array, and where, as in an onyx, there may be an alliance of rust reds and yellows, the hues are from neighbouring sections of the spectrum. In the limestones and breccias their auburns, browns and ochres appear dominated by no more than two or three shades of one colour.[11] Most commonly, gradation in marble is the result of veining with relatively colourless greys and whites, and sometimes blacks. In short, the amount of pure hue in any marble is limited; the *appearance* of chromatic richness is due to the modulation of hue by veins of relatively colourless whites, greys and some blacks. In addition, the coloured marbles are framed and set off by the 'field' of pale grey and the punctuation of black. Of the Venetian painters, it is Veronese who learned to increase brilliance and variety of colour by extensive deployment of intervening greys, as well as by strict adherence to boundaries.

A further point (again pertinent to Veronese) may be added, and concerns the absence of blue. As Blagrove pointed out in his concise nineteenth-century handbook on marble decoration, 'Pure blue in any considerable size is never found, all the so-called blue marbles being greyish or slate-coloured'.[12] In the absence of pure blues on the pavement, the greys will take on some hint of blue by complementary contrast if they are near yellows and browns. In Venetian Gothic architecture, on the other hand, the absence of blue in marble is made up by the extensive painting of blue on the recessed parts of mouldings, which inhibits the production of optical blues in the marble itself. For the late Gothic period the extremes of light and dark are represented (decoratively at least) by the contrast of gold and ultramarine: it was not until the later fifteenth century (and then not universally) that the tone of marbles, particularly white and black ones, was again esteemed, thereby restoring to grey marbles a positive value in taking on shades of optical coloration.

★ ★ ★

48 Paolo Veneziano, *Madonna and Child with Donor* (mid-fourteenth century). Panel, 142 × 92 cm. Venice, Accademia.

regularity contrasting with the veins of marble. The dentil, adapted into a billet moulding and similarly polychromed, punctuates the gilded frames of Paolo (fig. 48) and Lorenzo Veneziano, and the same chequers of the billet run in endless repetition as rectangular frames around windows, doors and inset panels in Venetian Gothic architecture. Although occurring in a quite different context, this Venetian moulding recalls the geometric alternation of black and white tesserae, in chequers or in serrated edges, which are characteristic of *opus tesselatum*.

On the pavement of San Marco, whereas the relatively homogenous porphyries were given regular positions, other marbles, notably the duller reds and the

50, 51 and 52 San Marco, floor of the atrium.

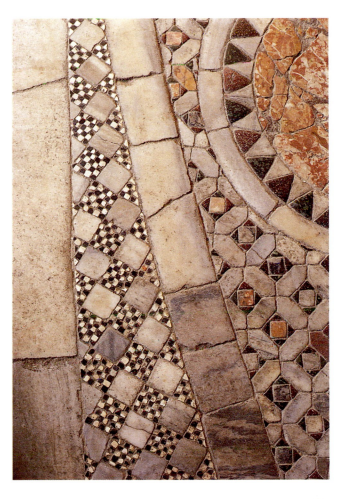

49 *(below)* San Marco, floor of the atrium with coral breccia
(twelfth to thirteenth centuries, relaid in twentieth century).

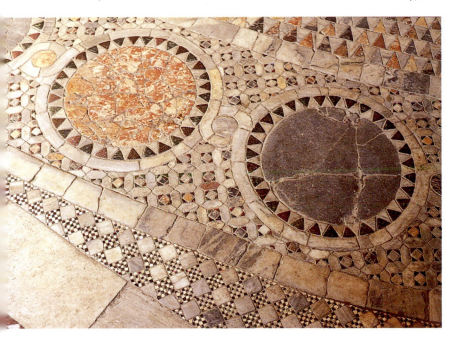

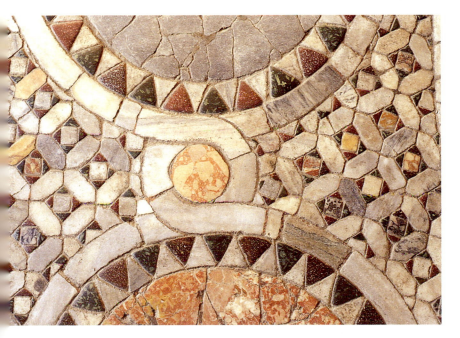

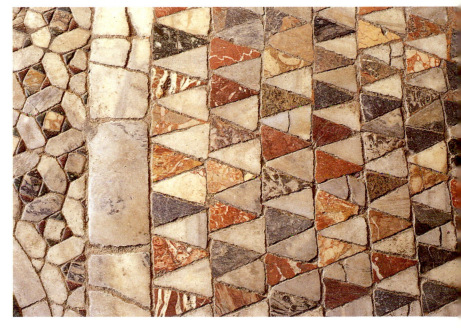

The revetment of the walls

On the walls of San Marco, the linear breaks between tesserae characteristic of the floor, give way to grander organic waves in the scantlings of marble that encase the brickwork. Expansive pictorialism replaces geometric definition. Francesco Sansovino, in his sixteenth-century account of the city, described the marble sheets as 'tavole d'assai honesta grandezza', employing the same word, *tavole*, as is used to designate panel paintings.[13]

A revetment of marble clads the building to the height of the galleries. Sansovino indicated that the cladding is so complete and so snugly fitted that no bricks or mortar are anywhere to be seen. Brought as precious cargo from the East, these marbles were cut into thin sheets and arranged in pairs or quartets, their sutures as inconspicuous as possible, and the pattern of their veins unfolding symmetrically across the walls in a series of great butterfly wings. The effect of this marmoreal damasking is to introduce an undulating, gravity-defying lightness into the monumental masses of the architecture. For the Victorian architect G. E. Street the lightness suggested by marble veneer was appropriate only in limited positions. 'In Venice', he declared, 'we have some grand examples, at St. Mark's, of this system of encrustation filling in the whole of the space within large arches; here it is lawful, because we have no weight upon it to thrust it out of its place or disjoint it, as the least pressure most certainly always will. So far in praise of the Venetian system.'[14] Elsewhere, as on arches and piers, such use of veneer was illegitimate for Street.

What the Victorian moralist could not countenance – the denial of the weight of the structure – was the very quality that the Byzantine Procopius in his account of the sixth-century church of Hagia Sophia admired. He wrote of the great church in Constantinople:

> Rising above this circle is an enormous spherical dome which makes the building exceptionally beautiful. It seems not to be founded on solid masonry, but to be suspended from heaven by that golden chain and so cover the space. All of these elements, marvellously fitted together in mid-air, suspended from one another and reposing only on the parts adjacent to them, produce a unified and most remarkable harmony in the work, and yet do not

allow the spectators to rest their gaze on any one of them for a length of time, but each detail readily attracts and draws the eye to itself. Thus the vision constantly shifts round, and the beholders are quite unable to select any particular element which they might admire more than all the others.[15]

Procopius' account of how the interior of a Byzantine domed church creates a floating lightness, and in the spectator a continually shifting attention, could equally be applied to San Marco. A Venetian painter such as Tintoretto understood much better than G. E. Street the aesthetic and religious force of relief from gravity.

Evidently the Venetians of the late twelfth and thirteenth centuries, when San Marco was being vested in marbles, prized those with bold markings. (The names for marbles are confusing – ancient, Renaissance and modern names are rarely consistent. In what follows I adopt the nomenclatures used by Susan Connell in the admirable chapter on marbles in *The Employment of Sculptors and Stone-Masons in Venice in the Fifteenth Century*.)[16] Most of the revetment of the interior is *marmo greco fiorito* and *marmo greco venato*, Greek marbles in which smoky tones of grey alternate with lighter, creamier waves that glow from within; a few are in the mottled greens and corals, *verde antico* and *breccia corallina del Palatino*; some marbles are *cipollino apuano*, which resembles a slice through an onion, with green-grey veins on a greenish ground; others are *paonazzo apuano*, which are either sprinkled with blackish striations or spots, or veined in green, yellow or brown on a yellowish-white ground.

These coloured revetments mark the boundary between the hard surface of the wall and the space in front of it. Considering the scale of the building, the mouldings (fig. 53), string-courses and corbel tables, which normally assist the eye in gauging the volume of interior space, are relatively discreet in San Marco. They are neither massive in profile nor boldly distinguished in tone. Standing in the twilight of the interior induces a sense of ample containment, one body within another. The walls of the greater body, the building, may be imagined as membranes, semi-diaphanous. Henry James felt this when he wrote of the interior of San Marco, 'Beauty of surface, of tone, of

detail, of things near enough to touch and kneel upon and lean against – it is from this the effect proceeds'.[17] By touch and sight the marble veneers are located upon the inner surface of the wall, yet their patterns, mobile and undulating, offer an invitation. Some seem to pulse, contract and expand like body tissue: not surprisingly, descriptions of marble call forth similes from cuts of meat, rashers of bacon, brawn, salami, or the layers of beef fat. Other veneers – particularly the Greek grey marbles – open depths as between layers of cloud. From a distance the butterfly patterns read as an opening of the heart of things and the spreading of what was inside upon the surface.

Archetypal associations of body and marble abound. Consider onyx, the word for finger-nail applied since antiquity to a variety of quartz of similar complexion. The rituals of the commemoration and preservation of the dead in sarcophagi of stone and marble drew upon and reinforced these associations of marble and the body. When the Venetians forgot the hiding place of their most sacred relic, the body of Saint Mark, it miraculously reappeared from behind the marble veining of the column in which it lay concealed. The event, as recorded in mosaic (fig. 54), seems to symbolize the intimate bond between the body of the Evangelist and his marble-clad church.

Like the human body, the veneers of marble unfolded on the walls demonstrate symmetry. The visual litany of answering patterns is a sign of the cleavage of two halves.[18] Moving closer to the wall, marble reveals its own narratives of veiling and unveiling, as when pale crystals of feldspar loom through 'glazes' of colour; in serpentine, for example, splinters of pale green glow, embedded within the darker matrix of green. Such welling up towards the surface appears as a visual enactment of the very process of igneous formation; inviting both lateral scanning – even stroking – of surface and imaginative penetration of its veiled depths. By the late fifteenth century this looming of coloured shapes within a seemingly molten matrix was realized in Murano in chalcedony and *millefiori* glass (see chapter 5).

The configuration of edges of three-dimensional objects in a field of vision changes as an observer moves through a scene, and the visual system is programmed to correlate the changing configuration of objects with

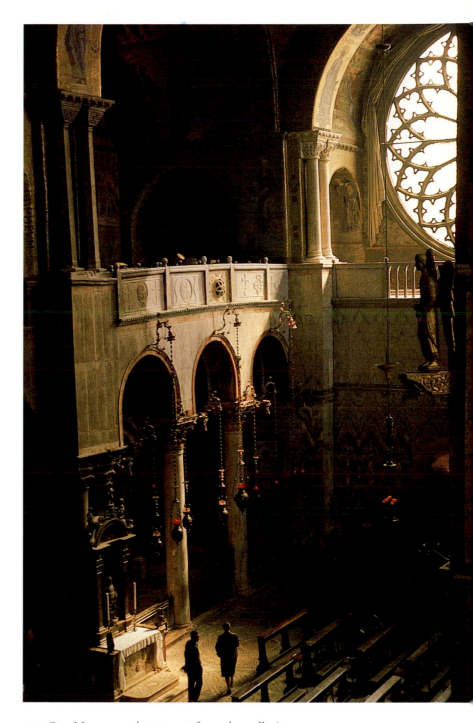

53 San Marco, south transept from the galleries.

41

·DUX·

the shifting angle of vision. By constantly gauging change in angle of vision the visual system establishes constancy in the perception of three-dimensional form. But in San Marco the pattern in the marble revetment is slow to change with a shift in the angle of vision. This means that anyone walking slowly through the interior is relatively unaware of his or her changing angle of vision. The building addresses the body as much as the eye, embedding the body within a larger unfolding.

Recent studies of visual perception have increased understanding of the how the sharp vision of the fovea (the centre of the retina) is accompanied by peripheral and para-foveal vision. The pattern of the marble revetment effectively invites the broader visual awareness of para-foveal vision. In this it prefigures the perceptual habits brought into play by the paintings of Titian.

The lower walls of San Marco, although seemingly infinite in gradations of colours, blend to a mid-tone in which grey and rose are closely keyed. No doubt the duskiness of the interior has been deepened by centuries of smoke from lamps and candles, and the waxing of the marble veneer with pork fat has turned many surfaces browner or more sallow; in the Renaissance it would not have had quite that golden dinginess beloved of Walter Sickert. Then and now the earthy rose – tending towards orange – of the *broccatello* from Verona furnishes architraves, benches, corbel tables, balustrades and simple flat bands, which delimit the larger fields of grey.

There is almost no fluting of pilasters or columns in San Marco, and in this the contrast with the twelfth- and early thirteenth-century interior of the Baptistery in Florence is instructive (fig. 55). In Florence, where the columns and pilasters are in white marble, the architectural idiom is ultimately Roman: in Venice, where columns and pier casings are in veined marbles, the architectural idiom is derived from Byzantium. Why flutings are preferred in one and not in the other tradition is explained by Blagrove in his handbook for students:

54 *(facing page)* *Apparition of the Relics of Saint Mark*, thirteenth-century mosaic in the south transept of San Marco.

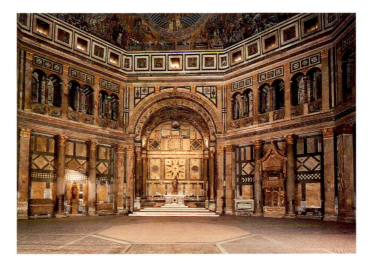

55 Interior of the Baptistery in Florence (mainly twelfth century).

56 San Marco, north arcade of the nave.

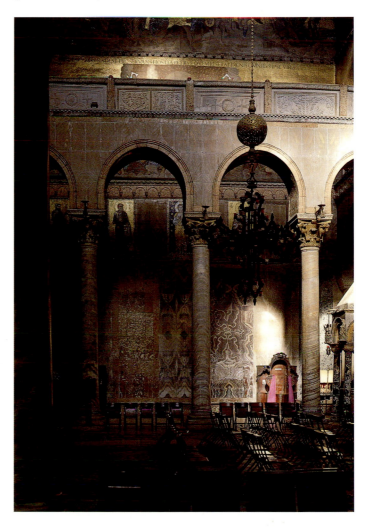

Flutings, like mouldings and enrichments, are extremely effective in columns of white or pale uni-coloured marble. But in marbles of strong, dark colours, flutings become almost invisible when viewed from a short distance, especially if they are executed in polished work. Again, if the marble, whether dark or light in colour, has a pattern of veins or alternations of colour, the effect of flutings is to cause kinks or notches to appear in the veins or markings, and to destroy the unity of pattern. As a general rule, therefore, flutings in marble columns and pilasters must be pronounced undesirable.[19]

Intervening within the space of San Marco, between the nave and the revetments of the aisles, are the unfluted marble cylinders of the columns. Those in the north arcade of the nave, of Greek veined marbles, are particularly beautiful. Ruskin's designation of them as alabaster has been contested by Seipp, but they certainly have alabaster-like qualities.[20] The upstanding monolith of column is swathed by the horizontal drift of the markings, the convexity of the shaft bowing the veins into ascending arcs of grey and cream, reminiscent of an evening sky barred by pearly strands of cloud, and like such a sky, the lucidity of bands of grey and cream creates a tranquil spaciousness. Any shadow on the cur-vature of the column is mitigated by the softly reflected lights of the interior and by the translucency of the marble itself. Of course the colour of Greek marble varies according to the light incident upon and trans-mitted back from within the crystals. As John Unrau, walking in the steps of Ruskin, observed of his own photograph of the north arcade, taken by natural light (fig. 56), 'The variation in these three identical shafts is remarkable: the greyish-pink of the most brightly-lit one on the right becoming a rusty orange in the darkest on the left, while its flax-blue veins have become a blackish blue'.[21]

On the crystalline surface of the columns some vein-ings register convexity like a sectional line, others tease the eye with loops and billows. Hard rotundities melt or flatten like a sail bereft of wind. Moving down the nave, seeing a little further round each column, losing a little as the far side curves out of sight (but not out of memory) so the drift of the markings unravels, the arcing pattern of the columns cutting across, tempo-rarily occluding, the larger symmetries of the wall-slabs. By such inter-rhyming of waves on marble, the inter-vening air itself becomes gently scarfed with colour. Henry James fed his eyes 'on the molten colour that drops from the hollow vaults and thickens the air with its richness': indeed, where orientation of surface is understated, uncertain, even camouflaged, colour may float detached from surface, hang in the air. It is a kinetic experience, albeit an adagio, that would have been enjoyed by many Venetian patricians and *cittadini* when they processed, with long gowns slowly swaying, through their state church.

Interpretation

Pictorial evidence of the reactions of Venetians over the centuries to the beauty of San Marco is plentiful, whereas written testimony tends to be disappointingly general or derivative. There is, to my knowledge, no specifically Venetian medieval text, such as exists in the writings of Abbot Suger about St Denis, that interprets or explains fully the marbles of San Marco. It may be supposed that in the aftermath of the Fourth Crusade, those responsible for revetting the building with marbles brought from Constantinople were well aware that they were following the precedent of Hagia Sophia and other early Byzantine churches.[22] When Pietro Contarini (1477–1543) described the marbles of San Marco in his *L'Argoa volgar* his account is reminiscent of Paul the Silentiary's sixth-century description of Hagia Sophia.[23] What impressed Contarini about the façade of the Venetian church was the sheer variety of marbles brought from all corners of the earth, and it was this far-flung origin of beautiful marbles that became a sign for the Renaissance commentator of the reach in time and space of Venetian dominion. Such perceptions were mediated by a reading of Pliny the Elder's *Natural History*. Pietro Contarini's catalogue of marbles is entirely dependent on book XXXVI of Pliny.[24]

As far as the pictorial qualities of marble are concerned, there are diverse written sources that indi-cate a tradition of imaginative response. They belong to a common Christian heritage rather than a specifically Venetian orbit. John Gage has drawn attention to the *titulus* or inscription, which refers chiefly to a marble

revetment, in the ruined fifth-century church of Saint Andrew the Apostle in Ravenna: 'Either light is born here, or, confined here, rules freely. Perhaps it is the earlier light, whence comes now the beauty of the sky. Perhaps the modest walls generate the splendour of daylight, now that external rays are excluded. See the marble blossom, a quiet glow, and the reflections from every compartment of the purple vault.'[25]

When interpreting the marbles in San Marco two broad points should be kept in mind. The first is the tradition of drawing upon gemstones as similes of the divine: Saint John had written in the Apocalypse that he who sat upon the throne 'appeared like jasper and carnelian' (Revelation 4:3).[26] The second is the tradition of reading into marbles, or the effect of marbles, similes of daylight, fire or cloud. The Ravenna *titulus* speaks of the walls generating the splendour of daylight, and, as Gage remarked, 'the conceit that the church interior rivalled the light of day was one which became a commonplace in early medieval aesthetics'.[27] In the biblical exegesis of Rabanus Maurus there was frequent play on stone, fire and cloud, and their manifestation in the form of a column.[28] The idea of metamorphosis, or of one material taking the form of or making an allusion to another, is common in anagogic meditation. In this light to see similes of cloud and fire in the marble columns of San Marco is entirely fitting in a Christian church. If coral breccias readily suggested fire, the undulating veins of Greek grey marbles evoked the waves of the sea. At the centre of San Marco, in the crossing, quite exceptionally the floor is not tessellated but consists of three great slabs of proconnesian

marble (fig. 57). These fine slabs were undoubtedly loot that had been laid down in pride of place at the centre of the floor. The veins of this Greek marble, broad and undulating, may explain why this area was known in the Renaissance as *il mare*, the sea. A number of other early churches around the Adriatic have wave-like imagery in their pavements; as in them, the sea at the centre of San Marco's floor suggests the idea that the imagery of the church replicates the essential features of the cosmos.[29]

More playful reading into the markings of marble of images made by chance is documented by a passage in the well-known text, written in the thirteenth century, of Albertus Magnus's *Book of Minerals*. In it the famous theologian testified that 'when I was at Venice, as a young man, marble was being cut with saws to decorate the walls of a church. And it happened that when one marble had been cut in two and the cut slabs were placed side by side, there appeared a most beautiful picture of a king's head with a crown and a long beard.'[30]

In the fifteenth century Filarete devoted space to the discussion of marbles in his treatise on architecture. He mentioned that in some veined marbles the forms of animals appear, and singled out a bearded hermit on a wall in San Marco. As Connell has pointed out, the same head was mentioned in the sixteenth century by Fra Leandro degli Alberti and also by Francesco Sansovino.[31]

All this evidence indicates the diversity of ways in which marbles were both valued in themselves and imaginatively read as imagery. Before leaving the subject of the veining of marble, a few early instances of the appearance of marble reflexively entering the Venetian pictorial idiom may be mentioned.

When, in the mid-fourteenth century the upper walls of the Chapel of Saint Isidore were decorated with narratives in mosaic, the deep embrasures of the windows were also covered in mosaic (fig. 59). Here there is no figurative or floral decoration or geometric pattern, but wavy lines of grey and white tesserae that imitate the veins of Greek marble. To counterfeit marble revetment in fresco as Giotto did in the dado of the Scrovegni Chapel in Padua involves a saving in materials: to counterfeit it in the less tractable medium of mosaic is perverse, given the labour and expense involved. Accordingly it is rather rare.

57 *Il mare*, slabs of proconnesian marble at the centre of the floor of San Marco.

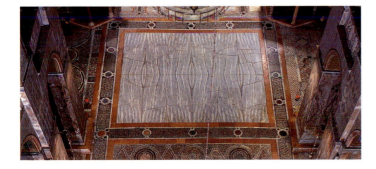

59 San Marco, Chapel of *Saint* Isidore, window embrasure
with marbling in mosaic (fourteenth century), with marble
revetment below.

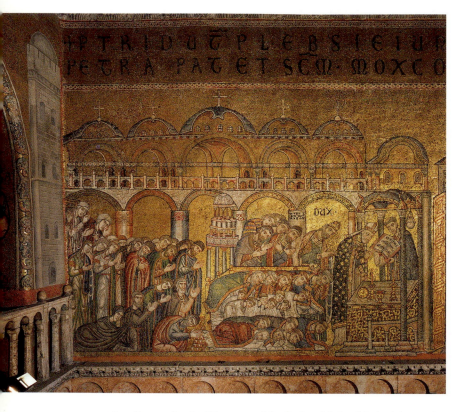

58 *Prayers for the Discovery of the Body of Saint Mark,* thirteenth-
century mosaic in the south transept of San Marco.

That it was the veins in marble as much as the colour
that denoted the material is evident from the
thirteenth-century mosaics in the right transept, which
document the prayers for the discovery of the body of
Saint Mark (fig. 58) and the apparition of the relics. In
these key narratives the story is set in the basilica of
San Marco itself: true to this setting, the mosaicists have
reproduced the wavy lines of veneer in the spandrels of
the arches and on the panels in the pulpits. In the
history of Venetian colour, pleasure in wayward undu-
lation of veining is inseparable from pleasure in colour
itself.

The mosaics

Above the marble revetment of the walls hover the domes and vaults of mosaic – golden almost seamless, curving around corners, pendentives and arches, broken only by the variations in its glints and sparkle (figs 60 and 61). To call this gold the background for the figurative mosaics is misleading, for, like the marble below, it is a clothing of the building itself; the golden mosaic wraps around its grand shapes, and in softening its corners to curves it prompts sparkling highlights to play on them and animate their surfaces. Although marble and gold are an inner sheath only, the intended illusion – as usual in Byzantine mosaic decoration – is that this is a Christian temple built entirely of the most precious materials.[32] No measurable pictorial space is hollowed out behind these precious walls, rather on the curves of domes and the wide arcs of barrel vaults the fields of mosaic embrace the actual space and light of the church. In the larger areas of the medieval mosaics neither a threshold nor a rear plane of pictorial space is defined: gold surrounds the pictorial elements, it infiltrates between them, fills space as molten light and sustains the saints, just as salt water laps and buoys up a swimmer. Like the light on water in the Venetian canals at dusk, the gold background oscillates between extremes of brilliance and darkness, changing as the viewer moves. As Marcel Proust noted, 'all the figures of the Old and New Testaments appear against the background of a sort of splendid obscurity and scintillating brilliance'.[33]

Such interchange between obscurity and brilliance became so vital to the colouring of sixteenth-century Venetian painting – witness Veronese's burnished skies or Tintoretto's incandescent *contre-jour* – that we must peer into it further.

Browner than yellow, gold is an impure colour. Gold mosaic is made by sandwiching gold leaf between layers of glass, which often have a greenish tinge. The glass lying above the reflecting surface of gold leaf may account for the elusive watery-green cast that, in certain lights and from particular angles, floats over the gold. Brown marbles mixed among the glass tesserae fleck the gold with deeper tones. Save where it scintillates, the gold field is darker than the grey and white marbles used to highlight the figures, and for this reason

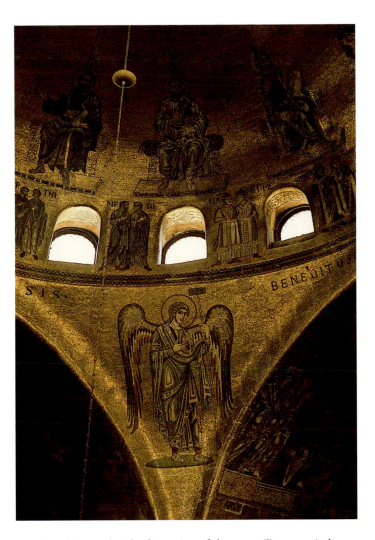

60 San Marco, detail of mosaics of the west (Pentecost) dome, with angel in pendentive (twelfth century); photographed by natural light.

nowhere does gold suggest an analogue for the even luminosity and infinite recession of sky. In San Marco, as in early Byzantine domed churches, if the gold fields evoke a heavenly vault it is, as Procopius and Paul the Silentiary observed, one whose light is not borrowed from the day, but rather a surrogate for that light. With the light of the windows, Ruskin's phosphorescent streams, it has little commerce. Some distance separates light as modelling from light as subject or symbol. In the rather damaged mosaics of the Creation cupola of the atrium, where God separates light from darkness (fig. 62), the orb of light is pale brown and ringed with red, the orb of darkness, indigo; the bunches of rays that

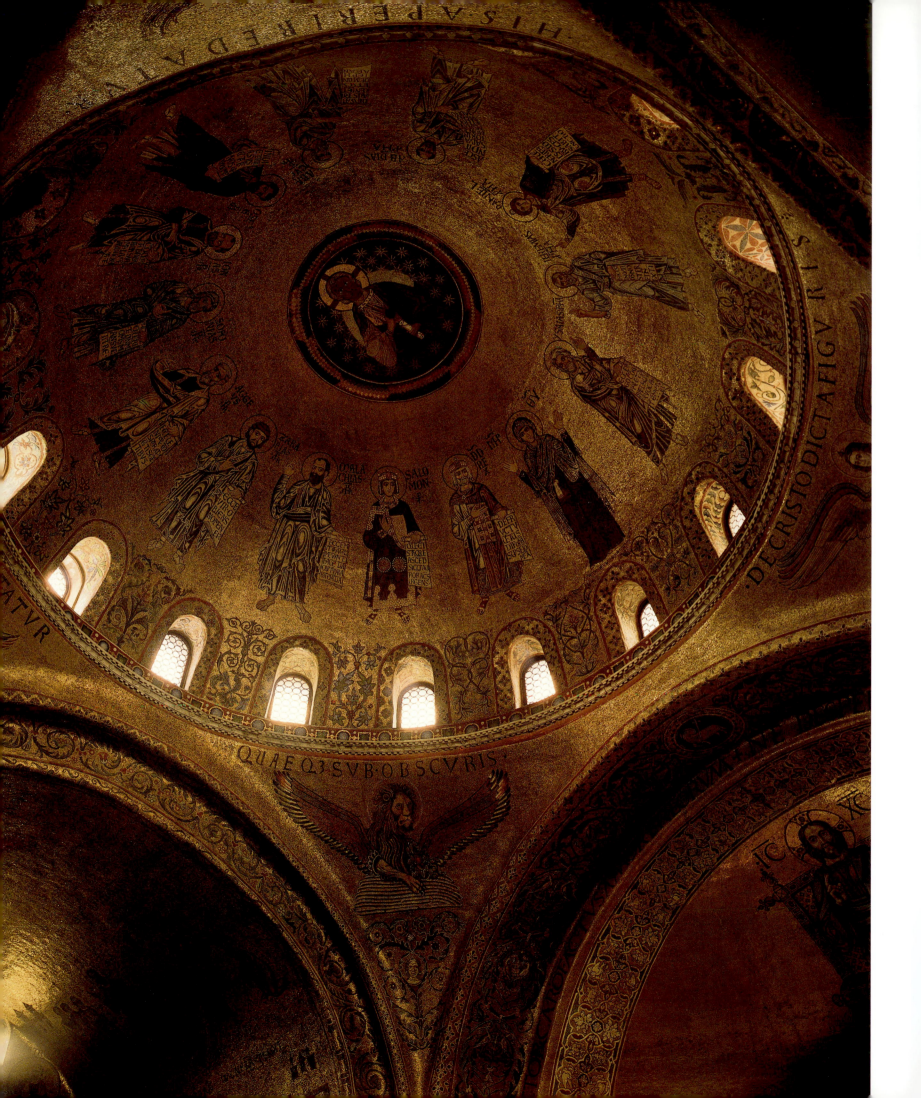

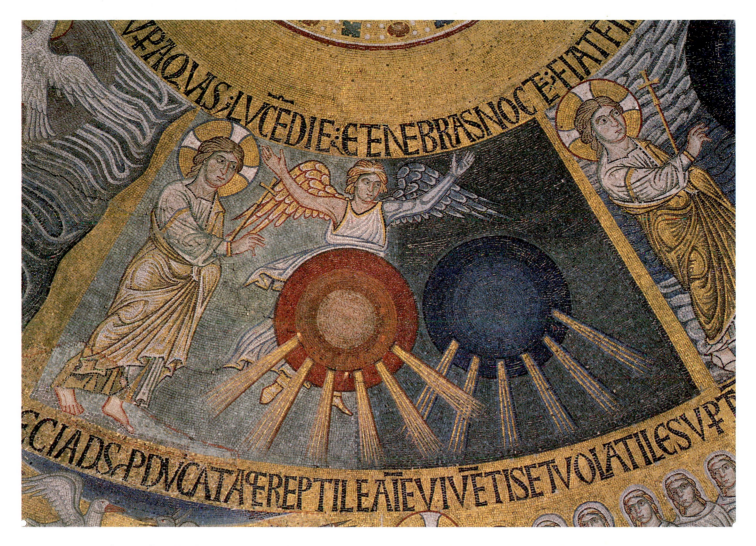

62 *Separation of Light from Darkness*, mosaic in the Creation cupola in the atrium of San Marco (thirteenth century).

emanate from both are yellow gold and white, relieved by a single line of umber tesserae. Pure light, then, may in theory have been symbolized by red, as in the red face of cherubim. If so, only in a limited number of subjects is this use of red given pictorial value: the field is usually left free for the play of gold and white.

The mosaicists' basic unit of colour is the tessera. Whereas the painter can get smooth gradations of colour by adding white to the pigment, the mosaicist is dependent upon a pre-ordained set of colours, tones and textures. The tesserae are available in two materials, glass and stone.[34] Glass tesserae may be smooth and lustrous, or given a more matt finish by roughening the surface. In Venice dark blue and black glass was some-

times granulated in this way. Colours available in glass include a shiny black, several purples, reds in shades tending towards brown, blue in a wide range from pale to dark, turquoise, transparent light green, emerald green and shades of greenish olive, amber and light yellow, and an opaque white glass. Until the thirteenth century the Venetians used a distinctive orange vermilion, evocatively known as *becco di merlo*, 'beak of the blackbird'; it was employed mainly for accenting flesh modelling.[35] Gold tesserae too were – as already noted – made with glass.

Colours available in tesserae of stone or marble consisted principally of white limestone, a white stone from conglomerates, shades of pink and coral-coloured

61 San Marco, mosaics of the eastern dome, with Christ, Mary and Old Testament prophets (twelfth century).

marble, a beige green and diverse greys ranging from brown to slate blue. Even more than with glass, the texture of stone tesserae varied, ranging from the duller limestones to the crystalline marbles. In addition, an enamelled white offered a brilliant contrast to glossy black glass.[36] Occasionally, as in Christ's halo in the mosaic of the *Agony in the Garden*, mother-of-pearl introduced a nacreous iridescence; according to Saccardo, writing in the late nineteenth century, other touches of mother-of-pearl in scrolls and draperies had been widely replaced by white enamel.[37]

Mosaicists frequently model by employing slight shifts of hue: a red drapery may be shaded with brown marbles and blacks; a blue may have purplish tesserae in the mid-tones, blacks in the shadows; flesh tones move between whites, greys, sandy pinks and browns, to reds and black. Sometimes these shifts were necessitated by the lack of regular gradations available within a single hue: their effect is far reaching. Differences in lustre between glass, gold leaf, mother-of-pearl, enamel and marble also nuanced the many variations of tone.

In the Christ seated on the double bow of the firmament at the apex of the central dome (fig. 63), the gold tesserae are naturally darker than the enamelled whites. Christ is wearing a white vestment which is modelled with red in the folds and gold in the mid-tones, and this same gold is used for the highlights of his golden mantle, where the half-tone is a liver brown, the folds and contours black. With great skill the mosaicist weaves gold through his composition, letting it shuttle between highlight and mid-tone. Physically gold is more or less the same whether on Christ's hair, his mantle or his vestment: optically it changes according to context. When seen from the great distance of the floor, the exchange of values between highlight and mid-tone is a source of unity both within different zones of the figure and between figure and field. Notice the accents of blue on Christ's garments, down the inside of the shin, at one shoulder and around his scroll and his halo – accents which are just enough to pick up the blues of the circles of the heavens. This is not the precise tonal unity that Leonardo achieved at the end of the fifteenth century by tempering or glazing his pigments to compensate for their tonal discrepancies, but it is equally effective in bringing a visual parity between diverse drapery colours. Such inter-

weaving also preserves the integrity of the figure and its bond with the coloured field.[38]

Black-and-white photography may have made twentieth-century art historians lay too great weight on tonal unity as an issue involving the entire visual field. Recent studies of the visual system indicate that it is *local* calibration of brightness differences that matters, and may overrule discrepancies separated within a wider view. In Venetian mosaics the repetition of local contrasts do indeed create their own global consistency – not the tonal unity of a black-and-white photograph, but a unity responsive to shifting points of focus or attention.[39]

Broader unity across the field of mosaic in San Marco is often achieved by repetition of browns and purples. The same mid-purple may lie between a lightish blue and indigo on one drapery, and between light and dark mauve on another. Our estimate of these colours varies widely according to the influence of neighbouring hues. Purple is nearly the complement of gold, yet seen – as so often here – in association with dusky brown, it suggests an earthy darkening of gold rather than its opposite. Mosaic is full of such surprises, in which opposition turns to alliance. (Of course, to write of complementaries in the post-Newtonian sense of opposites on the colour-circle is anachronistic. The Aristotelian conception of colours as essentially produced by varying degrees of participation in light and darkness, which lay behind Renaissance discussion of colour, created no difficulty in conceiving of colours that were close in tone as neighbourly.)[40]

Blue, as noted above, is not present in any quantity in the marble floor or revetment, and unlike at Ravenna, neither is blue used as a background or field in the mosaics. For these reasons the presence of blue tesserae in descriptive passages is all the more telling. Dark blue draperies, such as Christ's in the *Agony in the Garden*, turn out on close inspection to be modelled with relatively unsaturated blues, often tending to indigo. Sometimes these blues are modelled with browns and duller purples, yet in appearance they are overwhelmingly blue. The introduction of more blues, especially strong ones achieved by enamelling on glass, occurs in the fifteenth century.[41]

In the better preserved of the thirteenth-century mosaics of the atrium pale blue is used to beautiful

63 *Christ on the Bow of the Firmament*, mosaic at the apex of the central dome of San Marco (twelfth century).

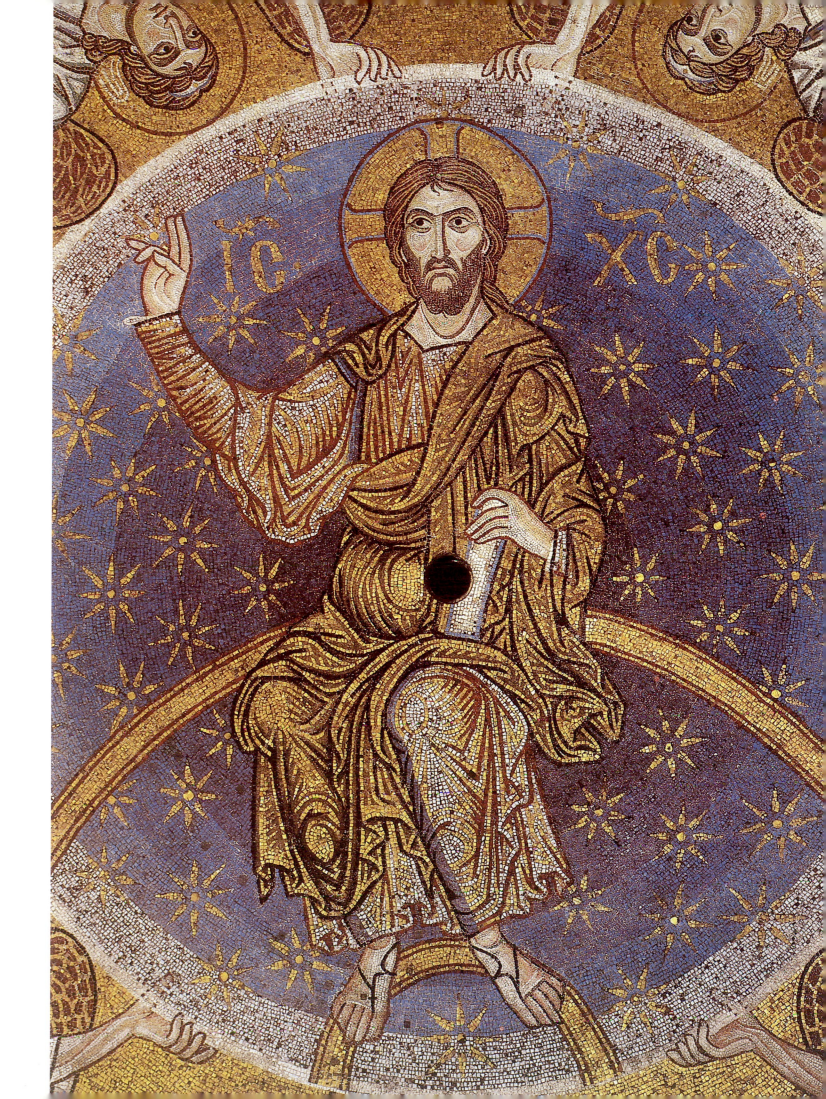

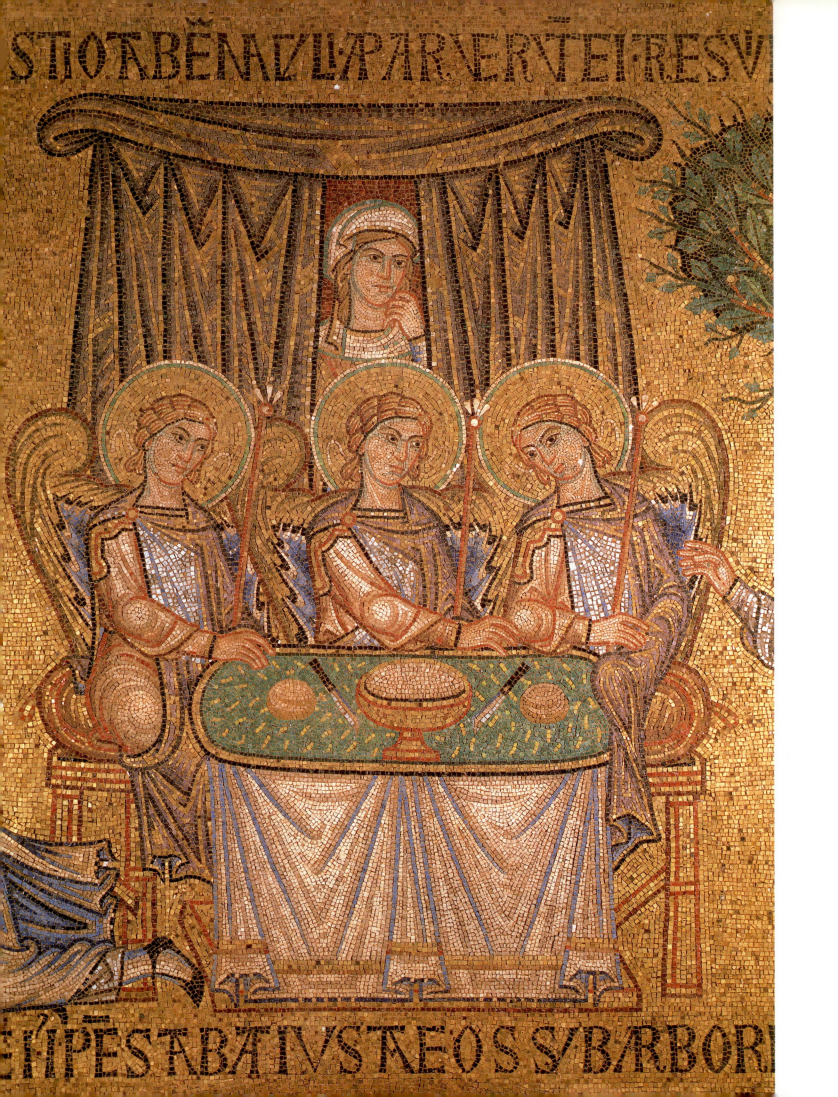

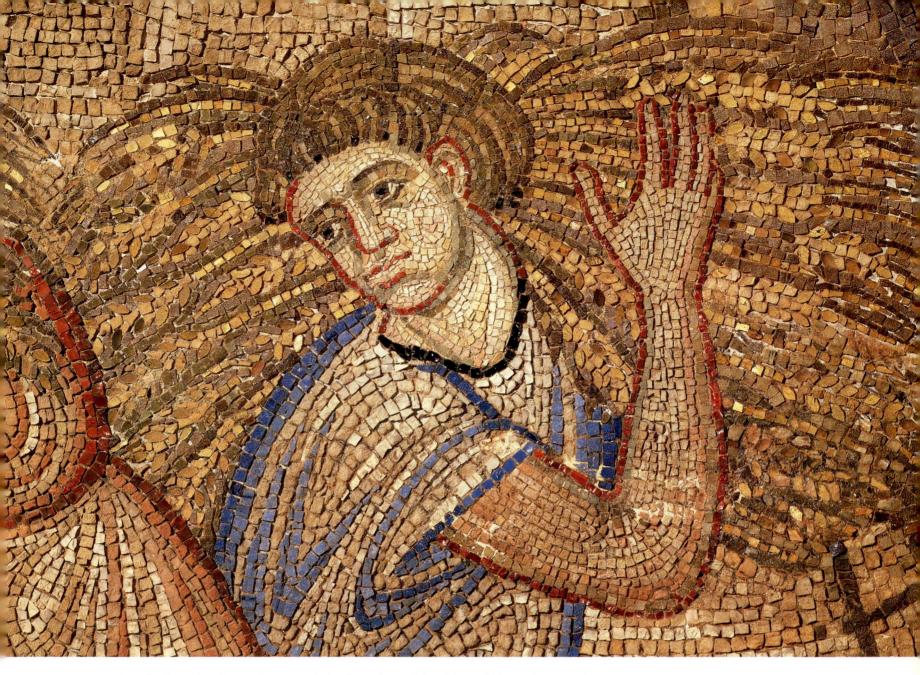

65 Detail of *Joseph gathering Corn*, mosaic in the atrium of San Marco (thirteenth century).

effect. The Noah and Abraham cycles are dominated by the contrast of white turning to mid-blue, and gold turning to greyish brown or purple. On white draperies warm shades of grey, oatmeal or biscuit intervene between the white highlight and sky-blue shadow, as in the tablecloth in the *Hospitality of Abraham* (fig. 64). This combination of gold deepening to a warm dark and enamelled white shading to pale blue, is hardly to be found in medieval panel painting. It captures flaxen splendour of cornfields in the sun and white cumulus piled against a blue sky (fig. 65). In painting it was not until the late fifteenth century – in Antonello da Messina, Giovanni Bellini and Jacometto Veneziano – that whites so skilfully modelled by pale blue to create a feeling of the open-air can be found.

Two further characteristics of the mosaics must be mentioned here. One is derived from Byzantine practice in depicting ecclesiastical and court costume in which individual motifs are distributed almost like brooches over the surface of the garment, floating quite detached from any modelling system. Sometimes they take the form of a spattering of groups of gold dots. They add zest to the colours they spangle.

The other characteristic derives from the shaping and

64 *Hospitality of Abraham*, mosaic in the atrium of San Marco (thirteenth century).

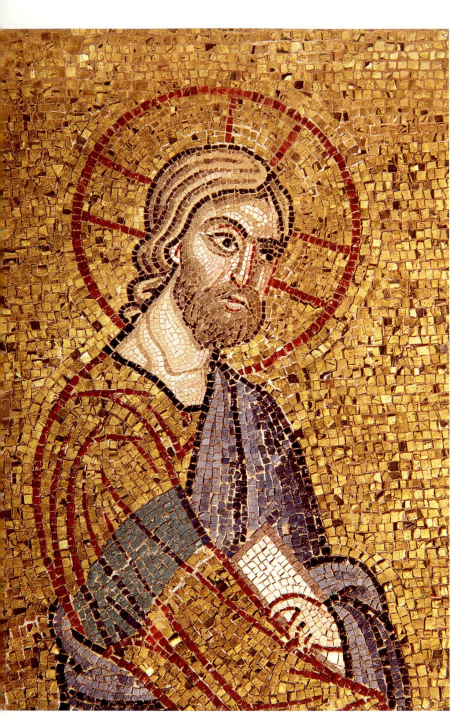

66 Head and shoulders of Christ in the *Third Temptation*, mosaic on the south vault of the central dome (first half of twelfth century).

laying of the tesserae. In a detail such as the head and shoulders of Christ in the *Third Temptation* (fig. 66) our reading of the form is guided by changes in the alignment and scale of the tesserae. Generally the mosaicist lays the tesserae in rows of the same shade. The gold tesserae for the background are arranged in horizontal rows, but the two rows of cubes next to the contour of the figure are shifted to follow and contain the contour. Down the left side of Christ's back and shoulder this change of alignment is important because his vestment is gold and only distinguished from the colour of the background by a contour and folds laid in red. The same is true of the halo. Within the figure changes in the alignment of tesserae occur at significant junctions: the vertical alignment of the blue robe over the wrist emphasises its fall; the slanting orientation of the same blue tesserae below the shoulder to the left indicate that the robe is curving out of sight as it wraps around the back of Christ. In the face the more complex changes in alignment are accompanied by a reduction in scale of tesserae. All this is obvious, but these changes in alignment and in scale contribute to changes in perception of texture, and as a result of a change in texture a very subtle change of tone. To some degree this is an illusion. The changes in alignment by indicating orientation of form, or the distinction between figure and field, offer a compensation, for example for the daringly undifferentiated repetition of gold on the shoulder and in the background. One kind of distinction is being substituted for another. But as more is discovered about vision this may have to be rephrased.

Attempts in recent decades to construct machine vision have uncovered surprising evidence that coarsening the visual grid may lead, in some circumstances, to an increase in clarity of information. If transitions are too smooth, they fail to register; they lack bite. At the same time it is becoming clear that at elementary levels our visual systems correlate information about slant with readings of tone so that attempts to make a perfectly objective and *local* reading of tone is, if not impossible, at least going against the grain of our perceptual system. So if the laying of tesserae in rows communicates something about orientation it may subliminally affect judgement of tone as well – a correlation takes place. The change in scale of tesserae

on Christ's face creates – at a constant viewing distance – a slightly greater optical fusion. Surprisingly perhaps, this fusion instead of sharpening clarity of detail leads to a soft effulgence of light. Whereas in a photograph viewed at arm's reach, flesh in mosaic may appear more finely modelled, viewed on the wall it may be more blurred – endowed with tender effulgence.

Studies of the relation between mosaic and the history of painting have paid too little heed to how the laying of tesserae in rows offers a precedent and analogue to the brushstroke in oil painting. Both make statements about direction. Observe the microstructure of that modern master of flesh painting, Lucian Freud, and you will note that it is strongly linear, its linearity sustained by shifts between warm creams and bluish markings: such flesh might almost be reconstructed in undulating rows of minute tesserae. With Titian the alignment and the texture of the brushstroke allows an abbreviation of the mid-tones; the brushstroke will actually stand in for some of the job that tone as modelling once performed (fig. 67).[42] This is yet another reason why the mosaics of San Marco set the tenor for the painterly achievements of Venetian colour in the sixteenth century.

67 Titian, detail of fig. 46, with the Virgin and Mary Magdalen.

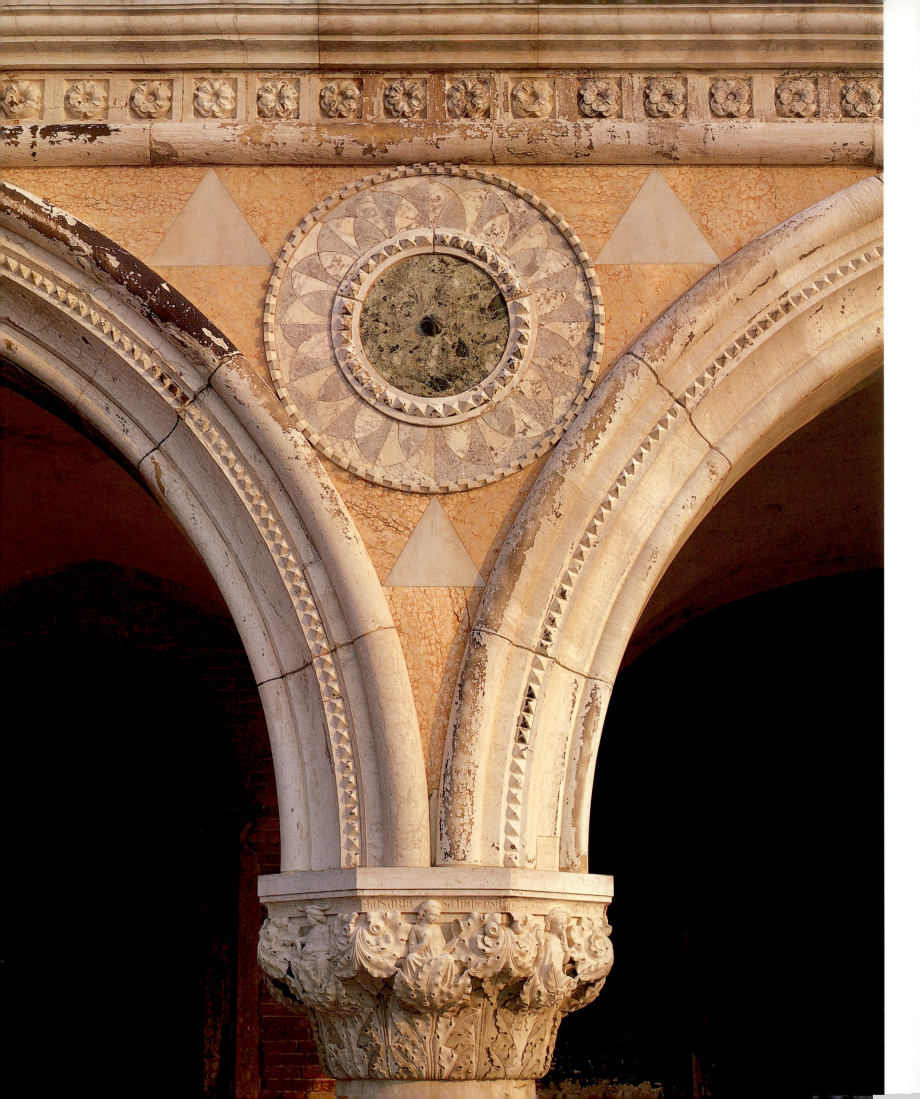

3

POLYCHROMY IN EARLY FIFTEENTH-CENTURY ARCHITECTURE AND SCULPTURE

Circa 1400: the triumph of gold and blue

During the fourteenth century Venice absorbed many elements of the Gothic. As a Western style it brought with it new combinations of materials and new preferences in shape and pattern which modified the tastes that Venetians had acquired in contact with Byzantine and oriental sources.

A significant example of the fusion of Veneto-Byzantine taste with elements from the Latin West is the iconostasis or choir-screen in San Marco (fig. 69). Commissioned from Jacobello and Pierpaolo dalle Masegne, it was built between 1394 and 1404 using exceptionally rich marbles, some of which may have come from a pre-existing screen, others from the long-standing deposit of Greek and oriental marbles which the procurators in charge of the fabric of San Marco had at their disposal. Three of the columns are of Egyptian marble, a luxurious glossy black with white markings, and the remainder of *marmo greco fiorito*. The large mottled panels of the parapet alternate between brick-red Portasanta marble and *verde antico*. What are new in the context of San Marco are the diamond-shaped insets in black marble framed by Veronese red.[1] On the architrave, which forms the base for the statues and their octagonal pedestals, the small triangles that fill the corners outside the diamonds are made of deep blue glass resembling lapis lazuli.[2] Such use of polychrome materials is busier than the earlier Byzantine-inspired revetment of marble on the walls. When it was first installed the sheer flush of colour on the architectural part of this screen must have made a striking contrast with the whiteness of the Carrara marbles of the Virgin and Apostles.

69 San Marco, view of the choir, with iconostasis by Jacobello and Pierpaolo dalle Masegne (1394–1404).

68 *(facing page)* Spandrel with inlaid disc on the Molo façade of the Palazzo Ducale (*c.*1400).

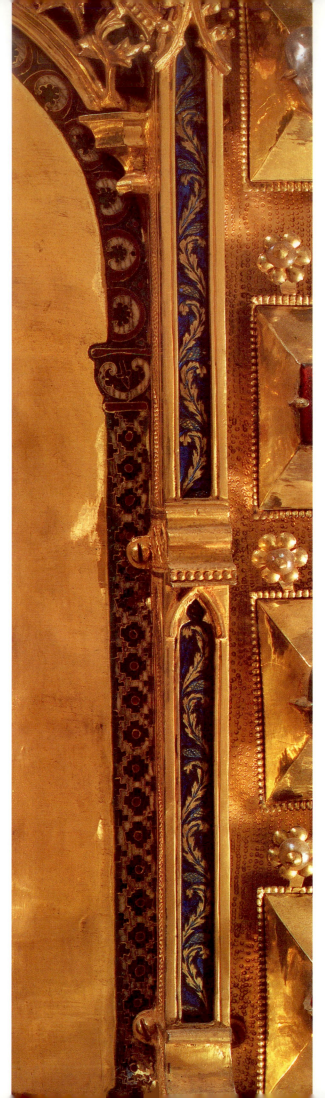

71 Antonio Vivarini and Giovanni d'Alemagna, *Santa Sabina* altarpiece (1443). Panel, with original frame 347 × 185 cm. Venice, San Zaccaria, Chapel of San Tarasio.

During the fourteenth and early fifteenth centuries deep blue became an increasingly resonant feature of Venetian colour. In the early mosaics of San Marco, blues for draperies were achieved by using few tesserae in saturated blue compared with the larger number of browns, blacks and purples deployed in the modelling; backgrounds or fields of blue were rare. It was in fresco cycles on the Italian mainland that fields of blue became common around 1300, notably in Giotto's frescoes in the Scrovegni Chapel in Padua. It is likely to have been mural painting that played some part in the introduc-

70 San Marco, detail of blue enamel on the Pala d'Oro (1340s).

tion of expanses of blue into Venetian decoration and architecture.

In the Gothic period Venetians relished the juxtaposition of shining gold against dark blue. Nothing was more brilliantly golden than the Pala d'Oro, and when it received its Gothic framework at the hands of Venetian goldsmiths in the dogate of Andrea Dandolo (1343–54) elongated panels of transparent blue enamel were inset in the golden borders (fig. 70). Similarly, the salient mouldings on the carved frames of Paolo Veneziano's polyptychs are gilded and the recesses painted blue, the start of a tradition that survived until the 1440s and 1450s in the altarpieces of Antonio Vivarini and Giovanni d'Alemagna. In spite of the fact that most of the blue on the frames of polyptychs such as the *Santa Sabina* altarpiece in the Chapel of San Tarasio in San Zaccaria (fig. 71) has been renewed with a pigment less deep than ultramarine, it still gives the effect of spying the nocturnal blue of the heavens through a gilded lattice.

Gilded frames were sometimes backed by a large box-like wooden case, a *cassa*, placed between the wall of the church and the altarpiece. They were commonly painted blue.[3] The documents for the church of Santa Maria della Carità record that Antonio Vivarini's high altarpiece was to be provided with a *cassa*, for which payment was made for blue and stars.[4] An example can be seen be at the centre of Vittore Carpaccio's *Vision of Prior Ottobon* (figs 73 and 74), where it is clear that the blue *cassa* isolates the polyptych from the supporting wall. That Venetian altarpieces from the time of Paolo Veneziano onwards occasionally echoed the two-tiered façade of San Marco has often been noted: we may add that the blue boards of the *cassa*, rising clear of gables and finials, lent plausibility to the conceit that Gothic altarpieces were glorious aedicules, buildings within buildings, yet set against the unchanging blue of heaven. In the Renaissance, on the contrary, the altarpiece frame delimited a fictive aperture in the wall of the church. Blue migrated inside the frame, and turned from a timeless nocturnal blue to the changeful modulations of the daytime sky.

Gilding and paint increasingly camouflaged and transformed materials, converting the base into the noble. This reached a climax in the style known as International Gothic, fashionable around 1400, but its roots go back much earlier. In Venice this trend competed with regard for the colour and intrinsic beauty of marble, nevertheless, from the fourteenth century blue and gold increasingly disguised stone as well as wood. To cite one example, on the tomb of Francesco Dandolo (d.1339) in Santa Maria Gloriosa dei Frari, the background of the stone reliefs on the sarcophagus was painted blue (fig. 72); above them, inserted within the stone arch, gold dominated Paolo Veneziano's panel of the doge and dogaressa presented by their name-saints to the Madonna and Child. The eighteenth-century illustration of the tomb by Giovanni Grevembroch shows rich gilding on the stonework and on the panel, foiling the blue.[5]

72 Tomb of Francesco Dandolo (after 1339), Venice, Frari, Chapter House. Detail showing the *Dormition of the Virgin*.

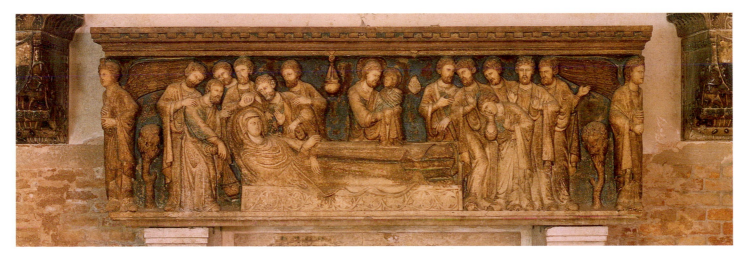

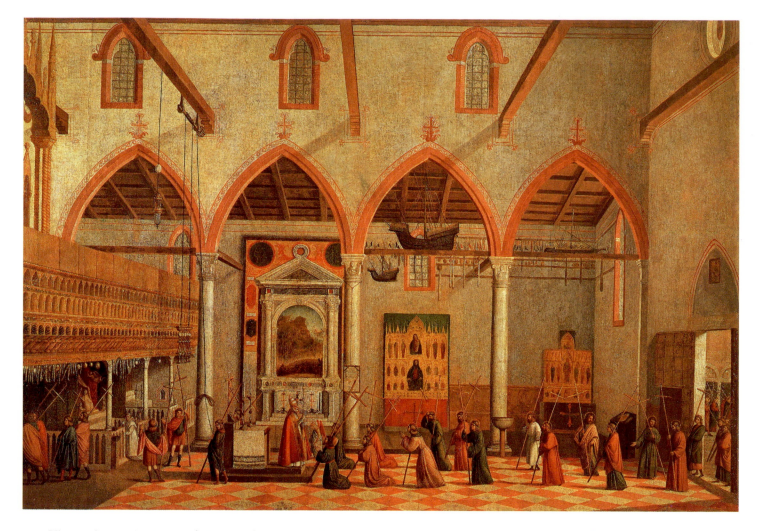

73 Vittore Carpaccio, *Vision of Prior Ottobon in Sant' Antonio di Castello* (c.1515). Canvas, 121 × 174 cm. Venice, Accademia.

Stars and sky: colour and architecture

The rise of blue and gold in the constellation of Venetian colour was steered by one rather personal touch on the tiller of patronage. Between 1400 and 1413 the doge was Michele Steno, whose personal insignia was the star (in German, *Stern*), and it is from the period of his dogate that nocturnal blue spangled with golden stars descends to earth as decoration on public buildings.

Francesco Sansovino said that in Steno's time the ceiling (*il cielo*) of the Sala del Maggior Consiglio in the Palazzo Ducale was covered with gold and stars, and that stars adorned the great window and balcony that was built on the Molo.[6] The starry firmament that hung above the Venetian doge and patriciate when they met in the Great Council no longer exists. The south balcony on the Molo, a major sculptural project commissioned in 1400 from Pierpaolo and Jacobello delle Masegne, survives stripped of its polychromy (fig. 78). Even though some of the thirteen figures of saints and virtues are as nearly two metres high, they look fairly insignificant from the ground; clearly, colour was vital to any reading of the work, and once dimmed by fading, erosion and dirt the glory of this ceremonial balcony is all but lost. Gilding was clearly an essential part of the iconography of this 'fenestra grande indorada', at which the doge would appear resplendent before the people.[7] The contract stipulated that the saints and virtues should be of 'petra pulcra de craria

74 Carpaccio detail of fig. 73.

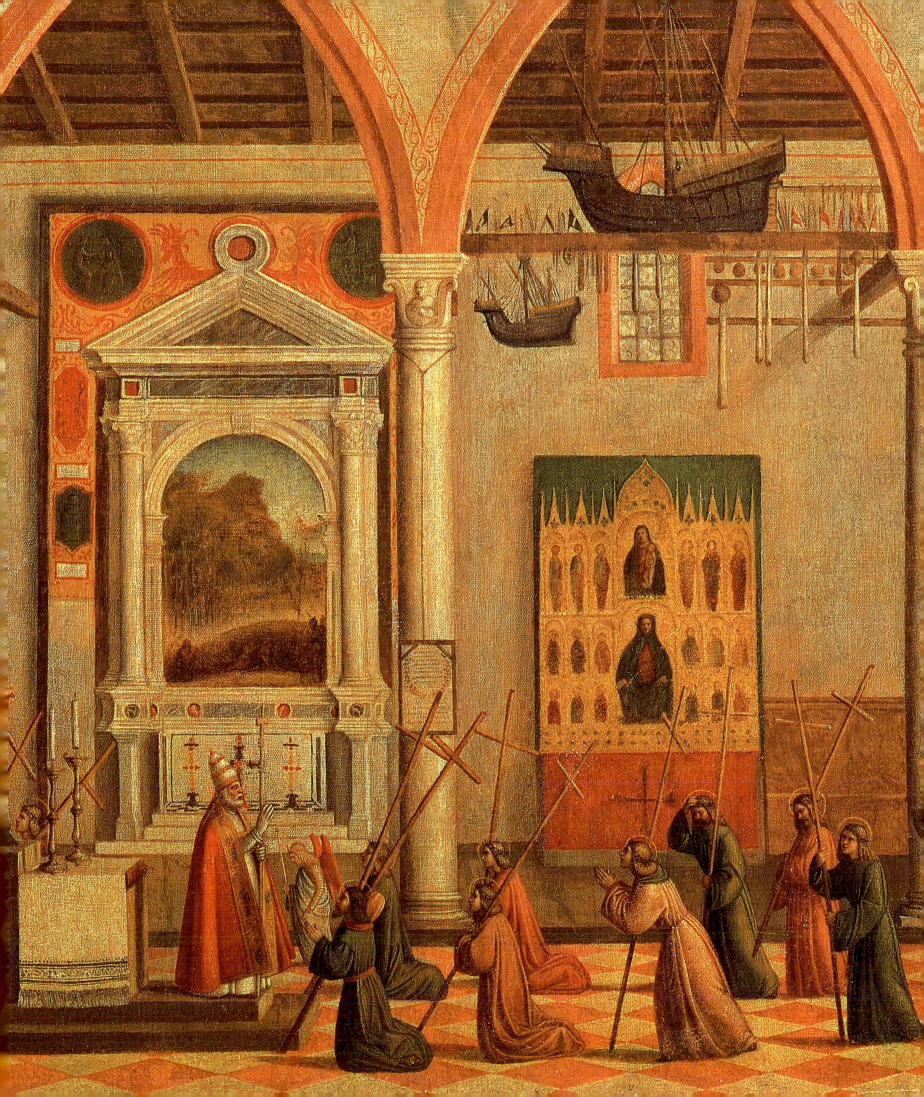

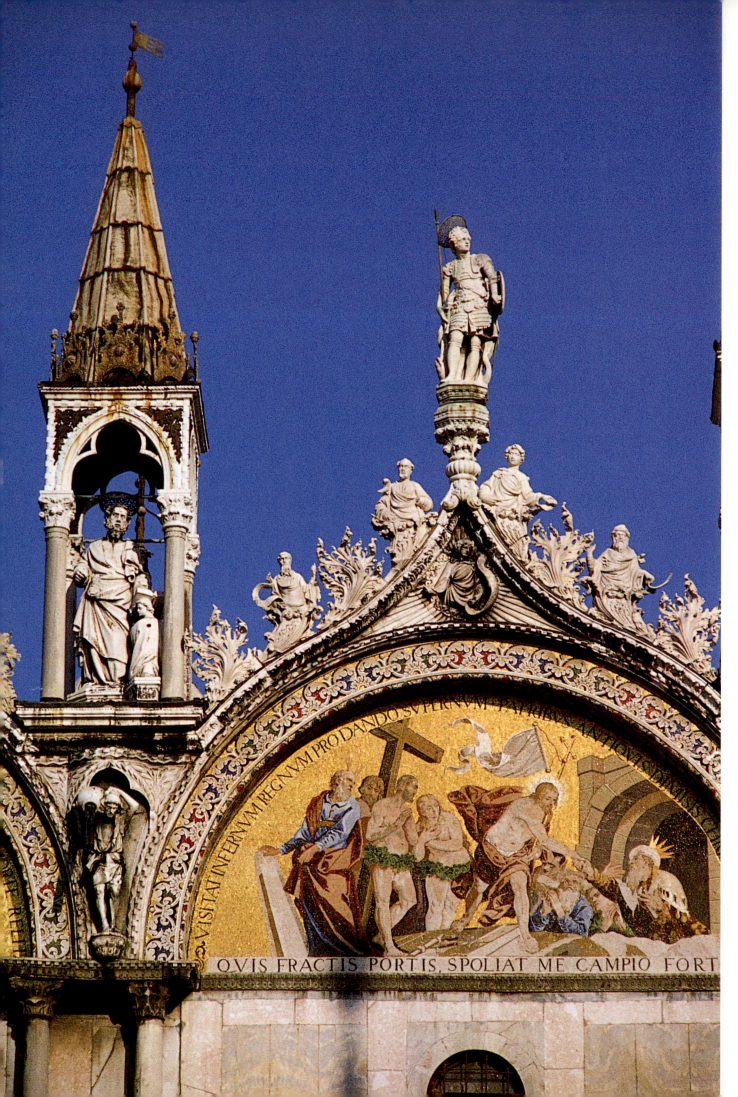

77 *(facing page bottom left)* Gentile Bellini, detail of fig. 36, showing the crowning lunettes.

75 *(left)* Detail of the west façade of San Marco, second lunette from the left.

QVIS FRACTIS PORTIS SPOLIAT ME CAMPIO FORT

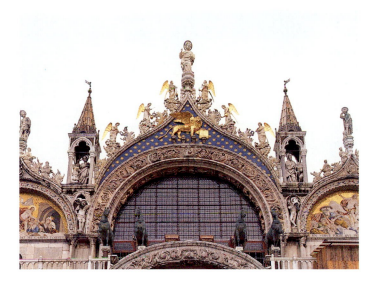

tabernacles between the lunettes are open at the back and sides, thus they 'enclose' a section of sky beneath them, on clear days a blue background for the saints within. Many traces of gilding survive, especially on their roofs. Gentile Bellini's *Procession in Piazza San Marco* shows that the foliage and the prophets that form the lacy crests to the ogees over the lunettes were also gilded (fig. 77), whereas the statues on the finials and the angels above the central ogee were left in the natural whiteness of their stone. The wings of these angels were gilded, and in the 1980s were regilded, so

76 Coping of the west façade of San Marco (the crowning ogees, early fifteenth century).

78 *(below)* Balcony on the Molo façade of the Palazzo Ducale by Jacobello and Pierpaolo dalle Masegne (commissioned 1400).

marmorea', but dirt now obscures the distinction between their crystalline whiteness and that of the cheaper Istrian stone; and the contrast between the candour of Carrara and Istrian as opposed to the red of Verona, has been diminished by the usual fading to pink of the elements in *broccatello*.

Whereas the balcony of the Palazzo Ducale is hemmed in by wall, the coping of the façades of San Marco – another project under way in the first decades of the fifteenth century – embodied an open embrace of sculptural ornament and sky (figs 75 and 76). The

79 West façade of San Marco with the lion of Saint Mark against blue mosaic.

that once again they gleam against the sky (or, at a certain distance, against the pale, dove grey of the lead sheeting of the domes).

In this scheme of things the azure sky became the ideal complement to gilding. Sky fulfilled the architecture. By the time Marc'Antonio Sabellico was writing his description of the city at the close of the fifteenth century, the epithet attached to San Marco, the state church, was 'la chiesa d'oro', the church of gold. Venetians would have noticed how, on the façade, the literal brightness of gold mingled with symbols of brightness and glory. Within the ogees, saints are carved in low relief within stylized radiances, and in the larger field of the central ogee the winged lion of Saint Mark, symbol of Venice, appears golden as the sun against a background of deep blue glass (fig. 79). Today this glass mosaic is decorated with rows of golden stars: in Gentile Bellini's view it appears to be decorated with silver stars of varying size, which gives greater prominence in the firmament to the golden lion of Venice. As the tabernacles are open to the real sky, so the central ogee is open to a symbolic sky.

Alliance between architecture and sky is characteristic of the new openness of the late Gothic style, with its flamboyant termination of forms, its trellises and perforations, and as such it is a development not altogether peculiar to Venice – and yet on the lagoon the interlace of stone or marble and sky or water is threaded with more exotic influences. On the Palazzo Ducale the delicate crenellations that cap the lozenge pattern rise against the sky, their arches cupping the blue within the whiteness of their stone (see fig. 82). Richard Goy has written of this and the crenellation at the Fondaco dei Turchi: 'The origin of these peculiarly Venetian forms of *merlatura* (in this characteristically insubstantial manner) is still a matter of some conjecture, although they undoubtedly owe more to the influence of Muslim Cairo, Damascus and Beirut than to the genuinely defensive swallowtail battlements of nearby Verona.'[8]

★ ★ ★

White and red: Istrian stone and Verona marble

In late Gothic Venice pairing of blue and gold was diversified by the pairing of two favoured building stones, the white Istrian and the red Verona. In Tuscany the dominant colour-pairing in marble-faced buildings, such as the Florentine Baptistery, is white and green: in Venice the pairing is white with red. When Francesco Sansovino, son of the architect Jacopo, published his *Venetia città nobilissima et singolare* in 1580, he followed Vasari before him in emphasizing that Istrian stone and Verona marble lent special distinction to the city.[9] Of Istrian, Sansovino reported, 'a beautiful and marvellous building material is the hard stone brought from Rovigno and Brioni, a citadel on the Dalmatian coast. It is white in colour and like marble, but sound and strong . . .' He described how it could be used to make statues, and rubbed with pumice and polished with felt to resemble marble.

It was this white stone that was used to edge the quaysides, to run as quoins and string-courses, and to furnish surrounds for windows and doors. A limestone, fine-grained and compact, Istrian is not as crystalline as marble; it has a dense, milky whiteness that looses none of its pallor when seen at a distance, particularly across water. Looking across to the island of the Giudecca, the Istrian membering around the doors and windows on the houses lining the north-facing waterfront is normally seen in shadow and looms pale across the interval of wide canal in contrast to the dark apertures (fig. 80). A painter's eye will register the faintly bluish cast which Istrian in shade typically picks up from the sky.

To answer Istrian's whiteness, the Venetians imported the orange-red *broccatello* from near Verona. 'Then the stone from Verona is highly valued', Sansovino explained, 'because being red and with various markings, it beautifies buildings, and they make chequered floors for churches and palaces from it, and other works which are very lovely, such as lavabos, fireplaces, cornices and other similar things.' When first quarried, carved and polished, the red mottling is strong, tending towards orange and brown: when it fades it turns more towards pink. In the lagoon, amid the blues and greens of water, the red of Veronese marble – like the reds of Venetian brick and stucco – brings an essential warmth. Green marble, by contrast, is restricted to decorative

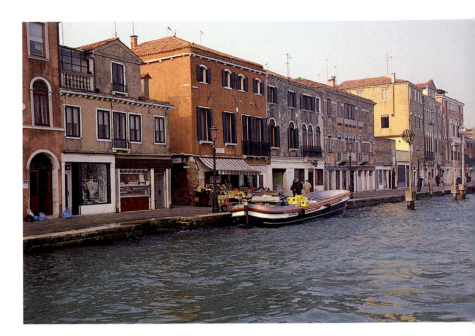

80 View of the Giudecca waterfront in shadow.

accents of serpentine discs or small slabs of *verde antico*; there is nothing comparable in Venice to the regular blocks of *Prato verde* that characterize Tuscan Romanesque.

Pattern on the Palazzo Ducale

The most influential use of Istrian and Verona was at the seat of government, the Palazzo Ducale (fig. 81). The façade on the Molo, the waterfront facing the island of San Giorgio, was rebuilt from 1340 onwards, but it was not until the Piazzetta façade was being completed after 1424, under Doge Francesco Foscari, that the present diaper facing of the upper walls was put in place. It consists of tiles of stone set in an interlocking pattern of lozenges. The longitudinal slabs are laid horizontally, each row overlapping by half to create a regular pattern of red and white that zigzags diagonally across the wall in stepped rhythm (fig. 82). At first sight it appears that all the slabs are either two squares wide or, at a few points in the design, half this; but looking closer at the shared interface in red marble between one diamond and the next, it appears that the apex of one diamond and the base of the one above consists of a slab one and a half times the standard width of the

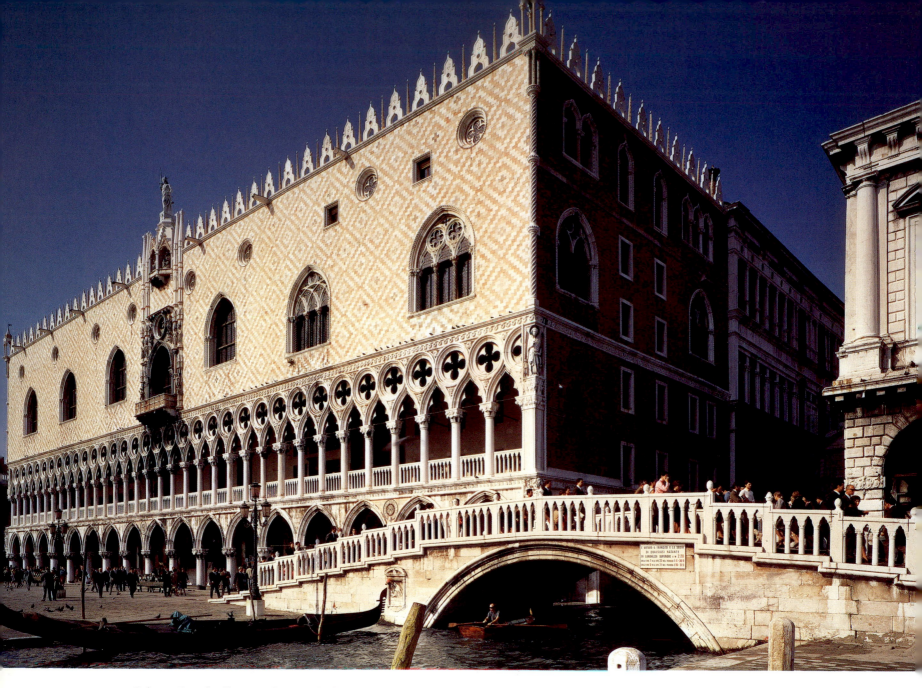

81 Palazzo Ducale (fourteenth to early fifteenth centuries).

others. Similarly in the white and red inner diamonds the bridging slabs near the apex and base are half as wide again as the other rectangles.

The shared interface of red marble between each diamond does not quite become a continuous diagonal because of the extra width of the step at their junctions, which creates a ripple in the colour as it runs across and up the wall. Seen from the ground, this shift is just enough to maintain a teasing ambiguity as to whether the diamonds should be read as locked into a mesh, subordinate to a larger design, or whether the larger design is simply the aggregate of the individual motifs.

Originally this fabric of colour must have appeared more vibrant than today. Veronese marble bleaches in the sun and the saline air. Writing just over a century ago, Giacomo Boni maintained that some of the *broccatello* and some of the Istrian showed traces of red and white paint to camouflage imperfections and intensify contrast.[10] At the centre of each lozenge on the Palazzo Ducale are crosses of grey marble (mostly *bardiglio*), with some squares in Veronese red. The configurations vary, adding an element of surprise to the overall pattern.

The diaper facing is non-architectonic, a veil that disregards architectural members but begins and ends

66

82 The crenellation and diaper facing of the Palazzo Ducale (*c.*1400).

seemingly at random, like a cut from a huge roll of textile. At the bottom edge the pattern is taken up one row below the point of intersection of the diamonds and again at the roof-line the motif is cut off in mid-flow. Nor are the scale and sequence of the diamonds gauged according to the spacing of apertures in the tracery below; thrown over the building without connection to its weight-bearing structure, the veil of colour lightens the top-heavy mass of the palace.

One historian has argued that the polychromy derives from imperial buildings in Constantinople,[11] but the use of lozenge shapes is closer to Islamic sources.[12]

'The inlaid tiles of the upper wall', Deborah Howard observes, 'are reminiscent of the characteristic Persian decorative tradition, brought to Turkey by the Seljuks in the eleventh century and certainly known to the Venetians.'[13] However, the blues and greens of Persian tiles, refreshing in dry lands, are replaced by the Venetian builders with orange-rose and white.

Here the qualities of Venetian light demand attention. The Molo façade of the Palazzo Ducale faces south, and the great watery arena in front of it provokes a flood of light – as Turner later recorded. On cloudless days in winter the sun illuminates the façade from

an almost horizontal angle; and in summer too this low-angled light prevails near dawn and dusk, while at midday the reflections thrown up by the water add the brilliance of footlighting. This light undermines the shadows that mouldings in stone normally induce; a problem that the dense whiteness of Istrian only compounds. On days of mist or vapour, light is again lacking in direction from above, and therefore equally undermining to the force of relief in stone.

In this marine site, where the three-dimensional force of mouldings is sapped, colour differences lend order to architecture. Looking at the Palazzo Ducale on a bright day, it appears as a mass of white and rose punctuated by dark intervals – the windows and recesses. Originally this contrast must have been mitigated by colour, for it was colour that stood in for, and then usurped, the light and shade provoked by carved stone. In this sense Venetian Gothic is very different from the Gothic of northern Europe.

The Venetian interlocking between form and colour can be observed more closely on the Molo façade in two spandrels which retain the veneering in marble that, presumably, was planned for them all. In architectural theory the spandrel is an interval in the masonry of a building that justifiably appears free of the burden of weight carried by the arch and pier or column; therefore the spandrel may be filled with veneer that is self-evidently decorative and nonconstructional.[14] In one spandrel (figs 68 and 83) a disc is centred in a field of Veronese marble, into which roseate field have been inlaid three triangles in grey marble, pale and unveined, as large as each space allows.[15]

Starting from the salient axial point of this disc, the hub of mottled *verde antico* is protected by the chiselled fangs of a belt of dogtooth. Around it, radiating arcs in white and grey set the disc in a spin. All this is contained, not too closely, by a rim of billet moulding, which projects discrete from the pattern within it, spinning at its own tempo, another circle of the roulette wheel. Outside the wheel the triangles of grey, their bases horizontal in the field of mottled rose, appear delicately balanced, perfectly still. There is a beautiful fitness in the joinering of colour in the flat veneer of the marble and in the geometrical mouldings that facet the shadow and light. It is likely that the mouldings were originally polychromed, for billets in Venice were

83 Detail of fig. 68.

regularly gilded on the salient face and painted dark blue on the recessed. This would not have impaired the logic of this decoration, which was to proclaim its freedom from loadbearing.

The façade of the Ca' d'Oro

For defiance of gravity, contrast of light and darkness, brilliance of surface, intricacy of effect and richness of polychromy nothing can compete with the palace constructed between 1421 and 1433 by the patrician Marin Contarini, and known to posterity as the Ca' d'Oro (fig. 84).

The documents that provide the basis for Richard Goy's illuminating monograph on the building of the palace reveal the care with which Marin Contarini instructed the masons, carpenters, glaziers and painters, but caution against presuming that the patron had a master-plan worked out in all its details from the start. The reuse of materials such as low-relief carvings from the pre-existing palace, the division of the workforce between different materials, the extended time-scale of

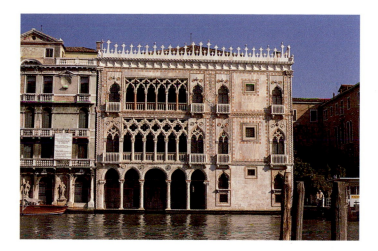

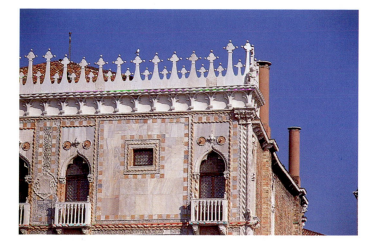

84 *(above left)* Façade of the Ca' d'Oro (1422–33).

85 *(above right)* Roofline of the Ca' d'Oro.

86 Detail of the upper loggia of the Ca' d'Oro.

the building campaign, the frequent coming and going of artisans, all mitigated against a unified design. In these circumstances gilding and polychromy were a necessary act of pictorial unification – a final pulling together. Marin Contarini's contract with the painter Zuan de Franza was drawn up after the façade was built.

Contarini's taste was steeped in the Venetian tradition. His instructions to the painter show that he conceived of the polychromy on the façade in terms of two pairs of colours, gold and blue, red and white, with the addition of the less usual contrast of black and white. Projections and sculptures of special importance – the balls on top of the crenellations, the capitals at the top on either side of the façade, the sejant lions above them, numerous rosettes and paterae or 'ducats' – were to be gilded (figs 85 and 86). Ultramarine was to be painted on backgrounds as accompaniment to gilded relief, for

example on the capitals. All this accords with earlier usage of gold and lapis lazuli. Gilding of the little balls (*pomi*) of red Verona marble that surmount the fantastically delicate crenellation would have created tiny sunbursts of gold against the sky.

Given that the Ca' d'Oro was the first private palace to have its façade entirely covered with stone and marble, and bearing in mind the similarities between the tracery on the first-floor loggia and that of the Palazzo Ducale, the squares of Istrian stone and Veronese *broccatello* – although confined to single rows of chequer used as borders – would have prompted Venetians to make the connection between Contarini's palace and the seat of patrician government (fig. 87).[16] The fading of colour contrast in Istrian and Verona deprives us of one of the patron's desired effects: for Marin Contarini it was essential that red marble appeared as red as

possible – 'And then I wish', he instructed Zuan de Franza, 'that all of the red stonework that is in the said façade and all of the red dentil [-courses] are to be finished with oil and varnish so that they appear red'.[17]

If Verona marble needed improvement in Contarini's eyes, so too did Istrian stone. Since the beginning of the century the whiteness of Istrian stone had been increasingly overshadowed by imports of marble from Carrara. Carrara had been used for the figures on the iconostasis of San Marco, on the south window of the Palazzo Ducale and for some of the figures in the tabernacles on the façades of San Marco. In 1429 Contarini instructed Giovanni Bon to leave the Istrian stone of the crenellation without its customary final smoothing and polishing, and two years later commissioned Zuan da Franza to paint it in oils with white. This was to enhance its whiteness and to counterfeit a more precious material, for Zuan was also told that 'all of the crenellations are to be darkened [ombrizadi] in the manner of marble, and with some touches of black around the gold of the said crenellations, as it appears necessary'.

The wording – 'as it appears necessary' – acknowledges the painter's judgement of the optical effect.[18] Mention of flecks of black suggests a departure from the colourful marbling of the Middle Ages. The patron may have had in mind the imitation of Greek veined marbles which were to be seen on the battlements of the richer Veneto-Byzantine palaces.[19] Equally, his instructions imply that another function of black paint was to reinforce relief.

By 1431 the patron would have been able to contemplate his pristine façade from across the waters of the Grand Canal; he could have observed that in the flood of light from sky and canal the encrustation of carved stone appeared little more than crinkles on the surface, while the recesses of the watergate portico and the loggie were dark intervals within the overall brightness of the façade (fig. 88). In such a situation, gilding adds zest to the sparkle that plays across the building's surface, and it is pigment rather than shadow that articulates ornament by distinguishing figure from field, whether on newly carved foliage and rosettes, or on reused Byzantine-style strips of low relief. 'I wish', said Contarini, 'that all of the roses and vines that are on the said façade are to be finished with white oil paint,

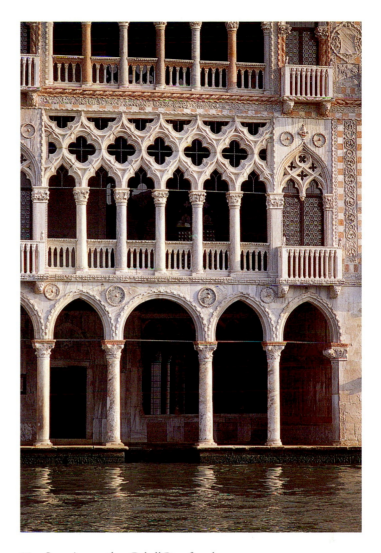

88 Loggie on the Ca' d'Oro façade.

and to paint the fields with black oil paint so that it appears well. And in the same way I wish to be painted all the background to the foliage of the cornice of the first floor . . . with black oil paint.'[20]

A glance again at the façade of San Marco reveals how this interaction of carved ornament and wall-plane fits within the Venetian tradition. On the Porta di Sant'Alipio low-relief carving of the thirteenth century appears as a dark interlace against a brilliant field of gold mosaic. From across the canal the tracery of the loggie of the Ca' d'Oro appears bright against the dark recesses: by contrast, from the depth of the portego – the central hall of the piano nobile – the tracery is reduced to a dark silhouette by the dazzle of canal-light beyond (fig. 89).

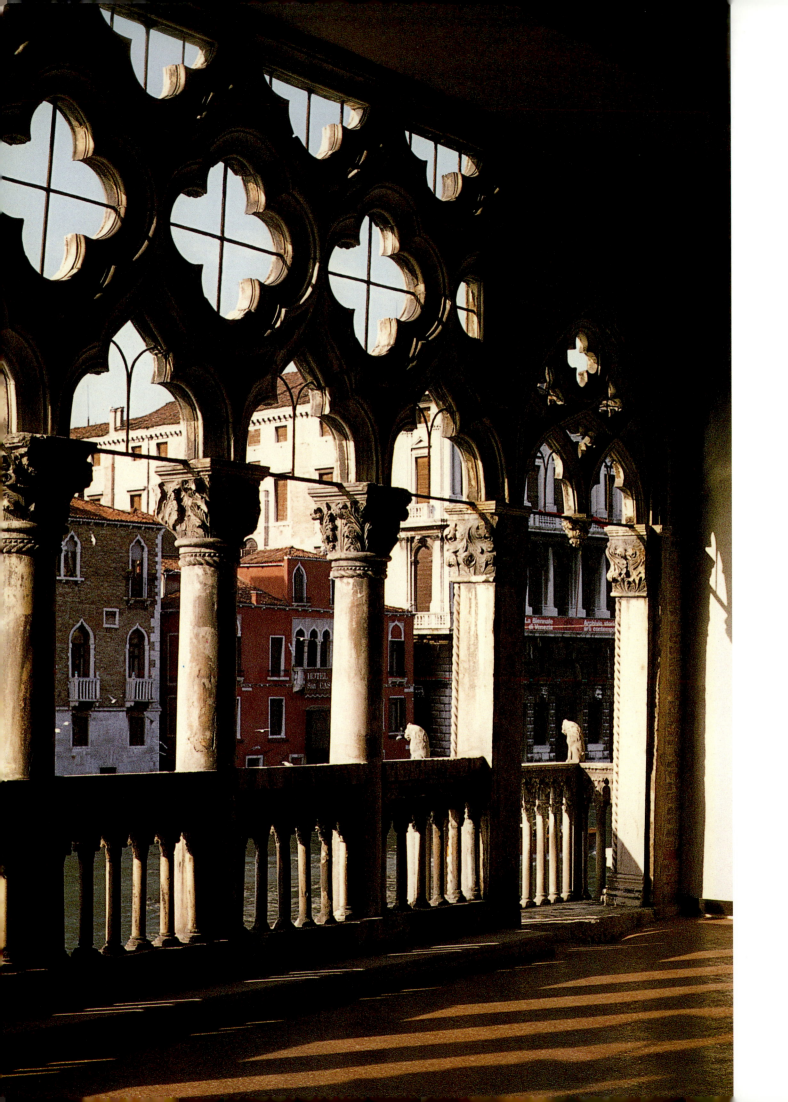

90 Looking out from the ground-floor *androne* through screens at the Ca' d'Oro.

91 Close-up of the *androne* screen at the Ca' d' Oro.

89 *(facing page)* Looking out through the loggie of the first floor of the Ca' d'Oro.

Often in Venice the force of light beamed off water burns into the darkness of stone viewed in *contre-jour*. Observed from within a palace, a row of close-set balusters on a Venetian balcony appear dark silhouettes that wobble against the brightness. The shape-shifting dynamics of light permeate experience on the lagoon. Within the ground floor of the Ca' d'Oro the builders added an extra mesh of silhouette by inserting a screen, sharply profiled and exceedingly slender, between the *androne* – the ground-floor hall – and the portico of the watergate (figs 90 and 91). Move ever so slightly within the *androne* and the interlace of darkness is reconfigured.

Time and again the energies of Venetian buildings reconfigure according to the vantage of the viewer. Moving between inside and outside, repeatedly witnessing the exchange between darkness and light, was a daily experience of patrons and artists alike, and undoubtedly one source of the manipulation of *contre-jour* that contributed so much to the dynamism of sixteenth-century Venetian painting.

Houses of gold, blue and marble

At the Ca' d'Oro Marin Contarini improved stone and marble with paint, and imitated black-and-white marble in paint. There the documents refer to the exterior: a telling reference to the internal polychromy of a Venetian palace occurs in documents relating to Giovanni da Ulma (who is probably identical with Giovanni d'Alemagna). In 1437 he was summoned to paint a chapel in the palace of the Bishop of Padua, on the strength of his decoration in the house of Giovanni Cornaro in Venice. Beneath the *hystorie* the artist was to paint 'serpentini et porfidi et strafori tuto in olio in la forma che sta quelli de messer zuan cornaro et meio'.[21] Evidently Giovanni da Ulma had painted the interior of Giovanni Cornaro's palace with fictive fretwork and inlays imitating serpentine and porphyry; as at the Ca' d'Oro, oil was used as the binder in marbling. Earlier in the same Paduan document, the painter is instructed to work with fine gold, the finest blue ultramarine that can be found, pure lakes and greens, and other colours all of the purest quality.[22]

'The houses are very notable . . . They are richly adorned with gold and blue and marble.'[23] This reac-

tion in 1430s by Pero Tafur, a Spaniard, encapsulates what most impressed visitors in the late Gothic period. Gold, ultramarine and marble were the materials and colours that were most precious and esteemed. In 1384 Lionardo Frescobaldi, passing through Venice on his way to the Holy Land, attended a banquet in Remigio Soranzo's house: he remarked that the interior appeared like 'a house of gold', for almost everything in the rooms was decorated in finest gold and blue.[24] Over the next century the luxury of domestic buildings continued to astonish.

The city depicted in the narrative canvases of Gentile Bellini and Carpaccio is one that had been embellished by extensive rebuilding since the fourteenth century (figs 92 and 93). Between about 1360 and 1460 medieval Venice, predominantly of wood and plaster, was rebuilt as a city of brick and Istrian stone. As the city grew richer – and by the early fifteenth century it was the richest in Europe – so standards of construction and finish, notably in plastering, flooring and glass fenestration, advanced to an unparalleled level of luxury, evident not just in the grandest palaces but in a wide swathe of domestic architecture.

A paean, based supposedly on a report by the brother of the Byzantine emperor John VIII Palaeologus who passed through Venice in 1438, speaks of 'that most wondrous of cities, so rich in colour and in accoutrements of gold, exquisite as a perfectly carved sculpture'. The account clearly goes beyond literary formulae, for the Byzantine visitor noted that the Palazzo Ducale and patrician palaces were 'embellished with reddish marble and gold': evidently the new fashion for Verona marble made an impression on the Byzantines.[25]

Bricks and painted bricks

Apart from Verona marble, it was bricks that lent a flush to the late Gothic city.[26] The primary material for walls, they were known as *piere cotte* or simply *cotte* and were of two basic colours – most a warm red from kilns in Mestre, some a coarse-grained yellow from Treviso. Like most of the materials of Venetian architecture, bricks were often reused from earlier buildings: at the Ca' d'Oro they came from the pre-existing palace on the

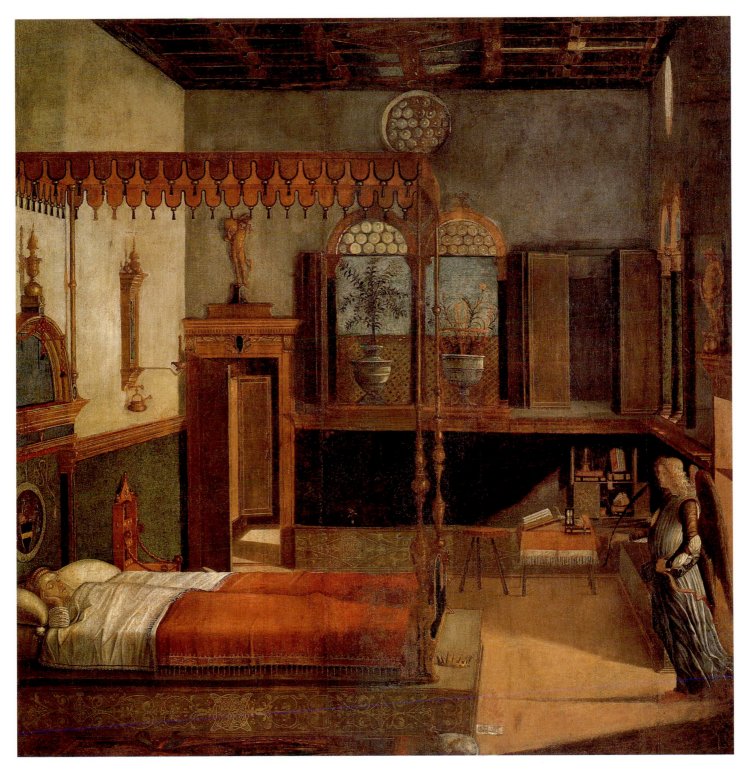

92　Vittore Carpaccio, *Dream of Saint Ursula* (1495). Canvas, 274 × 267 cm. Venice, Accademia.

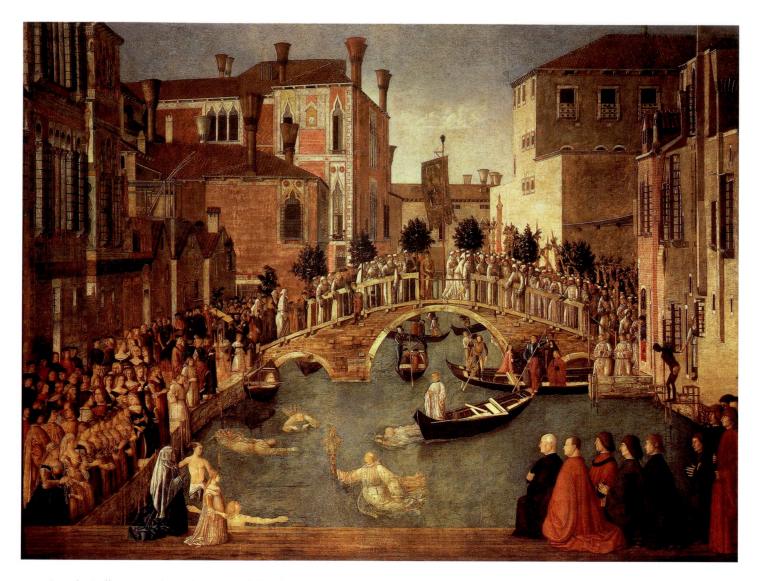

93 Gentile Bellini, *Miracle at the Bridge of San Lorenzo* (1500). Canvas, 323 × 430 cm. Venice, Accademia.

site. Where they were left exposed, the warmth of red brick was all the more noticeable when bounded, as was common, by the whiteness of Istrian stone. Seen in shadow beneath clear skies, the brick red is deepened towards purple or even umber violet by the reflection of sky blue; if the mortar joints are set back very slightly then at the edge of the brick, at the turning of the corner, a fringe of shadow will shift and intensify the colour.

Rarely massed in large expanses, at first yellow bricks hardly catch the eye. Yet on wider acquaintance with Venice their sandy glint can be detected in the walls of quite ordinary buildings. In low-angled light, veins of

umber and yellow gold surprise on quiet, side canals (fig. 94). Venetian builders knew how to make a humble brick glow like a golden tessera.

Bricks of red and yellow occasionally were laid in lozenge patterns similar to the lozenges in Istrian stone and Veronese marble on the Palazzo Ducale. An example can be seen on the façade of the old church of San Zaccaria to the right of the present church (fig. 95). Such patterning in two hues of brick crops up in a number of buildings throughout northern Italy around 1400: to judge how common it was in Venice is complicated by the frequent imitation of such patterns in paint.

94 Coarse-grained yellow bricks (probably *c.*1400) at the rear of Ca' Cappello.

95 *(below)* Brick pattern on the façade of the former church of San Zaccaria (*c.*1400).

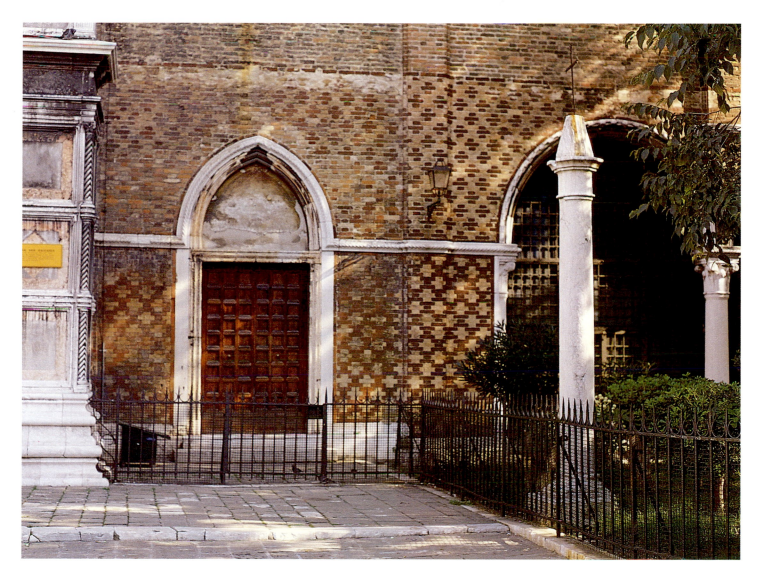

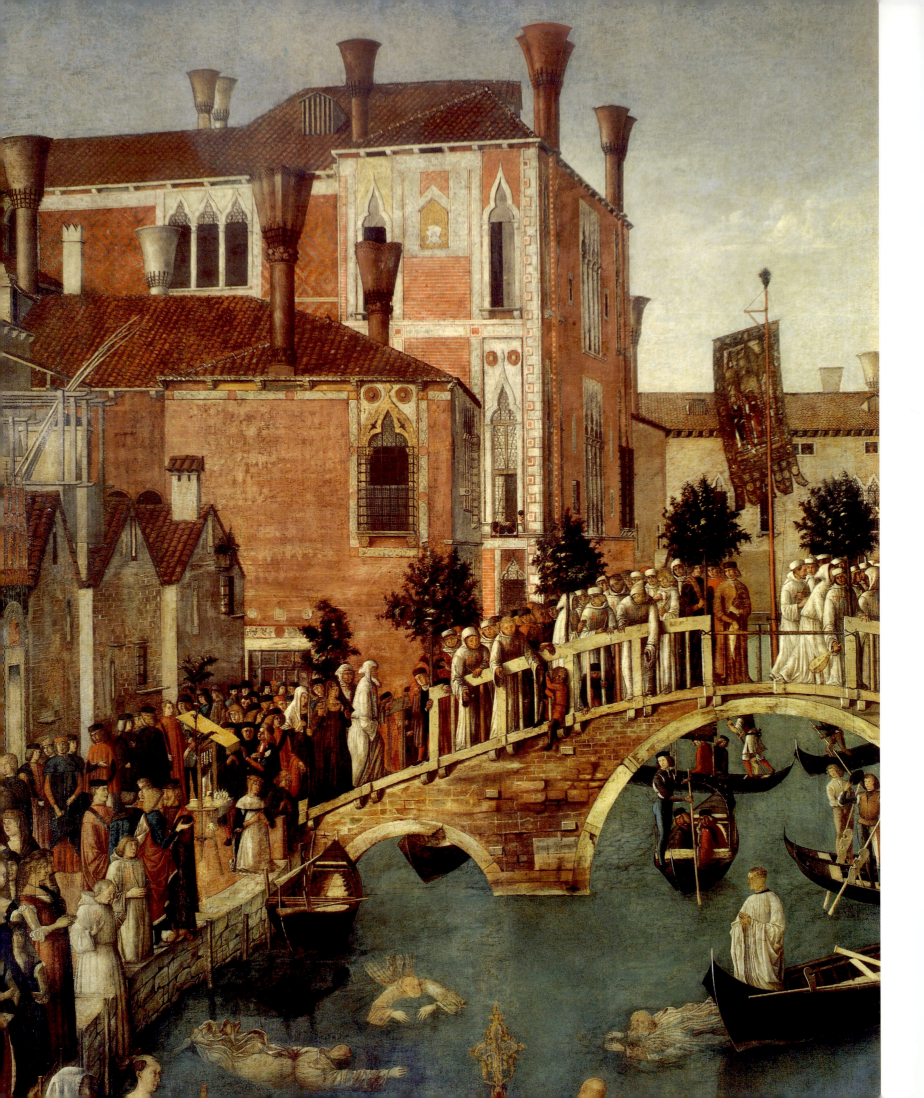

Evidence is steadily accumulating of the extent of painting over brick and stone in medieval architecture throughout Europe.[27] What may seem a curious feature of Venetian brickwork on walls, namely that patterns of bonding were someimes imitated in paint – red for brick, buff for mortar – has parallels elsewhere. By inventing a bond in paint, a wall could be made more orderly, more homogeneous in colour and more perfect than the actual bonds of brick and mortar hidden below. The extra expense may itself have been cause for pride.

In the Frari and Santi Giovanni e Paolo this fictive brickwork painted over real can still be seen; though much renewed, it probably dates back to the fifteenth century if not earlier. The artificial trimness of painted brickwork can be detected in many passages of the cityscapes of Gentile Bellini and Carpaccio. In the *Miracle of the Bridge at San Lorenzo*, for example, the section of wall running back from the palace at the top left, the Ca' Cappello, is diapered like the Palazzo Ducale, but in brick rather than stone and marble (fig. 96): the wall still stands today, and as the brickwork shows no sign of lozenges nor of complete rebuilding, either Gentile Bellini made up this diapering on his canvas or, more likely, he was describing a pattern that had been painted over the bricks and mortar of the palace and subsequently has worn away. Elsewhere on the same canvas, Gentile shows the mortar between courses as though it had been picked out with paint, and this also reflects a common Venetian practice.[28]

Painting over brickwork appears less odd bearing in mind that brick was a humble material, low in status, more suitable for treading underfoot than for admiring on a palace wall. Builders who laid bricks (*mureri*) were inferior to stonemasons, and belonged to a different guild. The cost of bricks at the Ca' d'Oro was small compared to that of other materials and to the wages of masons;[29] even at Santa Maria della Carità, a church begun in 1441, which was overwhelmingly in brick, the cost of bricks and tiles only amounted to 724 ducats out of total building costs of 7,433 ducats.[30] So although the colours and textures of bricks may be admired today in all their gradations, it is unlikely that this attitude was consciously shared by Venetians mindful of the cost of materials.

Venetian patricians walked in long gowns, scarlet or black, on the redness of terracotta. From the thirteenth century the more frequented streets were being paved in brick. By 1500 the more important *campi* (literally 'fields' because they were originally grassy spaces) had been paved, or at least crossed with paths, as Jacopo de' Barbari shows in his great woodcut published in that year (fig. 97). The material was brick, red *cotte*, laid in herring-bone with the narrow edge forming the surface (a pattern known as *spicatum*).[31] Versions of such paving survive under the arcade in the courtyard of the Palazzo Soranzo Van Axel, in front of the Scuola Vecchia della Misericordia, and – renewed – in front of the Madonna dell'Orto.[32] In Piazza San Marco (see fig. 204) the bricks were divided at intervals by lines of Istrian stone, presumably to demarcate the rows of temporary stalls. The substitution in the nineteenth century of the red-brick paving by dark grey trachite, dulls the full blush of Venetian colour. Set in the blue-green waters of the lagoon, Renaissance Venice must have glowed, a city of reds.

97 Jacopo de' Barbari, detail of fig. 3, showing *campo* in front of San Zaccaria.

96 Gentile Bellini, detail of fig. 93, showing Ca' Cappello.

79

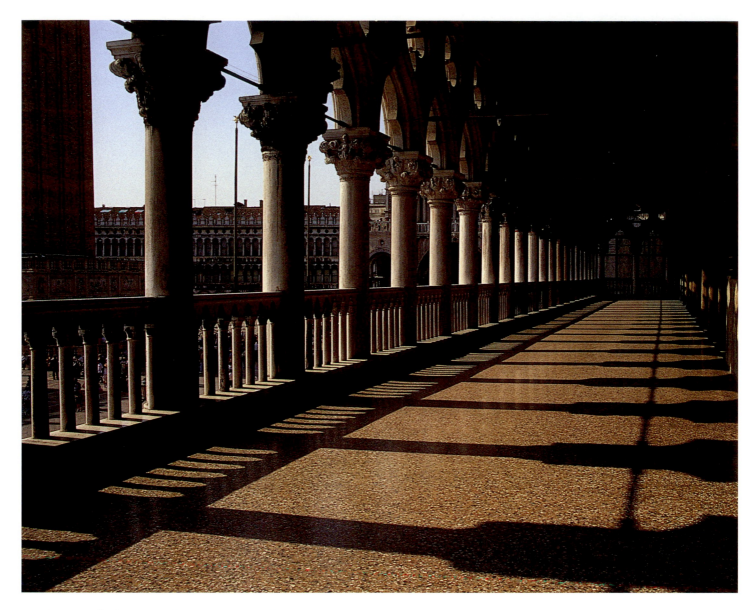

98 Loggia of Palazzo Ducale with terrazzo floor.

Sowing with colour and polishing with oil:
terrazzo

In their rebuilding of the city in the late Middle
Ages Venetians developed new techniques of flooring.
By 1400 floor surfaces were commonly made of an
amalgam of lime and ground brick or stone, known as
pastellon. This was laid over the usual floor structure of
wooden joists and, after pounding and levelling, the first
coarse mixture was covered by a second layer of more
finely ground brick with lime. Cinnabar was added to
the second layer to redden it. After further pounding,
skilful work with a plasterer's trowel rendered the
surface smooth and resistant, and finally, the floor was
sealed with linseed oil and buffed to a high polish. Such
floors, brick red or tending towards maroon, faintly
speckled, must have been common throughout inte-
riors in the fifteenth century.

Exactly when the Venetian terrazzo floor reached its
definitive form is uncertain. By 1430 the skill of laying

floors was evidently held in some regard: at the Ca' d'Oro Marin Contarini paid Iacomo, his *terazer*, about one lire a day, which was roughly equivalent to the wage of a young stonemason.[33]

By the beginning of the fifteenth century it may have been common to sprinkle chips of Istrian stone – the sweepings of the stonemason's yard – into the cinnabar-tinged *pastellon*. Certainly by the late fifteenth century artisans in the Venetian Friuli had started to sprinkle chips of coloured marble into the bed of ground brick and lime, and this embellishment was rapidly adopted in Venice. By 1500 the character of terrazzo – the marmoreal Russian salad we still tread today – was established (fig. 98). In 1586 the Arte dei Terrazzeri was ratified by the Council of Ten, and terrazzo floors have been made ever since, as innumerable examples in palaces and more simple dwellings, albeit restored or renewed, testify to this day.

For our purposes Venetian floors are significant on a number of counts. The warmth of *pastellon* must have coloured many domestic interiors of the quattrocento, so that just as out-of-doors Venetians walked on the red of brick paving, indoors red also lay beneath their feet. *Pastellon* and terrazzo floors were often extensive – that of the Sala del Maggior Consiglio in the Palazzo Ducale covers 1,200 square metres; the technique was such that it could accommodate underlying unevenness of support, and it could be spread seamlessly, apparently without limit; unlike its classier kin, the mosaic or tessellated floor, terrazzo was not regulated by geometric design. Sprinkling the marble chips into the bed was known as sowing, and like that of the sower of the fields, the action of the sower of terrazzo was essentially a rhythmic movement of the body. Colour was governed by pre-selection of chips of two or three hues of marble (fig. 99). Unconstrained by any plan or linear design, the sower intuited with hand and eye appropriate density in the seeding of colour. Occasionally the floors were given a very simple border or a central star motif, but never more than this: taken as a whole they never imitate anything, or describe anything, either by colour or geometry. In pounding and levelling the flattest face of the chips tended to assume the surface-plane of the floor, and yet the pointillist scattering of colours neither insisted upon flatness nor relief. These chips of colour have no orientation relative to an

observer other than what may be termed the reassuring and taken-for-granted support and flatness of the floor. The speckle of hues is restricted by the stones: browns and sandy reds may dominate; whites, blacks and greys add contrast.

Sixteenth-century sources testify to the runaway popularity of terrazzo, and to the esteem in which it was held, and as so often in Venetian building, it was texture – in this case high polish – as much as any subtlety of colour-mixture that was singled out for admiration. Treatment with linseed oil maintained a provident elasticity in the amalgam and lent the surface a much prized lustre. Francesco Sansovino hardly exaggerated when he declared that terrazzo took such a good polish that a man could see himself mirrored in it.[34] Typically Venetian floors were kept so spick and span that they reminded Sansovino of entering a well-kept church of nuns – a nice example of the moral overtones of polish for the Renaissance commentator. Lustre proclaimed devotion and cleanliness.

Daniele Barbaro, in his commentary on Vitruvius published in 1556, found a classical motive for respecting terrazzo: in his view it corresponded to Vitruvian precepts regarding high-quality finish of interior surfaces.[35] So, by the sixteenth century terrazzo, with its curious speckle of colours and its broad expanses of lustrous surface, had become a quintessential part of the admired luxury of Venetian domestic architecture.

99 Detail of terrazzo.

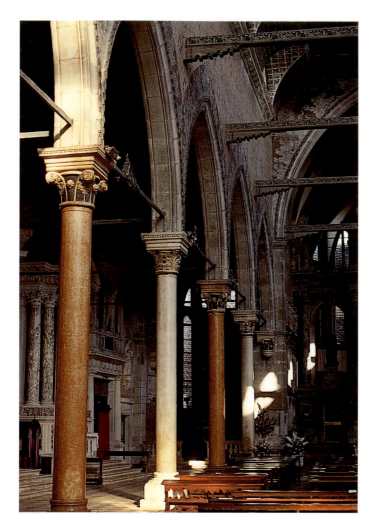

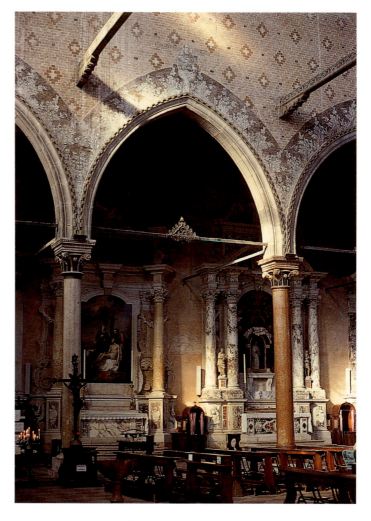

100 Nave arcade of Santo Stefano (early fifteenth century).

101 Nave arcade of Santo Stefano (early fifteenth century).

Colour alternations in Santo Stefano

Apart from the floors, the polychromy of domestic interiors has not survived. On exteriors the red of Verona marble has faded, gilding and polychromy has been washed away. To get some inkling of the richness of Gothic polychromy it is instructive to enter the church of Santo Stefano (fig. 100). The architecture was completed in the second half of the fourteenth century; the internal decoration and painting may well have continued until the mid-fifteenth century. The floor, like that of many Gothic churches, is a chequer of rectangular paving of white stone and Veronese *broccatello*, a more expensive form of pavement than terrazzo. The nave arcades are supported by shafts of white marble and

Verona red arranged alternately down each arcade, a zigzagging of colour across space characteristic of Venetian late Gothic. A similar principle of alternation occurs on the loggie of the palaces (such as Ca' Bembo), although in these out-of-doors positions today it is often hard to see the contrasting colours of column-shafts that are bleached by sun and salt or obscured by dirt. Alternation of coloured material relieves symmetry of structure and plays across load-bearing members as though to make light of them. The preference was so ingrained in Venetian habits of building that – in subterranean ways – it endured the Renaissance return to classical order to re-emerge in the least conventional compositions of Titian and Tintoretto.

In Santo Stefano, above the alternating shafts,

102 Capital in Santo Stefano.

103 Painted wall above nave arches in Santo Stefano.

the carvings on the capitals are gilded and the fields between painted dark blue (gold and pigment were renewed in the 1980s) (figs 101 and 102). A gilded billet moulding marks the upper limit of the stonework of the arches, and, outside this, grisaille painting of scrolled acanthus and half-length saints is relieved by a darker band (fig. 103). These motifs of acanthus and prophets pay homage to the recently carved crests on the façades of San Marco; the walls above are painted with a lozenge pattern similar to that at the Palazzo Ducale – except that here brick red predominates over white; thus the decoration refers both to the state church, San Marco, and the seat of government, the Palazzo Ducale.[36] By making this allusion through paint rather than costly materials the builders respected the ideals of

modesty of the Augustinian Eremites, to whom the convent church belonged.

The Porta della Carta

Following the completion of the west façade of the Palazzo Ducale on the Piazzetta, the rebuilding campaign was brought to a climax with the erection of a monumental gateway that bridged the gap between the palace and San Marco (fig. 105). It was commissioned in 1438 by the magistrates of the Salt Office from the stonemasons Giovanni and Bartolomeo Bon, and must have been completed shortly after the visit of the Spaniard, Pero Tafur. As the principle entry to the seat of govern-

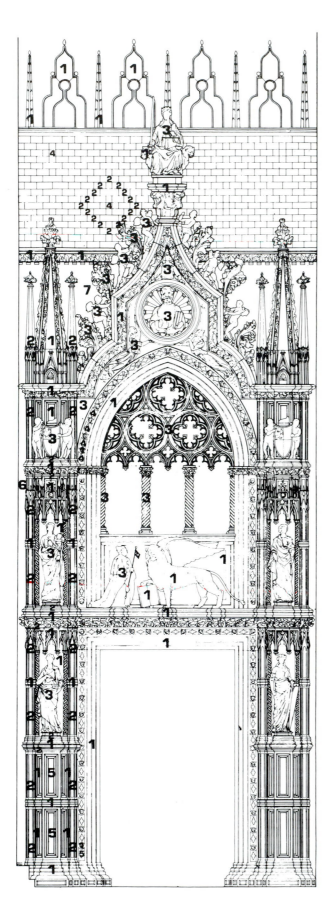

ment, the gateway is the most overt statement of Venetian power in the period of Francesco Foscari (1423–57), a doge committed to territorial expansion on the mainland. If the architectural idiom of the gate recalls the international tongue of mainland Gothic, its richness betrays a peculiarly Venetian accent. According to the contract, the commissioners promised to supply some stone from Rovigno, the source of finest quality Istrian, as well as some marble; the remaining materials were to be provided by the masons. The diagram in figure 104 shows the materials identified during the restoration in the 1970s, and is indicative of the importance that must have attached to variety.[37] Major architectural members, such as the frame of the door, are in Istrian; figurative carvings are in white Carrara; the elongated framing elements running up either side of the niches are in red Verona; the panels in the piers on either side of the door, and the small cusped insets around the door and window-frame are in *verde antico* or *verde aostano* (figs 106 and 107).

Originally these diverse colours of stone and marble were reinforced by gilding and painting. As usual, blue was applied to deepen recesses: the conservators found traces of lapis lazuli covering the Istrian stone inside the niches with Virtues, behind the bust of Saint Mark and inside the frieze of the crowning arch. Salient stonework was gilded: traces of gold on leaves of the frieze, the canopies above the Virtues, the capital supporting Justice and the tracery around the window, confirm that the glimpse of the gateway in Gentile Bellini's *Procession in Piazza San Marco* (fig. 108) is reliable in this respect.

104 Diagram of materials used in the Porta della Carta. 1: Istrian stone; 2: red Verona marble; 3: Carrara white marble; 4: Carrara Bardiglio marble; 5: *verde antico* or *verde aostano*; 6: Carrara veined marble; 7: grey Greek marble; 8: Carso grey stone (in some parts of the decorative masonry).

105 *(facing page)* Palazzo Ducale, Porta della Carta (1438–*c.*1443).

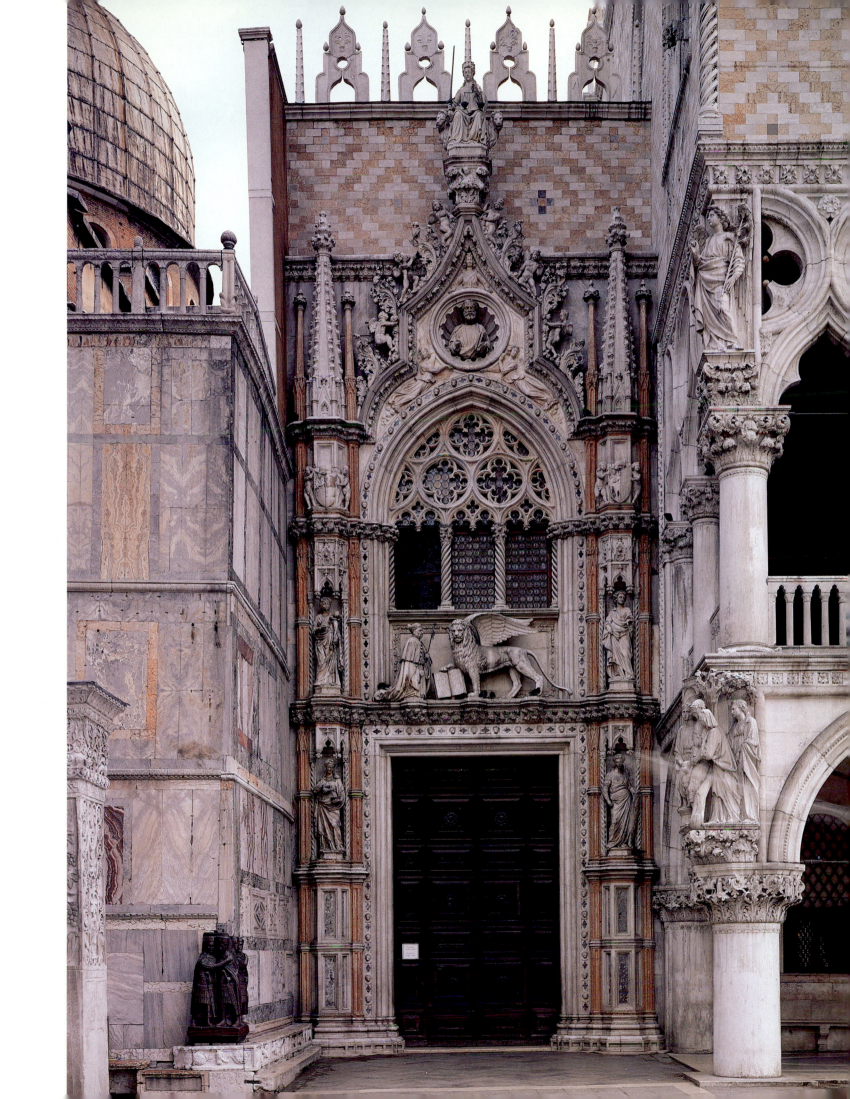

106 Detail of the Porta della Carta with the statue of *Prudence*.

107 Detail of marble inlay on the Porta della Carta.

Although in a work of this kind it is more appropriate to speak of a 'material scheme' than a 'colour scheme', it is relevant that the whiteness of figures in Carrara marble was intended to be foiled by blue. Apart from some gilding on the Virtues' robes, most of the Carrara was left uncovered, and must have been thrown into relief by the darkness of lapis lazuli, by the glitter of gold and by the red of Verona marble – and the bottle-glass in the great window added its own flicker of silver and black.

At the Porta della Carta as elsewhere to separate colour from texture is to misconstrue contemporary intentions. High polish signalled the riches of the Republic. The contract stipulates that the stones must be rubbed and pumiced.[38] The insets of polished marble are *specchi*, reflective as mirrors. Glass, Carrara marble, pigment of lapis lazuli, gilding, inlay of *verde antico*, and *broccatello* are exploited for their textures and their distinctive reactions to sunlight and shadow.

Colour across mouldings, 1440–1470

Shortly after the completion of the Porta della Carta a new fashion reached Venice. Its first manifestation may have been in an oculus window designed by Bartolomeo Bon in the west front of the church of Santa Maria della Carità. By using alternate voussoirs of

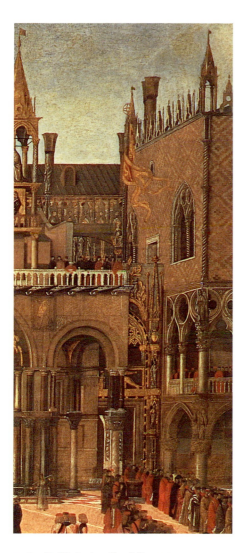

108 Bellini, detail of fig. 36.

109 Façade of Madonna dell'Orto (completed in mid-fifteenth century).

Istrian stone and Verona marble, the masons constructed a regular pattern of red and white – a simple contrast which ran athwart the carved mouldings and thereby, to some degree, interrupted the sequence of light and shadow created by relief. The window at Santa Maria della Carità is lost, but it had been imitated before 1444 in an oculus on the façade of the Madonna dell'Orto (fig. 110), and in the following decade the system of alternating blocks was applied to the main door of San Gregorio, both of which survive. Approval of the fashion at the highest level of government is indicated by its adoption in the Arco Foscari in the courtyard of the Palazzo Ducale, at the other end of the passage that leads to the Porta della Carta (fig. 111), the construction of

which was not completed until well into the 1460s. On this double-decker archway the radiating pattern of voussoirs in alternating material sets up lines of energy that cut across the continuities of moulding and, like the perspective lines in a drawing by Jacopo Bellini, point to a notional centre. The geometry of such linear junctions between colour dissects and counterpoints the light and shade of architectural relief.

By alternating the stone of voussoirs, the Venetians were producing a variant of a pattern that had been popular on the mainland in such cities as Padua and Verona since the mid-fourteenth century. In the church of Sant'Antonio in Padua (the Santo), for instance, there is very extensive alternation of red and white in the

110 Detail of the portal of Madonna dell'Orto (mid-fifteenth century).

111 Arco Foscari in the courtyard of the Palazzo Ducale (*c.*1450–70). Detail with upper storey.

material fabric of the building, but it is achieved by alternating groups of bricks and blocks of white stone. How popular this must have been can be gauged from its eye-catching imitation in the late fourteenth-century frescoes of Altichiero, such as those in the Oratorio di San Giorgio. Half a century later Donatello, in one of the predella panels to the high-altarpiece of the Santo, the *Miracle of the Speaking Babe*, adapted this fashion by using gilding to pick out alternate voussoirs.

Venetian merchants who travelled east would for some generations have noted the eye-catching alternately coloured voussoirs in Islamic architecture (fig.

112). More recently, in 1406, Padua and Verona had become part of the Venetian mainland territory; therefore knowledge of architectural polychromy in those centres would have become more widespread amongst the Venetian patronal classes. But there was one compelling reason why Venetian builders did not adopt the terra-firma use of brick and stone in the same arch or pier, at least where shared mouldings were involved, and this was the division between low-status brick workers or *mureri* and the superior stonemasons or *tagliapietre*.

In Venice one workman would cut Istrian stone or Veronese marble, and a different one would have to be called upon to lay and, if necessary, cut brick. The

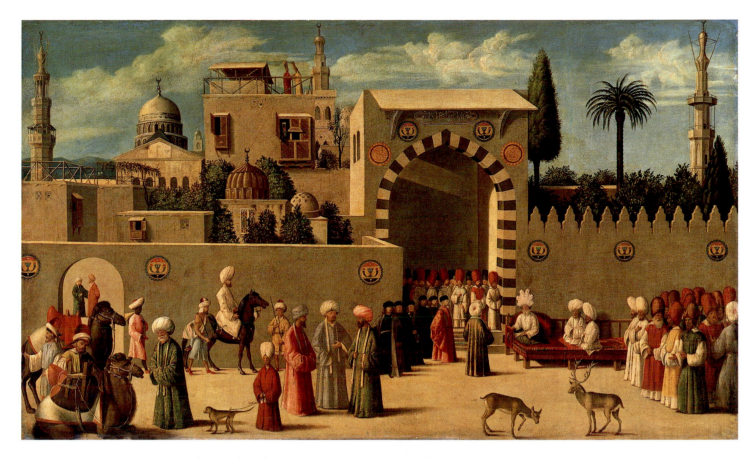

112 Venetian artist, *Reception of an Ambassador in Damascus* (*c.*1500). Canvas, 118 × 203 cm. Paris, Louvre.

statutes of the stonemasons guild forbade using different qualities of stone in one construction, let alone mixing stone and brick.[39] By banishing brick from the interchange of red and white on structural members the Venetians slimmed down the beds of mortar characteristic of brickwork, and thereby sharpened the linear junctions between blocks.

Guild rules and protective practices are inherently conservative: the explanation for changes must be sought elsewhere. For example, why do the bands of moulded brick or terracotta that were laid around windows on the outside of some Gothic churches, such as the Frari or Santo Stefano, disappear in Venice after 1450? The reason is cultural rather than technical, for with the growing prestige of classical antiquity, patrons knew from Pliny and Plutarch that terracotta was a material of humble status in the ancient world, and therefore they would have shunned it, at least in their palaces.[40] The fact that terracotta ornament, mass-produced in moulds, was a Gothic import rather than part of the repertoire of Veneto-Byzantine building, would have further discredited it in the eyes of patriotic Venetians.

113 Illumination attributed to the circle of Jacopo Bellini, *Guarino presenting the Strabo to Jacopo Marcello*, f. 3*v* of Strabo, *Geography*, translated from the Greek by Guarino of Verona (1458–9). Parchment, 37 × 27 cm. Albi, Bibliothèque Municipale, MS 77.

4

HUMANIST PRIORITIES:
ORNAMENT AND REPRESENTATION

'The science of painting'

To understand fully the changes that take place in fifteenth-century attitudes to colour, it is necessary to turn for a space from bricks and terracotta to what one humanist termed 'the science of painting'. Although the sources in this section will rarely be strictly Venetian, the traffic in ideas amongst the patronal classes between Venice and Padua justifies their inclusion.

Towards the end of the fourteenth century a follower of Petrarch, Coversino da Ravenna, writing in the context of a discussion of nobility, made a comparison with painting: 'When a painting is exhibited, the knowledgeable beholder expresses approval not so much of the purity and exquisite quality of the colours as about the arrangement and proportion of its parts, and it is the ignorant man who is attracted simply by the colour . . .'[1] Giovanni Conversino (1343–1408) was attached to the chancery in Padua and frequently in correspondence with early Venetian humanists. In setting arrangement and proportion (*ordinem proportionemque membrorum*) above beauty of colour (*colorum puritatem ac elegancium*), he was following the Aristotelian elevation of form above matter, the intellectual above the sensuous. This in turn became grounds for Conversino's distinction between the informed and the uninformed beholder. If order and proportion correspond to virtue, colour corresponds to wealth. Significantly – in a period when bankers needed reassurance from humanists regarding nobility and virtue – Giovanni Conversino went on to argue that both wealth and colour elicit admiration when rightly distributed: 'But if someone admires the proportiona-

lity of parts in fine paintings, they are still bound to be worthy of more admiration when beauty of pigment is added to this proportionality. The same is true of nobility, family property being added to finished virtue . . .'[2]

The most loaded categorization of colour that writers of the Renaissance inherited from classical antiquity was the valorization of austere colours as superior to florid ones. In the ancient world the easy attraction of florid colours, *colores floridi*, was condemned as morally suspect because it interfered with the higher cognitive function of reading form, a view repeated in such key texts as Aristotle's *Poetics*, Pliny's *Natural History*, and Vitruvius' treatise on architecture. With the spread of humanist learning in the early fifteenth century it is hardly surprising that superiority of austere colours over florid once again became a literary topos. Leon Battista Alberti refers to it in his treatise on painting, *De pictura*, of 1435,[3] and it crops up in context closer to Venice, in *pars* LXVIII of Angelo Decembrio's *De politia litteraria*, a dialogue set in the court of Leonello d'Este at Ferrara.

It was at the Ferrarese court in the 1430s and 1440s that Italian figurative art, notably by Pisanello and Jacopo Bellini, hung alongside tapestries from north of the Alps, therefore inviting comparison (figs 114 and 115). Angelo Decembrio argued that it is proper for the painter to exercise his skill in rendering the nude, whereas to depict ornaments in period or contemporary costume is suspect because it disturbs the timeless values of representation. Tapestry designers and weavers from Transalpine Gaul are criticized for being 'more concerned with opulence of colour and the

114 Pisanello, *Two Male Nudes*, reverse of medal of Leonello d'Este (*c*.1443). Diameter 6.8 cm. Paris, Bibliothèque Nationale.

frivolous charm of tapestry than they are with the science of painting'.[4]

A number of prejudices are hitched together in this humanist text. Underlying its hierarchy of values is the assumption that the canonical object of representation and highest form of visual truth is the nude human body. The male nude according to this view is essentially colourless or monochrome, like the sculptures in which the ideal forms of the naked body were transmitted by the Greco-Roman tradition: the female body, more prone it was believed to blushing and to blanching, and so often disguised under the tints of cosmetics, could not be so emblematic of visual truth. Colourlessness in this scheme of representation is linked to timelessness and to universality. Just as costume and cosmetics are supplementary to the body, so colours are extrinsic to mimesis. As with Giovanni Conversino's comments on nobility, it is a question of the priority of form over matter. Representation is superior to decoration; thus the reason-utilizing science of the painter is opposed to the material-based handwork of the weaver. What makes the opposition effective in Decembrio's dialogue is the identification of the medley of colours with the essentially foreign art of tapestry, an art that was highly esteemed at courts for furnishing palaces and yet one that could be stigmatized as tainted by the barbaric taste in multicoloured

pattern – a taste belonging to those who were not heirs to the civilization of ancient Greece and Rome.

It was an adroit reworking of that archetypal prejudice, which based a moral view of colour on the opposition of the indigenous to the foreign. In antiquity Pliny and Seneca had claimed that florid colours had come from the East to corrupt the sterner taste of the civilized world, as though they feared the Roman virtues of order, discipline, reason and legibility would be sapped by sensuality of exotic and oriental origin.[5] When Angelo Decembrio warned Leonello d'Este against 'opulence of colour and frivolous charm of tapestry', he had simply shifted the site of dangerous sensuality north of the Alps. As it turned out, this was only a temporary relocation of the site of the Other; unsuccessful because northern Europe was very much part of Christendom, and French and Burgundian fashions were popular as sign of élite status amongst the mercantile and princely classes of fifteenth-century Italy. Courtly consumption declined to conform to the puritanism of humanist theory. Truly dangerous, siren sensuality of colour and customs would continue to lie in the East, land of the infidel.

Lying behind Angelo Decembrio's remarks – although not fully articulated – is the subordination of colour to modelling, an accepted part of the workshop tradition of painters of the figure that stemmed essentially from Giotto.[6] Cennino Cennini, writing his *Libro dell'arte* in or near Padua in the 1390s, established at the outset his artistic descent from Giotto, before going on to instruct (in chapter 9) 'Come tu de' dare, (secondo) la ragione della luce, chiaro e scuro alle tue figure, dotandole di ragione di rilievo'. Directional lighting, light and dark in modelling (chiaroscuro), and relief (*rilievo*), are the top priorities for the painter of narratives: the 'reason' (*ragione*) of these takes precedence over colouring, or rather colour is subsumed within light and shade.

Similarly, when Guarino Guarini, the celebrated educator at the court of Ferrara, eulogized Pisanello's (now lost) painting of Saint Jerome, it is light and shade that display *ratio*, reason: 'Quae lucis ratio aut tenebrae! distantia qualis! / Symmetriae rerum! quanta est concordia membris!'[7] Notice here that praise for Pisanello's light and shade is followed immediately by wonder at his *distantia*, a term with an ambiguity that is worth

115 Jacopo Bellini, *Virgin and Child with (?)Leonello d'Este* (c.1440). Panel, 60 × 40 cm. Paris, Louvre.

savouring. Michael Baxandall translates these lines as: 'What understanding of light and shade! What diversity! / What symmetry of things! What harmony of parts!'[8] In classical Latin 'distance' or 'remoteness' is the literal sense of *distantia*, 'diversity' or 'difference' the figurative; it is the spacing, standing-apartness or separateness of things which allows their difference to be perceived.[9]

The articulation and bringing into concord of the difference/distance that is *distantia* is a characteristic concern of humanist discourse and early fifteenth-century painting. In placing things that differ and are distant from one another adjacent on the surface of a painting the painter needs a system for grading colour as well as size. It is precisely this question of the relation of colours to *distantia* which is addressed in a text by a fifteenth-century Venetian, Giovanni da Fontana. A hydraulic engineer and student of optics, he dedicated a little book on the rules of painting to his compatriot Jacopo Bellini. Although the full text of the treatise is lost, a summary records Fontana's instructions on how to

> apply bright and dark colours, with a system that not only the parts of a single image painted on a surface should seem in relief, but also . . . they should be believed to be putting a hand or a foot outward, or . . . seem miles away from the men and animals and mountains also placed on the same surface. Indeed the art of painters teaches that near things should be coloured with bright colours, the far with dark, and the middle with mixed ones.[10]

Two problems for painters of narrative are confounded by Fontana in a manner characteristic of the period: the first concerns how to model – the challenge of creating relief, the second how to establish recession from foreground to distance – the construction of space. As Gombrich has pointed out, the notion that light areas in a painting protrude, and dark ones recede, has a long history.[11] The Pseudo-Longinus, writing in the first century BC in his treatise *On the Sublime*, observed of painting, 'For although light and shade as represented by colours may lie side by side on the same surface, it is the light that first catches the eye and seems not only to stand out, but also to be much nearer'.[12] Artists in the Middle Ages used conceptual modelling:

they rendered surfaces parallel to the picture plane as light, and those at an oblique angle to it as darker, and also darkening towards the further edge. This modelling tone created relief, and was easily taught as a simple rule, therefore useful in workshops relying upon teamwork, such as those painting fresco cycles, where modelling techniques needed to be standardized.[13]

What is puzzling at first in Fontana's text is the move from conventions of local modelling to what would now be called aerial perspective. If his description of distant objects as darker than near objects seems to fly in the face of experience, it must be borne in mind that the modern vocabulary of colour, which distinguishes three axes of colour variation – hue, saturation and value or tone – did not exist. The terms Fontana used are 'clear' for near colours, 'obscure' for distant and 'mixed' for those between – *propinqua claris, remota obscuris, mediaque permixtis*. To Fontana, 'obscuring' of colours may have meant subtracting (i.e. loss of intensity) rather than darkening in terms of tone, but his terminology did not allow him to make this clear either to himself or to his readers. It is also true that the great thirteenth-century authorities on optics or *perspectiva* – Roger Bacon, John Pecham and Witelo – identified rays of sight with rays of light, argued that the further a ray had to travel the weaker it became, and equated weakening with loss of light: by implication, then, objects seen in the distance appeared darker.[14] The same linguistic problem clouded Alberti's discussion a generation later, when in *De pictura* he described distant colours as *fuscus* he could mean either brown or dark.[15]

What may be gleaned from the scattered and fragmentary texts – from Giovanni Conversino, Angelo Decembrio, Cennino Cennini, Guarino Guarini and Giovanni Fontana – is that among informed opinion painting was governed by rules, that an admirable painting displayed the reason, or *ratio*, that the painter deployed in applying these rules, that a higher value was placed on form and proportion than on colour, and that making figures and objects stand out in relief was the principal goal of the highest branch of painting which was the rendering of figures. The best workshop traditions since Giotto had absorbed these priorities and built them into their modelling procedures. But by 1400, and in the following decades, there is evident in texts such as Giovanni Fontana's, a growing fascination

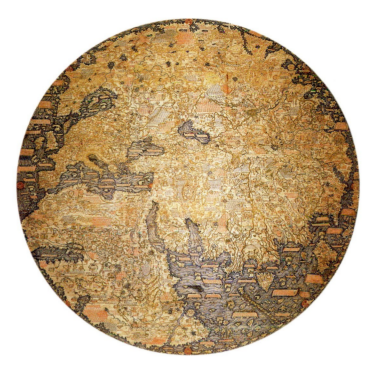

116 Fra Mauro, *Mappamondo* (*c.*1460). Venice, Biblioteca Nazionale Marciana.

with distance, with geography and with ways of conceiving and representing connection and separation in space. By the 1450s it would appear that there was a workshop in Venice devoted to the production of maps: in that decade Fra Mauro made his vividly coloured *Mappamondo* (fig. 116), and another map – which has not survived – was ordered from the maritime Republic by Alfonso V, King of Portugal.[16] How to handle line and colour without sacrificing either *rilievo* or *distantia* was the challenge that faced painters of the quattrocento, and to which the Venetians reached solutions, particularly in the paintings of Giovanni Bellini (for example, figs 18 and 171), of far-reaching consequence.

Sculpture into painting

The search for a new balance between relief and distance took place in a context in which painters and their patrons were attentive to sculpture – a fact of which any history of colour must take account. Before the late fifteenth century, Venice did not have a vital

tradition of monumental sculpture. As will be evident from earlier chapters, in Byzantine and Gothic Venice the arts of architecture, sculpture, painting and mosaic were intertwined: the tomb of Doge Michele Morosini (d.1382), in Santi Giovanni e Paolo, for example, combined sculpted figures in relief and in the round, painting in blue and gilding on architectural ornament, mosaic in the lunette, and fictive architecture painted on the surrounding wall (fig. 117). As sculpture was

117 Tomb of Doge Michele Morosini (d.1382). Venice, SS Giovanni e Paolo.

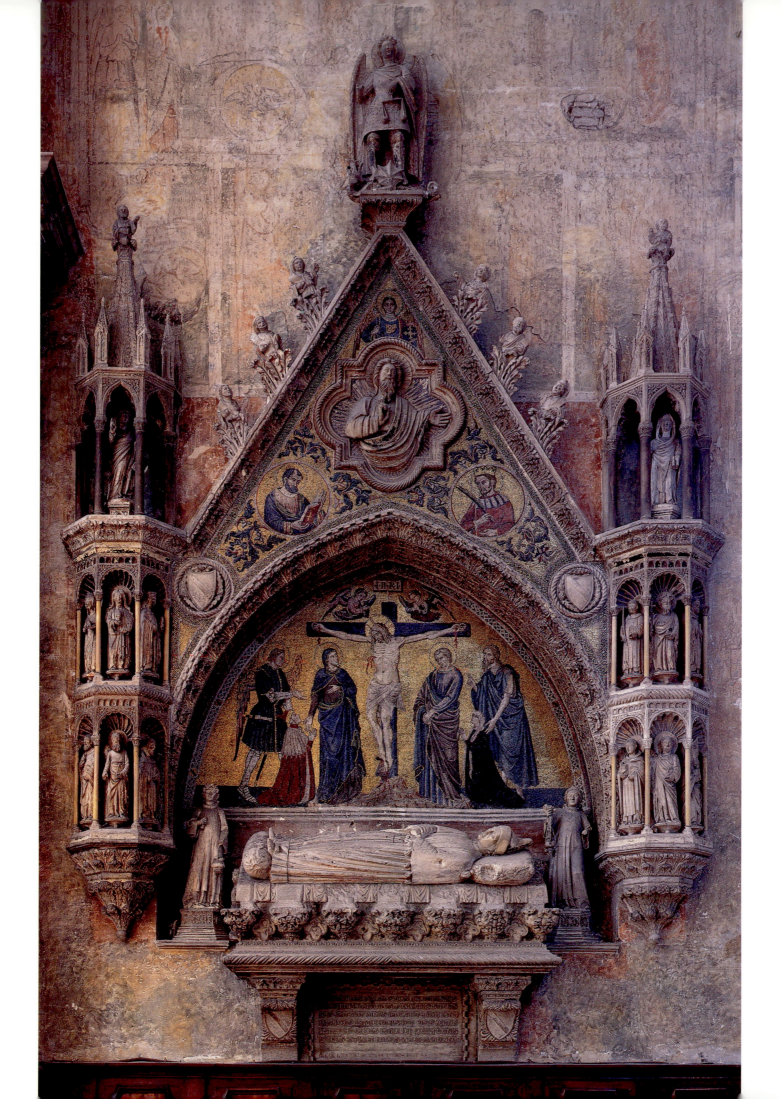

to the Madonna and Child, donor and angels in full colour.

In the late Gothic period the monochrome integrity of sculpture was compromised by the employment of variously coloured stones and by painting and gilding. By the 1440s there are signs of a change in taste. It shows up first in the pictorial representation of architecture and sculpture. In the panels of Antonio Vivarini and Giovanni d'Alemagna the narratives are set amidst a festive architecture of pinks and whites without

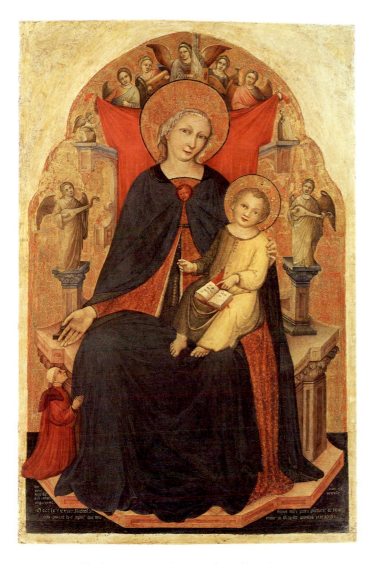

119 Niccolò di Pietro, *Madonna and Child with a Donor* (1394). Panel, 107 × 65 cm. Venice, Accademia.

rarely free-standing or self-supporting, the Venetian eye – unlike the Tuscan – was untutored in discerning the essential four-squareness of the human figure as emergent from the cubic quality of the stonemason's block. So painters working in Venice – at least from 1365, when Guariento completed his *Coronation of the Virgin* for the Sala del Maggior Consiglio of the Palazzo Ducale – borrowed from sculpture to create playful distinctions in degrees of illusion rather than solidity of form. In Niccolò di Pietro's *Madonna and Child* in the Accademia, dated 1394 (fig. 119), a diminutive Gabriel and Annunciate Virgin, as well as a pair of music-playing angels, are painted in grey as if stone, in clear contrast

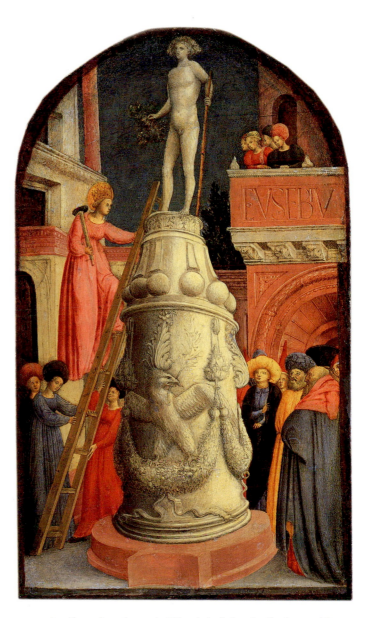

120 Attributed to Antonio Vivarini, *Saint Apollonia attacking an Idol* (c.1450). Panel, 60 × 34 cm. Washington, DC, National Gallery of Art, Samuel H. Kress Collection.

embellishment with blue and gold: in *Saint Apollonia attacking an Idol* (fig. 120) the pagan sculpture and its huge pedestal are painted in shades of white and grey, with no change in colour between relief and field. By offsetting the polychrome Christian world of living figures against a monochrome antique sculpture the painter offered the quattrocento viewer a tidy contrast of classical and contemporary.

The *ratio lucis et tenebrae* and the quality of *rilievo* is modest in the Saint Apollonia panel compared with what Andrea Mantegna demonstrated in the frescoes in the Ovetari Chapel in the early 1450s. Trained in the university city of Padua in the humanist-inclined workshop of Squarcione, Mantegna was mindful of the priorities of 'the science of painting'.[17] As with Pisanello before him, the representation of light for its own sake is subordinate to the graphic definition of form. Hatched shading on the figures accents the curvature of each surface; polychromy in the architecture is limited. In the double scene of archers shooting at Saint Christopher and his body being dragged away after his beheading (fig. 122) each building is dominated by a single material in a meaningful hierarchy of marble, stone, brick. As a consequence each building displays integrity of colour. The most important, the ruler's palace in the centre, is distinguished by discs of

121 Mantegna detail of fig. 122, showing the busts and frieze on the palace.

porphyry and serpentine but has no applied colour or gilding, and the low reliefs which decorate it are modelled in white and grey, without difference of colour between figure and field (fig. 121). Mantegna directed attention to material, its solidity and mass; architectural colour is far from skin-deep. In seeking this integrity of material he rejected the prevailing Gothic tradition in which salient carving was gilded and fields covered in blue, a rejection springing from the artist's awareness of the historical distance separating the present and the late antique world, the era in which Saint Christopher lived. For Mantegna, antique architecture differed from Gothic in colour as well as form.

Mantegna's early paintings are the most sophisticated example of the imitation of sculpture in painting in the mid-fifteenth century in northern Italy. It is the graphic element of design, not opulence of colour, that demonstrates the painter's science, his exercise of reason. The modelling, which is essentially an extension of the drawing, demonstrates the painter's mastery of the figure, especially the nude. The pagan stigma of the classical – still problematic in *Saint Apollonia attacking an Idol* – is redeemed by the virtue in the means of representation itself. As in classical theories of rhetoric which dominated humanist education, there is a new awareness of the mode of presentation – how the orator or the painter orders and disposes, how something is set before the eye. The vehicle of representation colours its content.

Although few contemporary painters could match Mantegna's austere virtue, his reform of polychromy in architecture and ornament was influential in the Veneto. In an altarpiece which Bartolomeo Vivarini, younger brother to Antonio, signed in 1465 (fig. 123), the carving on the Madonna's throne is white, modelled in grey against a field of white. Veronese rose *broccatello*, popular in the Veneto in the previous half-century, is excluded in favour of whiteness. Bartolomeo has attempted to match the *all'antica* style of the throne with a modern, non-Gothic handling of colour, but his striving after *rilievo*, at once classicizing and sculptural – the angels have become Grecian caryatids – has mired him in an essentially local conception of the modelling of the figures as so many separate areas of relief. What is missing in Bartolomeo's pursuit of Paduan-inspired modernity is a feel for the unifying power of light.

122 Andrea Mantegna, *Archers shooting at Saint Christopher* (*c.*1453–7). Fresco, 332 cm wide. Padua, Church of the Eremitani, Cappella Ovetari.

Inscribing colour and faceting form

Turning from fresco and panel painting to manuscript illumination, amidst pervasive signs of Mantegna's spell a chromatic version of his graphic conventions can be discerned. In the portrait of the Venetian patrician Jacopo Marcello, in the *Passion of Saint Maurice*, attributed by Millard Meiss to Mantegna himself, the profile head is relieved by a halo of individual blue strokes (fig. 124).[18] More loosely spaced as they eddy outwards from the profile, they create a vibrant transition from a dense blue setting off the flesh to a paler fringe where the individual brush-strokes are infiltrated by the field of the parchment. Such a shredded fringe invites a different reading from the tautly bounded forms of the figure, serving at once as relief shading, coloured foil and means of easing the transition from the relief and colours of the figure to the flatness and whiteness of the page.

The coloured fringe is even more intriguing in another manuscript illuminated for Jacopo Marcello,

Strabo's *Geography* translated from Greek by Guarino of Verona (fig. 113).[19] This luxurious manuscript dates from 1458–9, a couple of years later than the *Passion of Saint Maurice*. In the full-page miniature of *Guarino presenting the Strabo to Jacopo Marcello*, blue strokes relieve the pedimented arch, separating its whiteness from the field of parchment (fig. 125). Such a fringe of colour unites two conventions found in antique bas-relief: one is the shadow cast by the relief on to the adjacent flat ground; the other is a colour/tone distinction between the materials of relief and field common in cameos. The contradiction of shadow falling on a field that is notionally distant yet physically adjacent, is 'condoned'

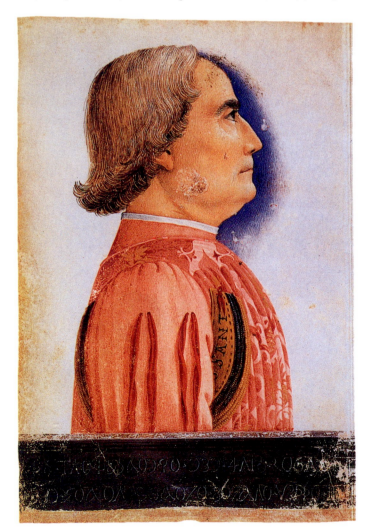

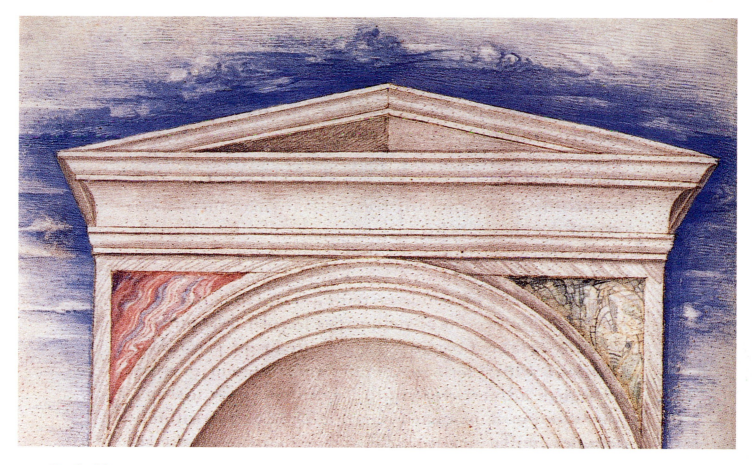

125 Detail of fig. 113.

by the informed viewer because he esteems materials and manner (both prestigious by antique association) as much as illusion and content. The illuminator of the Strabo manuscript nudges these conventions towards naturalism without camouflaging their stylistic pedigree. Strokes of blue setting off the pediment are modulated to become distant clouds seemingly drifting in from the whiteness of the parchment; yet because this same blue laps the architecture, it is as palpably close as the veined marble set within the spandrels of the arch. Such artful conventions of colour and shading taught Venetian artists and their patrician public to relish colour for its own sake, as signifying luxurious materials *and* pictorial illusion. To borrow terms used by Richard Wollheim, it could be said that the decoration of books in the Veneto in the second half of the fifteenth century fostered the ability to switch between 'seeing in' and 'seeing as' – between seeing colours as tokens of luxurious materials *and* seeing them as modulations within an optical continuum (fig. 126).[20]

Typically, in Venice techniques of luxurious ornamentation became adapted to descriptive purposes. In 1441 Matteo de' Pasti wrote excitedly from the lagoon to his patron Piero de' Medici to inform him of the technique he had learnt there of using powdered gold in manuscript illumination.[21] Used in Venice and Padua since the late fourteenth century, powdered gold was far more adaptable than burnished gold leaf in combining the splendour of the art object with the description of light. Jacopo Bellini (see fig. 127) used gold dots to model the Madonna's blue mantle in a 'pointillist' technique indicative of both light and texture.

Writing with colour has a long history as sign in sacred and secular texts. Rubrics and red-letter days are named after the red ink in which they were inscribed. In the 1460s the celebrated scribe Bartolomeo Sanvito

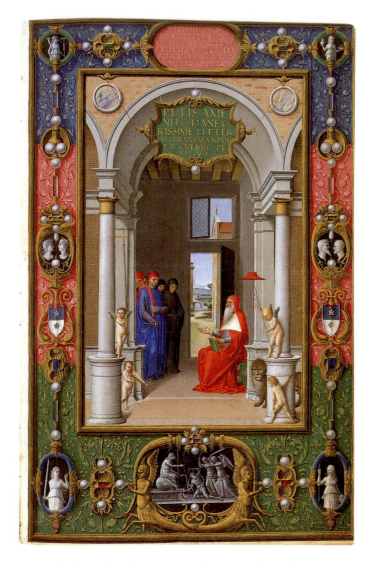

126 Attributed to the Master of the London Pliny, opening miniature (f. 5r) of *Letters of Saint Jerome* (*c.*1478–80). Parchment, 29.7 × 19.5 cm. Berlin, Staatliche Museen zu Berlin, Preussischer Kulturbesitz, Kupferstichkabinett, MS 78 D 13.

letters, even though text is significant of something other, not visible on the page, whereas letters as ornaments are visual manifestations to be enjoyed for their own shape and colour. The humanist passion for classical epigraphy disturbed this relaxed dualism by foregrounding the visible aspect of writing. From the mid-fifteenth century, as the entire painted page came to be treated as field for illusion, so letters had to be incorporated on the page as representations or figures of themselves.[23]

This is the context in which the device of faceted three-dimensional initials, christened by Millard Meiss *littere mantiniane*, comes into view.[24] The examples in the

127 Jacopo Bellini, detail of fig. 115, showing modelling with gold dots.

of Padua revived the conceit of manuscripts written on parchment stained in purple (and sometimes green), in which this staining signals that the book is as expensive and enduring as imperial porphyry (or serpentine, in the case of green) (fig. 128).[22] In the fifteenth century the inscription of colour – the chromatics of the graphic sign – become subject to vision in a more self-conscious and more problematic manner than in earlier centuries. The medieval viewer/reader of the illuminated manuscript apparently could move with ease between semiotic *reading* of text and pictorial *looking at*

a hallmark of the Renaissance style. Paolo Uccello, who in his youth contributed designs for mosaics in San Marco and painted a cycle of frescoes in Padua, was a pioneer of the faceted, perspectival style (fig. 130). The growing popularity of marquetry or intarsia may be explained, in part, because of the manner in which the inlays of different coloured woods lent themselves to crisp divisions between planes: in Venice the earliest surviving inlaid panels are Marco Cozzi's in the choir of the Frari, completed in 1468. But it was epigraphy

128 Bartolomeo Sanvito, frontispiece (f. 149*v*) to Petrarch, *Trionfi*, (*c*.1463–4). Parchment, 23.3 × 14.2 cm. London, Victoria and Albert Museum, L. 101–1947.

129 Page (f. 230*v*) from Strabo, *Geography*, translated from the Greek by Guarino of Verona (1458–9), written in Venice or Padua. Parchment, 37 × 27 cm. Albi, Bibliothèque Municipale, MS 77.

Strabo, based on Roman epigraphy, are amongst the earliest of this influential type (fig. 129). For the purposes of this inquiry the faceted initial is significant because it leads the way – acquiring authority from its classical prototype – towards a more general faceting in painting in the later fifteenth century. It is exemplary of the change from cursive shapes and colours 'blended like smoke' characteristic of International Gothic to the more regular geometries and demarcations that became

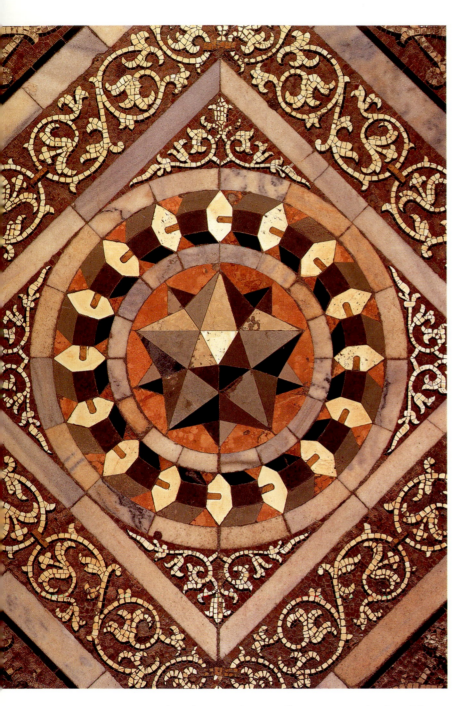

130 Attributed to Paolo Uccello, pavement in San Marco, inside the portal of San Pietro in the north aisle (*c.*1430).

that surely accelerated the change in patrician taste. Whereas previously in book illumination pliancy of forms and softness of their modelling indicated a lack of asperity that was a token of *gentilezza*, by the late 1450s forms as clear-cut as epigraphy stand in adamantine contrast to blurred transitions in the colour fields surrounding them. To put it in terms of modern understanding of visual categorization, the distinction between what is an edge and what is merely an effect of light or colour was clarified. Such faceting is based upon principles (derived from classical majuscules) rather than observed from life, and the same kind of conceptual faceting would be applied to such figurative elements as drapery. A new grammar of form and colour, bounded and unbounded, emerges within this sphere, as can be seen with exemplary clarity in the work of Marco Zoppo, a painter and illuminator active from the mid-1450s to the 1470s, who moved to and fro between Bologna, his birthplace, and Padua and Venice (fig. 131).

Although attention to the essentially monochrome discipline of modelling relief was a priority of the 'science of painting' as loosely defined by the early humanists, it would be over-simplifying the historical situation to omit to note an impulse that was contrary to any subduing of colour. Felice Feliciano, antiquarian and friend to Mantegna and his brother-in-law Giovanni Bellini, inscribed pages which have been described as 'a rainbow of coloured inks'. Through the exercise of *fantasia*, Feliciano brought back to life the pale vestiges of the ancient world by brightening their hues.[25] A mid-fifteenth-century manuscript in Ferrara on the technique of illumination testifies to contemporary interest in reviving ancient Greco-oriental recipes for refining lapis lazuli, making liquid gold *alla moresca*, manufacturing inks that shine, as well as describing recipes for writing over varnished surfaces, some employing finely ground glass.[26] Of course the luxury of the splendid had long been part of the appeal of illuminated manuscripts: what is new in the Ferrara compilation is a rapprochement with the techniques of painters.[27] When the arbitrary colours of letters and their decoration were absorbed within the field of representation, when the white of the parchment could be interpreted as light or sky, then the artist might awake to referential or expressive possibilities latent

in the conception of mimesis between Early and High Renaissance fails to take sufficient account of how colour that is non-descriptive gets framed within a representational context, thereby transforming the merely visible into the meaningfully visual. Colours that are not in origin determined by descriptive reference are enfolded within the order of the visual. In the art of the Veneto, in manuscripts as well as monuments – for instance veined marbles framed for view on the Scala dei Giganti (fig. 132) – colour is enlisted before it is imitated. In terms of the language of fifteenth-century contracts, what is designated as *ornamento*, once quite distinct from figures, now becomes absorbed into the field of representation.

Book illuminations of the later fifteenth century present strong contrasts between three-dimensional form, hard and bounded, and the fields outside them. The hatched or 'pointillist' fringes of colour, unlike the surfaces of the forms, decline to be read with any positive orientation, tilt and slant. If the newly fashionable science of perspective, expounded by Alberti, heightened awareness of the angle from which every solid is viewed and hence its foreshortening, the fringes of colour were the 'other side' to that insistence on point of view – suggesting colour that floats unanchored in space. Recent commentary on the 'scopic regime' of quattrocento perspective has failed to note how a certain kind of visual ordering, ultimately deriving from the distinctions of figure and field in antique

131 Marco Zoppo, *Dead Christ with Saints John the Baptist and Jerome* (*c*.1470). Panel, 26.5 × 21 cm. London, National Gallery.

within the decorative use of colour. The fringes of colour in Jacopo Marcello's manuscripts, or the coloured dots employed by Bartolomeo Sanvito and associated later fifteenth-century scribes have their origin in the act of inscription, not in things seen.

Colour and visual order

In an influential discussion of colour in Renaissance theory and practice, James Ackerman pointed to a shift from Alberti's notion of colour as a property of the object to Leonardo's of colour as generated in the eye.[28] According to Ackerman, Alberti conceived of pictorial mimesis as object-centred, whereas for Leonardo painting was a record of things seen by a subject – crucially affected by point of view and by atmosphere between the surface seen and the eye. But this model of the shift

132 Palazzo Ducale, Scala dei Giganti, detail of marbles (after 1484).

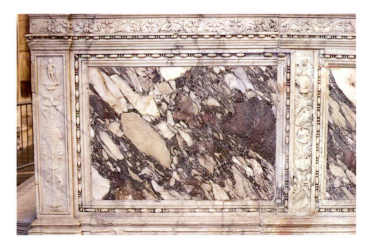

In ceruicibus quatuor obscuras sed maxime lucet
quæ proxima caput apparet: In humero claram
unam : In pectore unam Inter scapulio unam : In
umbilico nouissimam unam duæ andromede uo
catur : In genibus utrisq singulas: In utrisq popli
bus singulas: Ita sunt omnio nuo deteg & septe

De toton autem ut triangulum deformatur : æ
quis quodam modo lateribus duobus uno bre
uiore : sed prope æquali reliquis inter æstiuu
& æquinoctialem circulum supra caput arietis
no ab andromedæ dextro cruce : & persei ma
nu sinistra collocatum : cum ariete toto ocideg
exoriet autem cum eiusdem dimidia parte pri
ore : Habet aut stellam i uno quoq angulo una.

133 Paduan illuminator, *Constellation of the Horse*, f. 48*v* *of* Hyginus, *De astronomia* (*c.*1465–70). Parch-
ment, 23.4 × 15 cm. New York, Public Library, Astor, Lenox and Tilden Foundations, Spencer MS 28.

reliefs, endures within and works against the overall dominance of subjective point of view.[29] The craft tradition understood this, and had a well-used word for what lies outside the boundaries of the figure, namely the field, *campo*. To fill this in with a colour was termed *campeggiare*.[30] Colour subdued as modelling, graded to assist the detection of edges and angles, is surrounded by colour released from these very functions (fig. 133). In Paduan manuscripts these two aspects of colour may seem opposed: in the paintings of Giovanni Bellini this contrast becomes a mutual alliance. Like his patrician patrons, Bellini was certainly aware of developments in manuscript illumination; in the mid-1470s Felice Feliciano had penned a eulogistic letter in Latin to him.[31]

The 'science of painting' of early humanist texts gave precedence to the rendering of the human figure in relief and to monochrome modelling; the charms of colour were to be distrusted. Alberti added an insistence on *istoria* or narrative. The outcome of these demands was that as vision became all-encompassing, attention became selective: figure is bearer of narrative, of meaning, while field drops back. Therefore the colour of field, of *campo*, is not focused upon; yet, being framed within the order of representation, it is subject to optical effect. The fields of colour, free of the full responsibilities of descriptive reference yet embraced within the visual, will transform the symbolic order of things.[32] Like the waves lapping Venice, colour floods in from the margins.

TRANSPARENCY, *LUCIDEZZA*
AND THE COLOURS OF GLASS

The new lucidity in stained glass and mosaic

When painters abandoned a predominantly egg-tempera technique in favour of one that was pre-dominantly oil (see the next chapter), they participated in a taste for translucency which had been strengthening since the late thirteenth century. The new aesthetic modified, rather than eclipsed, long-standing esteem for deep and glowing colour.[1] The change is obvious in stained glass. Starting in northern Europe, the trend was towards glass that admitted more light into churches: the jewel-like colours of the twelfth century gave way to a more expansive luminosity. White glass and clear glass become more widely used. The invention around 1300 of silver-stain, *jaune à l'argent*, allowed white and yellow to be used side by side on a single piece of glass without intervening leading. Thanks to silver-stain pale yellow became a dominant hue in late medieval glass. Techniques of flashing – covering or partially covering a sheet of colourless glass with a film of colour – starting in the fourteenth century with ruby red, became more widespread in the fifteenth. These novel glaze-like uses of colour were described in a treatise on glassmaking, written about 1400 and attributed to Antonio da Pisa, a text which specifies the materials to add to molten glass to achieve the newly fashionable colours – the yellows produced with silver, the more translucent reds, the deep blue made with *chafarone* or *zaffera* (essentially cobalt oxide), and an aquamarine, 'the most beautiful glass that can be made', produced by the addition of copper oxide.[2] Indicative of the new taste for cheerful lightness is the recommendation that in the composition of colours one third part should be white

(i.e. colourless) glass to make it more cheerful (*allegro*) and striking (*comparascente*).[3]

One explanation for the oddity that the Venetian lagoon should be so celebrated for its production of table-glass, yet relatively undistinguished in its stained glass, may be that the traditional decoration of churches in mosaic and marble revetment pre-empted the development of stained glass on a grand scale.[4] Mosaic itself consisted of coloured glass as well as marble. It is in fifteenth-century Venetian mosaic we find another aspect of the new ideal of lucidity and pictorial legibility.

Evidence can be found in the Mascoli Chapel, a simple barrel-vaulted chamber off the left transept of San Marco (figs 135 and 136). In the mosaics made in the 1430s and 1440s for the lunette and vault, figures and architecture are rendered with an eye to the Albertian priorities of perspective and directional light. Whereas earlier Venetian mosaics glint and sparkle as the viewer moves through a building because of the deliberate unevenness in the setting of the tesserae, in the Mascoli Chapel (fig. 134) they have been laid flush with the plane of the wall and placed as close together as possible.[5] Liveliness of surface reflection has been sacrificed to improve the reading of three-dimensional form.

Traditionally, glass tesserae were coloured throughout their depth, *a corpo*; in the fifteenth century some tesserae were made with just a layer of colour, *a cartellina*. Laying an almost paper-thin layer of colour over the body of colourless glass was essentially an enamel technique. By this means glass tesserae were produced in deep black, gleaming white, a light and a deep red,

134 Michele Giambono, *Birth of the Virgin* (*c*.1440). Mosaic. San Marco, Mascoli Chapel.

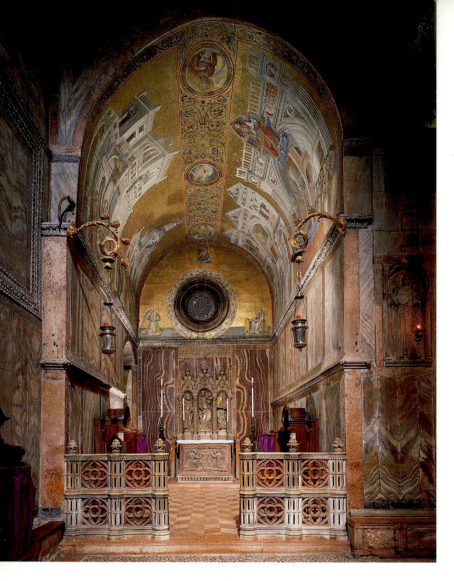

135 San Marco, Mascoli Chapel (late 1430s to *c*.1450).

some an opaque white layer, an oxide of tin, was glazed with a thin layer of coloured glass and then covered with a skin of transparent glass, a multi-layered technique which resulted in complex tints. The novelty of a white enamel base for some colours produced an underlying lucidity that is suggestively analogous in its effect to an underpainting of lead white beneath glazes in oil painting: in both media incident light passes through translucent colour and is then reflected back through the colour by the dense white beneath.

Since enamels had long been among the glories of medieval colour, it is worth defining what is new here. Translucent enamel, *smalto traslucido*, applied over silver was well established in Venice and Tuscany by the 1320s. The Venetian fourteenth-century products have been described as modest in quantity and high in quality.[7] Enamel in mosaic is related to that applied by the goldsmiths, but the replacement of silver by white enamel as the reflecting base brings a subtle change. White enamel is smoother, less volatile in its reflection of the light than silver, therefore the colour values shown in modelling are more stable yet no less luminous. Significantly, enamel as a pictorial technique rose in status in the course of the Renaissance thanks to the discussions of encaustic in Pliny's *Natural History*. The Venetian humanist Ermalao Barbaro argued that encaustic was a *genus picturae*, rather than an entirely separate species of picture-making.[8] In the eyes of patrons informed by humanist literature the different media – mosaic, enamel and painting – shared a common goal of representation.

Confirmation that mosaic technique was being reformed in favour of lucidity can be found in an early fifteenth-century Venetian text on the application of tesserae, *Sul modo di tagliare ed applicare il musaico*.[9] It advises that tesserae should be laid as close together as possible, and that if the mortar between them shows it should be brushed over with the appropriate colour; if the surface of the mosaic is splashed with mortar, it should be cleaned off with a sponge dipped in linseed oil, or, failing that, white of egg. Flesh colouring is characterized as diverse spots or smudges of colour, 'diverse machie di colori', a phrase prophetic of sixteenth-century discussions of Venetian *colorito*.[10]

a reddish purple, a green resembling oil called *oglino*, three or four blues and as many violets could be produced. According to Saccardo, the enamelled tesserae made in Murano and used in the Mascoli Chapel show an exceptional lucidity and brilliance of surface compared with earlier Byzantine ones. There are several reasons for this brilliance: a vitreous paste high in tin; a lengthy purification of the frit in the furnace; and – most importantly – final firing after the skin of clear glass had been blown over the coloured glass.[6] Since this 'fire-polish' on the surface of glass heightened the difference in texture between glass and stone tesserae, fifteenth-century mosaicists had to be careful to select stone tesserae where they wished to avoid shinyness in flesh.

The Mascoli Chapel mosaics signed by Michele Giambono exploit tesserae enamelled *a cartellina*. On

<center>★ ★ ★</center>

136 San Marco, mosaics on the vault of the Mascoli Chapel.

Bottle-glass: vetro a rui

The desire in the late Middle Ages for increasing light-ness in churches led in Venice to the extensive use of bottle-glass, known as *vetro a rui*.[11] The clear discs can already be seen in Paolo Veneziano's depiction of San Marco on the cover of the Pala d'Oro painted in the 1330s (fig. 137), and became increasingly common thereafter. San Marco itself was repeatedly modified to admit more light into the interior, in the earlier phase perhaps to compensate for the blocking of windows in the extension of the mosaic programme. In the thir-teenth century rings of windows were opened round

the bases of the cupolas; in the fourteenth, galleries were removed over the aisles and a rose window inserted in the south transept, and in the fifteenth century the great central lunette of the west façade was glazed.

One of the most beautiful examples of a design in bottle-glass, easily overlooked, is in the Mascoli Chapel (fig. 138). It is glazed with four concentric circles of clear bottle-glass, the discs diminishing in size towards the centre, with the disc at the hub framed by a star pattern. Each glass has a perceptible thickness, colloidal and slightly uneven in the concentric rings, which like a lense condenses the light passing through them into gleams of silver. Centrally placed within the lunette

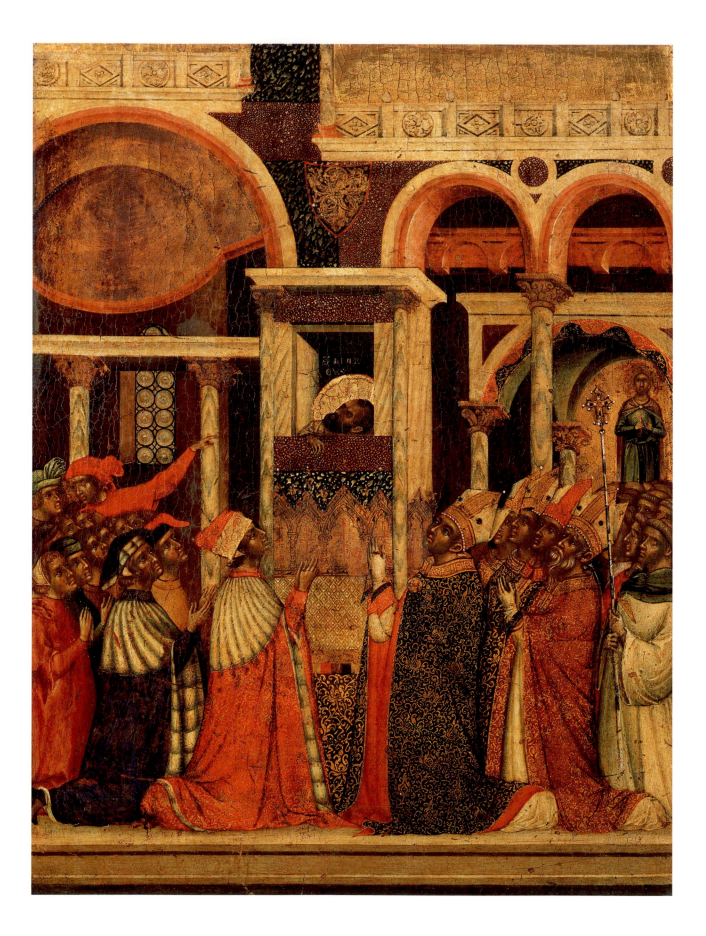

the eyes of Venetians were accustomed to bright light blazing in from the banks of windows on the canal and fading abruptly into obscurity in the unlit depths. Nothing could be further from Leonardo da Vinci's ideal studio illumination of a veiled top-light: rather than the gradations of chiaroscuro, Venetian bottle-glass created juxtapositions of light and darkness, black and white and silver. These too are *macchie*, patches or spots, not of colour but vivid concentrations of light and dark.

* * *

139 Casement in Ca' d'Oro with bottle glass (renewed).

138 San Marco oculus window in the Mascoli Chapel, with *vetro a rui*, from the interior.

mosaic of the Annunciation, this silver light incarnate in the discs of bottle-glass may fittingly call to mind the Virgin's immaculate conception of 'the light that lighteth every man that cometh into the world'.[12]

In his account of the city, the diarist Marin Sanudo (1466–1536) notes with admiration that all the palaces had windows of Murano glass and every parish its workshop of glaziers.[13] Francesco Sansovino, writing in the mid-sixteenth century, reported that Venetian rooms, in ordinary dwellings as well as palaces, are the envy of foreigners, being 'very bright and full of sun' on account of windows made, not with waxed cloth or paper as was usual elsewhere, but of the clearest and finest glass (fig. 139).[14] Growing up in rooms that were long, low and frequently unlit from any windows at the side – as typically one palace abutted the next –

137 *(facing page)* Paolo Veneziano, *Invention of the Relics of Saint Mark*, detail of the Pala Feriale (1345). Panel, 58 × 42 cm. Venice, Museo di San Marco.

Cristallo *and sandwich-glass*

Whereas no great sculptors were born or bred amidst the waters of the Venetian lagoon – the stonemasons being mainly immigrants from Lombardy – natives of the lagoon excelled in the making of glass vessels. Like water, and unlike stone, glass is a medium that resists chiaroscuro and gradations of tone; it displays colour and light in space without density of matter.

By the late thirteenth century glassmakers were well established in Venice with their own guild and statutes (*capitolare*).[15] Following a decree of 1292, the glasshouses and their furnaces were removed to Murano, and it was there that over the next fifty years a group of 'painters

140 The Aldrevandin Beaker (fourteenth century). Venetian enamelled glass, height 14 cm. London, British Museum.

of beakers' (*tintor de mojolis*) decorated high-quality drinking vessels with colours in enamel. The most celebrated, in the British Museum, bearing the inscription '+ MAGISTER · ALDREVANDIN · ME · FECI:', is enamelled on the interior as well as the exterior (fig. 140).

By the fifteenth century the *fiolari*, as they were known, were a highly regulated industry producing luxury goods for a largely export market. To grasp the dynamic behind the rapid development of Venetian glassmaking in the Renaissance, it is worth thinking of the masters of glass as counterfeiters who were for ever extending the materials and shapes that they imitated. Using the versatile material of glass, made from pebbles of high silicate content and soda-lime ash from Levantine coastal plants, they mimicked the more precious materials of rock-crystal, metalwork, hardstones and, finally, oriental porcelain.[16]

On a standing cup with cover in the Victoria and Albert Museum (fig. 141), coloured prunts or bosses of glass in sapphire, garnet, green and amber have been applied to the colourless vessel in imitation of cabochon stones or gems – a reminder that there had long existed in Venice a separate group of counterfeiters of coloured stones, known as *veriselli*.[17] Alone of all the glassmakers in the lagoon they were allowed furnaces in Venice itself, perhaps on account of the small scale of their activity, or perhaps so the government could keep an eye on their potential trickery.

The glassblowers of the fifteenth century diversified their products to create a varied range that sharpened discrimination of the absolutely transparent, the translucent and the opaque. Angelo Barovier was the most celebrated of a select band of Murano masters. Active from the 1420s until his death in 1461, he was credited by contemporary sources with perfecting colourless glass that was transparent and bubble-free and shone with great surface brilliance. Because it matched the transparency and lustre of rock-crystal (a much traded luxury in Venice, with its own guild, the *cristalleri*) the glass was known as *cristallo*.[18]

141 *(facing page)* Venetian standing cup and cover, with applied red, blue and green glass, enamelled and gilt decoration (late fifteenth century). Height 24.5 cm. London, Victoria and Albert Museum.

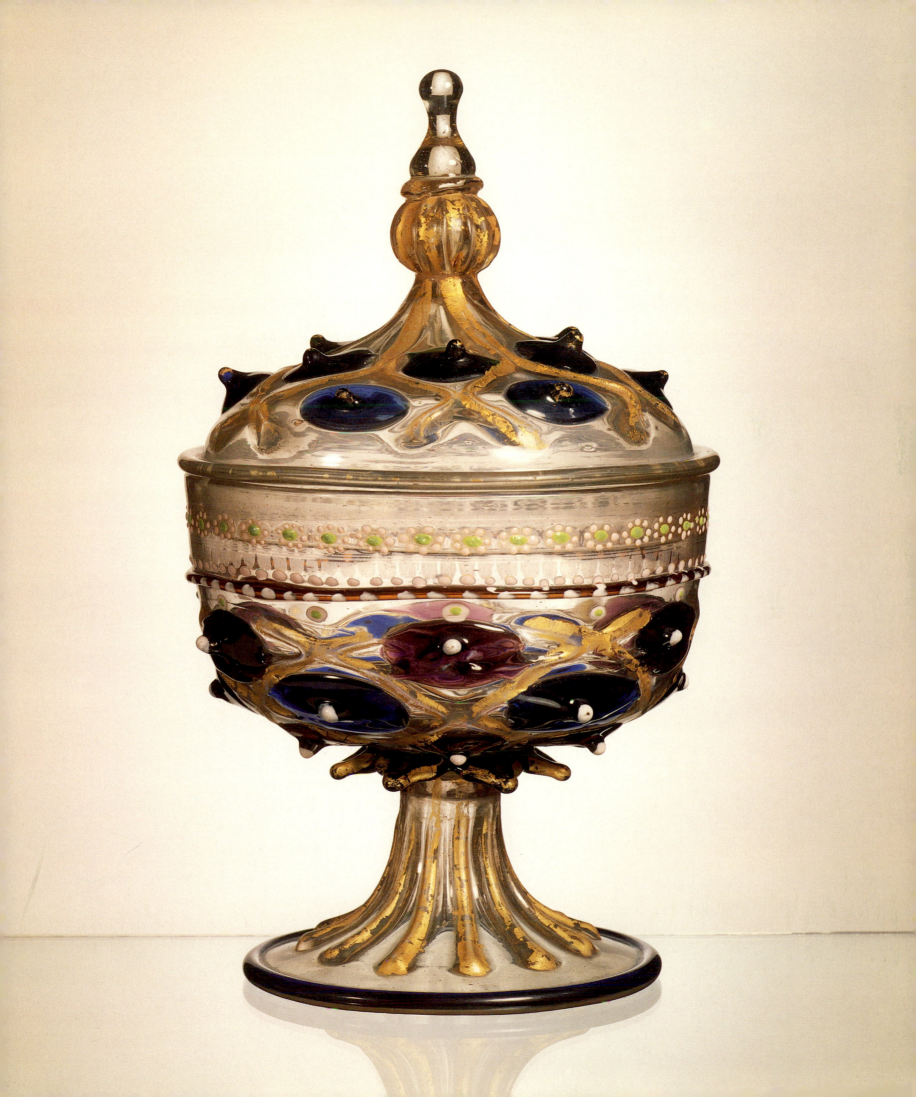

143 *(top)* Standing bowl with sandwich-glass (*c.*1500–20). Height 13.5 cm. Oxford, Ashmolean Museum, on loan.

144 *(above)* Mould-blown dish with sandwich-glass and applied blue and aubergine trails (beginning of sixteenth century). Diameter 22.8 cm. London, British Museum.

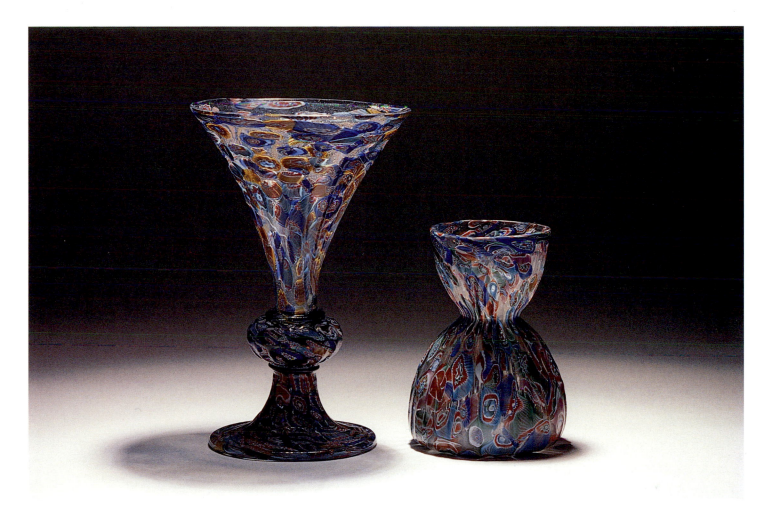

147 Goblet and bottle illustrated in fig. 146, lit from behind.

He said that it is 'none other than a gathering of almost all the colours, and *scherzi*, which can be made in glass, not a common thing' – *cosa non vulgare*.[20] That playful, musical term, *scherzo*, repeated several times by Neri, is an apt description of the wayward swirls of deep colour.

Giovanni Bellini's *Agony in the Garden* (fig. 148) is datable to the 1460s, a decade when chalcedony glass was a rare novelty. The goblet in the Wallace Collection (fig. 149), may be twenty years later than Bellini's painting, but belongs essentially to the same visual culture. As two products of the lagoon, goblet and painting reward comparison, their diversity of media helping to discern what is essential about Venetian quattrocento taste in colour. The landscape of the *Agony in the Garden* is strangely molten, as is fitting for this most tremulous moment of Christ's passion – 'let this cup pass from me'

– yet it also conveys an adamantine hardness. In the chalcedony-glass goblet and in the painting a common range of colours oscillate between dull mauves, hints of violet and twilit greens, with sandy gold browns glowing between. Goblet and painting both imitate the qualities of marble and both have much in common with water.

To make chalcedony glass several different gathers of molten glass are overlaid before marvering. The Wallace Collection goblet, which is mould-blown with applied and tooled decoration, stands eighteen centimetres high. Its interior is pale green, like jade. The beauty of the technique depends upon the skilful superimposing of semi-translucent colours and the partial blending of others. That glassblowers such as Angelo Barovier perfected methods of superimposing and fusing layers

148 Giovanni Bellini, *Agony in the Garden* (*c*.1464–5). Panel, 81 × 127 cm. London, National Gallery.

of colour just a few years before Venetian painters took up the oil medium with all its possibilities of glazing, blending and floating colour is highly suggestive.

What Theodor Adorno called the 'luxury' of the enjoyment of nature, in Renaissance Venice was anticipated and prepared by the enjoyment of those luxuries in marble and glass in which matter revealed energy.[21] Marc' Antonio Sabellico, writing at the close of the fifteenth century, marvelled that 'there is no type of precious stone in existence that has not been imitated by the glass industry; a sweet contest between nature and man'.[22] This 'sweet contest' was set up within the order of manufacturing technology, indeed it could be argued that it was within this context of highly skilled making that the beauty of nature was defined.

Not every Venetian needed to be a glassworker for the processes and products of the industry to frame

a shared imagination of the world, or to condition communal habits of attention. The furnaces of Murano, as well as the industries of the Arsenal, were celebrated sights of the lagoon.[23] The liquefaction of vitreous pastes in the heat of the furnace, the controlled breath of the glassblower, the changing shape of the ductile glass as it was spun on the blowpipe or on the pontil, all informed the imagination of the molten flux in which marbles first received their veining. A chalcedony goblet, so finite and graspable, yet dynamic and changing when rotated in the hand, could offer a conceptual microcosm of a landscape in flux, which in turn becomes the arena for Bellini's drama of the *Agony in the Garden*.

A clue to the attention Giovanni Bellini paid to glass is the chalice-bearing putto-angel translucent against the sky (fig. 153). By picking it out merely with a

120

149 Venetian goblet in chalcedony glass, mould blown with applied and tooled
decoration (late fifteenth century). Height 18 cm. London, Wallace Collection.

150 Venetian bowl in chalcedony glass (*c*.1510). Height 17.5 cm, width 27.2 cm. Kunstgewerbemuseum Berlin.

ghostly skein of highlights, like trails of enamelled white, Bellini ensured that the image of Christ's prayer was sufficiently insubstantial not to rupture the realism of the dawn landscape. The supernatural, normally invisible to mortals, is rendered glassy. Perhaps even more telling than this translucency is Bellini's curvilinear construction of the world, which recalls the sphericity, blown and spun, of glass vessels. To describe Giovanni's achievement purely as a synthesis of Florentine space and Flemish light, as has been done, is to miss the Venetian dynamic, at once vitreous, marmoreal and aqueous, of his space-encircling arcs.[24]

Although art is naively supposed to imitate nature,

it is nature that imitates art. When marble was cut into veneers and spread on buildings, when chalcedony glass was rotated in the hand, when *millefiori* canes were scattered and twisted in *cristallo*, eyes and minds of patrons and their painters were tutored to enjoy cognate beauties in the veining of rocks and currents of water. When, nearly half a century later, Titian painted the *Noli me Tangere* (fig. 151), he was recognizably working within the same tradition: like a movement in water or sky, colours, such as the red lake glazed over the white of the Magdalen's robe, spread outwards, flooding beyond the contours.[25] Titian's deeper harmonies again find some analogue with what Neri will call the *colori*

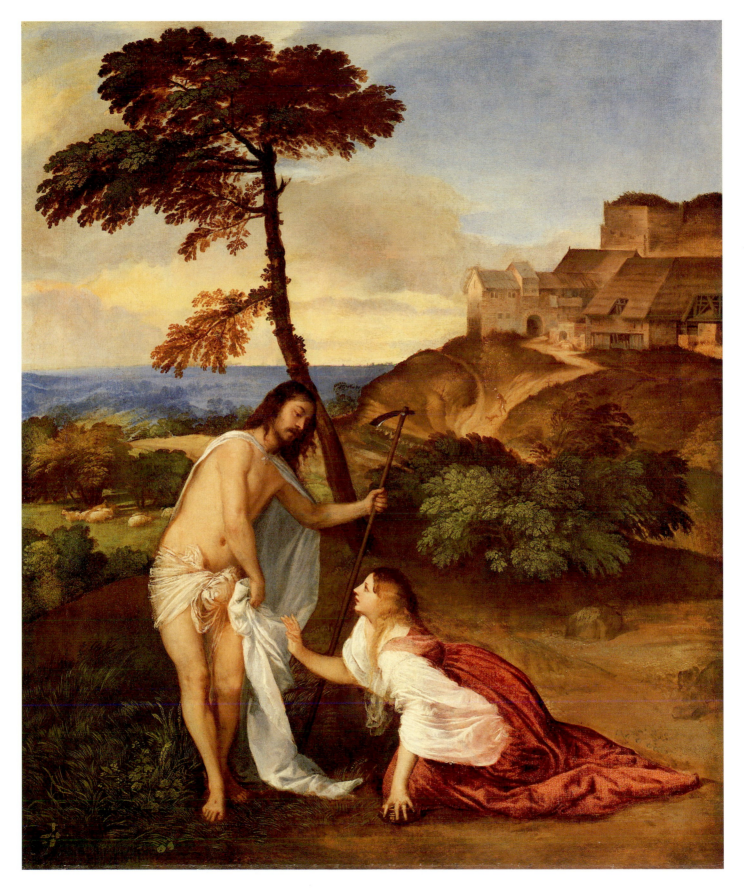

151 Titian, *Noli me Tangere* (*c*.1509). Canvas, painted area 109 × 90.8 cm. London, National Gallery.

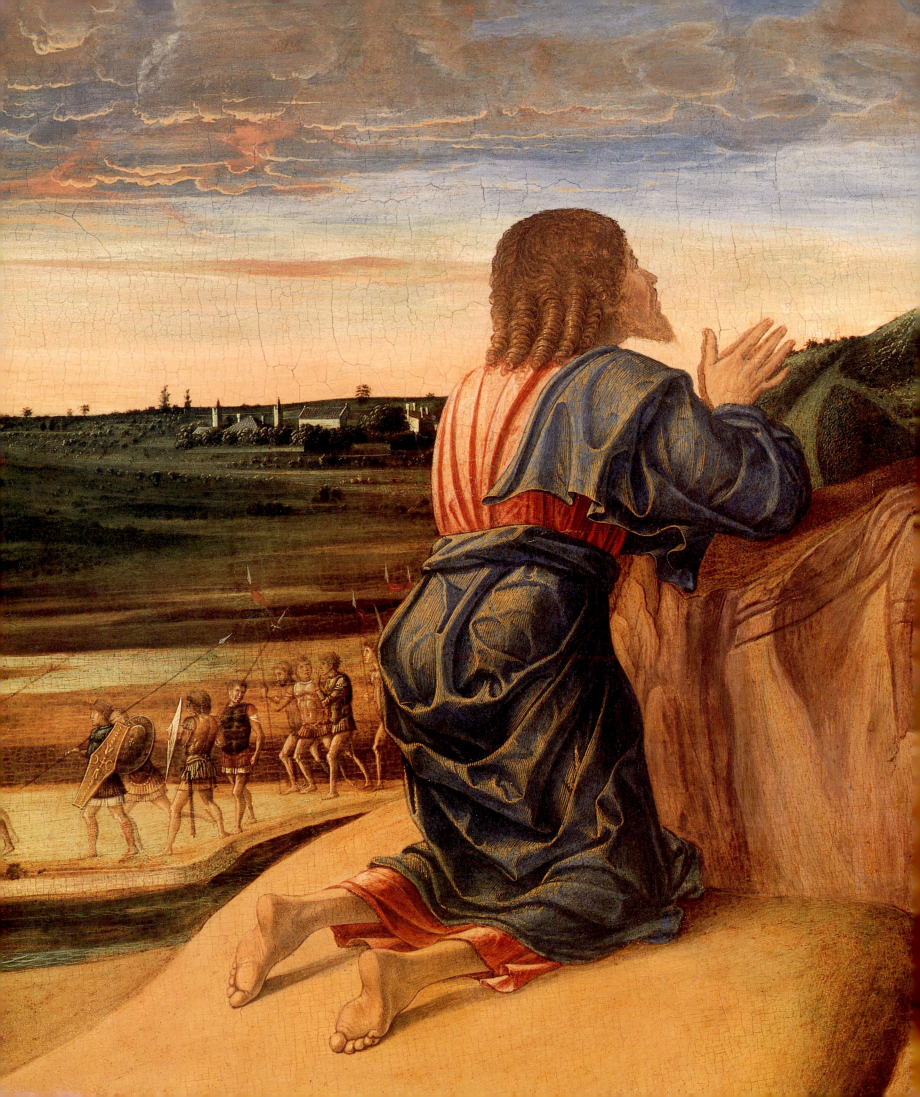

153 Giovanni Bellini, detail of fig. 148.

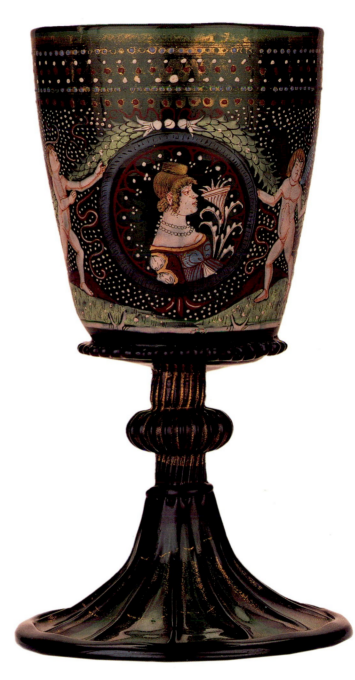

154 Betrothal goblet (late fifteenth century). Venetian enamelled glass, height 22.4 cm, diameter 10.4 cm. London, British Museum.

accesi of chalcedony glass, such as the fiery garnets and changeant greens of a bowl in Berlin (fig. 150), datable to about 1510.[26] In Bellini and Titian, as in glass vessels, the arcs and *scherzi* of colour create space, which – far from being plotted and pinned down by linear perspective – is alive with curvilinear energy.

Enamelling and lattimo: *the rise of white*

From the mid-fifteenth century, when *cristallo* was perfected, a range of saturated colours also became popular. Many of these hues, deep and translucent, were produced with materials described by Antonio da Pisa in his treatise on stained glass. For instance, cobalt oxide (*zaffera*) was used to make beakers and betrothal goblets in sapphire blue.[27] In a Murano inventory of 1496 listing glass in the following colours, 'azurro, beretino, lactesino, rosso, turchese', *azurro* would be a mid-blue, *turchese* (or *turchino*) sapphire.[28] In addition, the Murano masters achieved the deep emerald green of a goblet in the British Museum (fig. 154). Both emerald and sapphire glasses were commonly decorated, particularly on the foot and stem, with *spruzzi d'oro*, sprays of gold applied with an adhesive. The brilliance of these dots of gold on the deep colour of the glass is reminiscent

of delicate chrysography of powdered gold (known as shell gold) that veins the back of Christ in Bellini's *Agony in the Garden* (fig. 152).

A rare colour in glass, achieved briefly around 1500, was the soft reddish purple derived from manganese already noted both in sandwich-glass and in trailed

152 Giovanni Bellini, detail of fig. 148, showing the chrysography on the back of Christ.

threads; occasionally, as in a dish now in Trent, the entire vessel was made in this beautiful hue. Venetian society was adept at discriminating between many shades of crimson and scarlet (see chapter 9), so it is not surprising that the glassmakers were eager to develop reds in Murano glass. According to Luigi Zecchin the first mention of *rosechiero*, an enamel colouring derived from copper or gold, in the Murano archives is from 1493.[29] Traditional enamel reds were created with copper and iron and were opaque, whereas *rosechiero* was a clear or translucent rose (literally *rosa chiaro*). It was enamelled on to glass, and like red-lake glazes in painting, became particularly prized – if never common – in sixteenth-century Venice. No pieces with *rosechiero* are known to survive. It should not be confused with 'ruby glass', an innovation of the later seventeenth century.[30]

Enamelling red and blue on to glass vessels required great skill because the enamels required firing at such high temperatures that the vessel could be deformed.[31] The techniques of enamelling on glass, which had been practised in the fourteenth century, made a come-back between the late 1460s and 1510 as part of the glassmakers' repertoire of distinctions between the transparent, the translucent and the opaque. Generally, fifteenth-century Venetian enamelling on glass was much thinner, no more than a film, than in fourteenth-century or Islamic examples.[32] Even so, the opacity of some enamelled colours could be exploited by laying figurative bands or vignettes on a darker matrix of blue or green glass. Designs for this applied painting seem to have been supplied by Vittore Carpaccio, but the execution is rarely distinguished. One exception is the green goblet in the British Museum (fig. 154), where it is noticeable how the whites of the enamelling, in figures and dots, are more telling than the old-fashioned *spruzzi d'oro*, the spray of gold. Enamel on the green goblet is very much a surface colour, bounded and tangible, seen against the deep film colour of the field or *campo* of glass. As with late fifteenth-century manuscript illuminations, so here colour exists and persists as field or ground, yet is more valent than as mere foil for design or *disegno*: the luxury of this coloured material, weighed in the hand and lifted close to the eye, was enjoyed for its own sake. After 1510 glasses were no longer passed over to painters' workshops for decora-

tion: shape, translucency and colour, not figurative reference, were what counted.

In sophisticated circles the taste for clear glass or for white enamel was beginning to make gold ornamentation look a little *passé*. In 1496 the fashion-conscious Isabella d'Este, Marchioness of Mantua, was concerned that the drinking-glasses that she was ordering from Murano should not follow their prototype in having a circle of gilding around the rim; and she insisted that other glasses in the same commission should be plain without gold – 'schietti senza oro'.[33] In the sixteenth century the turn from gold to white lead to the lacing of *cristallo* with a filigree of white canes: in 1529 Isabella again asked for glasses without gold but now with 'fili

bianchi', and in 1534, aged yet ever eager for novelty, she specified glasses 'lavorato a reticella bianco'.[34]

The whites in enamelling were made with oxide of tin, a material that was occasionally used as an ingredient together with lead white and a soda-lime silica frit to create entire vessels in an opaque milk white. Documentation and survival of this white glass, sometimes known as *lattimo*, is sparse: it may have been produced by Angelo Barovier as early as the mid-fifteenth century; references to it become more common in the 1490s until it disappears from the documentary record after 1512 (fig. 155).[35] *Lattimo*'s sudden prominence as novelty in glass is further evidence of the growing status of whiteness in refined taste. In the *Hypnerotomachia Poliphili*, the dream-romance published by Aldus Manutius in 1499 (which will be discussed more fully in the last section of chapter 8), a wall of milk-white stone is described as being of a whiteness excelling even that of the *lattimo* of Murano ('di tale albentia quale non se vide il composito lacticinio murianense, contumacissima et perlucida').[36]

It is probable, although not proven, that vessels of white glass were developed in imitation of the highly prized whiteness of porcelain. Like *lattimo*, the finest porcelain allowed light to be transmitted through its opacity. Celebrated in Marco Polo's accounts of his travels, Chinese porcelain, as well as Islamic imitations of it, were being given as presents to the doges of Venice from the 1420s onwards: by the end of the century it was higly prized in North Italian court circles. For a brief period – from about 1490 to 1520 – *lattimo* may have been adapted and refined to counterfeit porcelain. In 1519 Alfonso d'Este, Duke of Ferrara, brother of Isabella and patron of Bellini and Titian, was informed of the purchase of two pieces of *porcellana ficta*.[37] For the same Alfonso, in 1514 Giovanni Bellini had painted the *Feast of the Gods*, in which in addition to depicting vessels of *cristallo*, elegantly devoid of gilding, he displayed bowls of blue-and-white and red-and-white porcelain (figs 158 and 159). Twenty years earlier, in the *Baptism of Christ* in San Giovanni in Bragora, Bellini's rival Cima da Conegliano had Saint John perform the baptism with a bowl of blue-and-white porcelain (figs 156 and 157). Its cool harmony of mid-blue on white, gently shaded, is like a key in miniature to the *plein-air* tones of the painting.

156 and 157 Cima da Conegliano, *Baptism of Christ* (1492–4), and detail. Panel, 350 × 210 cm. Venice, San Giovanni in Bragora.

155 *(facing page)* 'Ring-handled' vase of Henry VII of England. Venetian *lattimo* glass (*c.*1500). Height 19.8 cm. London, British Museum.

158 Giovanni Bellini, *Feast of the Gods* (1514). Canvas, 170 × 188 cm. Washington, DC, National Gallery of Art, Widener Collection.

159 Giovanni Bellini, detail of fig. 158, showing the blue-and-white porcelain.

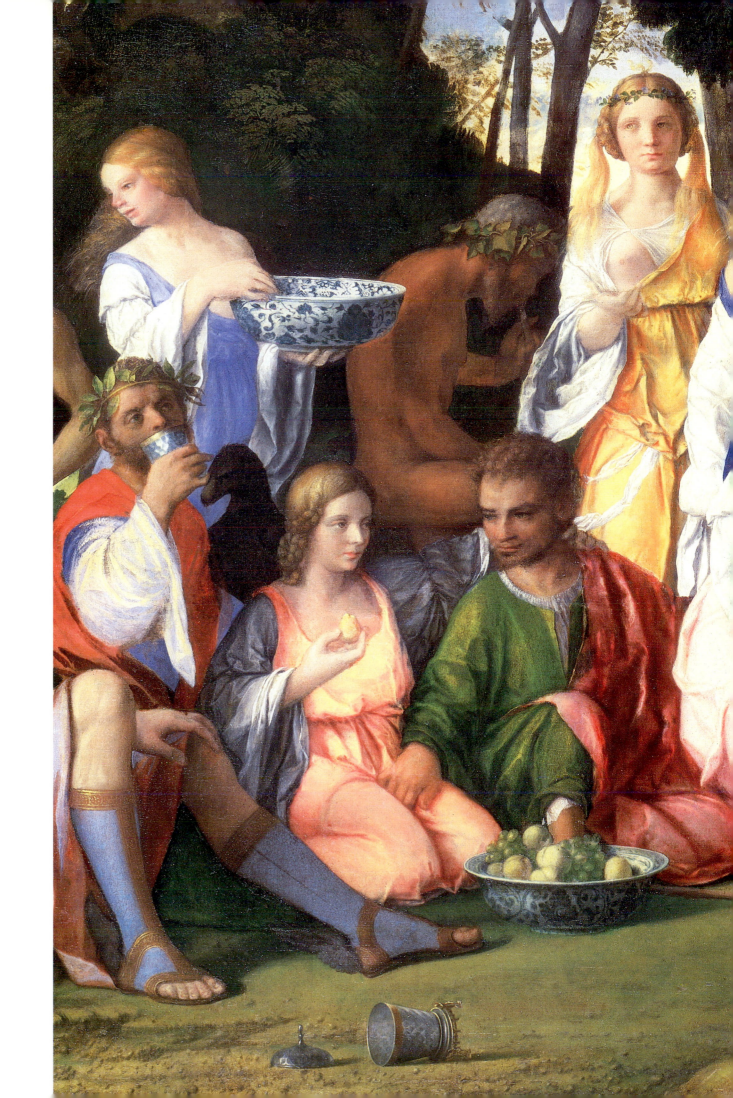

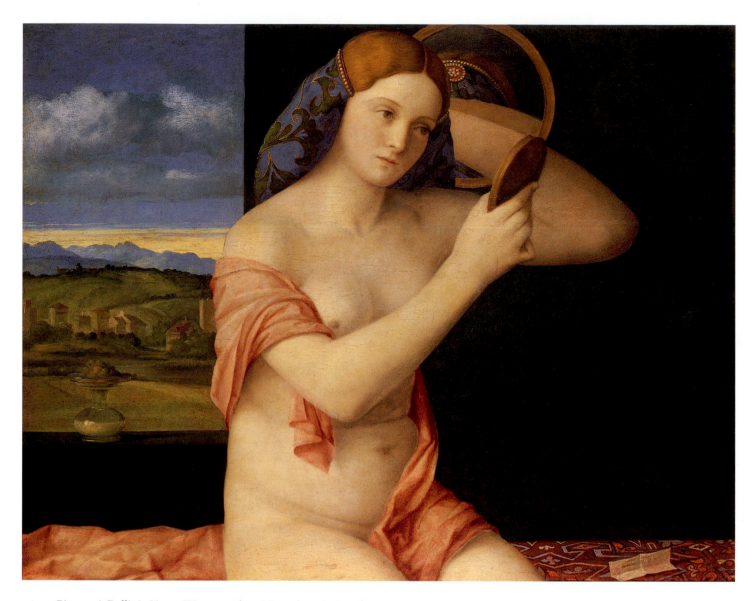

160 Giovanni Bellini, *Young Woman with a Mirror* (1515). Panel, 62 × 79 cm. Vienna, Kunsthistorisches Museum.

Mirrored colour

Although reflections, glints and sparkles, had long characterized Venetians' experience on the lagoon, plate-glass mirrors were a late addition to the products of the Murano glass-furnaces. In 1493 a Master Robert from Lorraine, in France, was allowed by the Venetian government to stay for six months with the Murano glassmaker Giorgio Ballarin. First he introduced plate-glass for glazing windows, 'plastras vitreas pro fenestris', in the place of bottle-glass. The next step was to utilize this plate-glass for mirrors, to replace the metal ones

that were common in Italy. In 1507, at a time – three years before Giorgione's death – when Titian was finding his style, the Council of Ten granted a licence to make mirrors in Murano.[38]

The most subtle meditation on transparency and reflection, on seeing colour through glass and in glass, is found in the aged Giovanni Bellini's *Young Woman with a Mirror*, now in Vienna (fig. 160). By 1515, the date inscribed on the *cartellino*, mirrors such as the one that like a displaced halo reflects the back of the woman's head and the small one she holds in her hand were notable products of Murano. Earlier Bellini

himself had painted small allegorical panels to go round a type of Venetian furniture incorporating a mirror in an elaborate carved surround known as a *restello*, which would have invited comparison between mirrored image and painted image.[39] On the window-sill in *Young Woman with a Mirror*, Bellini depicted a glass carafe on which appears to rest a shallow dish, or *tazza*, bearing a bunch of white grapes (fig. 161). Both the carafe and dish are of perfectly clear *cristallo* glass, save for two trailed threads of manganese purple round the rim of the *tazza* – lines barely distinguishable at a glance, yet an apt foil to the sandy greens around them. Like a lens, the transparency of the carafe engages the nearness of the interior and the distance of the land-scape view. (Lenses for eyeglasses, incidentally, are men-tioned in Venetian guild regulations from 1300, but by the mid-fifteenth century there is evidence that the best lenses were produced in Florence.)[40] Alberti recom-mended that painters check their work in a mirror:[41] Bellini not only looked in glass (note how he slightly darkened the mirrored image) but through *cristallo* vessels and bottle-glass windows, and so came to regis-ter the atmospheric play of adjacent colours lying at different depths of space. The painterly blurring induced by looking through glass is likely to have been a more significant influence on the *sfumato* of Bellini's late style than anything he learned from Leonardo.

By showing colours through glass and mirrored in glass, Bellini's painting creates of the coloured fabric of the world a visible order which is both delicate and strong. The cristalline and the glowing, the transparent, the opaque and the translucent – all qualities of Murano glass – Bellini transformed in pictorial synthesis. Like the reflection in the mirror, which at the least movement of the viewer's head may slip across the plate-glass, colours hover over the surface of things. A contemporary Venetian, Cristoforo Marcello in his *De Anima*, stressed the 'accidental' nature of light and colour reflected by a mirror.[42] The subject of Bellini's picture inscribes the act of looking, but the composi-tion resists being read as index of a point of view. Lustre, which in reality moves over the surface of things as the spectator moves, is played down in favour of the broader, more stable, architecture of colour; surface shine is renounced in favour of internal glow, and trans-parency purged of lustre is reified in colour.[43] By

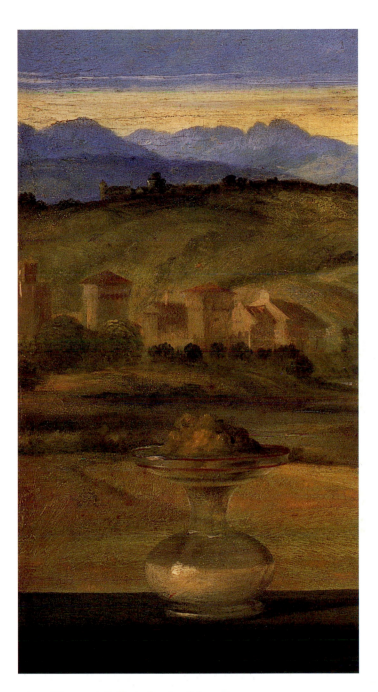

161 Giovanni Bellini, detail of fig. 160.

deploying wedge shapes – large in the woman's elbow, small in the distant roofs and in the dark triangle at the base of the mirror – Bellini dovetailed space. Avoiding the obvious orthogonals of linear perspective, he lent his compositions energy and direction by means of diagonals. Like marble inlay or pattern in a carpet, tri-angles of colour float parallel to the surface.

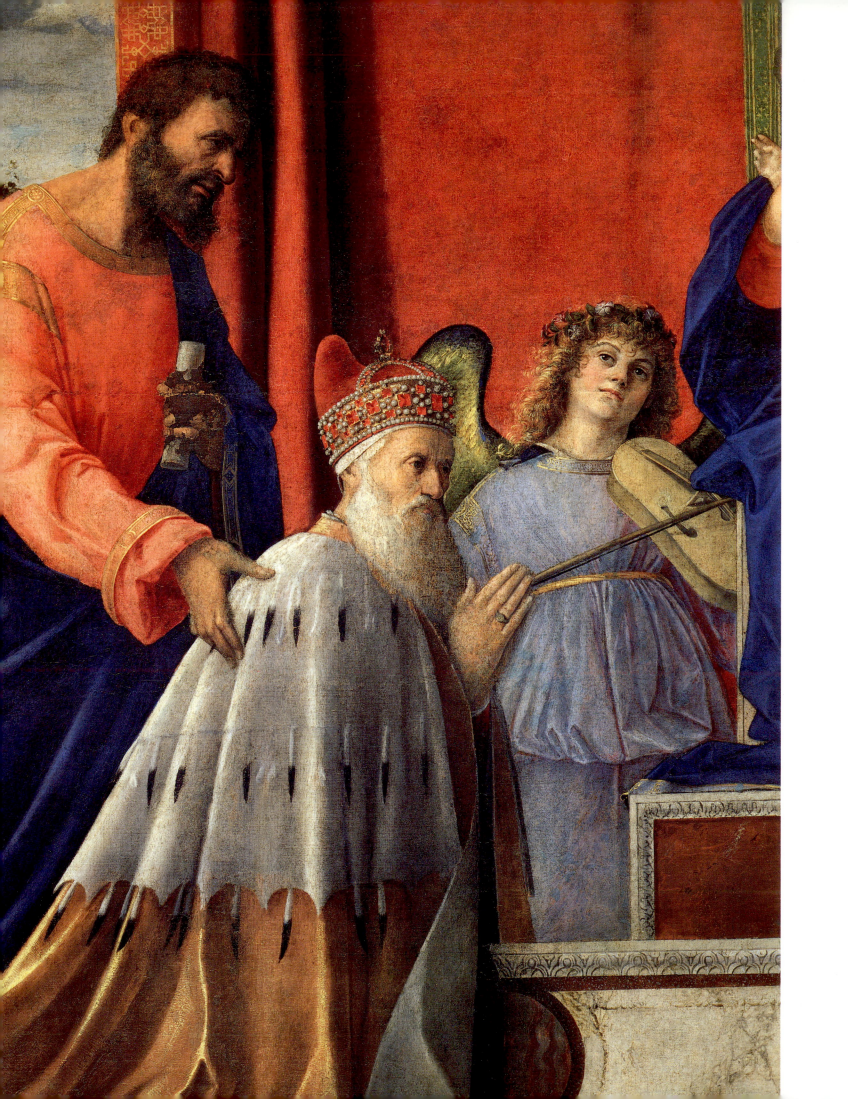

PIGMENTS AND COLOUR PREFERENCES
IN THE TIME OF GIOVANNI BELLINI

From tempera to oil

The shift from tempera to oil in Venetian painting was a symptom as much as a cause of changing attitudes to luminosity and colour. Recent research indicates that the story told by Vasari and Ridolfi of Antonello da Messina single-handedly introducing the Netherlandish technique of oil painting to Italy in general and Venice in particular is too clear-cut.[1] In his *Materials for a History of Oil Painting* (1847), Charles Eastlake drew attention to a Venetian manuscript in the British Library, dating from the second quarter of the fifteenth century, which includes recipes for mixing colours with oil for painting on glass.[2] Its recent editor stressed the significance for the transition to oil painting of the nine recipes for mixing colours with oil, as well as for the use of coloured varnish on glass, and pointed out that Ferrara was the favoured centre for exchange of technical expertise.[3] By the early 1460s Cosimo Tura was using glazes in oil in a painting executed in Ferrara.[4] Venetians, such as the young Giovanni Bellini, had learnt something of the technique, probably through contact with painters from the terra firma, before Antonello's visit to Venice in 1475–6. Undoubtedly, Antonello's paintings, with their clarity of form and luminous depth of tone, brought home to Venetians what mastery of the oil technique could achieve, but this chapter is concerned to trace shifts in colour preferences rather than a history of technique, and regarding colour it is Bellini, not Antonello, who is central to the Venetian tradition.

From early in his career Giovanni Bellini conceived forms in broad planes of light and shadow: unlike his father, who preferred the *gentilezza* of soft blending, he possessed an instinctive preference for lucid demarcations. In two early panels in the Correr Museum, the *Transfiguration* (fig. 163) and *Crucifixion*, which are painted predominantly in egg tempera, conservators report a layer of lead white laid over the gesso.[5] One function of this underpainting was to reduce the absorbency of the gesso; another was to increase the amount of light reflected from the ground, since lead white has a higher refractive index than the calcium sulphate used in Italian gesso. At the same time there are traces here and in the *Blood of the Redeemer* (fig. 164), in the National Gallery in London, that he was making detailed underdrawing, possibly in bone black.[6] Through most of his career he remained faithful to this preparatory drawing stage, constructing the volume of his figures with brush hatching, and laying the boundaries for the broad planes of colour of the finished paintings.

By the 1470s, when Giovanni Bellini painted the *Coronation of the Virgin* for San Francesco in Pesaro (figs 12 and 165), he had moved from a largely tempera-based medium to one that was predominantly oil.[7] His choice of pigments remained much as before: lead white, natural ultramarine, azurite, vermilion, lake, verdigris and so-called copper resinate, lead-tin yellow, yellow ochre and other earth pigments. A change of medium, however, altered the relative transparency of pigments. Giovanni was alert to this. Over the smooth gesso of the *Coronation* he has applied a thin layer of animal glue to prevent the oil medium sinking into the absorbent chalk. Lead-white underpainting was applied selectively to add luminosity to particular zones of colour. The blues were sometimes laid in with an

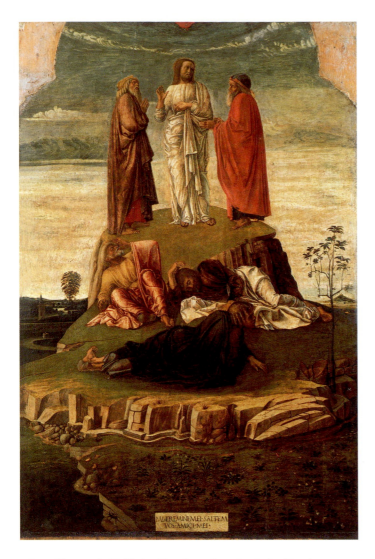

163 Giovanni Bellini, *Transfiguration* (1460s). Panel, 134 × 68 cm. Venice, Museo Correr.

to blue – a seemingly small change – is a telling sign of the turn from medieval to early modern colour. Giovanni Bellini, ever aware of luminosity, was quick to register a distinction between the behaviour of blue in oil as opposed to tempera: in egg tempera, as in fresco, addition of white to ground lapis reduced its saturation, therefore, given the expense of the pigment and esteem for its depth of violet-tinged blue, this was to be avoided; in oil, by contrast, a little addition of lead white actually increased the intensity of the blue. Blue pigments, whether azurite or ultramarine and, in the sixteenth century, smalt, lost their colour if finely ground, while large particles required a bigger proportion of oil, yet bonded poorly with the medium and dried erratically: the addition of lead white, particularly in the case

164 Giovanni Bellini, *Blood of the Redeemer* (*c.*1465). Panel, 47 × 34 cm. London, National Gallery.

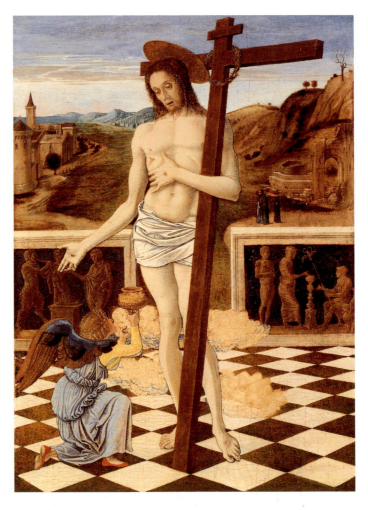

underlayer of azurite, with the final layer mostly derived from lapis lazuli, and almost always mixed with lead white (fig. 166). Occasionally Bellini also mixed the lapis with a little smalt, a pigment that consists of finely ground potassium glass in which the colorant is cobalt.[8] Given that smalt is a product of the glass industry, and was very rarely used in painting before the sixteenth century, its employment by Bellini – albeit limited – may be indicative of his interest in the technology of Murano glass and its painting with enamel.

Intense blue was source of admiration in the early fifteenth century. Pisanello's murals in San Giovanni Laterano drew praise for their blues.[9] Adding white

165 *(facing page)* Giovanni Bellini, detail of fig. 12.

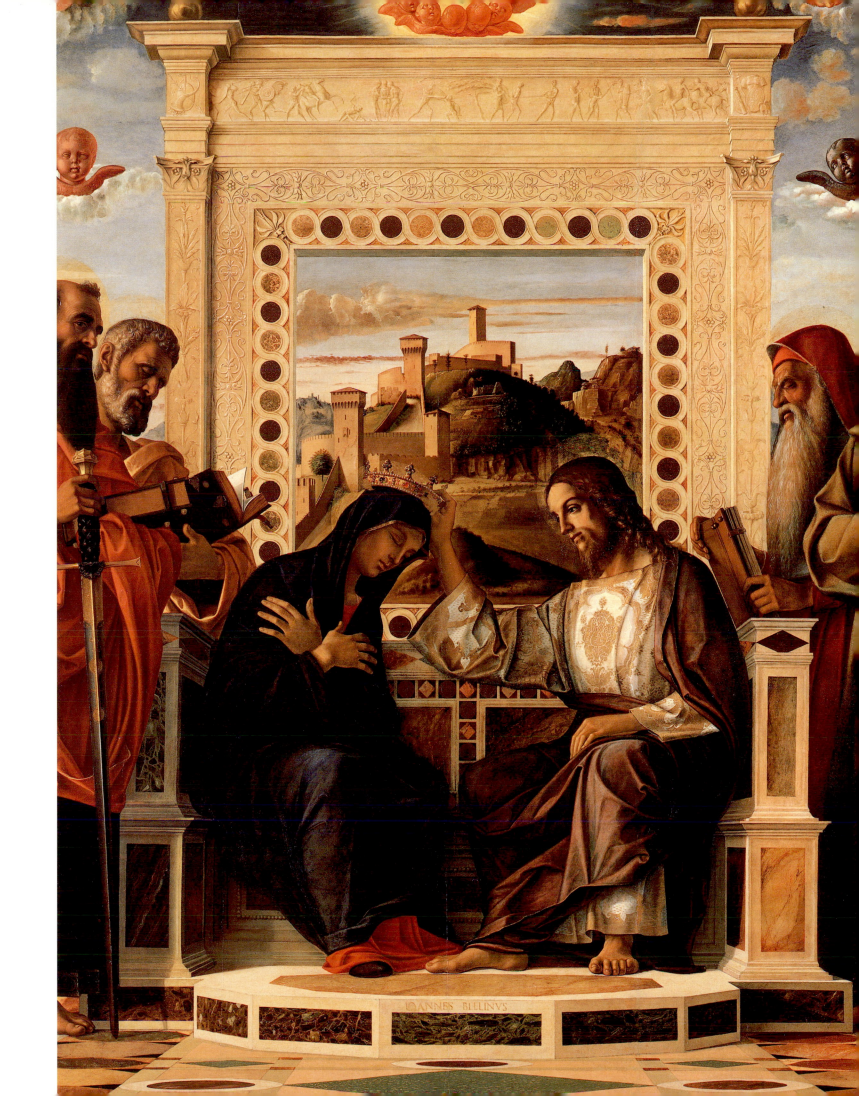

166 Giovanni Bellini, detail of fig. 12.

of lapis, helped to remedy these problems.[10] Of course pale blues are to be found in painting before the 1470s, but often with a jump between the pale and the dark. Only once the long-standing reluctance to mix ultramarine with white was overcome were painters free to discover the value of a whole range of blues in gradations of lightness; only then were painters equipped to rediscover the pale blues and whites that had given a *plein-air* freshness to some of the thirteenth-century mosaics in the atrium of San Marco (see chapter 2). Blue by the fifteenth century was moving away from its association with starry night, the vault of the heavens, to the changeful sky of day.[11] In sophisticated circles white within blue and white candid beside blue came to rival the gold on blue of the late Gothic tradition.

Adapting to canvas

Giovanni Bellini's shift from an egg tempera to an oil medium was inflected by his early contact with canvas as a support.[12] Canvas had long been used for banners, stage properties and festival ephemera: it was in Venice in the fifteenth century that it increasingly came to be adopted for works in a fixed position and on a large scale. By 1500 paintings on canvas had become the Venetian equivalent to interior mural painting. The original motive for finding an alternative to fresco was probably the saline atmosphere of the lagoon, which rendered fresco vulnerable to salts in walls. Venice's sail-cloth industry meant that painters did not have far to look either for a textile support or the technology of sewing loom-widths together to create large expanses for narrative. Low humidity rather than high humidity is more dangerous for panels, inducing warping and cracking, so the gradual shift after 1500 from panel to canvas for smaller paintings, is not explained by the lagoon climate.[13]

The early patrons of large-scale works on canvas were the Venetian devotional confraternities or *scuole*. Canvas was used by Antonio Vivarini and Giovanni d'Alemagna when they painted the Virgin and Child enthroned with saints for the Albergo of the Scuola Grande della Carità in 1446. By the middle of the century Jacopo Bellini was painting a cycle on canvas

for the Scuola di San Giovanni Evangelista.[14] In the 1460s the Scuola Grande di San Marco commissioned canvases from Jacopo and Gentile Bellini, while at the same time the Scuola di San Girolamo turned to Giovanni. In 1474 Gentile was entrusted with replacing the perished wall paintings in the Sala del Maggior Consiglio of the Palazzo Ducale, and in 1479 Giovanni also started work on the same programme; in 1488, when 'uno teller' was commissioned from Alvise Vivarini, he was ordered to paint it in the manner in which the two Bellini brothers were working, an indication that in the eyes of the patrons they had mastered a novel technique.[15]

In painting large canvases for fixed public positions, two generations of the Bellini were learning how this pictorial surface responded to light. Painting in the immense Sala del Maggior Consiglio (54 metres long, 25 wide, 15.4 high) presented peculiar problems – of sheer scale, big viewing distances and pre-determined positions. The team was called upon to repeat the subjects and perhaps even the appearance of the pre-existing wall paintings.[16] They were also faced with tricky ambient light, for the room was punctuated by a number of large windows at the same height as the canvases. These windows, glazed in clear bottle-glass, admitted a fierce cross-light, tending towards horizontal but with the complications of reflections thrown upwards from the pavement outside as well as from the water of the Bacino di San Marco. White or pale surfaces, such as plaster, that might have gently reflected an even light were in short supply in this sumptuous room: in Bellini's time the original ship's-keel roof with Doge Steno's panels of blue with gold stars was still in place.[17] In this context the legibility of narratives on canvas was all too easily lost in surface glare or in the gloom of the dark intervals between the windows.

It is a fair conjecture that Giovanni Bellini's technique evolved in addressing these problems of visibility. Canvas – as Cennino Cennini observed – should not be as thickly gessoed as panel, since gesso was liable to crack over the flexible textile support.[18] Thin gesso was feasible, but provided a less brilliant ground; some trace of the canvas weave showed through. Jacopo's canvases in a distemper of glue medium presented a matt surface which absorbed light; the colours may well have dulled rapidly because of the tendency of the rough surface to attract dust. Jacopo's son-in-law Mantegna exploited two distinct techniques: one of glue-size medium applied to linen with little or no gesso, which he left matt; the other of egg tempera applied to gesso, which he varnished.[19] Giovanni, on the other hand, pooled his early experience of panel and canvas, thick gesso and thin gesso, to forge a technique that was resilient on either surface.

The weave of a canvas, showing up through thin gesso and lead-white priming, affects how paint is deposited. Egg tempera, hatched with a soft miniver brush, is consistently wet on application and dries fast: pigments bound in oil are slow-drying, they may be stiff or liquid, almost scrubbed on with the brush or floated in a glaze. Working on canvas in oil, the painter learned to respond to the tactile surface by varying the pressure of his brush and the consistency of his paint.

Giovanni Bellini's votive picture *Doge Agostino Barbarigo kneeling before the Virgin and Child* (fig. 167), signed and dated 1488, is one of the few canvases by him to survive, albeit in a worn condition.[20] Its gesso is so thin that it hardly conceals the plain weave of the canvas. On to this Bellini laid out key areas such as heads and some draperies in outlines of carbon black. He then made the most of the reduced luminosity of his thin gesso ground in two ways: he avoided any unnecessary superimposition of one area of colour over another by laying in the figures and their draperies first; he painted most zones of colour in no more than two thin layers – the exceptions are in the shading of curtains and draperies and some decorative details. The colours appear to be bound in oil, with no more than two to three pigments per tint. Luminosity is enhanced by careful use of lead white. This potentially stiff pigment with a high refractive index when bound in oil, is mixed with vermilion in flesh, with red lake in the underlayer of the curtain, and with lapis lazuli for the underlayer of the Virgin's mantle, Saint Mark's robe and the blue of the sky.

Compared with sixteenth-century exploitation of impasto, Bellini's use of white lead is restrained, but on the doge's golden robe there is a granular sheen where he has let his brush skip from ridge to ridge of the weave leaving the brown golds of the darker undertone in the furrows (fig. 168). On the angel behind the doge,

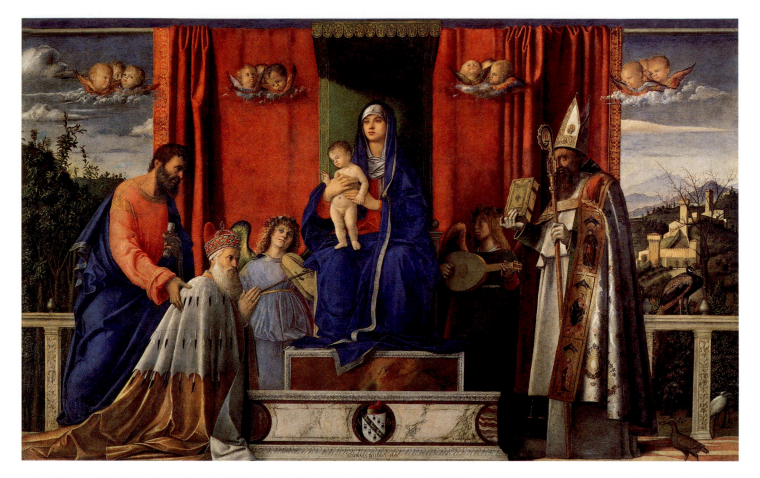

167 Giovanni Bellini, *Doge Agostino Barbarigo kneeling before the Virgin and Child* (1488). Canvas, 200 × 320 cm. Murano, San Pietro Martire.

a pale blue scumble has been dragged over an oatmeal underlayer: the half-tones here may be achieved by an increase in the proportion of oil to pigment; the lilac scumble is a blend of lapis and red lake.

Much of the surface of Bellini's *Doge Agostino Barbarigo* describes curtains or draperies – paint representing light on the texture of cloth. Where a lesser painter might have sought to differentiate textures, Bellini underplayed them, and because the texture of the canvas is more insistent in its *continuity* across the edges of forms than smooth gesso it unifies by generalizing and invites imaginative passage between layers or depths. Continuity of texture, in effect comparable to the rough bluish paper that Carpaccio favoured in his drawings (see chapter 9), supports Bellini's capacity to play between implied depth and actual breadth.[21] Unobtrusively, he paired shapes that lie in front and

behind: Doge Barbarigo 'lends' the musician-angel his praying hands to support the bow, and the one visible arc of the angel's wing rhymes with the shape of the dogal *cornu*, its green complementing the red. Like the pattern in a carpet, colour areas softly lap one another, but unlike a carpet, these zones of colour invite imaginative traversing of layers of illuminated space.

Venice was the natural theatre where colour was daily observed through degrees of proximity and distance, density and transparency. Working on a big scale in the wide space of the Maggior Consiglio was a crucial experience, which led the mature Bellini to realize colour as if seen from a distance. From the late 1470s Bellini's colour was relational in that it internalizes, optically and emotionally, the distance, light and air between the viewer and his vision. These were lessons that he later applied to panel and canvas alike.

168 Giovanni Bellini, detail of fig. 167.

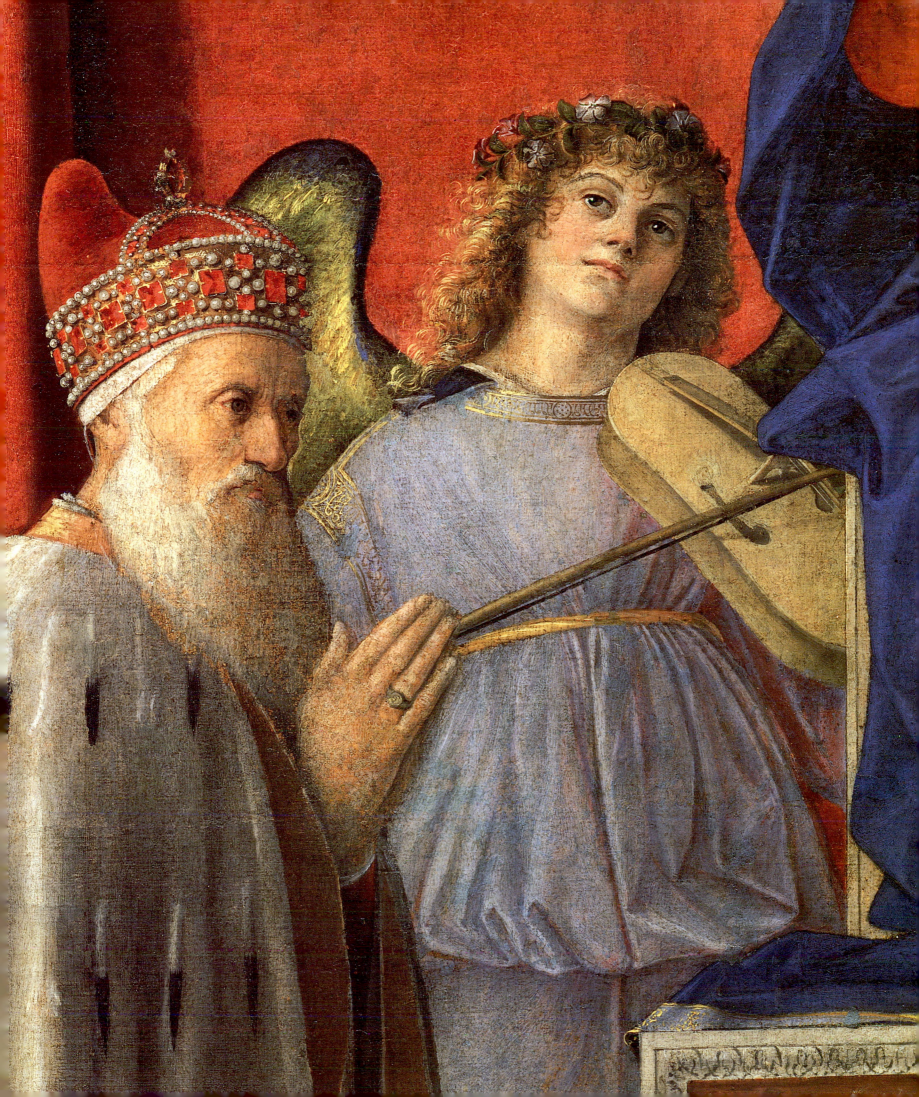

Transmuting yellow

Lead white was crucial to Bellini's solution to the problems of the legibility of narrative on canvas and it was also, as already noted, a key player in the rise of blue and white at the expense of blue and gold. But when gold was ousted from its place shining against blue, what happened to the associated tints of yellow through to brown? Here what Giovanni Bellini avoided is as telling as what he favoured. In the early panels in the Correr he employed lead-tin yellow. This is a yellow that was common in European painting from the fourteenth until the mid-eighteenth century, and then its existence was forgotten until identified in 1940; it is probably the *giallorino* or *giallolino* of Renaissance texts.[22] As a lead-tin oxide this yellow was widely used in glass manufacture. Significantly, in his discussion of yellows, Antonio da Pisa twice alluded to Venice: in a recipe for painting on top of glass, he instructed, 'take some of those little paternosters of yellow glass, that is those fine Venetian ones that appear yellow amber, and grind them well'.[23] Such glass beads were basically silicate and oxide of lead; mixed with copper-oxide filings this produced a yellow enamel; used on its own it produced a white for shading, 'colore bianco per ombrare'. Antonio's second reference occurs in a recipe for silver-stain, where, somewhat ambiguously, he wrote, 'To make yellow colour, take some filings of fine silver, that is Venetian . . .'.[24] Further evidence of yellows in Venetian glass is found in the Darduin family collection of texts on making coloured glass, compiled in Murano between the late fifteenth and the seventeenth century, which include many recipes for yellows from oxides of tin.[25] In documents recording the purchase of colours in Venice on the orders of Philip II of Spain, yellow is referred to as 'giallo lino da Murano'.[26] Lead-tin yellow had long been used amongst painters working in and around the Venetian lagoon. Antonio and Bartolomeo Vivarini, whose father was a *fiolario* or glassblower in Murano, were noticeably fond of bright yellow, particularly for draperies; so too was Antonio's son Alvise (fig. 169).

Giovanni Bellini, by contrast, was wary of yellow. In the early *Transfiguration* he followed iconographic precedent by giving Saint Peter a yellow vestment (identified as lead-tin yellow), a rare instance in Bellini's work of

169 Alvise Vivarini, *Saint Peter*, from the Montefiorentino polyptych (1476). Panel, height 101 cm. Urbino, Galleria Nazionale delle Marche.

anything approaching a saturated yellow drapery. Usually he employed lead–tin yellow, as well as yellow ochre, as additives to other colours to vary his tints by modifying the dominant pigment. In the *Transfiguration* he used lead–tin yellow in some areas of green and some of red, and it shows up mixed with lead white in some flesh tones.[27]

In the *Coronation* at Pesaro Bellini employed four varieties of yellow pigment – orpiment, lead–tin yellow, ochre and yellow lake – but yellow as hue is inconspicuous. The sleeve of Saint Peter, who stands on the left, is largely dulled by shadow towards fawn to prevent it from jumping forward. This fawn corresponds to *lionato*, 'lion-coloured', a common colour term for cloth.[28] Bellini shaped and toned Peter's folds to rhyme with the walls and towers that crown the distant hill. Elsewhere he used lead–tin yellow for accents of lemon. The shifting tones of brown and grey-green, noticeable in the saints on the pilasters, are mixtures of lead white and black (probably bone black) or brown ochre, with glazes of yellow lake (fig. 170). These tints, so hard to name, which today appear so characteristic of Bellini, may once have been less grey, more colourful. Recent research is indicating a wide range of dyestuffs used in Venetian painting; these are vulnerable to loss of colour over time and are hard to detect in laboratory analysis, but it is clear that Bellini was already using dyes, notably red and yellow lakes, both mixed with body-colour and as glazes.[29] Glazes discreetly modify illuminated surfaces, throwing over them a blush of tinted light. Yellow lake is glazed over azurite to make green. Azurite, the cheaper blue with a faintly greenish undertone, composed of carbonate of copper, has been identified beneath final layers of lapis and lead white in the sky: evidently Bellini spread azurite under areas of distant landscape *and* the sky above it, then greened the landscape with a glaze of yellow lake, and modulated the sky with lead white or with layers of lapis mixed with lead white. So yellow lake, like light itself, modifies rather than constitutes hue, and the same may be said for the more fugitive red lake.

Two altarpieces painted a few years after the *Coronation*, the *Madonna and Child with Saints* from the Venetian church of San Giobbe and the *Transfiguration* from the cathedral in Vicenza, break new ground in their modulation of colours (figs 185 and 171).[30]

170 Giovanni Bellini, detail of fig. 12.

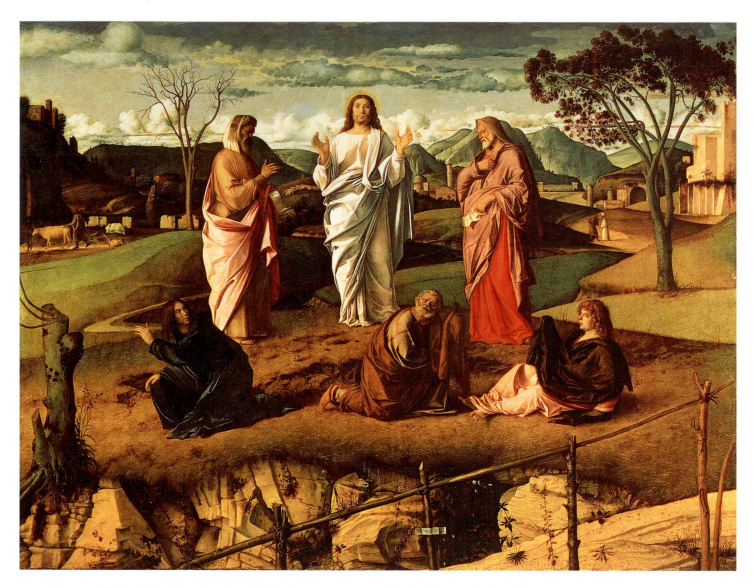

171 Giovanni Bellini, *Transfiguration* (*c.*1480). Panel, 115 × 150 cm. Naples, Museo di Capodimonte.

Switching between indoor and outdoor settings, Bellini's orchestration of tints of sand, fawn (or *lionato*) and deeper brown grew richer in emotive power: the golden interior encapsulates the memory of landscape, while rocks and strata in landscape evoke the marble container of architecture. The pigments used in the San Giobbe altarpiece, as reported by Lorenzo Lazzarini, are relatively restricted – no orpiment, no lead-tin yellow – although it is possible that if more cross-sections are taken more might be identified. Visually, bright yellow is absent, and Bellini's care for the overall luminosity of his interior, which bright yellow

might have disrupted, is evident again in the use of lead-white underpainting. In the San Giobbe altarpiece this layer of *biacca* was more generally applied than in the *Coronation*.

Recent work on the neurophysiology of vision indicates that yellow remains remarkably intense in bright light, whereas other colours are bleached. Giovanni Bellini did not need to be versed in neurophysiology to learn from looking at his own paintings that a yellow patch, while in harmony with other colours in one light, could appear out of key in another.[31] He would have noted that areas of yellow pigment tend to stand

142

out as local colour disrupting any reading of pictorial light.[32] This is probably the reason why in his second version of the *Transfiguration*, painted for the duomo of Vicenza, he revised the traditional yellow for the mantle of Peter, and replaced it by brown (fig. 172).[33] Bellini's distrust of yellow might conceivably have had something to do with the association of yellow with the Jews, but other Venetian painters, such as Bartolomeo Vivarini, showed no fear of robing saints in yellow, and neither did Andrea Mantegna. Indeed, Bellini's tempering of yellow might have been a critique of his brother-in-law's often clamorously bright yellow draperies. Where Giovanni in his later works used a deeper yellow it has more in common with the ochre tending towards the brown of lightly stained wood that is a characteristic tint – particularly for the mantle of Christ – in the late fifteenth-century Cretan icons that were imported in vast numbers into Venice.[34] In the late Byzantine palette this ochre is deepened to set off the chrysography. A fine example is the *Virgin of the Passion* by Andreas Ritzos (fig. 173), where the inscription in Latin rather than Greek implies it was painted for an Italian market.

173 Andreas Ritzos, *Virgin of the Passion* (second half of fifteenth century). Panel, 103 × 84 cm. Florence, Accademia.

172 Giovanni Bellini, detail of fig. 171, showing Saint Peter.

If, as is likely, some of Bellini's patrons were acquiring contemporary Cretan icons, they would have become accustomed to a gamut of colours – purple cinnamon, crimson, indigo and ochre – that are closer to the deep harmonies of Paolo Veneziano's trecento painting than the rose and blue of Jacopo Bellini and Antonio Vivarini a century later. Italian Madonnas of the fifteenth century, whether Florentine or Venetian, generally wear a red robe and blue mantle: the contrast of hues is great, and requires careful modulation of their relative intensity and brightness if the integrity of the figure is to be preserved. Giovanni Bellini's early Madonnas show him searching to adjust the intensity of this red and blue combination. The Cretan icons offered an alternative model, which allowed Bellini to recuperate an earlier Venetian tradition and turn his back on the Florentine and Paduan bright hues. In the Cretan works the Madonnas are usually shown in

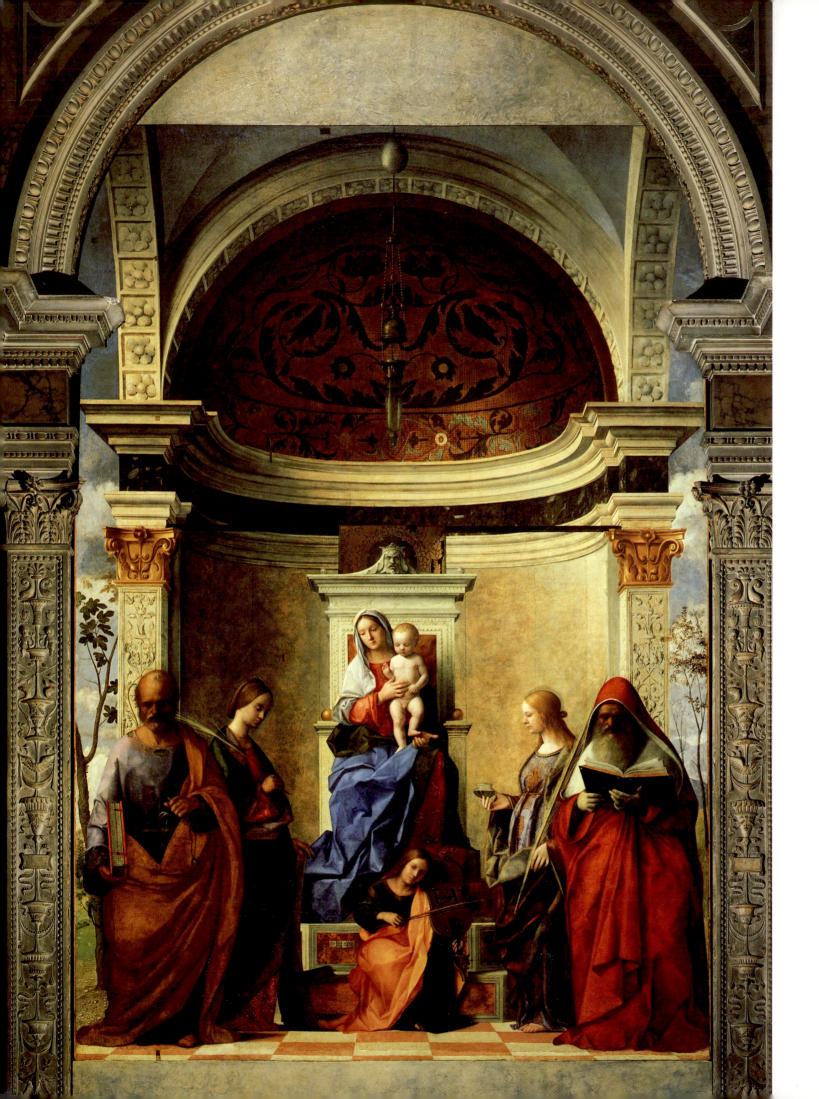

blue robe and purple-cinnamon mantle: the contrast of hue is reduced, thereby rendering both garments comparable in tone. In the Madonna by Ritzos both blue and purple are down-modelled towards black in the shadows, and the stylized lights are carried no higher than a mid-tone. In his later work, such as the altarpiece in San Zaccaria (fig. 194), Bellini also damped down his highlighting. Unlike Leonardo's contemporary chiaroscuro, the Venetian approach is closer to the late Byzantine with its residual chrysography. Bellini allies areas of deep colour and solemn shadow with much crisper passages where pattern and colour emerge sharply: in the fictive mosaic semidome in the San Zaccaria altarpiece the pattern of birds and scrolls is precisely rendered even in the penumbra.

Vasari's identification of the 'maniera greca' with all that was debased in painting before the reform initiated by Cimabue and Giotto has cast a long shadow, obscuring the contribution of Byzantine art to Western painting. It is far from the whole story but the deeper gamut of colour in the Byzantine tradition lends a solemn resonance to the painting of the Venetian High Renaissance.

Re-evaluating brown

In medieval Europe the medium which above all others set the standard for the beauty of intense colour, what Italians termed *bellezza di colore*, was stained glass. Now it is hardly surprising that brown is a colour that comes across badly in stained glass. Tertiary or impure colours such as brown or beige cannot be matched by spectral light. In medieval stained glass there are few true browns: what might have been brown tends to be replaced in glass by grey, by red or by violet or mauve hues, known in Italy from the mid-fourteenth century by the term *biffo*.[35]

Neither Latin nor Italian trecento vocabulary was rich in words for brown: Petrarch and Boccaccio do not use terms such as *marrone* or *castagno*, relying on the unspecific and latinate *bruno*.[36] In medieval texts, brown, *brunum*, is referred to as a dead colour, *color mortuum*.[37] The range between brown and gold was generally considered too muddy to dignify a painting; browns

looked dull beside vermilion or ultramarine. Purplish hues such as *biffo*, on the other hand, enlivened golds and yellows by complementary contrast.

Systems of classification may have played a part in impeding exploration of the value of brown. In Leon Battista Alberti's writings the four elements are associated with what he calls the four genera of colour: fire is red, air is blue (*celestrino* or sky blue is Alberti's term rather than the more usual *azzurro* which generally denoted a mid-to-dark blue), water is green and earth is ash colour (*cinereum* in Latin, *bigia e cenericcia* in Italian). As John Gage has noted, this denomination of earth as ash accords with Alberti's Aristotelian system of a scale of colours between the poles of black and white in which the ash grey of earth represents a mean.[38] In this scheme all colours partake of earth. The single scale from black to white leaves no place to assign to what would now be called tertiary or mixed colours such as brown.

The Venetians were not alone in representing browns – one can point to earlier examples in Netherlandish painting and contemporary ones in Ferrarese – but they are to the fore in demonstrating the potential *richness* of brown as a colour. Here it may be significant that mosaic rather than stained glass had embodied the dominant tradition of brilliant colour in Venice, because in mosaic mixed tones of browns, sands and beige are vital in the modelling. In Venetian mosaic, browns, deep and purplish, often infiltrate blues. Taking their cue from the mosaicists, Venetian painters from Paolo Veneziano onwards used less green and more brown and red in their flesh colouring than the Tuscans. Again, the influx in the late fifteenth century of Cretan icons, such as those by Andreas Ritzos, with their solemn brown purple for the Madonna's mantle may have reawakened Venetian esteem for the value of brown because of its association with that most imperial and yet indefinable of colours, purple.

Exploration of the brown region of the palette was propelled by the change from tempera to oil as binder, for the adoption of oil expanded the number of glazes at a painter's disposal, and glazes have a natural tendency, when applied over a pale ground, to create warm tones. Glowing golds or amber browns can be achieved more readily in oil.[39] In chalcedony glass, which was attracting admiration at the end of fifteenth century,

174 Giovanni Bellini, *Virgin and Child with Saints Peter, Catherine, Lucy and Jerome* (1505). Canvas, transferred from panel, 402 × 273 cm. Venice, San Zaccaria.

rich browns swirled between *scherzi* of jades and violets. In addition, the disappearance by 1500 of gold backgrounds – those areas of burnished and highly reflective gold that overwhelmed subtle golden-hued or brownish tints within a painting – freed the golden to be treated as colour, to be mixed with other tints or experienced as part of a gradation from the flaxen to the brown. In terms of colour appearance brown is nothing but a darkened yellow, therefore it is note-worthy that Giovanni Bellini, who was so cautious in his use of yellow, should have responded to brown.[40] An example of brown as a rich drapery is worn by the female saint on the right of Bellini's *Circumcision* in the National Gallery in London.

Scientific explanation of colour vision is a con-tentious field, where the leading theory in one decade is often thrown into doubt in the next, but if there is one point that many researchers into vision in the last fifty years have emphasized it is that colour is *relational*, not just in terms of adjacent contrasts, but in terms of the sum of degrees of lightness reflected from the visual field. The disappearance of gold leaf has a tonic effect on perception of relative lightness which – according to the Retinex theory of vision – is crucial to the emergence and stability of recogniz-able colours, or 'colour constancy'. As a recent summary points out, there are certain colours 'known as dark or contrast colours' which have no representational identity when seen in total isolation through an aperture: 'Brown, for example, exists only when the wavelengths from a yellow surface are darker than their surround; maroon and olive are other examples of this class of colours.'[41] Whether or not this theory will attain general acceptance (and there are those who are sceptical), it is precisely what some students of vision call 'contrast colours' – brown, maroon and olive – that Bellini brought into play. Their effectiveness *in relation* to more saturated or brighter colours is secured by the representational context of the Renaissance frame.

★ ★ ★

Orpiment and realgar

In the reorientation of colour preferences in Venetian painting around 1500 two pigments, orpiment and realgar, played a lively part.[42] Chemically related as sulphides of arsenic, they were often paired. Orpiment, known in the Middle Ages as *auripigmentum* because of its golden yellow, was traditionally the more widely used: it has been identified, for instance, in Bellini's *Coronation* (fig. 165), but mixed with cinnabar and lead white in flesh, and in some places with yellow ochre. It was not until the 1490s that orpiment shaded with the orange hue of realgar was exploited to paint drapery strong in colour, glowing and auburn.

Given that Giovanni Bellini in the 1470s was wary of strident yellow, it may have been Cima da Conegliano, his rival in painting altarpieces, who raised the stakes by deepening yellow to amber and even orange. In Cima's *Madonna of the Orange Tree* (fig. 175), painted in the mid-1490s, the lining of the Madonna's mantle is one of the earliest examples of orpiment shaded with realgar to give an yellow-orange hue like the fruit of the tree.[43] Orange had not been used as a colour term by Petrarch or Boccaccio: Italians refer to the yolk of egg as *rosso d'uovo*, so it is likely that any yellow deeper than crocus was traditionally categorized as red. But in the *Hypnerotomachia Poliphili*, published in Venice in 1499, the adjective *naranceo* is frequently used to describe the orange-coloured. Thereafter *naranzìn* becomes a colour term in dress, and the dyers' manual the *Plictho*, by Giovanventura Rosetti, published in Venice in 1548, gives recipes for dying 'color rancio' and 'color narancino'.[44] One may add that orange trees were valued in Venice for their decorative quality; Pietro Aretino, for example, looking out from his lodgings on the Grand Canal in 1537, recorded, 'I am charmed by the orange trees which gild the foot of the Palazzo dei Camerlenghi'.[45] So orange, fruit and colour, was in the ascendant in Renaissance Venice. By 1504, in his altar-piece of the *Incredulity of Saint Thomas* (fig. 176), Cima was using a wide range of amber and orange tints in hair and drapery.[46] Like Bellini, he deepened the yellow of Peter's mantle to tawny orange (fig. 177), which – according to the National Gallery's scientific laboratory – is built up in a complex sequence: first lead-white priming over gesso; next a khaki underpaint consisting

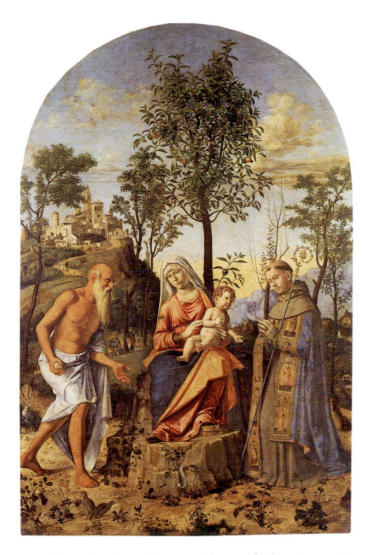

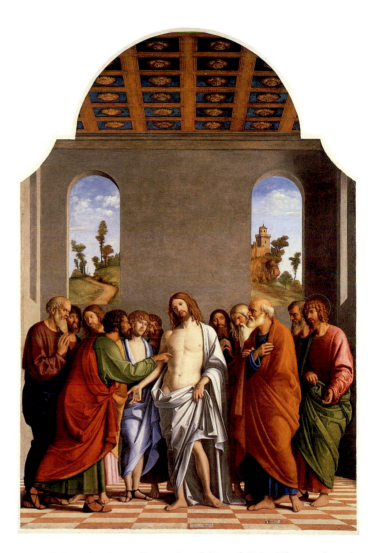

175 Cima da Conegliano, *Madonna of the Orange Tree* (*c.*1496–8). Panel, 212 × 139 cm. Venice, Accademia.

176 Cima da Conegliano, *Incredulity of Saint Thomas* (1504). Panel, transferred to synthetic support, 294 × 200 cm. London, National Gallery.

of a blend of lead white, a brownish yellow (possibly yellow lake) and some black; the main layer is a mixture of orpiment and realgar; the final layers develop the darks, first with a thin orange-brown glaze, perhaps a softwood tar or resin, and last, for the darkest areas, with a rich semi-transparent brown consisting of realgar blended with some of the orange-brown glaze, a little red earth and umber.

Removing the stigma attached to browns opened eyes to a gamut of warm glazes running from gold to auburn, rufous and tan. Cima's use of a conifer resin of softwood tar, the earliest identification in a Venetian

painting in the National Gallery, indicates that the search was on to find new means of modelling orange and brown. The mixture of orpiment and realgar will create the fiery auburns, *colori accesi*, that light up sixteenth-century Venetian painting. In Veronese the gamut of ochre and orange is especially striking (figs 178 and 179).

It is worth adding, to avoid misunderstanding, that the Venetians were not alone in discovering in auburn orange a thoroughly modern colour. The emergence of orange as quite distinct from yellow is evident in maiolica from about 1470 onwards. In maiolica

178 *(above)* and 179 *(facing page)* Veronese, details of fig. 13.

177 Cima da Conegliano, detail of fig. 176, showing Saint Peter.

180 Maiolica floor tiles in the Cappella Lando, San Sebastiano, Venice (1510).

painting yellow is made from antimony, orange from antimony with iron; after 1500 the proportion of iron was often increased to give rich orange browns (fig. 180). Given the general absence of gold leaf on maiolica, the effect of distinct hues of yellow and orange or brown is especially striking. In panel painting it was only when gold backgrounds disappeared that the fire of orange was fully kindled. In Central Italy Michelangelo deepened yellow to orange in the Doni Tondo, and on the Sistine ceiling he demonstrated the power of auburn and orange in fresco.[47]

Differentiating violet

The rise of brown, orange and auburn took place while violet, aubergine and purple were becoming distinct from blue or from red. Yellow and violet, although near complementaries, are quite unequal in tonal value, so that darkening yellow towards brown or gold, as Giovanni Bellini chose to do, opened up the possibility of a more balanced contrast between shades of purple or pale violet and gold or auburn. In his late work, starting with the San Zaccaria altarpiece of 1505, he exploited orpiment and realgar for draperies, adding bitumen for shadows, and foiling these orange browns with violets, purples, and lilac greys. 'Bellini more than any of his contemporaries', Lazzarini writes, 'used a mauve, mixing ultramarine and red lake, or using violet lakes directly.'[48] These tender mauves and violets are easily underestimated as they are readily turned brown by discoloured varnish.[49] Some may reappear after careful cleaning. The full force of the new fashion can be seen by about 1510 when Titian painted the *Holy Family and a Shepherd* (fig. 181), in which Joseph is dressed in a resonant combination of auburn and violet rather than his customary yellow. But any final estimate of violet or purple, as well as brown, in Venetian painting must acknowledge how often the red-lake component in mixtures or glazes has faded, irretrievably changing the tint that we see today.[50]

★ ★ ★

181 Titian, *Holy Family and a Shepherd* (*c.*1508). Canvas, 106.4 × 143 cm. London, National Gallery.

Valuing white and grey

Of all the shifts in colour preferences in the era of Giovanni Bellini the most quietly transforming was the growing esteem for white. It has been seen how white beside blue and modulating blue enabled Renaissance exploration of *plein air*. The last chapter noted the rise of white enamel as backing for mosaic tesserae coloured *a cartellina*, the use of white in *lattimo*, the prestige of porcelain and the evidence that the Murano glass-makers were producing *porcellana ficta*. The same col-orant, oxide of tin, constituted the white slip, the *bianco*, which was the first coating of the clay vessels of

Renaissance maiolica. Like the taste for maiolica, the re-evaluation of whiteness was not peculiar to Venice: in Tuscany the whiteness of the glazed terracotta of Luca della Robbia belonged to the same fashion for candid purity. The Renaissance cult of whiteness stemmed from the growing esteem for the sculpture of antiquity, for form as the pre-eminent value, and hence for unpigmented marble, particularly white marble from Carrara. White became the colour for sacred space. Leon Battista Alberti cited the view of Cicero and Plato that temples should be 'perfectly clean and white' – a point reiterated in a book published in Venice in 1526, Mario Equicola's *Libro di natura d'amore*.[51]

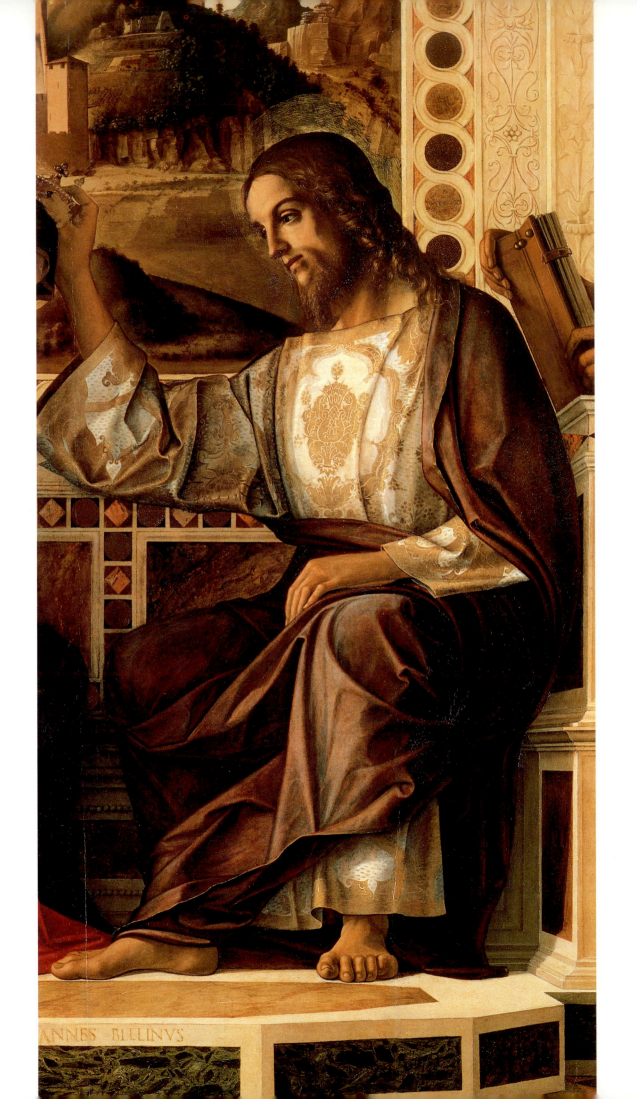

ANNES BELLINVS

White, like orange, came into its own as the use of gold leaf declined. Bellini differed from the Florentine painters in limiting anything approaching white in modelling so that white might be valued in areas of local colour. Consider again the *Coronation* in Pesaro. The lighting and the colour of Christ is astonishing: no *bellezza di colore*, no crude richness of hue, but immense dignity and richness *implied* through the orchestration of whites and slate greys (fig. 182). Christ's mantle defies categorization — slate blue in the lights, it turns a warmer charcoal with undertone of rose in the mid-tones, then blacker and denser in the shadows; it may once have been closer to purple if red lakes have faded, but the evidence is lacking.[52] His robe is certainly a dazzling white satin, adorned with damask in pale gold, and modelled in the broad shadows with luminous greys. In late fifteenth-century Italy one word for grey or mixed tones of no definite hue was *berettino*, and in Venice the Franciscan house of the Frari was known as the *berettin convento*. Even if the *Coronation* originally appeared more colourful, Bellini's technique is nevertheless remarkable for its manifold mixtures of lead white with black or brown ochre, and surely it was apt that in a Franciscan commission Bellini should have valued white and used grey — *berettino* — so gloriously.

182 Giovanni Bellini, detail of fig. 12.

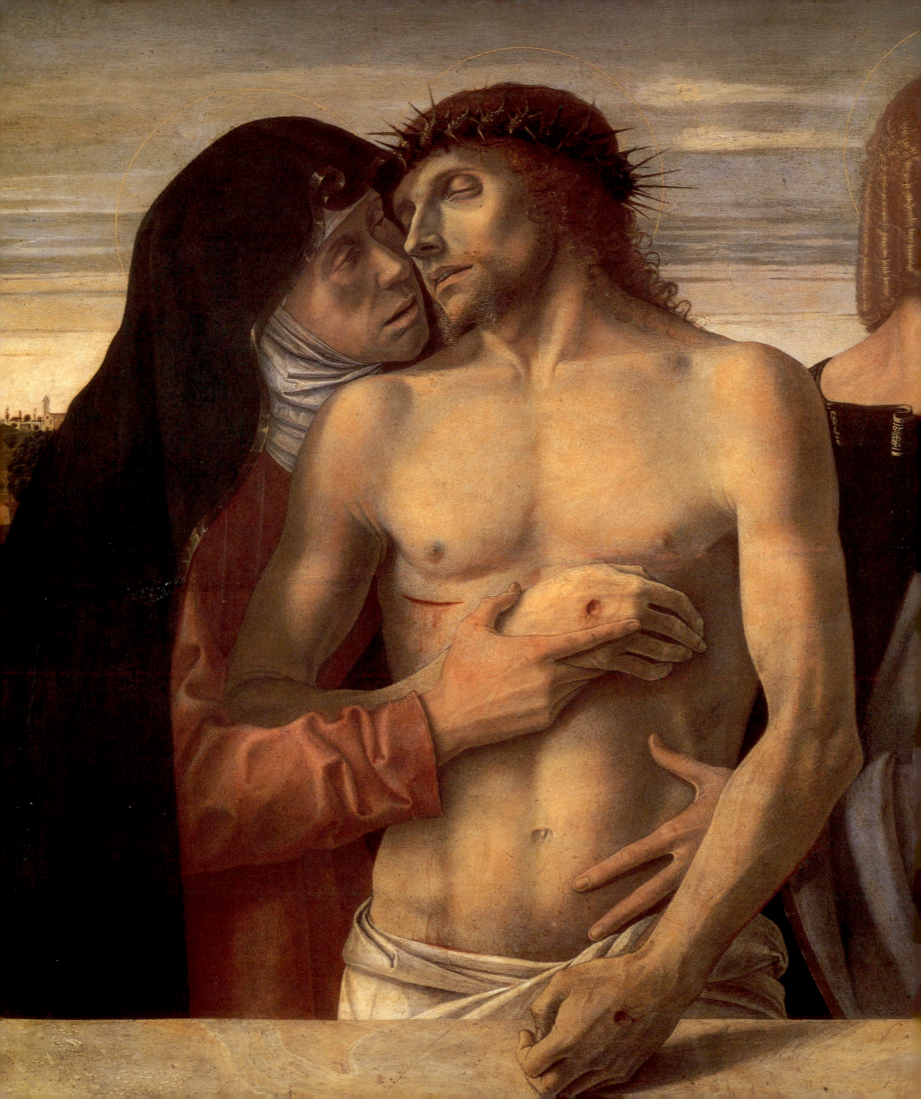

7

GIOVANNI BELLINI'S LIGHT
AND THE RISE OF THE PICTURE

Light restores unity to vestigia

Quattrocento antiquarians in northern Italy viewed the remains of the ancient world essentially as *vestigia*, vestiges or tokens of a vanished order.[1] They felt this keenly on the mainland, in such cities as Verona and Padua, where the visible fragments of Roman buildings and inscriptions pointed to a loss. In the Venetian lagoon, where indigenous tokens of antique civilization were lacking, the mercantile patriciate acquired the habit of incorporating *spolia*, particularly in and around the state church of San Marco. The task of artists within the Serenissima was not so much to realize an antique past with archaeological correctness, as Mantegna did, as to accommodate it within the Venetian scene. Jacopo Bellini attempted this in his drawing-books by incorporating antique sculptural detail and elements of Roman architecture into urban settings that are in some instances recognizably Venetian (fig. 184). Giovanni, perhaps discerning the stylistic discordance in his father's drawings, changed tack; using light as the pictorial balm to heal fragmentation, he absorbed *vestigia* into an optical continuum. The unifying power of light, still lacking when Bartolomeo Vivarini imitated sculpture in painting (see chapter 5), came into its own as the means to forge a pictorial reconciliation of past and present.

Giovanni Bellini was tentative at first, but even in the early *Blood of the Redeemer* (fig. 164) the reliefs of pagan sacrifice are subdued by the pearly light; later, in the Pesaro *Coronation* (fig. 12), one and the same daylight falls on the saints and the *all'antica* carvings of the throne – a pictorial light that realizes unity of place and affirms a present in which antique marble and

184 Jacopo Bellini, *Dormition of the Virgin* (c.1440–45). From the Louvre Book of Drawings, f. 27. Paris, Louvre.

183 *(facing page)* Giovanni Bellini, detail of fig. 187.

Christian saint coexist. Giovanni's instinct for unity – the sense that things endure together under the light – flowed from an understanding of time as much as place. His major patrons, the closed caste of the Venetian patriciate, valued endurance through time as a sign that their most serene Republic was established and protected by divine will: Bellini's modulation of colour and light within the stable frame of a picture afforded a view of man's existence, and social coexistence, in sympathy with the patrician respect for collective values, for *unanimitas*, and their sense of the persistence of the timeless within the present moment. Far from being a mere reflection of what Venetian society already believed, painting in its seductive embodiment of fiction transmuted and propelled belief. From Giovanni Bellini onwards painting in slow-drying oil has the potential to redeem by blending into unity: the painter adjusts, softens, discovers with each brush-stroke the pictorial amity of neighbouring elements, whether flesh, marble or cloud. Paint – newly substantial, layered, glazed – is connecting tissue, and paintings make accessible to sense the slow absorption of vestige or ruin into the wholeness of place.

Florentine action and Venetian being

Giovanni Bellini's repetitions of a limited number of Christian subjects – Madonna and Child, Pietà, Transfiguration – all reveal a temperamental tact, a receptive passivity. Figures do not exert themselves as do those in Florentine painting of the quattrocento. In their stillness, ruminative or expectant, Bellini's figures receive the light – they are acted upon more than acting.

Svetlana Alpers has argued that Dutch seventeenth-century and Italian Renaissance art followed two opposing modes of representation: Dutch art is concerned with describing, as in mirroring or mapping; Italian art – the dominant mode of the academic tradition – is concerned with narrating, telling a story.[2] Alpers's Italian mode accords with the doctrine of Aristotle's *Poetics*, which in turn is founded upon the conventions of Greek drama, that to represent is to show or report action: a narrative or history is a story of deeds, and what a person does is more significant than the minutiae of their appearance. A moment's contemplation of Bellini's figures, absorbed in light, reveals that Venetian art does not correspond fully to either a narrative or a descriptive mode, and by the significance it attaches to colour, and what might be termed the narrative of colour as independent of the controlling will of an individual actor, it calls into question any binary opposition of modes.

If Giovanni Bellini's altarpiece for the church of San Giobbe (fig. 185) is compared with a contemporary Florentine painting, such as Sandro Botticelli's San Barnaba altarpiece (fig. 186), it is evident that the Florentine, working in an Albertian tradition, shows that his figures are alive – and therefore lifelike – by their activity. Botticelli's angels exert themselves, and line communicates the energy of life – even if it is inflected by the weariness of sorrow. In Bellini's altarpiece there is a larger, airier space, and this atmospheric envelope weighs, very lightly, upon angels and saints. Botticelli's figures, however dreamy, twist and turn to assert their presence: Bellini, by contrast, in declining to over-energize the figure by its own muscle-power, established balance between figures and ambient. (Whereas central Italian painters in the fifteenth century preferred grey architectural settings as foil to brightly coloured draperies, Bellini tended towards chromatic balance between figure and surroundings.)[3] Coloured surfaces in the San Giobbe altarpiece receive light and reflect light in concord. For the Venetian being there, not action, embodies existence.

In Bellini's altarpiece the radiance of light on flesh is the pictorial token of loving attention – sign that the saints, advocates who share incarnation, dwell under the worshipper's gaze. The Virgin is poised in light, and her raised hand, gently shadowed, feels its passage. Christ's naked flesh is enshrined against the nocturnal blue of her mantle. Touch as well as gaze is brought into play in this invitation to adore: Saint Francis, the *alter Christus* who is most overt in his acknowledgement of the spectator in liminal space in front of the altar, touches the stigmata in his side just as the Christ Child gently and proleptically reaches across his body, turning a hand that might have blessed into one that feels the mortal flesh that will be pierced by Longinus' spear.[4]

★ ★ ★

From icon to picture

A political explanation may be proposed for how coloured light functions as sign of continuity and endurance within a conservative republic. Bellini's glow of light, embracing figures and ambient, affirms the myth of a world at ease with itself. In the last quarter of the fifteenth century, in the aftermath of the fall of Constantinople and in the face of the renewal of Turkish threats to their religion and empire, Venetians grew more conscious of their historic links to Byzantium and Greece: in church building they repeated the plan of the central dome and crossing of San Marco, and in the fictive apses and semi-domes of altarpieces they faithfully imitated its golden mosaic. In Bellini's many panels of the Virgin and Child the skin of the Madonna takes on the effulgence of gold mosaic: *aurum* – gold – becomes aura. In Italian poetic usage *aura* can, as in Latin, mean air in motion, atmosphere, emanation, as well as aura or halo.[5] Aura in Bellini blends two traditions, the iconic Byzantine one of frontal presentation of saints against radiant gold, and the essentially Petrarchan one of celebration of the loving gaze and the dazzling light of beauty. Disseminated by printed editions of his sonnets, the spread of the Petrarchan vogue personalized the aura of the icon and carried it over into the secular realm. In Bellini distinct visual and poetic traditions come together: effulgence suggests personal address, while retaining the detachment and dignity of the iconic. Unlike in the Netherlandish school, no clutter of domesticity intrudes upon Bellini's Madonnas: a curtain, a marble parapet, an expanse of sky, frontally presented and broadly coloured, without distracting detail or fancy lustre, are sufficient properties for the staging of the appearance of the Mother of God.

Yet the affective power of Bellini's paintings is deepened by the shadow of pain. Incarnation entails mortality; awareness of being is clouded by consciousness of its passing. The death and resurrection of Christ is the archetype that distils or embodies this, and above all it is the Pietà, a subject in which the hero is inherently passive, which chimes with the quiescent and conservative tenor of Venetian piety. In Giovanni Bellini's *Pietà* in the Brera Gallery (fig. 187), Christ's hand resting on the parapet directs attention to the *cartellino*, which is inscribed in humanist majuscules with the Latin couplet, 'HAEC FERE QUUM GEMITUS TURGENTIA LUMINA PROMANT / BELLINI POTERAT FLERE IOANNIS OPUS' (When these swelling eyes evoke groans this very work by Giovanni Bellini could shed tears). This inscription inserts the artist's name into an elegy by the Roman poet Propertius which fictionalized a dialogue with the dead person who is being mourned.[6] As Hans Belting has commented, in the Brera *Pietà* it is both the beholder and the figures in the picture who have swollen eyes – 'TURGENTIA LUMINA'.[7] The sympathy in the beholder is a product of Giovanni Bellini's art, his *opus*. The *cartellino* affirms that art produces an effect on the beholder just as poetry does on the reader, or hearer. At the same time the artist interposes himself, or at least his name, between the image and the beholder.

Colour, emerging out of an iconic context, is modulated for affective purpose; rather than being fixed, it is part of the communicative force – the setting of a subject before the eye – which in rhetoric was known as *enargeia*.[8] In the last chapter it was noted that Bellini often departed from precedent in choice of drapery colour: in the *Pietà* he did so again, while retaining the breadth that in religious art serves to release the mind from distracting specificity. Saint John, on the right, is not in his usual red, but a slate blue – its grey picked up in the bands of cloud. Mary's vestment is muted to a brickish coral; her mantle darkened from blue towards black; the white of her wimple making a half-concealed rhyme with Christ's loincloth. Unlike Leonardo, who modified differences between local colours to achieve greater tonal unity, Bellini allowed the unmitigated darkness of Mary's mantle to frame the pallor of her son. Titian inherited this command of the expressive power of a mass of dark drapery.

The devotional traditions of Christian art and poetry had long privileged pallor and whiteness.[9] Eucharistically the body of Christ is the white wafer, the host; his blood is the red wine. Bellini took this devotional tradition and integrated it with a contemporary feel for the candour of marble. The flesh tones of the three protagonists are differentiated; John is slightly flushed with sorrow; Mary is pale with the pain of compassion; Christ turns almost green in death, the blood drained

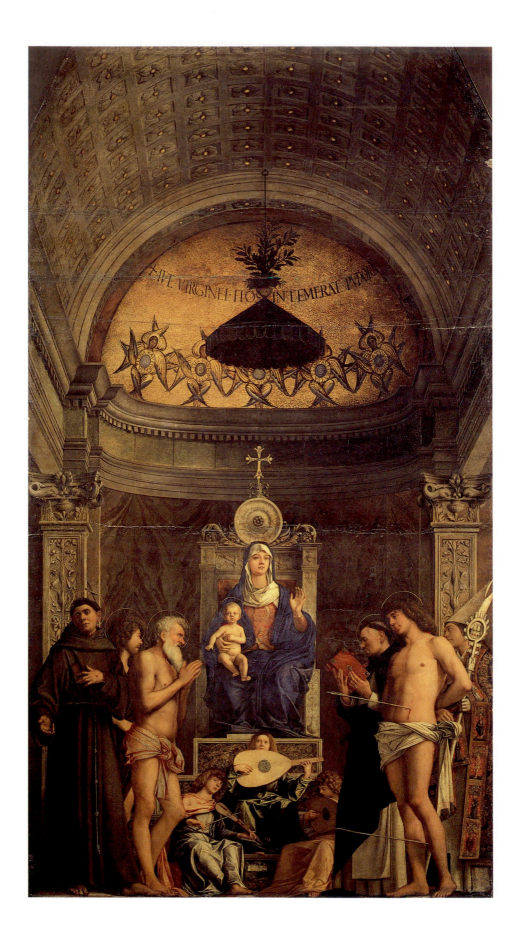

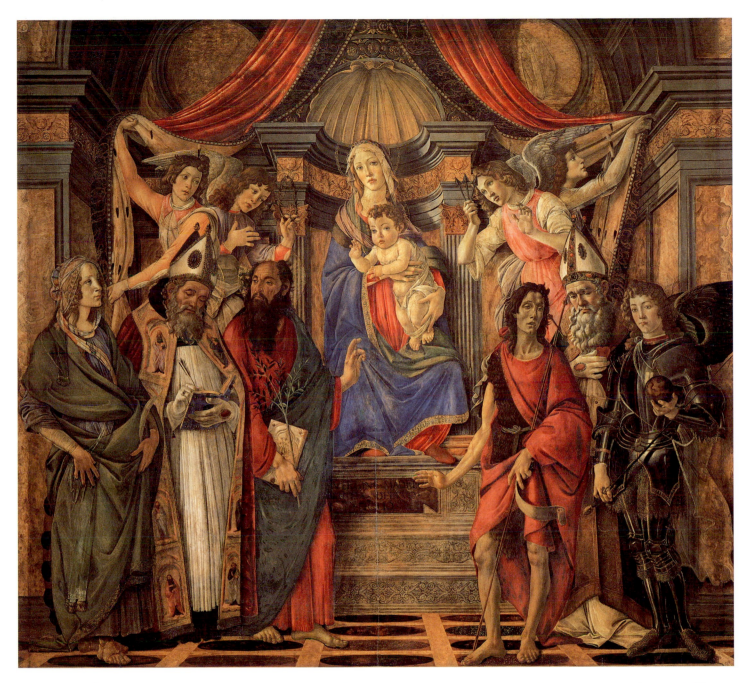

186 Sandro Botticelli, *Madonna and Child with Saints* (San Barnaba altarpiece) (*c.*1488–90). Panel, 268 × 270 cm. Florence, Uffizi.

185 *(facing page)* Giovanni Bellini, *Madonna and Child with Saints* (San Giobbe altarpiece) (*c.*1478–80). Panel, 469 × 261 cm. Venice, Accademia.

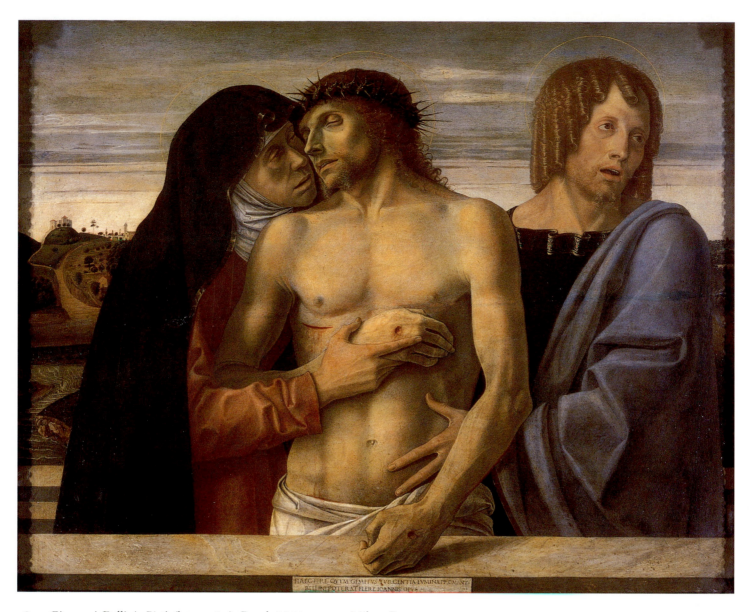

187 Giovanni Bellini, *Pietà* (late 1460s). Panel, 86 × 107 cm. Milan, Brera.

from his lips, his marmoreal pallor emphasized by contrast with the blood of his wounds. Along the shadowed contour of Christ's left arm blood is congealed as a red trace, a tell-tale sign that this same arm was recently stretched up, nailed to the Cross.

In leaning forward to support her son, the Virgin casts a shadow across his right shoulder and down his upper arm, thereby bringing shadow within touch at the very front of the picture. And shadow is also foregrounded within its subject: as childbirth is an issuing into light – and Lucina its Roman tutelary

goddess – so the fall of shadow on Christ's flesh is adumbration of the passage from life to death and from death to rebirth.[10] In this way Bellini's shadow elides two classical meanings of *umbra* as shadow and as ghost or shade of the departed. In the contemporary diaries of Marin Sanudo the use of the Italian verb *ombrare* in the figurative sense of to number, include or present, as well as the literal 'to shadow', is common.

A shadow falls on the body, clouds veil the sky. Clouds in many of Bellini's devotional pictures set the key for the inwardness of the saints, outward token of

the veiling of thoughts hidden behind lowered and unseeing eyes: clouds of unknowing. Whereas the brightness of the traditional gold halo has been attenuated to a single arc, Bellini's clouds are touched by aura, as though the glory of sacred presence has been diffused in nature. In the interplay of shadow and cloud, near and distant, Bellini preserved within the optical continuum of Renaissance painting consoling sites of concealment and dissimulation, of veiling from light – and from sight.[11]

In front of the *Pietà* in the Brera we may understand what the philosopher Hans Gadamer, has called the rise to sovereignty of the picture in the Renaissance. Gadamer argued that at the beginning of the history of the picture, 'we find picture magic, which depends on the identity and non differentiation of the picture from what is pictured'.[12] Later consciousness of the picture grows away from magical identity without ever entirely detaching itself from it. In Gadamer's argument, the independent being, or ontology, of the picture is first fully realized within the sphere of religious art: 'for it is really true of the appearance of the divine that it acquires its pictorial quality only through the word and the picture. Thus the meaning of the picture is an exemplary one . . . Word and picture are not mere imitative illustrations, but allow what they represent to be for the first time what it is.'[13] To translate this argument to Renaissance Venice: Venetians might know what a courtesan looked like, or the landscape of the Euganean hills, but they would not know what the Pietà looked like without reference to some prior description in word or picture. In so far, then, as the religious picture has an exemplary status it carries special responsibilities – and a special freedom.

The Brera *Pietà*, as the *cartellino* informs, is Bellini's *opus*, Bellini's picture, and the colour too is his, not nature's but art's. The shadow cast by Mary on to her son opens the iconic to the passage and pathos of time, easing apart – without quite dissolving – the magical identity of picture and what is depicted. Bellini's *Pietà* stands at the threshold of the modern notion of the picture in which colours and shadows in all their modulations and apt fitting together or *harmoge* – to borrow a word used by Pliny (see below) – is governed by depiction, that is to say by the address of what is depicted to the feeling and judgement of a viewer.

A return to order

It is striking that the ten years, starting in the late 1460s, in which Giovanni Bellini found his mature style, coincided with the rise of Venice as the leading centre of the new technique of printing with movable type. Whereas Gutenberg printed his Bible densely with chapters and verses running into one another, relying upon red letters, as in the manuscript tradition, to guide the reader, when the French printer Nicholas Jenson started to produce editions of the classics in Venice in the early 1470s, he introduced wide margins, and demarcated chapters by spacing in his black-and-white texts.[14] Under the pressure of competition Jenson's pages become more cramped after 1476 or so, but around 1470 the word printed in black and white becomes ordered by spacing rather than polychromy, an ideal that was revived in the 1490s by Aldus Manutius. In painting too it is spacing rather than space that becomes crucial. Spacing is to be understood as a form of ordering and rendering intelligible by holding apart rather than by joining together.[15] In the Renaissance the revaluation of holding apart, of interval and separation, is most evident in the change from Gothic cursive script to humanist majuscules. When humanist italic emerged as the modern cursive script it too was governed by a new sense of order and proportion. Perhaps it was the collision of very different traditions of calligraphy and ornament that heightened awareness of spacing: from the mid-fifteenth century the bindings of a number of luxury books produced in Italy were tooled with Islamic interlace, particularly knotwork. Tooling in this Islamic style was referred to in inventories as *alla damaschina*. A copy of Jenson's 1475 edition of Cicero's *Epistolae ad familiares* is tooled in a manner that suggests models from Mameluke Egypt or Syria (fig. 188).[16] The first usage of the term, in Italian, *arabesco*, 'arabesque', occurs in a book printed in Venice in 1499, the *Hypnerotomachia Poliphili*.[17] Knotwork, asserting connection, stands at the opposite pole to the dignified separation of humanist majuscules.

It may be no accident that the return to order by Nicholas Jenson and Giovanni Bellini, around 1470, came after a decade when rhetoric had enjoyed unusual attention in Venetian education.[18] Rhetorical theory, following the precepts of Cicero and Quintilian, stressed

188 Binding, probably Paduan, of Cicero, *Epistolae ad familiares*, copy on parchment printed by Nicholas Jenson (Venice, 1475). Paris, Bibliothèque Nationale, vélins 1149.

the importance of disposition (*dispositio*), that is the effective selection and ordering of points in a speech in order to move and persuade the audience. Copiousness (*copia*) must be governed by disposition.[19] Interpretation of *dispositio* in art historical writing has been dominated by the recognition that Alberti's division of painting into *disegno, colore* and *invenzione* follows the tripartite division of rhetoric into *dispositio, elocutio* and *inventio*. The equivalence of *disegno* to *dispositio*, and the tendency to reduce the broad concept of *disegno* to line, has limited wider understanding of disposition in fifteenth-century culture. Jenson's return to order overcame the *horror vacui* typical of late Gothic in favour

of effective disposition. In making spacing, positioning and interval the key to legibility, it was analogous to Giovanni Bellini's own reform of the copiousness of invention of his father Jacopo, and it was also a revision of the topic of *distantia* that Giovanni Fontana addressed earlier in the century (see chapter 4). Significantly, *distantia* became a key term, deployed in conjunction with terms for order, proportion, separation, remoteness and the cognitive apprehension or traversing of space, in the *Hypnerotomachia Poliphili*, published in Venice in 1499 (see below, pp. 198–9).

Tone as colour: the lessons of engraving

From the late 1460s Andrea Mantegna, Giovanni Bellini's brother-in-law, embarked upon raising the status of engravings to fully pictorial works of art. Mantegna's prints became exemplary in disposition, spacing and tone. To make up for lack of colour he developed a virtuoso description of light and shade by complex linear hatching.[20] It is a technique that honed awareness of interval, for it is the intervals, from the infinitesimal to the expansive, which determine tone and spatial values. Like most Renaissance draughtsmen, Mantegna treated his forms as monochrome, disregarded differences between local colours and developed hatching as a substitute rather than an equivalent for colour. If light and dark are said to stand in for colour, colour is to be understood not in the modern sense as variety of hue, but figuratively as ornament and emotional tenor, a combination close to the significance of the colours of rhetoric.

In the *Battle of the Sea Gods* (fig. 189) Mantegna heightened the radiance of his mythological creatures by darkening much of the background with diagonal hatching. He modelled with precise attached shadows and relieved his forms with generalized shading – the realism of the modelling lending plausibility to the artifice of the shading.

Mantegna's demonstration of the virtue of tone occurred just when Pliny's accounts of antique art were being widely disseminated. Nicholas Jenson's Venetian press published the Latin text of the *Natural History* in 1472, and followed it with Cristoforo Landino's Italian translation sometime before August 1476.[21] In Book

189 Andrea Mantegna, *Battle of the Sea Gods* (1470s). Engraving and drypoint, 28.3 × 82.6 cm. The Devonshire Collection, Chatsworth.

XXXV Pliny discussed *tonos* and *harmoge* with a concision that has vexed interpreters: broadly, the Plinian *tonos* may refer to the scale of tone arising from relations between light (*lumen*) and shadows (*umbrae*), and *harmoge* the 'fitting together' or juxtaposition of colours (*commisurae colorum*) and their transition into one another. Together, *tonos* and *harmoge* should govern relations between the lustre of *splendor* and the alternation of *lumen* and *umbrae*. By implication, variety of hue is subservient to this fitting together of a tonal scale that orders a depiction. *Umbrae* denote not so much individual cast shadows as shade – the umbrage that was essential to the pleasant place or *locus amoenus* of pastoral poetry.[22] The parallel is not exact, but Mantegna's hatched field is more akin to shade than to shadow. When Pliny approved that 'Nikias was painstaking in his treatment of light and shade, and took special care that his figures should be relieved against the background [*ut eminerent e tabulis picturae*]' we come even closer to qualities reborn in the *Battle of Sea Gods*.[23]

What Mantegna exemplified in black and white, Venetians integrated with polychromy. As ever, marbles tutored their eye. By the late 1470s there are signs that the ordering of marble and stone was being subjected to a classicizing discipline of spacing and tone. White and grey, as noted at the close of chapter 6, were increasingly valued in quattrocento painting after Alberti, and in Venice grey becomes used as background for relief on architecture.[24] Grey marble, notably *bardiglio*, was deployed by Pietro Lombardo, Mauro Codussi, Antonio Rizzo and associated masons: on the Scala dei Giganti in the courtyard of the Palazzo Ducale white marbles were placed against grey (fig. 190); the Barbarigo coat of arms was relieved against a circle of dark grey stone; strips of grey were commonly placed like bands of permanent shading lying beside and

190 Palazzo Ducale, Scala dei Giganti, detail showing the Barbarigo coat of arms (1490s).

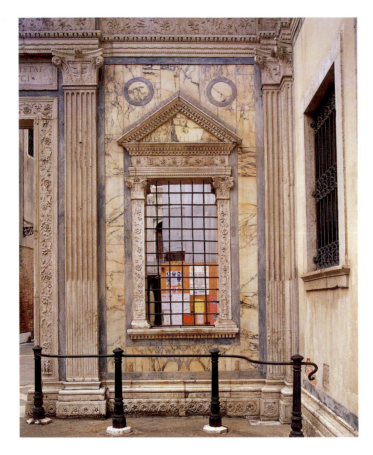

191 Forecourt of the Scuola Grande di San Giovanni Evangelista (1478–81), attributed to Pietro Lombardo.

slightly behind white membering; in the forecourt of the Scuola Grande di San Giovanni Evangelista (fig. 191) this grey offsets the pilasters and architraves. Dark marbles were sought as foil for sculpted figures in gleaming white, so that light and shadow became permanent and marmoreal, counterpointing the passage of time indicated by the changefulness of actual light and shadow. Colouristically, painters and sculptors moved in concert, rejecting the outmoded rose of terracotta and brick for smarter contrasts of white marbles and dark marbles. In 1476 Gentile Bellini provided a design for the pulpit for the Scuola Grande di San Marco, which the sculptor Antonio Rizzo was to execute with figures in white marble against a field of black marble ('figure cum el campo negro dele dite figure zoe el dicto campo de piera negra e le figure de marmoro biancho').[25] The same effect was achieved when, in the early 1490s, Tullio Lombardo provided for

the white statues of Adam and Eve to be relieved against niches of black marble on the tomb of Andrea Vendramin (figs 192 and 193). Similarly, Tullio's double portrait in the Ca' d'Oro retains traces of pigment along the contours of the busts which suggest that the background of this marble was originally coloured black (fig. 194).[26] Another sign of a classicizing taste for white relieved against black were the black-ground borders that can be found in Venetian woodcuts from about 1476 and became common in the last decade of the century at the time the Vendramin tomb was being executed (fig. 195).[27] Such a stark contrast of white against black, reminiscent of classical cameos, was

192 Tullio Lombardo, tomb of Andrea Vendramin in SS Giovanni e Paolo (c.1493).

noted. In the Islamic world, with its ban on the representation of the figure in religious art, lustre and shine were traditionally achieved through the handling of the materials, particularly the glazing of ceramics and damascening of metalwork. Lustre in Islamic art is dazzling and ubiquitous, abstract and impersonal. Where the figure was represented, as in fifteenth-century Persian miniatures, there was little attempt to *represent* lustre or to harness it to the communicative presence of the figure; neither was there any hierarchy implied by the reception of light to accord with the dominance of a prime luminant. Hierarchy and radiance, in the Platonic sense of the mode of appearing – the address of light, bearing meaning as its shines into a viewer's eye – are foreign to this culture. By contrast, in the Christian poetry and painting of Renaissance Italy the

196 Attributed to Gentile Bellini, *A Turkish Artist* (1479–80). Parchment, 18 × 14 cm. Boston, Isabella Stewart Gardner Museum.

197 Giovanni Bellini, *Doge Leonardo Loredan* (1501–4). Panel, 61.6 × 45.1 cm. London, National Gallery.

radiance of the figure, especially the face, informs, animates and acknowledges rapport.

The mercantile patriciate of Venice had long been accustomed to value the pattern and rich lustre of Islamic art and architecture. When Gentile Bellini travelled in 1478 to Constantinople at the invitation of the Sultan Mehmed II, the works he drew and painted combine an Italianate regard for modelling in light and shade with delight in the patterns and materials of Turkish costume (fig. 196). In wishing to be portrayed by an Italian painter, it may be that Mehmed II wanted to acquire something of the personal radiance that the Platonic tradition – identifying effulgence with appearance or coming into view – afforded to Christian rulers, but Gentile would not have found favour at the sultan's court unless his training in mercantile Venice

but no man can or will ever be able to do either.'[28] Medley of colours, *poikilos*, is gaudy and seductive – superficially charming the eye rather than informing the mind. Black and white, by contrast, gain approval; and red is viewed as another clarifying colour, an intermediary, the colour of blood, and what Plato called a spirit colour, 'holding the world together'.[29]

Later centuries could find in Plato a cluster of mutually reinforcing prejudices that link colour, drugs, dyeing and cosmetics. As Jacqueline Lichtenstein, who researched the debates about colour in the seventeenth and eighteenth centuries, put it, 'For Plato the painter is "a grinder and mixer of multicoloured drugs". Painting is a sophistic lie, a form of cosmetics that draws on the same means as dyeing. For those who love truth (essences), the only painting worth recognition should be colourless, i.e. paintless.'[30] It is easy to unpack these prejudices: colour is damned by association with material, with the physical labour of craft and with processes devised to deceive, such as the dyeing of fabric or the making up of the face. Since cosmetics is an essentially feminine art, in a mysogenistic turn, colour is damned by association with the means by which women trick men.

But there is something else in Plato which may be more important for patrons and painters in the Most Serene Republic of Venice, the Serenissima. This has to do with the unifying and revelatory power of the splendour, the serene shining of the sun, as opposed to the disunity and fragmentation induced by motley.[31] In the *Republic* (557c) Plato pointed to the superficial attractions of a democratic form of constitution: 'The diversity of its characters, like the different colours in a patterned dress, make it look very attractive indeed.' Colour in motley as a symbol for an unmanageable variety of views, noisy diversity, was a simile with which the Venetian patriciate, with its stress on collective responsibility, would have sympathized. In his praise of the city of 1493 Marin Sanudo wrote 'The gentleman are not distinguished from the citizens by their clothes, because they all dress in much the same way, except for senatorial office-holders, who during their term of office have to wear the coloured robes laid down by law. The others almost always wear long black robes reaching down to the ground . . .'[32] So if a reading of Plato would discourage patrons and painters who

sought an elevated style from indulging in riotous polychromy, it would equally encourage reflection on the unifying power of a bright source of light. In the *Phaedo* Socrates portrayed what he called the 'true earth' resplendent in the pure radiance of its twelve hues and their many gradations and variants, of which the pigments of the painter barely afford an equivalent. Yet Socrates' verbal picture of the uncorrupted earth is remarkably painterly: 'Even these very hollows in the earth, full of water and air, assume a kind of colour as they gleam amid the different hues around them, so that there appears to be one continuous surface of varied colours.'[33] By implication, in the Platonic world resplendence is a unifying factor which points to a primordial oneness in the source of all knowledge. Differences of colour are reconciled by radiance.

Platonic and Neo-Platonic doctrines of light were propagated in the later fifteenth century by Marsilio Ficino. Although Ficino's base was Medicean Florence, editions of his commentaries were printed and read in Venice, and he corresponded with leading Venetian humanists such as Ermolao Barbaro.[34] Ficino's emphasis on the role of the sun became part of a growing infatuation with the prime luminant and its *shining* which was to gather pace after 1500; indeed, it has recently been suggested that the period from Ficino to Newton should be called the Solar Age.[35] In late fifteenth-century Italy talk of revival of the Virgilian Golden Age, though loudest in the Florence of Lorenzo de' Medici, was also heard in Venice of the doges.[36] Niccolò Marcello (1473–4), imitating princely fashions of the terra firma, added robes of cloth of gold, *restagno d'oro*, to the traditional crimson of the doge.[37] When Giovanni Caldiera described the doge as 'splendid like the sun' in his *De politia* he started a fashion in eulogy.[38] Pietro Contarini (1477–1543) in his *L'Argoa volgar* tested the limits of republican tolerance with his hyperbole: 'The Prince with serene face entering dressed in cloth of gold, carrying with him splendour such that he seemed a God.'[39] As gold shines like the sun, the prime luminant in the heavens, so the prince – or doge – is the unique centre and source of unity in the state.

To understand how this fashion for solar metaphors impinged upon the painter's image-making, a difference between the Islamic East and Christian Italy should be

194 Tullio Lombardo, *Double Portrait* (*c.*1490–95). Carrara marble, 47 × 50 cm. Venice, Ca d'Oro.

195 Frontispiece, with black-ground woodcut border. From Herodotus, *Historiae* (Venice 1494).

exceptional in Venetian painting and sculpture; more typical were Giovanni Bellini's modulations of tone in greens, dusky maroon, greys, in the fictive marbles of the San Giobbe altarpiece. Essentially, Bellini and his heirs in Venetian painting understood that colour must be governed by tone, and that the disposition of tones is essential to good design.

A return to order through spacing and *tonos* could accord with the valorization of austere colours above florid ones, which the humanists inherited from classical sources (see chapter 4). In Florence, at least by the time Vasari was writing in the mid-sixteenth century, a similar valorization became attached to line as opposed to colour, to *disegno* as opposed to *colore*. Following Aristotle, who had maintained that beautiful colours were less valuable than clear outlines, line embodied in *disegno* was elevated by its association with the intellectual act of invention (*invenzione*) whereas colour (*colore*) was lowly because of its association with the material of colouring – for the painter the pigment with its medium.

* * *

Radiance rather than motley

It is tempting to locate a potential source of the denigration of colour in Plato, whose dialogues were being printed by the Venetian presses around 1500. In Plato's philosophy the material world apprehended by the senses is only a dim and often deceptive shadow of the eternal world of ideas. Concerning the mixture of colours, Plato argued in the *Timaeus* that there is a difference between divine and human cognitive abilities: 'for god has the knowledge and power that enables him to blend many constituents into one and to resolve the resulting unity again into its constituents,

193 Tullio Lombardo, detail of fig. 192.

had already disposed him to attend to material and pattern.

Gentile's brother Giovanni was even more adept at co-ordinating the particulars of textiles and marbles – impersonal materials – with the radiance of human presence, sign of animating spirit. In his portrait of Leonardo Loredan (fig. 197), an aura of serenity is achieved by orchestrating the colours of face, textiles and marble parapet within a limited range of white, silver, yellow, fawn and auburn brown (fig. 198). Their harmony, set off against the blue background, functions as effective sign of the restrained splendour and steadfast integrity of *il serenissimo doge*.

The potentia *of colour*

In a treatise on geometry and proportion published in Venice in 1494, Luca Pacioli extended the concept of proportion beyond the perspectival ordering of size to include the modulation of colours: 'The painter will never use his colours well if he does not attend to the strength [*potentia*] of this one and of that . . .'[40] The mathematician, friend of Piero della Francesca and Leonardo da Vinci, went on to imply that in painting flesh the painter would need to attend to the proportions of white, black, yellow and red in his mixtures. In itself this is hardly remarkable, but Pacioli's stress on the *potentia* or strength of colour as something to be controlled by the judgement of proportion indicates one way in which pictorial colour might escape its demeaning association with material.

The *potentia* of colour, joining forces with geometry, sustains Giovanni Bellini's altarpiece the *Baptism of Christ*, painted around 1501–2 (fig. 199). Still *in situ* in Santa Corona in Vicenza it is on panel, a large work, some four metres high.[41] Bellini structured his composition around the arched format of the panel, aligning God the Father, the dove, the bowl and Christ symmetrically down the central axis. To divide the semicircle of the arch from the rectangle below, Bellini extended a horizontal band of cloud, its pearly apricot differentiating it from the blue above. Colour articulates surface geometry.

The artist's imposition of order goes further than this, indeed it is so cunning that writers on Giovanni Bellini

198 Giovanni Bellini, detail of fig. 197.

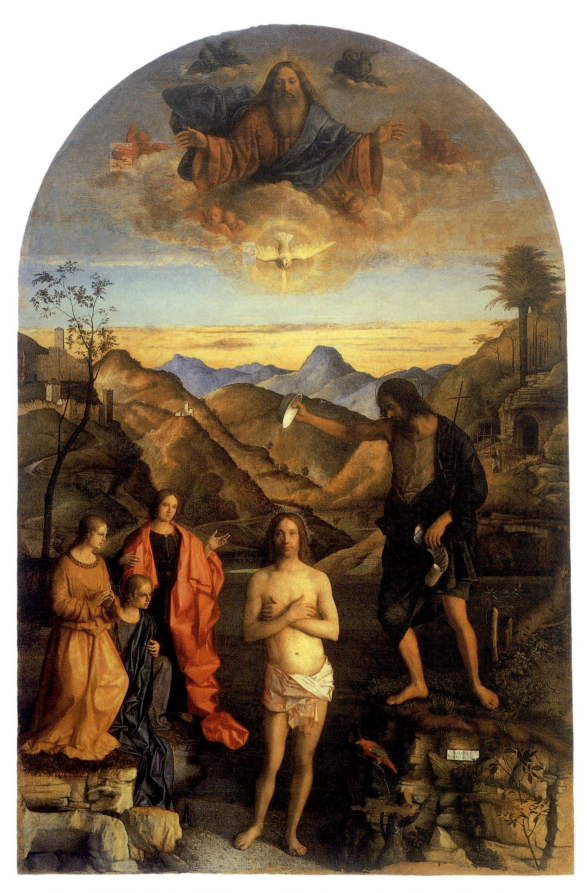

199 Giovanni Bellini, *Baptism of Christ* (*c.*1501–2). Panel, 410 × 265 cm. Vicenza, Santa Corona.

have never noted that the figures in the foreground are lit from the right and the distant landscape from the left, while an ill-defined area of shadow across the middle ground disguises the reversal of directions. By this master-stroke Bellini maintained balance around his central axis, which a consistent fall of light from one side would have disturbed. Within the geometry, broad planes of colour create colour space. The larger planes, particularly in the draperies but also on the hills, are blurred and shadowed at the edges, which accents their quality as essentially illuminated colour rather than local colour, and downplays their appearance as precise surface. In modern parlance, Bellini tipped the balance away from a 'surface mode' of perception in which the viewer attends to surfaces, their texture and slant, towards an 'aperture mode' in which colours appear more like a luminous film, without assertive orienta-tion.[42] (Lucretius, in his *De rerum naturae*, which was printed in Venice by Aldus Manutius in 1500, spoke of the blunting of angles and blurring of edges of things seen at a distance, as well as insisting upon the 'films' of colour given off by objects.) Bellini aligned near-verticals in distance and foreground, carrying them down the tumbling hillsides and on through the fall of draperies below, so that the eye may drop and ascend from far to near, from high to low, and back again. Space, no longer pinned down by linear perspective, is gently layered.

This coloured space affirms the privilege of revelation. What is involved here might be called an illusion of transparency, an illusion which, as Henri Lefebvre has argued, effectively masks the normal production of space through social relations. Too often art historians write of pictorial space as though it replicated physical space, whereas Renaissance painting at its most refined is a process whereby thought becomes incarnate in design: in doing so, space becomes luminous, self-evident, revelatory. 'Under the reign of transparency', Lefebvre observed, 'everything can be taken in by a single glance from that mental eye which illuminates whatever it contemplates.'[43] Colour, light and dark, substantiate the telling of story and now, at the same time, guide attention from cult value to artistic value. So the painter converts the duskiness of the John the Baptist, the forerunner, into the self-evident brightness of Christ: whereas Giovanni Battista's scroll is darkened, almost illegible, Giovanni Bellini's *cartellino* directly below is large and brightly lit, legibly asserting that the picture is his *opus*. Colour in all its *potentia* is now manifestly a product of the artist's impo-sition of order, a sign of the pictorial. In front of this picture we understand why Lorenzo da Pavia singled out colouring when, in 1504, he reported to Isabella d'Este, 'Giovane Belino in colorir è ecelente'.[44]

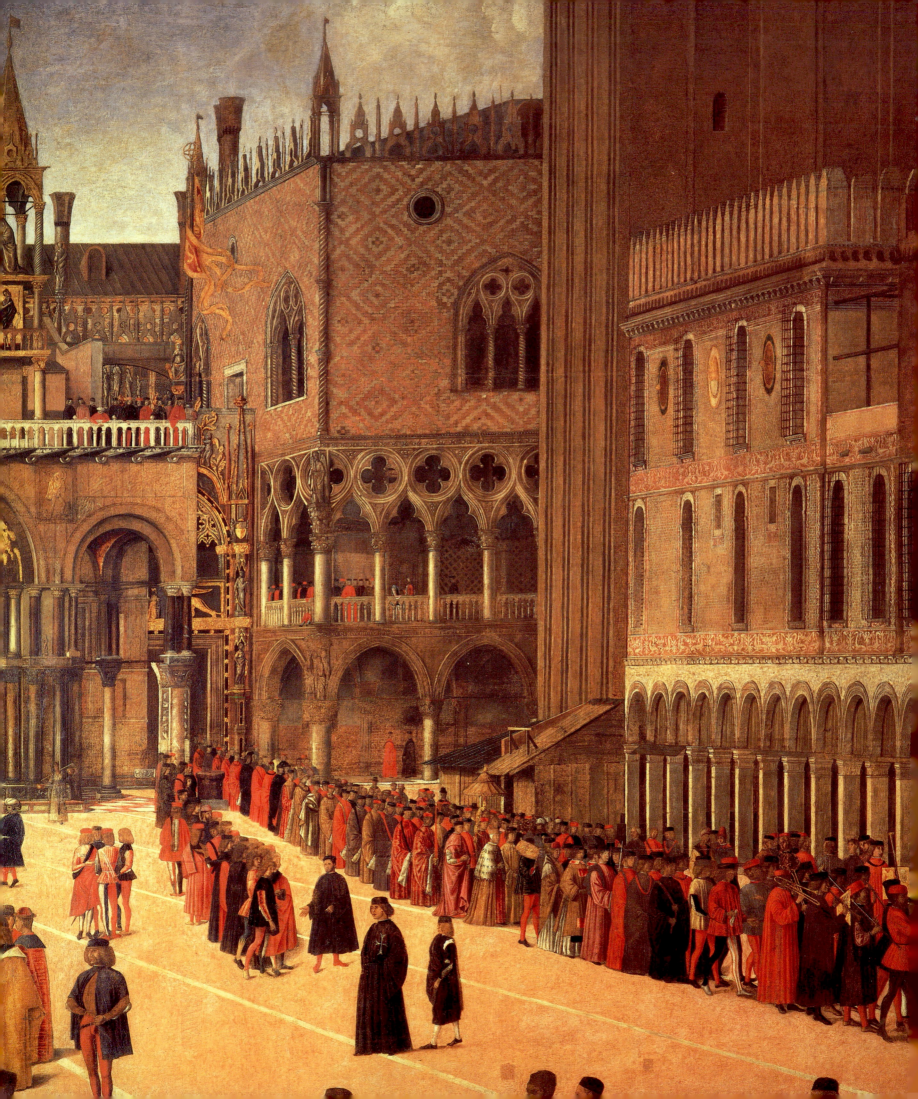

203 Giorgione, *Madonna and Child with Saints* (Castelfranco altarpiece) (*c.*1500). Panel, 200 × 152 cm. Castelfranco, Duomo.

clothes than their cut: only sleeves, which were regulated according to office or rank, attract specific comment.[12] In the later paintings of Giovanni Bellini, and in those of Giorgione (fig. 203) and Palma Vecchio, the Madonna is often swathed in drapery rather than dressed in specific costume, as if to invite enjoyment of an expanse of fabric rather than the fit of costume over body. Of course the stylistic shift from tight-fitting, obviously tailored costume to looser toga-like drapery reflects the adoption of a classical style around 1500, but in Venice this aesthetic was caught up with mercantile attitudes. Lengths of luxury silks were often given as gifts to visiting princes and their consorts. Italian cities followed the precedent of classical antiquity in awarding a pallium or cloak to victors in competitions, hence *palio* is the Italian word for a race and the silk cloth given as the prize: according to Francesco Sansovino the prize at a tournament organized by the Venetian Signoria in 1485 was 'cloth of gold interwoven with silver'.[13] Luxury cloth was international currency. Occasionally, sumptuous garments were left in wills to be converted into liturgical hangings or vestments.[14] Given these transformations of textiles, it may be supposed that Renaissance eyes readily perceived the enduring value in fabric over and above its temporary use as dress.

Since wealthy Venetians never left the choice of cloth to their tailors – a relatively humble profession – it paid to refine their own skill in assessing reds of varying tint, strength, colour-fastness and, of course, expense.[15] That this was difficult, and purchasers liable to be tricked by the dyers, is implied by legislation that the selvages of quality cloth used as merchants' samples (*da paragon*) should be colour-coded to indicate the dyes used. Samples had to be taken for inspection to an office at San Giovanni Crisostomo where three merchants and two dyers checked their quality. In 1457, when the local trade in silks was booming, it was decreed that crimson samples with kermes used throughout should have a plain green selvage with a thread of gold in the middle; if kermes was only partially used, perhaps just for the weft, the selvage should be green with a white stripe; if madder was used the selvage should be yellow; if grain, the selvage should be white; if the cheaper brazilwood (*verzino*), the selvage should be dark blue (*turchino*).[16] From the beginning of the sixteenth century the Venetian silk workers, the *samiteri*, complained that legislation forcing them to use the most costly dyes put them at a disadvantage since foreign competitors imitated their tints more cheaply.[17] But Venetian tints stood the test of time; the legislation was renewed at intervals throughout the sixteenth century, successfully protecting the reputation of Venetian-dyed silk and cloth – above all the luxurious reds that were celebrated under the generic banner *scarlatti veneziani*.

Scarlet and crimson

Here nomenclature contains a trap. For English-speakers, crimson implies a bluish red and scarlet a tomato red, whereas for Renaissance Venetians and their clients the designation *cremisino* or *scarlatto* depended as much, or more, on dye, intensity of colour and the nature of the material. Precise hue was secondary to the perceived brightness of the red inhering in a particular dyed fabric. *Scarlatto* was associated with the bright red of fine heavy cloth, therefore it was essentially the quality colour for wool.[18] Production of *scarlatti*, dyed with grain and made with the best English wool, was rising fast from around 1430.[19] *Cremisino* (a word deriving from kermes) was manifested essentially in silks – damask, velvet, satin – dyed with kermes.

The term *rosso*, unqualified, carried little resonance. Marin Sanudo described the sets of gilded silk standards of San Marco as being in four colours: two white, two blue (*celesti*), two *sanguinei over rossi* and two *cremesini*.[20] When Sanudo recorded the dress of the doge or councillors in his diaries he rarely used *rosso*, preferring to inform as to whether they appeared in *cremisino*, *scarlatto*, or – more rarely – *sanguineo*. (*Sanguigno*, sanguine or blood-red, traditionally described red-dyed linen or cotton.)[21] Undoubtedly *cremisino* was higher status than *scarlatto*: thus the doge, who was not allowed to wear anything less prestigious than gold and white or *cremisino* or *scarlatto*, donned *scarlatto* for mourning as the humblest colour in the ducal wardrobe.[22] On the basis of Sanudo's eye-witness accounts, Newton has commented that 'when an official welcome was given by the doge the warmth of that welcome could be noted not only from his words but from the exact quality of

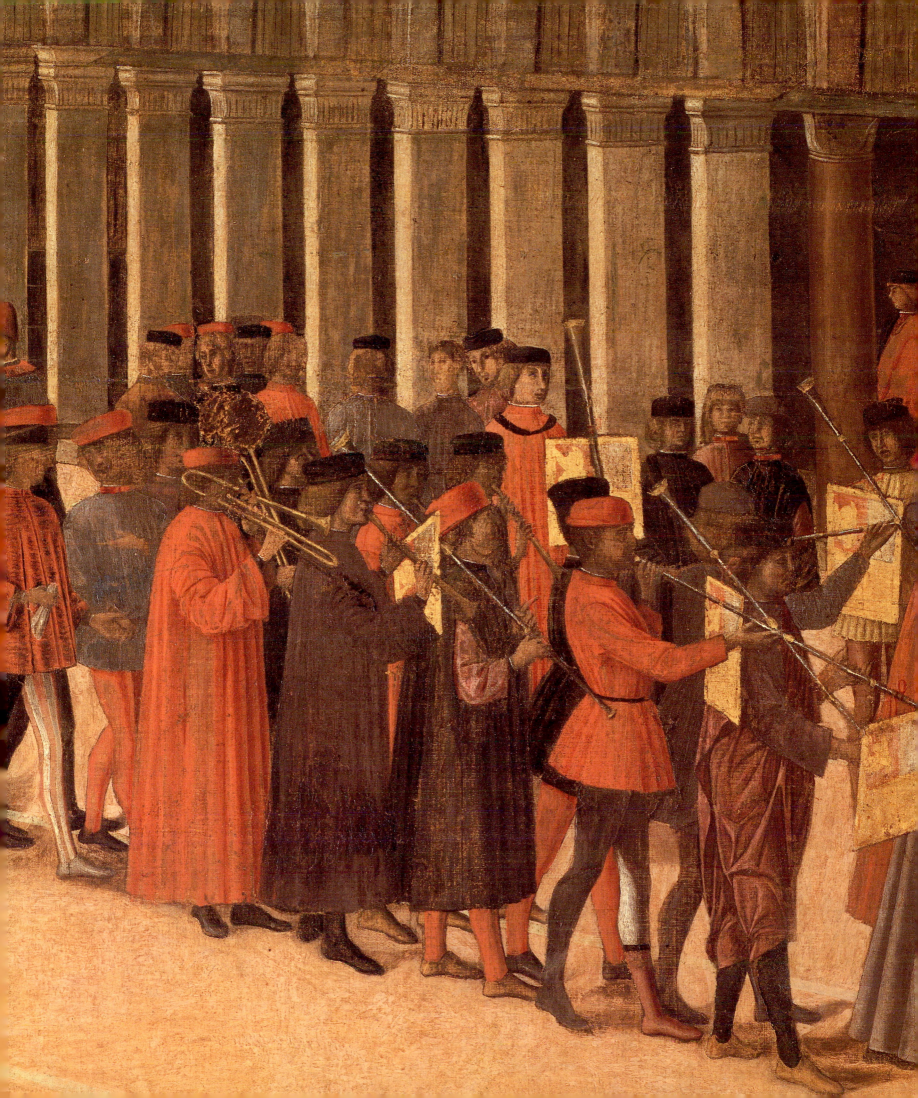

the crimson he had put on'.[23] In the 1520s, under the visually aware Doge Andrea Gritti, Sanudo noted that a new, or at least variant, dogal colour was introduced in the tint of *ruosa secha*, or old rose.[24] It appears that this was a rose with a blue or violet tinge, therefore close to faded purple: in the sixteenth-century Italian translation, published in Venice, of Sicily Herald's treatise on colours in blazon and livery *rosa secca* is reported as a synonym of *porpora* (purple).[25] From Doge Gritti's time onwards a range of *rosa secca* silks became popular in patrician wardrobes and commonly appear in the paintings of Titian and Veronese.

The hierarchy of colours and their 'host' fabrics can be reconstructed from descriptions of the flamboyant clubs of young male patricians, known from their particoloured hose as *compagnie della calza* (fig. 205). Twenty-three *compagnie* are mentioned between 1487 and 1565, and their sumptuous livery, donned for weddings and festivals, is recorded in the diaries of Sanudo.[26] In so far as the *compagnie* provided display on state occasions, their flamboyance was licensed, yet it sailed close to the wind, courting reprimand from the Magistrato alle Pompe, the office charged with enforcing sumptuary regulations.[27] Each *compagnia* elected a leader, the *signore* or *priore*, whose costume for a festival had to be a notch above that of the *compagni*: in July 1530 the *compagni* of the Floridi were 'vestiti di scarlatto', the *signore* in 'raso cremisin'.[28] At a wedding of a member of the Valorosi in 1526, the groom wore 'velluto cremisi', the other *compagni* 'di scarlatto'.[29] At the inauguration of the Reali, when the *compagni* dressed in crimson velvet, with *becheti* (rolled hood with liripipe), their prior topped this by appearing in crimson *alto-basso* velvet (see below) lined with crimson damask, and on his head a *bareta* of black velvet.[30] When, four days after their inauguration, the *compagni* of the Reali joined a party hosted by the Floridi, they dressed down a step by changing from crimson velvet to *scarlatto*. In all instances, it was fabric more than tint that established rank, as Francesco Sansovino made explicit in his dialogue, *Il ragionamento d'amore*: 'Should a gentleman dress in the same colour as his lady?' asks one speaker; 'No', the other replies, 'I mean that you ought to imitate not the colour of cloth but its quality. If she dresses in velvet, so should you; if she wears damask, you should do likewise.'[31] So chromatic difference between the

sexes was licensed provided gentlemen and their ladies dressed in comparable quality of fabric. Venetian gentlewomen were never as restricted in colour of dress as their husbands.

Few Renaissance writers are consistent in terminology: when they refer to someone 'vestito di scarlatto' this usually means woollen cloth dyed scarlet, but when they refer to the celebrated 'scarlatti veneziani' it is likely that they had in mind the precious crimson silks as well. Certainly it was the abundance of crimson silks, such as those that decked the state barge, the *bucintoro*, that gave to Venetian pomp the richness that impressed all who witnessed it.[32] Crimson was the princely, dogal colour *par excellence*: when the prior of the Floridi decked his ceremonial barge in crimson satin, Sanudo described it as 'raso cremizin a modo principe'.[33]

Despite linguistic slippage, the ability to discriminate between tints of red fabric would have been finely tuned among contemporaries of Giorgione and Titian. Looking at the *Concert Champêtre* (fig. 206) they would have noted the silken *cremisino* of the sleeve of the lute player as distinct from the *scarlatto* of his cap or *bareta*. Hats were significant social markers; they occur frequently in inventories. Makers of hats or berets in Venice had their own *arte* and statutes, their own hierarchies of value when it came to colour.[34] Just as the hood or *cappucco* of the Franciscans as *cappuccino* lent its name to a shade of brown, so *berettino* may have first designated the grey green or grey brown of the undyed wool of diminutive berets or skull-caps. By the fifteenth century hoods of undyed wool distinguished monks and friars, while the *bareta* or cap that accompanied the patrician gown was normally black. The dyeing of berets rapidly became so fashionable that it warranted separate chapters in the treatises, and attracted the attention of those who drafted sumptuary legislation. A contrast of tint between the beret and the rest of the costume became fashionable. Around 1510 scarlet in a beret was daringly smart; later black velvet, preferably highlit with a jewel, became just the thing to mark a man off from the crowd – in 1533 the *signore* of the company of the Cortesi wore 'a low beret of black velvet in the Spanish fashion with a beautiful jewel on top'.[35]

The contemporary viewer of the *Concert Champêtre*

205 Carpaccio, detail of fig. 25.

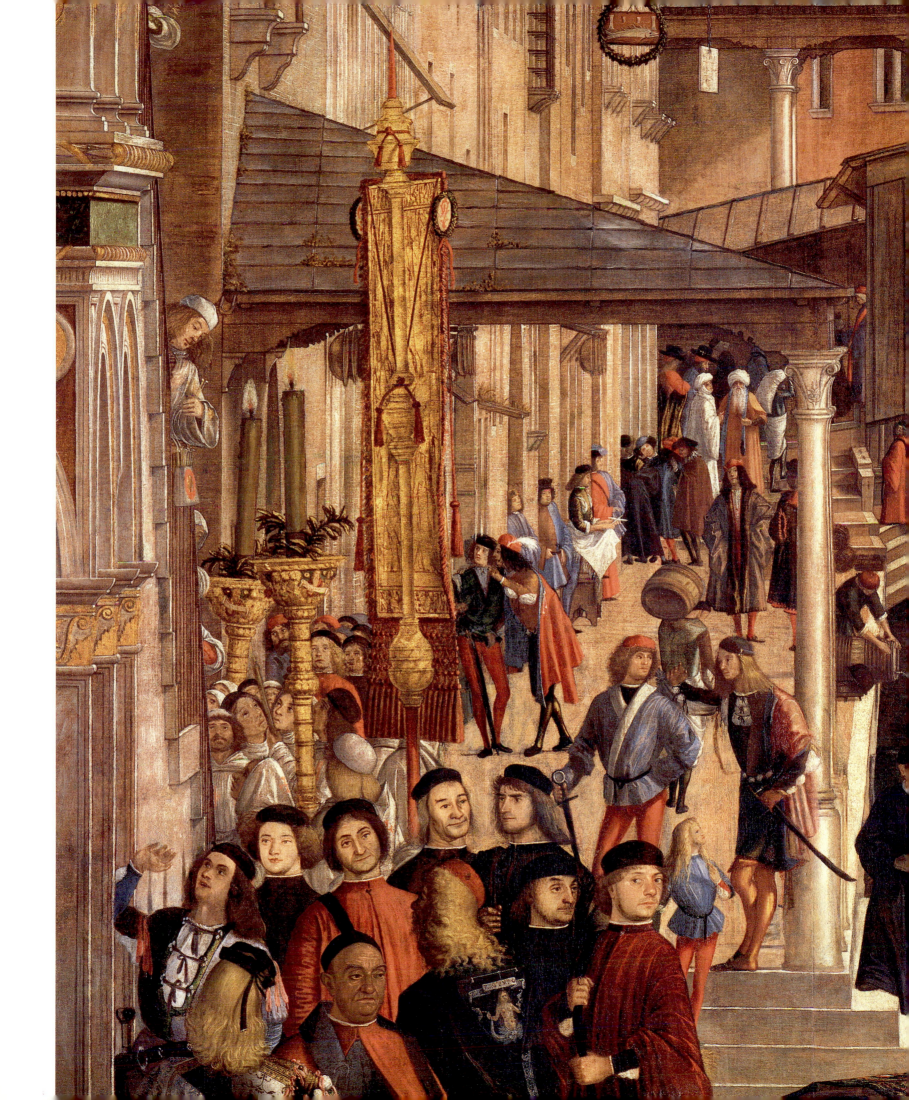

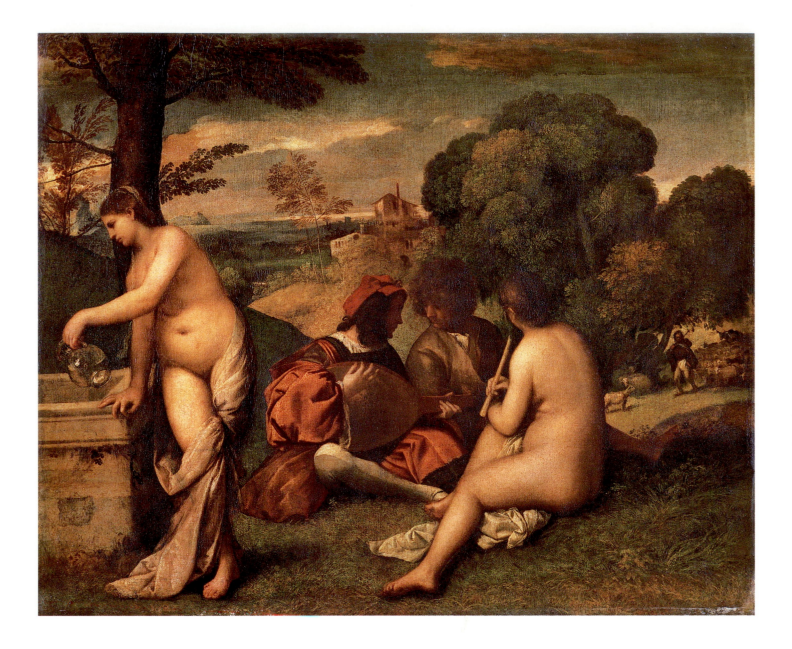

would have taken into account the fabric of the gar-
ments, sensing a distinction between crimson on sleeve
and scarlet on beret. Both were mildly transgressive in
their luxury, breaking out of the camouflage of patri-
cian uniformity to a degree that was tolerated in the
youthful members of the *compagnie della calza*.

★ ★ ★

206 Attributed to Giorgione, *Concert Champêtre* (*c.*1509).
Canvas, 110 × 138 cm. Paris, Louvre.

207 Attributed to Giorgione, detail of fig. 206.

Fashions in texture: satin and velvet

For Venetians experiences of colour and texture were interwoven. To a degree this is true in all societies, for if twentieth-century neural research is correct judgements about the colour and texture of surfaces are perceptually linked at the primary level of the firing of cells in different regions of the brain. Our visual system builds upon a network of cross-modal connections which link different kinds of sensory information. These connections help us detect constants within the world we inhabit, but they are far from uniform or automatic. Long-term factors in the evolution of our species and short-term experiences within the life of an individual establish hierarchies of response.[36] The question facing a historical study of art must be how these neural networks might be affected in the short-term of a lifetime.

First, a cautionary word. In considering how material culture – its manufacture, marketing and consumption – affects cognitive skills, it would be misleading to give the impression that Venetian society was entirely different from other societies that enjoyed luxury. It is a question of degree and nuance. Daily experience of luxury textiles conditioned responses to colour, pattern and texture in many schools of medieval and Renaissance art.[37] Venice was far from being the only Italian city to support a flourishing silk industry from the fourteenth century onwards.

In the fifteenth century, cloths of gold and silver, the last word in regal splendour, were manufactured in many centres and coveted by the rich and powerful. Characteristically, the Venetians sought to make their cloth of gold (called *restagno d'oro* or simply *restagni*) as sumptuous in colour and varied in texture as possible. Gold was either wound around a thread of silk, or filaments of silver were covered with finest gold leaf to give the illusion of solid gold thread; these delicate operations were performed by members of the long-established Venetian *arte* of the Tira e Batti Oro.[38] Next, the weavers used these glinting filaments to diversify their velvets: in addition to laying threads smoothly in a traditional brocade, sometimes they looped them at intervals in the velvet pile to raise flecks of gold or silver above the crimson, or they bunched the loops to fabricate a rough, light-catching surface – a technique known as *allucciolato* because the metal

208 Venetian velvet in *alto-basso* and *allucciolato* in gold thread (second half of fifteenth century). Venice, Feliciano Benvenuti Collection.

threads sparkled like fireflies (*lucciole*) (fig. 208).[39] In his portrait of Leonardo Loredan, Bellini applied rough flecks of paint to indicate that the dogal cape is brocaded with loops of gold thread (fig. 209). The invention of light-catching textures in costume prepared the ground for broken, painterly brushwork in the era of Giorgione.

Apart from the quality of dyes, what made Venetian production pre-eminent – though not unique – was the sheer diversity of textures in satins and velvets. In the fourteenth century heavy silks, known as samites, were worked with gold and silver. The weavers, the *samitèri*, were distinct from the weavers of velvet, the *veludèri*. In the fifteenth century satin, called *raso* – literally 'shaven' because of its smooth weave – became valued for its sheen, and, not surprisingly on the lagoon,

a variant of satin, shimmering watered silk, became popular. The French word *moiré* ultimately derives from the Latin *mare*; in Venice to work such silk was known as 'dar onda all'amuèr' – 'to make waves on the sea'. The statutes of the *samitèri* explain how this was done by passing the silk through a mangle; two-way rolling flattened the lie of the weave in contrary directions, rendering it variably *lucido* in a wave-like pattern.[40] The term *marezzato* might refer to marble or silk, and on either the pattern of ripples would often be tipped into the vertical. The wave-like veneer of marbles in Giovanni Bellini's San Giobbe altarpiece has been noted: in the *Madonna of the Little Trees* (fig. 210) he hung moiré silk as cloth of honour. Patterns on water that extended towards the horizon became undulations of colour lapping up and down the vertical surface of paintings or the marble-lined walls of churches. Was it the experience of wearing

210 Giovanni Bellini, *Madonna of the Little Trees* (1487). Panel, 74 × 58 cm. Venice, Accademia.

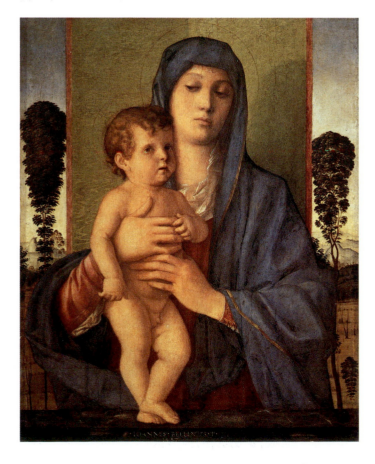

watered silk, or seeing it worn, which prompted the painterly transformation of horizontal to vertical? Certainly watered silk appealed to Venetian delight in appropriating the rhythms of the sea.

Satin is flashiest in pale colours. Satins in white and silver increasingly drew the fire of sumptuary legislation from the mid-fifteenth century onwards, a sure sign of their growing popularity. Velvet is richest in dark colours, the silk thread used for velvets usually being dyed twice; crimson remained the favourite colour, with black emerging as a luxurious alternative around 1500. The *veludèri* raised to new extremes two or more heights of cut pile, known as *alto-basso* (see fig. 208). Consider how the cutting of velvet – typically crimson – deepens the colour at the edge, a tiny cliff between the higher and lower pile, and renders it more vivid at its summit. Differentiation is introduced within a colour field simply by the cutting of the pile, and line emerges as a step within colour rather than a boundary or something separate from colour itself. Since our visual system is geared to distinguish edges from gradations of local colour, an edge that is both faintly blurred and internal to a colour field teases, and by delaying perceptual classification (is there a discontinuity or only a gradation?) the false edge heightens response to colour itself. In the sixteenth century, when *alto-basso* remained the showiest velvet, plush on every senator's stole, Titian excelled in creating its pictorial equivalent, understanding, like the *veludèri*, that the richest *colorito* – and most *signorile* – could be attained by animating a single hue by stepped modulations within it (figs 211 and 212). Monochrome had never been so colourful, and Titian's patrons would have appreciated it's artifice.

It is important at this point to distinguish between the literal and the painterly imitation of texture. By the end of the Middle Ages ingenious techniques for punching, impressing or incising the textures and patterns of luxury fabrics into painted surfaces had been perfected: one device recently termed 'press brocade' was a widely popular means of applying relief.[41] These mechanical devices were the stock-in-trade of furniture painters; the literal transfer of pattern appealed to provincial taste, and is reflected in the obsessive attention to textiles in the work of a late quattrocento realist such as Carlo Crivelli. The painterly

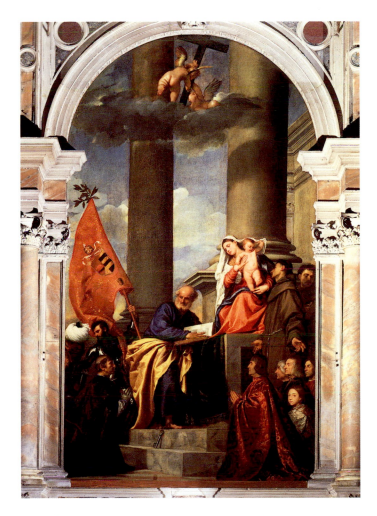

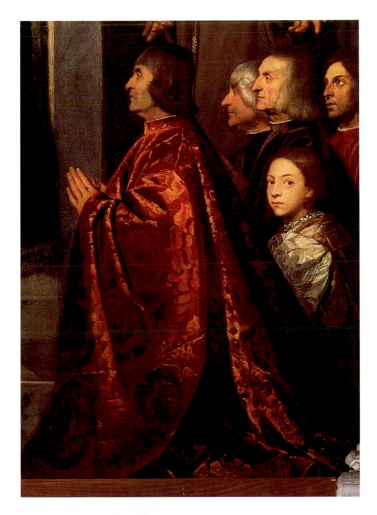

211 Titian, *Virgin and Child with Saints and Donors* (Ca' Pesaro altarpiece) (1519–26). Canvas, 478 × 266 cm. Venice, Frari.

212 Titian, detail of fig. 211.

imitation of texture by Titian and painters in his orbit, in accord with the social dynamic of sophisticated metropolitan taste, distanced itself from anything mechanical. In the early sixteenth century, as David Rosand has pointed out, there are indications that the figure painters or *figurer* were attempting to draw apart from other members of the Venetian painters' guild, the Arte dei Depentori, which included gilders, textile designers and embroiderers, leatherworkers, makers of playing cards and mask makers.[42] Texture for the *figurer*, as opposed to texture for the more humble decorator of objects that would be handled, was a matter of optical judgement. Thus Paolo Pino, in his *Dialogue on Painting*, published in Venice in 1548, praised the rendering of such diverse textures as armour, silk, linen,

velvet and woollen cloth as achieved not simply through the variety of colours available but by the painter's skill in handling colours.[43] Yet, more than anything, it was through the dress they wore and touched – their camouflage and sign of distinction – that Venetians, patrons and painters alike, became cognitively attuned to colour texture, to *colorito*. It is surely a sign of the accord between dress and painting that in the course of the sixteenth century the embellishment of Venetian velvets with gold, brocade or *allucciolate* threads gradually disappeared, whereas the painterly *alto-basso* remained popular.[44]

★ ★ ★

The luxury of black

Sanudo ended his account of Venetian dress, written in 1493, with the blunt observation, 'to conclude, they wear black a lot'.[45] In Venetian dress codes the overriding choice was between black and any other colour. Black was the norm: 'to wear colour' meant relinquishing black, either because a gentleman had become a holder of high office, or for the occasion of a festival. Patricians and *cittadini* wanted cloth and silks that were unmistakably black, but good blacks were difficult to come by. The black cloths of Burgundy and the Low Countries – beautifully described by painters from Van Eyck to Memlinc – were admired for their depth and fastness; indeed the growing fashion for black in the later fifteenth century may have reached the Italian peninsular from Burgundy and Spain via the Aragonese court in Naples.[46] In Venice by the late fifteenth century dyers were divided into two groups of artisans: quality dyers, who enrolled in the *arte maggiore*, and common dyers, who belonged to the *arte minore*.[47] Status depended upon the dyes they used. Whereas members of the *arte minore* primarily used tannins and iron-gall to create browns, greys and inferior blacks, the superior dyers used expensive materials such as madder, woad and kermes. In particular, the members of the *arte maggiore* had to prove themselves capable of producing strong blacks that neither tended towards brown nor faded. This may have been particularly difficult in the lagoon because of salt in the rinse-waters of the canals.[48] It is likely that the Venetians needed ingenuity to produce the finest blacks, and to defend their reputation: an entry of 1558 in the *mariegola* or statute book of the Arte della Seta banned import of black silks, and claimed, defensively, that the Venetians made black velvets to match 'the most beautiful that come from Genoa'.[49] The honour of Venice was bound up with its production of black silk and cloth, so it is not surprising that the second largest number of formulae in Venetian manuals on dyeing concerned black: ten in the fifteenth-century treatise, twelve in the *Plictho*. An essential ingredient in the best black dyes was woad, which gave to black a luxurious hint of blue.

Of all colours black is tonally most volatile, changing according to texture. The wider the choice of materials, weaves and finishes available, the more sophisticated was a society's discrimination of black, and all the more so if its dyers were close by and its mercantile patriciate handling import and export. So the growth of the Venetian silk industry sharpened discrimination of black, especially since Venetian society was one in which the absoluteness of black – its separation from all colours – was a defining issue. Black as non-colour was emblematic of the purity of the ruling class in more senses than one. Visitors praised the cleanness of the city, the lack of mud or excrement in its *salizzade* or paved streets. Marbled walls gleamed brighter than in other cities for no hooves of horses raised the dust: by 1500 horses had been banished from the urban centre. Patricians, stepping from their palaces into black gondolas, did not even need to risk trailing their long gowns in the dirt of the *campi*, so the blackness of their garb remained unsullied.[50] At the Rialto, banking hub of the proto-capitalist emporium, we glimpse the ancestor of the businessman in black, sobersuited, cut off from agrarian toil.[51]

This was a society, fixed in hierarchy, headed by an elected doge but lacking a court, with a widespread taste for commissioning portraits. Between Antonello da Messina's visit in 1475–6 and Giorgione's death in 1510, the format of portraits extended to halflength, the scale to near life-size. Significantly, Marcantonio Michiel in his accounts of early sixteenth-century collections was alert to the scale of portraits, describing them as 'menor del naturale' or 'del naturale',[52] and in the same pages he took trouble to list mirrors as well as portraits.[53] Painting as large as life prompted artists to reflect upon the selectivity of attention when confronted by another human being – or themselves in the mirror. The advent of plateglass allowed painters, and their sitters, to rehearse in front of mirrors, to dramatize their own appearance, their own appearing. It may be that selective pictorial focus developed in part as a consequence of reflexive awareness of eye-contact: the viewer riveted by the eyes in a mirror, or in a portrait, is aware of the periphery as subordinate, unfocused. This has consequences for colour, for its definition and attachment to things: the register of colour texture becomes optically variable according to the spatial range of attention. Vision does not stroke every surface, feel every texture;

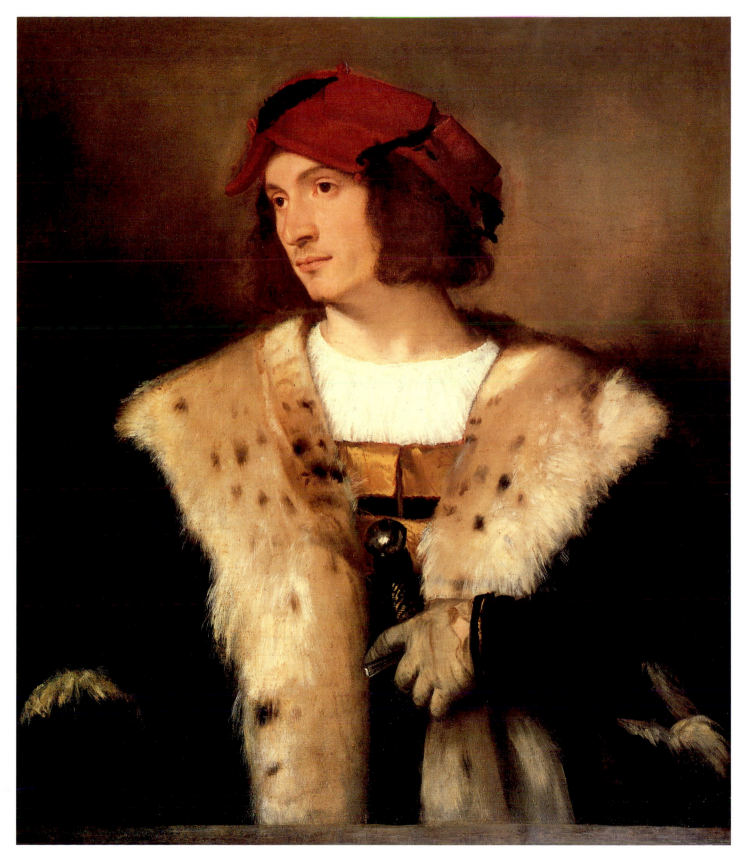

213　Titian, *Man in a Red Cap* (*c*.1515). Canvas, 82.3 × 71.1 cm. New York, Frick Collection.

it samples, leaps and overlooks. Placing a jewel on a beret of black velvet is an obvious way in which the selectivity of attention is controlled through dress and accessory. Titian's exploration of black belonged to this new orchestration of attention in which black could provide an interval of rest where texture disappears into inky shadow, or emerge as a tangible surface with a faint sheen, or – unlike earlier convention in which darkening signals recession – some deepest blacks might even loom forward as well as recede into a void.

In a few instances black was literally brought to the fore by the introduction of a black painted border. Titian's so-called *Sacred and Profane Love* (fig. 243) has such a flat black border all around the canvas; in Vincenzo Catena's portrait of Doge Andrea Gritti in the National Gallery, London, the black margin is cut off where the figure abuts the frame. Unlike the illusion of solid mouldings which occur as fictive frames in several fifteenth-century paintings, including several by Mantegna, Titian's black slip is perceptually liminal, submerged in the darkness of an unfocused periphery.[54] It is plausible that black borders on paintings on canvas originated as a guide to the placement of the edge of the picture surface where the stretcher would be overlapped when inserted in the frame, before being adapted by Titian to visual effect.[55]

Belonging to the first generation of Venetian painters to train using oil rather than tempera, Titian quickly discovered that richer blacks could be achieved in oil than in tempera or fresco, and it was this that offered opportunities to rival the chromatics of textiles. Titian became *the* master of black. If we could see his paintings in mint condition, it is likely we should notice that he varied their surface shine from area to area by tempering the leanness and fatness of his medium. Even today, if you look closely at the portrait *Man in a Red Cap* (fig. 213) in the Frick Collection, it is possible to see that the sleeve is painted a blacker, faintly glossier black than the black of the rest of the garment – a distinction which is lost even in the best reproductions.

Here, as in other early portraits, such as *Man with a Blue Sleeve* (National Gallery, London), Titian takes the risk of allowing black its full force, replacing conven-

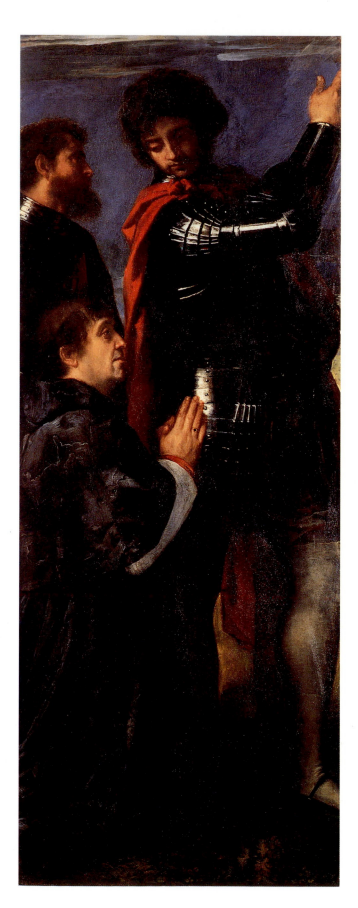

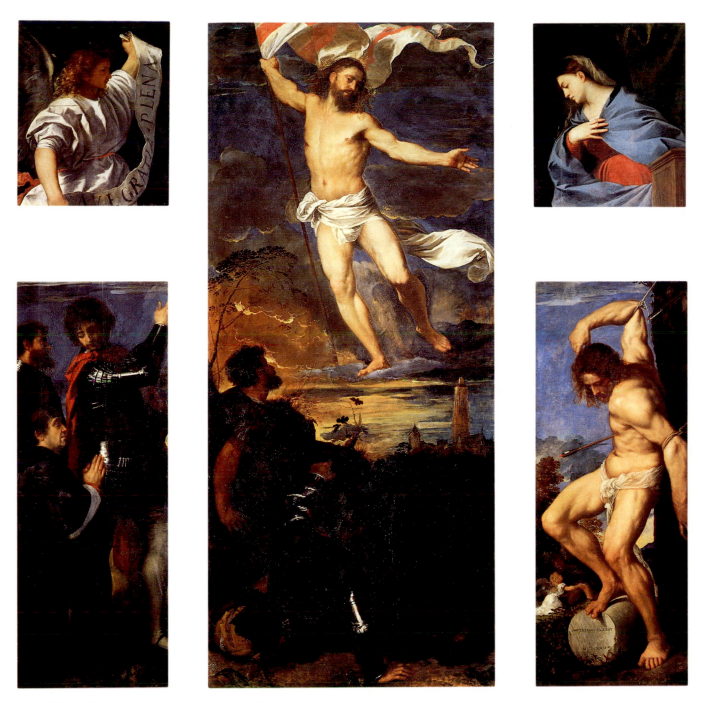

215 Titian, *Resurrection* (1519–22). Five panels: 278 × 122 cm (centre); 170 × 65 cm each (lower tier); 79 × 65 cm each (upper tier). Brescia, SS Nazaro e Celso.

214 *(facing page)* Titian, detail of fig. 215, showing the left-hand panel with the donor, Altobello Averoldi.

tional modelling by the merest hints – a glimmer here, an inclination towards blue there. In broad passages any orientation of fictive surface drops away, and the viewer is brought up close, as never before in painting, to an inky blackness. Giovanni Bellini brought shadow to the front of his Brera *Pietà*: Titian appropriated it for portraiture and deepened it to a velvet dark.

Titian's method of achieving blacks naturally differed from that of a dyer. A cross-section of the robe of Bishop Averoldi, who kneels as donor on the left of the polyptych signed by Titian in 1522 (figs 214 and 215), indicates a complex layer structure. Based upon Lorenzo Lazzarini's analysis, the text below shows the layers in diagrammatic form, reading from the surface down to the wooden support.[56]

LAYER STRUCTURE OF AVEROLDI'S BLACK ROBE

varnish (yellowed)

★

glaze of dark violet lake (changed)

★

dark blue layer of azurite mixed with dark blue-violet lake

★

thin layer of lamp black with a little vermilion and a little lead white

★

layer of lamp black with a little lead white and a few grains of azurite

★

thick dark brown layer of lamp black, vermilion and a little dark violet lake

★

brownish-red layer of burnt ochre with vermilion and a little lead white

★

film of siccative oil

★

brownish-layer of burnt ochre with lead white and a little vermilion

★

thin layer of lead white greyed with a few grains of lamp black

★

gesso with glue

★

poplar panel

(Lazzarini notes that the violet lakes in the upper layers have altered under exposure to light.)

Broadly speaking, Titian moved from warm mixtures, including vermilion and ochre, in the underlayers, to cooler ones, including azurite and violet lake, in the final layers. Five of the layers contain some lead white, a very dense pigment which tips the mixture towards opacity, and in turn makes it cooler. By overlaying cool over warm, Titian induced a dusky silver to hover over ebonies and sables.[57]

The intimacy of white

The rise of luxurious blacks was matched by the revelation of white. It has already been noted that towards 1500 there was a growing fashion for white in marble, in blue-and-white porcelain, in *lattimo* glass. Luxury Ottoman and Persian fabrics with sparse floral motifs on a white ground increasingly found their way into the Venetian market. In some cases white became the modern alternative or foil to gold – in heraldry it is its equivalent. Gold and white ranked above crimson or scarlet in dogal dress. For a bride to wear half *restagno*

216 Titian, detail of fig. 243.

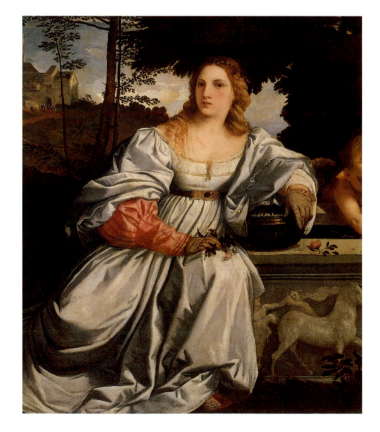

217 Titian, detail of fig. 181.

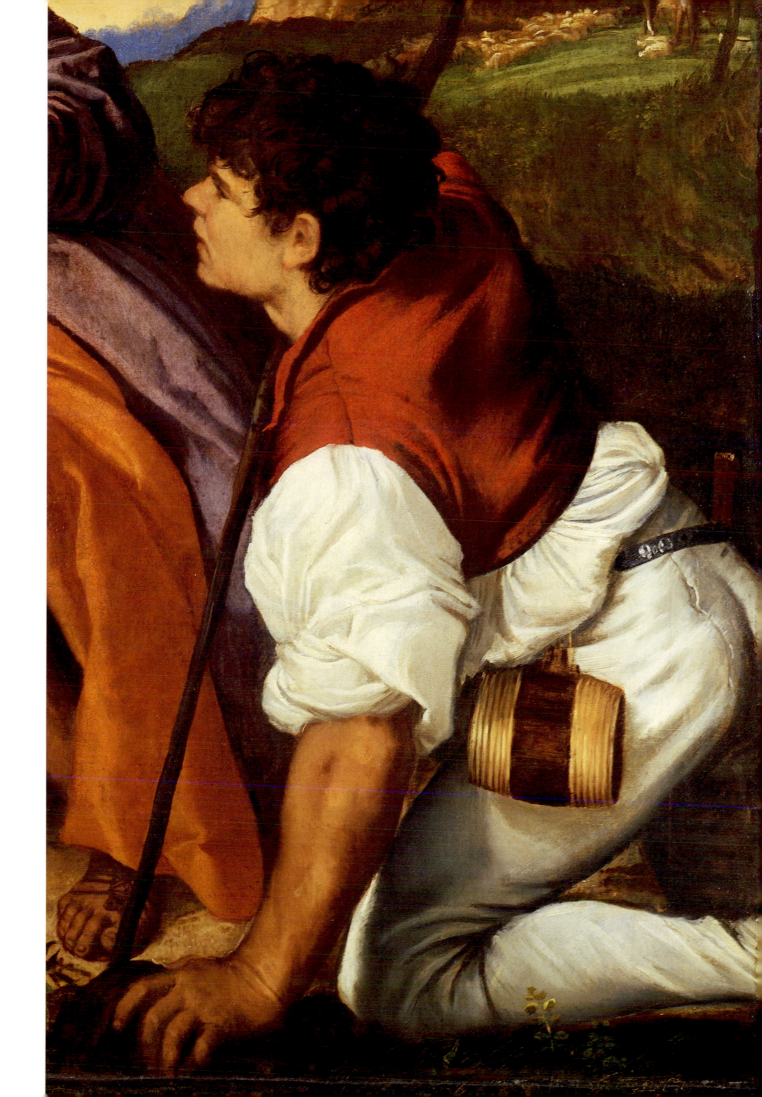

d'oro and half white was the most dazzling luxury (fig. 216); officially contravening the sumptuary laws, exceptions were made for the powerful, as at a Grimani wedding in 1517.[58] To be able to afford white clothes implied a rarefied life-style, for in an age when costly fabrics were rarely submitted to laundering, immaculate whiteness signified total protection from dirt, therefore leisured civility. When the young Titian painted the shepherd in the *Holy Family* (fig. 217) with white satin breeches, it was an inversion of the natural order, a pictorial conceit based most likely on costume for mummery or festival. No real shepherd wore white satin for, as rustic Corin will twit the courtier Touchstone in Shakespeare's *As You Like It*, the shepherd's hands 'are often tarred over with the surgery of our sheep' (III. ii). As Titian's hands – or rather his brushes – shaped the breeches, they discovered how lead white suspended in an oil medium could be worked in impasto to create the gleaming folds of satin.

In Venetian oil painting, narratives of texture – soft and flowing, crumpled or crisp, bunched or smooth, lacy or starched – cut across traditional hierarchies of modelling. The sensuous invaded religious art, and whiteness, once sign of purity, acquired intimate associations. During Titian's youth, white fabrics became ever more evident as a result of the emergence of the *camicia* or chemise. In the fifteenth century the number of *camicie di giorno* that appear in Venetian inventories is evidence of growing concern with comfort and personal hygiene. As these white undergarments became more luxurious, often in fine linen known as *tella di renz* (Rheims), sometimes embroidered, and later – from the 1540s onwards – trimmed with Venetian lace, so it became desirable to flaunt them at collar and wrists.[59] From about 1525 the white ruff flowered from this overflow of underwear.

Whereas in the Middle Ages it was usual to sleep naked, by the sixteenth century inventories list 'camisia di portare la notte' – a shirt for night-wear. At first the difference between night-shirt and day-shirt was slight, therefore any exposure of the *camicia* might hint at the intimacy of the bedchamber. The sight of white linen against female flesh or next to the blackness of the male gown could carry sensuous, even erotic overtones. The clothes of Titian's *Man in a Red Cap* (fig. 219) hang loose compared with the tight-laced portraits of the quattrocento, and the exposure of the chemise below the neck suggests private mood, soulful and poetic, emergent from beneath the trappings of public status.

Whereas in Alberti's system, and again in Leonardo's, the extremes of white and black are reserved for modelling in highlight and shadow, Titian's white and black convincingly belong to material things as much as to light and darkness.[60] Black may belong to velvet, sometimes to fur and to hair; white belongs to the chemise or to satin robes. The portraits are calibrated between these poles.

A new scale of value: greys, veils and velature

In the new scheme of values, grey is distinct from black and white, and it too may denote material things. The use of grey marbles, such as *bardiglio*, has been noted in the architecture of the Lombardi. In the early sixteenth century it was leather which elevated the lowly status of grey in dress. Rosetti devoted a section of the *Plictho* to dyeing leather, chiefly in blacks, greys and reds, more rarely in blues and greens. Red leather, much used for wall hangings, contrasted with the green that was common in Venetian furnishings.[61] Greys, referred to in the *Plictho* as *berettino*, were applied in pale shades to the fine leathers used for gloves, and it is these gloves – second skins, soft and loosely fitting – that Titian painted with exquisite sense of tone.[62] Unlike the humble *berettino* of undyed wool, the *berettino* of the leather glove endowed grey with aristocratic status. The gloved hand at the centre of the portrait *Man with a Glove* (figs 218 and 220) is as luxurious as the surrounding furs, and it is the shifting grey of the glove which, more than any other surface, communicates the touch of light on the figure. Early in his career, Titian learned that rendering light in one or two key passages of a painting invited the viewer to 'read' illumination into the whole. The master realized that the pictorial analogue to selective attention is selective modelling.

Grey is at the centre of another of Titian's early portraits, the so-called *Schiavona* (fig. 221), in the National Gallery in London. The sash encircling the woman's waist is a shade cooler than the background, and the

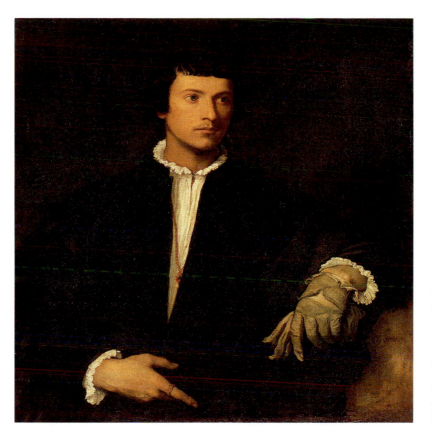

219 *(below left)* Titian, detail of fig. 213.

218 and 220 *(below right)* Titian, *Man with a Glove* (*c*.1523), and detail. Canvas, 100 × 89 cm. Paris, Louvre.

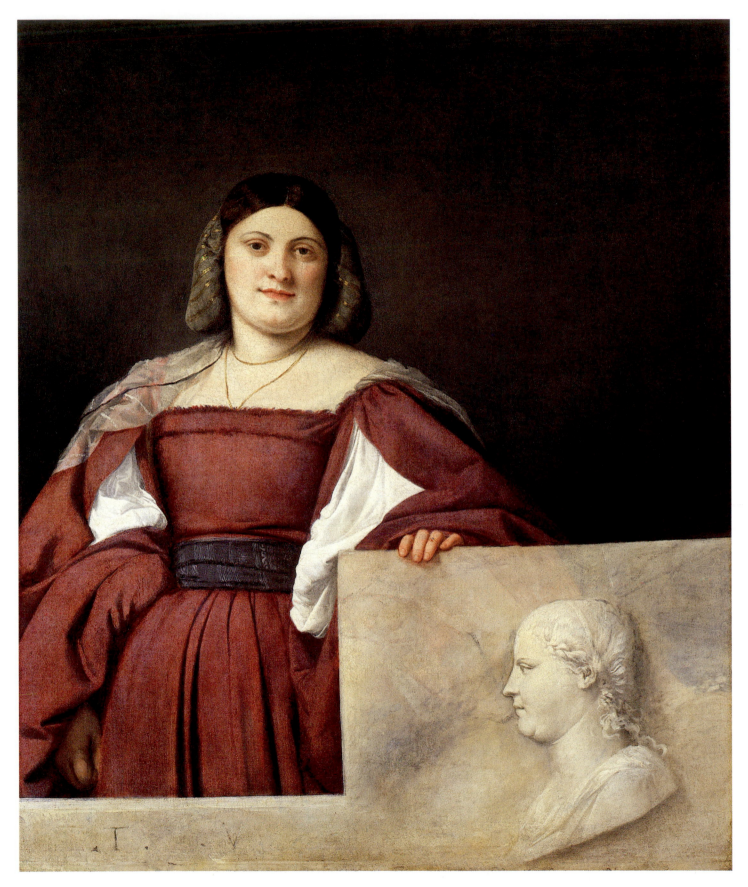

221 Titian, *La Schiavona* (*c.*1511). Canvas, 119.9 × 100.4 cm. London, National Gallery.

222　Pattern for *punti in aere* lace from *Le Pompe* (Venice 1559).

223　Bobbin lace insertion and edging from a coverlet (Italian, second half of sixteenth century). London, Victoria and Albert Museum, T.297–1975.

staves of milky white dashed over it confirm this elegant grey as surface colour in contrast to the portrait's background which is shadowy and yielding. By use of semi-opaque scumbles, *velature*, Titian introduced whiter greys in her hairnet or *scuffia* and in the kerchief or partlet on her shoulders.

Trading contacts with the east, and the large number of foreigners resident or transient in Venice, exposed Venetians to many fashions in veils, shawls and kerchiefs, and to exotic materials, patterns and manners of wearing.[63] So it was not surprising that it was Venetians in the cinquecento who led the way in discovering how interpenetrating layers in dress, part diaphanous part concealing, diversify and intrigue. The adoption of loose veils afforded sensations of layers of semi-

diaphanous colour texture casually brushing over one another. Somewhat later, starting around 1540, the efflorescence of the lace industry followed through from this movement of taste: the lacemakers of the lagoon devised more open styles of pattern and stitch, culminating in the *punto in aria*, which became popular from the middle of the century (figs 222 and 223).[64] Essentially, the open style of lace, like sea-spray over dark waters, drew attention to black layers lying beneath the whites of cuffs and fringes. Unlike embroidery, which was stitched to its textile matrix, lace allowed a little play between layers.

Titian's exploration of *velature*, of glaze and scumble, of the lacy impasto of lead white, crumbly at the edge over darker grounds, coincided with this new sen-

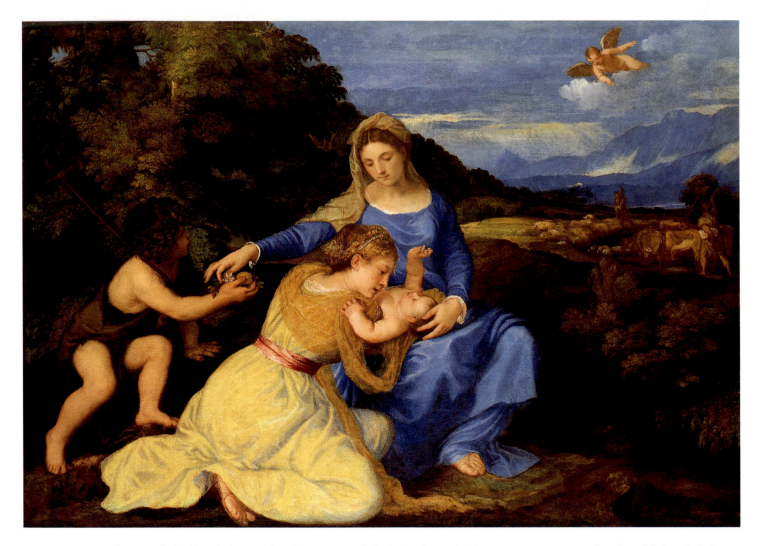

224 Titian, *Madonna and Child with Saints John the Baptist and Catherine* (c.1530). Canvas, 101 × 142 cm. London, National Gallery.

sibility in dress. From the 1520s, perhaps earlier, Titian was improvising with scarf-like coloured veils and kerchiefs, adding them at a late stage to his figures to diversify hue, soften a contour, or add a puff of movement. Just as wearing the kerchief or veil appears accessory, casual or improvised, so too are Titian's painterly additions; sometimes the diaphanous colour is barely visible, like the periwinkle-blue edging to the gauzy sash tied around the waist of the *Young Girl with a Mirror* in the Louvre, sometimes it is prominent, as in the golden yellow veil wound around Saint Catherine in the *Madonna and Child with Saints John and Catherine* (figs 224 and 225).

Titian's novel calibration of colour tone is evident in the *Gypsy Madonna* (fig. 226), a sobriquet that derives from the Madonna's dark hair and dark eyes. What is most striking here is that Titian contrasts these dark features with a pale mantle, in light blue with undertone of rose. In daring to replace the saturated ultramarine or lapis lazuli traditional for the Virgin's mantle with a far lighter blue, Titian anticipated that sophisticated viewers would interpret the pale blue as the sheen of silk, thereby reading the luxury of the fabric as compensating for the cheaper combination of pigments. Titian shifted attention from a value system based upon pigment to one based upon fabrics not out of parsimony – for he was usually unstinting in the use of the best pigments, especially ultramarine – but for reasons of design. In this instance it allowed him to take the aerial blue of the mountains and tilt it at right

225 Titian, detail of fig. 224.

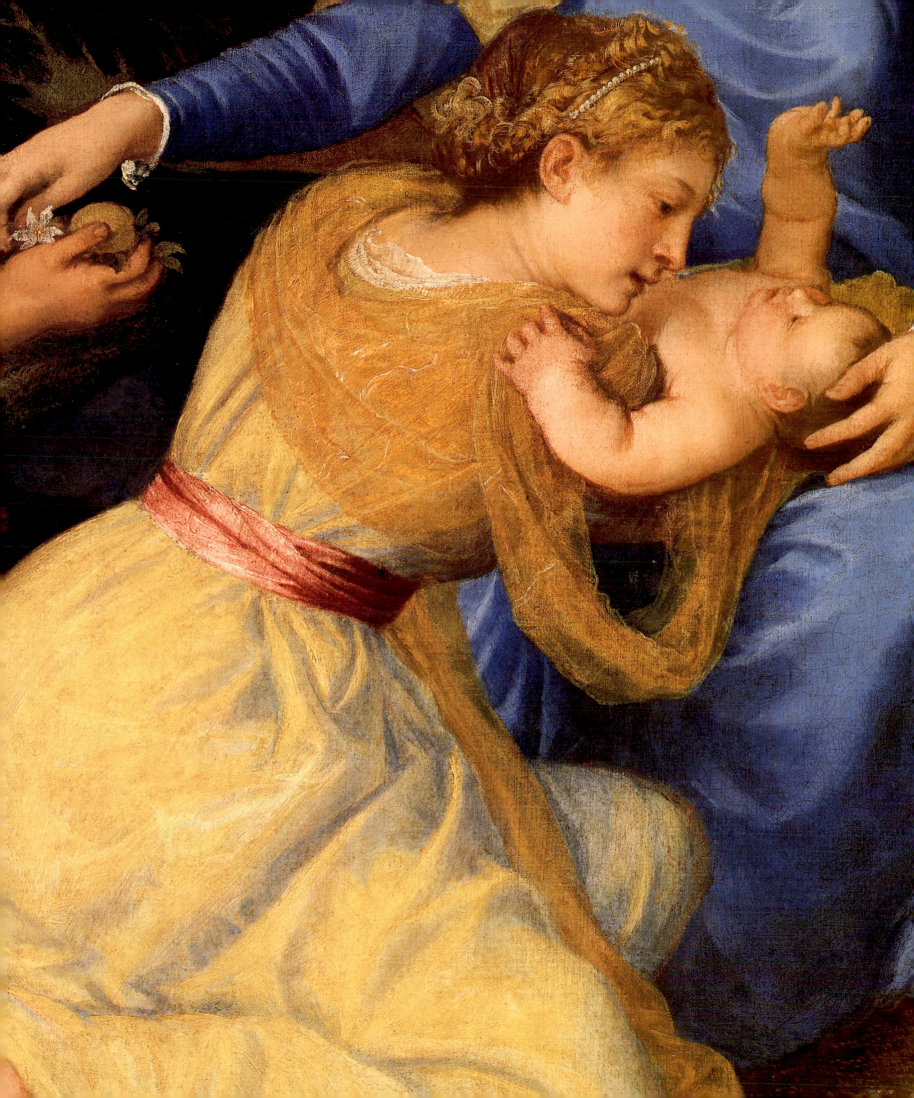

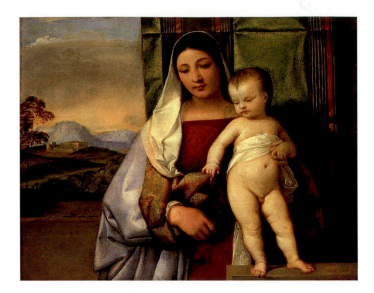

226 Titian, *Gypsy Madonna* (c.1510). Panel, 65.8 × 83.5 cm. Vienna, Kunsthistorisches Museum.

angles to shape the blue of the sleeve. Blurring the transitions from light to shadow, softening contours on silk and on mountains, the master from Cadore in the Dolomites felt for analogy between planes of distant blue and near blue, and generalizing with his brush he moved away from the exact imitation of brocades and damasks, such as Carpaccio achieved, or of coloured marbles, such as Cima da Conegliano painstakingly described, towards an art reaching for metaphor. A literary precedent helps to follow this turn: the coda to this chapter moves from the materials of dress to the stuff of the imagination.

Colours in the Hypnerotomachia Poliphili

The metaphorical turn can be traced in the most celebrated volume from the Venetian press of Aldus Manutius, the *Hypnerotomachia Poliphili*, known in its English translation as 'The Strife of Love in a Dream'. Published in 1499, the author of this dream-romance is something of a mystery: his name, disguised in an acrostic, is Francesco Colonna, and he is commonly identified with a Dominican friar of this name recorded at Santi Giovanni e Paolo.[65] To speak of colours in the *Hypnerotomachia* may seem perverse, for the book is honoured for the refinement of its black-and-white

woodcuts, illustrations in which no attempt was made to imply diversity of hue or even to model in light and shade beyond the most rudimentary cross-hatching to darken the trees in a scene such as the *Garden of the Senses* (fig. 227). Nor are any of the surviving early copies of the *Hypnerotomachia* coloured by hand. It is as though these woodcuts, unlike Mantegna's engravings, are merely a template for the imagination, accompanying a text rather than standing in for it. In this production of Aldus, printed word and woodcut *visually* proclaim the elegant sufficiency of black and white.

Although the vehicle, printed characters and woodcuts, is black and white, the tenor of the text is polychrome. Borrowing heavily from Pliny and Apuleius, Colonna revelled in coruscation of light on coloured marbles, on silks, fountains and the flesh of nymphs.[66] In his descriptions of fantastic architecture, he dwelt on the candour of white marble, the veins of coloured ones, the high polish, glint and sparkle of semi-precious stones, gold and lapis lazuli. Choice of coloured materials contributes to the *intonazione*, tone or emotional temperature of a building: the Temple of Venus is flushed with fire-gilt bronze.[67] Repeatedly, the splash of water refreshes and intensifies the dreamer's sight, seemingly meshing the eye's rays in a play of reflection and transparency, so that in these rebounds and penetrations viewer and dream-vision become entwined.

Two words, *coloratione* and *coloramento*, pepper the text. Dante had used *coloramento* in his *Convivio* to describe the transmuting of colours over distance; but in Renaissance texts on art these Latinate colour terms are exceedingly rare.[68] Rather than itemizing such-and-such a colour, references to *coloratione* imply a relationship, a dynamic, or at least a gradation of tint. In Colonna's syntax terms for colouring become transitive, their transformations and reflections active forces in the trajectory of the dream-prose. Typically *coloratione* unfurls, reveals itself, conceals itself, through movement, time and space: the nymphs that circle round Venus are dressed in gold and silk, the colour and sparkle of their mantles changes as they dance, the scintillating textures contrasting with the constant whiteness of their smooth flesh. Like Titian's gauzy kerchiefs, the tunics that Colonna described are of the thinnest silk (*bombacina tenuissima*) and not so much positively red or yellow but tinged with red (*conchiliata*) or yellow (*croceata*).[69] The

227 *The Garden of the Senses*, woodcut from *Hypnerotomachia Poliphili* (Aldus Manutius, Venice 1499).

spaces in which colouring plays are repeatedly described in terms of measured interval and 'composed' or 'proportioned' distance.[70]

The woodcuts renounce colour or sparkle, whereas the printed text evokes these qualities in excess of what might ever be comprehended in the waking world. Often it is luxuries such as silks and embroideries, as well as Murano beads and glass, that mediate between the chromatic plethora of the dream-text and the reader's sensory experience. A fabulous garden of Queen Eleuterilida is fabricated of pearls, silks and glass; its walls are studded with 'operimento margaritale', which might mean beads or *conterie* as well as pearls; and the tactile memory of clothes is called into play by the description of the ground of the garden as carpeted with green velvet, its silk pile like a 'meadow' that has just been mown.[71] Rather than being pure literary fancy, this may reflect the use of silks, floral or plain, to suggest verdure in theatrical scenery during winter, as the architect Sebastiano Serlio described in his account of the *scena satyrica*.[72] In textile terminology *zardin*, Venetian for *giardino* or garden, came to denote a polychrome decoration, particularly a velvet cut in different heights.[73] Metaphors reorder perception: velvet becomes grass, grass velvet, and as in Titian's paintings, mountains may glow with coloured light like silk, or mantles fold like mountains. What is within touch is brought into play with the distant, the imaginary, the inaccessible. The flux of *coloramento*, chameleon as shot-silk, invisible in the woodcuts, runs like restless desire through the language of the *Hypnerotomachia Poliphili*. This instability of colour characterizes the body itself and signals its changing emotional tenor. In sixteenth-century Venice this changefulness of colour, sign of life, of being alive, will be a source of both anxiety and celebration, a communicative force to be celebrated as well as kept under control.

9

THE TRIUMPH OF TONE AND *MACCHIA*

In the light of prints

Titian's fame as a colourist was established early in his career. In the 1530s Pietro Aretino praised his colouring as surpassing nature, a theme echoed in a dialogue entitled *L'arco celeste* (The Rainbow), written in the same years by the Florentine exile Antonio Brucioli and set in Titian's house as a conversation between the painter and the architect Sebastiano Serlio.[1] In the following decades, in Ludovico Dolce's *L'Aretino* and in letters by Pietro Aretino himself, the leadership of Titian as the champion of Venetian *colore* was proclaimed. For the master from Cadore it was the fulfilment of an ambition, conceived while still a tyro, to assume leadership in art, to prove himself the new Apelles, and to elevate painting above sculpture. When he painted *Venus Anadyomene* (now in Edinburgh) he doubtless had Pliny's tale of Apelles' picture of this subject in his mind.[2] He set out to realize with his brush in living colour the subjects of ancient art.

The separation of black and white from polychromy, woodcut from text, image from word that is so clear in the printed book of the *Hypnerotomachia Poliphili* is emblematic of a new stage in the history of colour in representation. Titian's ambitions as painter – his grasp of the possibilities intrinsic to painting and his determination to demonstrate them – were framed within a cultural context of rivalry, as well as give and take, between monochrome and polychrome media. Two aspects of this deserve scrutiny: the growing artistic value of black and white in the first age of print culture (a topic broached in chapters 4 and 7), and the debate, known as the *paragone*, about the relative merits of painting and sculpture. Together they constitute the necessary foil and stimulus to the rise of Venetian

oil painting in general and of Titian's colourism in particular.

By 1500 engraving had matured as an art capable of displaying powers of hand and imagination, *ars* and *ingenium*, and had extended beyond Christian imagery to embrace subjects of poetic invention: in David Landau's words, 'prints were being transformed from objects of devotion to objects of admiration'.[3] Frequently larger than before, with multiple sheets sometimes combined to create friezes, prints increasingly could compete with paintings; a few may have been framed, others were pasted directly on to the wall or mounted on canvas. Such exhibition prompted new kinds of pictorial expectation and attention to be directed to works on paper. To artists and collectors avid for subjects with a classical slant, prints encapsulated the poetic quality of light and shadow while at the same time in skilled hands advertised personal style. In the 1490s Jacopo de' Barbari developed hair-thin lines and rhythmical changes in direction of hatching. In his *Apollo and Diana* (fig. 229) the open-ended meshes suggest veils of shadow and light, hanging in the air, interpenetrating as radiant half-tones. Typically these prints evoke poetic imagery, such as sunlight as Apollo's rays or the brightness of the air and sudden mists as god-like influences, celestial and mobile. In the *Imagines*, a Greek text of the third century purporting to describe a number of celebrated works of art, which was becoming well known to educated viewers in the Renaissance, Philostratus praised the power of painting to represent the variety of colours of hair, houses, groves and mountains, and 'the air that envelops them all'.[4] In Venetian prints the connecting whiteness of the page, infiltrating between open hatching, assumes the values of the ambient air.

Building on Jacopo de' Barbari's technical finesse, he devised stipple engraving as a black-and-white equivalent to Giorgionesque *sfumato*.[5] Just as oil painting with its glazes and scumbles softened transitions, so Giulio with dots and flecks made by the point of the graver varied the passages from light to dark and induced new kinds of vibrant optical effect. In *Christ and the Samaritan Woman* (fig. 230) he moved beyond Mantegna's relief style towards a more complex interchange between light and dark, foreground and background: Christ's profile and raised hand are rendered not just in shadow but darkened in *contre-jour*. To achieve this the engraver reduced the lines delineating shore, sea and sky to the barest minimum. Vertical lines describe the shadowed wall of the church seen across the water, and these verticals extend downwards, with varying reach, to indicate dark reflections. One senses Giulio's response here both to Albrecht Dürer's graphic techniques – for the German's prints were becoming well known in the Veneto – and to experience on a lagoon where reflections readily become confounded with shadows (fig. 231). Such confusion of two categories of dark – reflection and shadow – has subtle consequences for how a painting registers as addressed to a viewer. Normally shadows remain in the same place if the light-source is fixed and the object casting the shadow immobile, whereas reflections shift according to

229 Jacopo de' Barbari, *Apollo and Diana* (*c.*1497–1500). Engraving, 16 × 10 cm. London, British Museum.

230 Giulio Campagnola, *Christ and the Samaritan Woman* (*c.*1509). Engraving and stipple engraving, 13 × 18.5 cm. Berlin, Kupferstichkabinett.

Engravers and painters were learning from each other. If it was oil painting that led the way towards softer transitions, it was engraving that prompted fresh thought about tonal relation between figure and field. A select band of engravers and painters, including Giulio Campagnola and Giorgione, was probably exchanging prints and drawings, and certainly mixing with the same group of patrons. Small scale and private at first, their engraved fictions little by little began to alter how the world was represented, and in turn how it appeared. The Paduan Giulio Campagnola was famed for his erudition and conversant with literary discourse.

231 Albrecht Dürer, *Virgin and Child with a Monkey* (1498). Engraving, 19.1 × 12.2 cm. London, British Museum.

the vantage of an observer. Jacopo de' Barbari and Giulio Campagnola anticipated a compositional feature of the most sophisticated Venetian sixteenth-century painting by endowing shadows with the mobility of reflections. The pictorial configuration of shadow/reflection potentially suggests the personal vantage of an observer.

The most accomplished prints demonstrate within their narrow compass that any reading of tone is context bound, therefore relative not absolute: the perceived brightness of the white paper depends upon the density of lines, hatching, flecks and dashes surrounding it. In the prints of Jacopo de' Barbari,

Giulio Campagnola and Marcantonio Raimondi generalized shade is diffused across space like the swathes and pockets of umbrage in Giorgione's paintings. Giulio's *Christ and the Samaritan Woman*, like Dürer's prints, involves the distance as a source of light, conclusively reversing the medieval notion – espoused by Giovanni Fontana (see chapter 4) – that distance increases obscurity. Titian in his out-of-doors subjects became a master of engaging or rhyming bright distances with masses of white in foreground draperies, and it is precisely the dynamic interplay between bright distance – buoyantly looming – and the actors in the foreground which lends plausibility to the suggestion that the painter collaborated with Giulio on *Christ and the Samaritan Woman*.[6]

Titian grew to maturity cognizant at first hand of the lessons of contemporary prints. In creating his great woodcut, published in 1515, the *Submersion of Pharaoh's Army in the Red Sea* (fig. 232) it appears he drew directly on to the blocks and then guided the cutter closely.[7] What is significant here is the licence with which he treated the range from white to black within the shifting focus of his panoramic narrative. In chapter 3 it was noted how the shape-shifting dynamics of light on the Venetian lagoon affect the interior and exterior viewing of the Ca' d'Oro: within the grand weft-like rhythm of marks in Titian's woodcut there is the same invitation to the eye to jump and fly across the scene, to alight at diverse landing points and to revise its readings according to the dynamic of *local* contrasts (fig. 233). The oscillation of attention which is induced is very different from the stable relief-inducing hierarchy of Leonardesque chiaroscuro.

Titian was the first oil painter fully to demonstrate how the direction of a brush-stroke creates form. Typically – as in the breeches of the shepherd in the *Holy Family* in the National Gallery, London (fig. 234) – he drew the brush across the form at right angles to the main axis, modelling very sparely, just allowing the grain of the brush-stroke – its microstructure of ridges and shadows – to inform about shape at the subliminal level of tactile response. This permitted Titian to keep an overall radiance in the light areas.

Titian's engagement with woodcutting brought home to him the importance of direction and changes of direction in line or stroke. Of course prints, unlike

232 and 233 *(right)* Titian, *Submersion of Pharaoh's Army in the Red Sea* (*c.*1514–15), and detail. Woodcut in twelve blocks, 122.5 × 221.5 cm.

235 *(facing page top)* Vittore Carpaccio, *Head of a Young Man* (*c.*1500). Drawing on blue paper, 26.5 × 18.7 cm. Oxford, Christ Church.

236 *(facing page bottom)* Titian and Ugo da Carpi, *Saint Jerome* (*c.*1516). Chiaroscuro woodcut, 1.56 × 0.96 cm. London, British Museum.

234 Titian, detail of fig. 181.

breadth of mid-tones that would be exploited in the sixteenth century.

Jacopo Bellini in his leadpoint drawings, unlike a Tuscan draughtsman, did not go in for white heightening, indeed white heightening was adopted rather late on the Venetian scene and to notably more pictorial effect than in the relief-oriented tradition of Tuscany.[8] Shifts in Venetian techniques around 1500 indicate give and take between pictorial art and printing technology. It was a German, the printer Erhard Ratdolt, who, during his years in Venice around 1480, pioneered colour printing by using multiple woodblocks.[9] Crude at first, this technology was refined north of the Alps in the hands of an artist such as Lucas Cranach, and by 1508 gave rise to what came to be called – when introduced into Italy – the chiaroscuro woodcut.[10] In 1516 Ugo da Carpi petitioned the Venetian Senate for a copyright privilege regarding a 'new method of printing *chiaro* and *scuro*', and probably in the same year he and Titian jointly signed the woodcut of *Saint Jerome* (fig. 236).[11] Chiaroscuro print-

oil paintings, have virtually no variety of literal texture, and perhaps for this very reason some printmakers followed the lead of painters in striving to make their drawings more pictorial by devising means to indicate texture and colour. A Venetian painter of the late quattrocento such as Carpaccio preferred to make brush drawings on rough blue-grey paper known as *carta azzurra* (fig. 235), rather than silverpoint drawings on prepared paper, which Tuscan artists favoured. In silverpoint, pale blue or pink was usually introduced to tint the preparatory calcium wash that was brushed on to the paper, creating a relatively homogenous colour, whereas in *carta azzurra* the blue-grey originated in the fabrication of the paper, appearing as a medley of minute, tonally varied, flecks of silver white, blue and grey. This colour texture prepared Venetian taste both for the granular quality of canvas supports and for the

ing was based upon the separation of a tone block, which was inked – usually in buff, sometimes in pale blue – to provide the background colour, and a line block, which was inked in black to delineate the forms. Additionally, the tone block could be excavated to reserve spaces of white paper in the printing, either by the removal of large areas, or, as the Germans preferred, in vigorous lines of highlight.

The visibility of the stroke, line or hatching in prints heightened consciousness of the role of the mark or trace in pictorial art. Whereas the delicate brush-strokes characteristic of fast-drying tempera painting were generally uniform in scale and hardly registered as optical effect at normal viewing distance, in slow-drying oil painting – as exemplified by Netherlandish painters of the fifteenth century – the brush-strokes could be so fused together as to leave no individual trace. Therefore, exploitation of the potential of the mark was due less to the rise of oil painting than to the interaction in Venice of the early sixteenth century of varied media – textiles (discussed in chapter 8), prints, mosaic and oil painting.

Tellingly, vocabulary adopted to describe the brush-stroke in the sixteenth century derives from the graphic media of drawings and prints. Pietro Aretino, in a celebrated letter of 1544, exclaimed before a sunset seen from a balcony on the Grand Canal – 'Oh, with what beautiful strokes [*trattegiature*] did nature's brushes [*pennelli naturali*] push back the air, making it recede from the palaces in the manner that Titian makes it recede in painting landscapes.'[12] Engravings, of which Aretino was a noted collector, elevated hatching or *tratteggi* as visible component of representation, while the term *pennellate* for the visible trace of the brush-stroke only gained currency by association with the graphic marks of *tratti* and *tratteggi*.

Although Titian's close association with chiaroscuro woodcuts was short-lived, it occurred at a crucial moment in his development of what Sir Joshua Reynolds termed his 'universal colour'. In brief, there are five aspects of printmaking relevant to the evolution of Venetian colour: the demonstration of how the sum of lights and shadows act in concert; the technical separation of colour and line which actually results in their pictorial interlocking; the provision of broad fields of muted colour by the use of tonal blocks;

the excavation of areas of white to create a dominant element in composition; and the exploitation of direction of line to explain forms and the intervals between.

Titian continued to furnish designs for single-block woodcuts throughout his maturity. The *contrapposto* of light and dark in woodcuts and engravings became in his paintings a *contrapposto*, equally bold, of juxtaposed areas of tonal colour (fig. 237).[13] In terms of Venetian art theory, as it emerged in the writings of Paolo Pino and Ludovico Dolce in the mid-sixteenth century, it is not so perverse to consider light in engraving as a precedent for Venetian colour: for Pino, himself a painter, light (*lume*) is the soul (*anima*) of colour.[14] For Ludovico Dolce 'the foremost element in colouring is contrast [*contendimento*], which produces light along with shadow'.[15] Again for Marco Boschini, seventeenth-century champion of Venetian painting, *colore* comprehends the organization of light and dark.

237 Titian, detail of fig. 46.

The lessons of mosaic

On his arrival in Venice, Titian's first artistic contact was with the Zuccato family of mosaicists, and it is in mosaic (as pointed out at the end of chapter 2) that a precedent to directional brushwork is to be found in the laying of tesserae in repeated rows.[16] Just as in mosaic the scale of tesserae, the width and density of rows, varies from fine in flesh to broad on draperies, so in oil painting the breadth of brush-stroke can vary far more than in tempera. The mosaicist used changes of direction in the rows to articulate changes of plane or breaks between figure and field, while the joints between tesserae enliven the microstructure. Mosaic introduced the young Titian to colour as individual chips or tesserae – substantial and distinct chromatic patches. In the mix of greys, whites, mauves and browns in the flesh modelling it introduced him to what (as noted in chapter 5) a fifteenth-century text on mosaic described as 'diverse machie di colori'.[17] I suspect that

238 Titian, detail of fig. 242.

239 *(below)* Giorgione (completed by Titian), *Sleeping Venus* (*c.*1510). Canvas, 108 × 175 cm. Dresden, Gemäldegalerie.

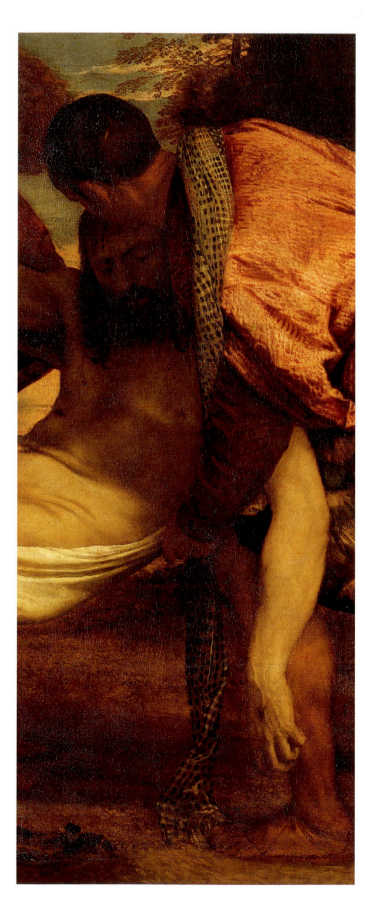

in the *Sleeping Venus* (fig. 239), begun by Giorgione and completed by Titian, the rectangles of golden yellow that enliven the lower border of the red drapery were added by Titian to give an accent of mosaic-like gleam. He had used similar tesserae-like dabs of highlight on the papal cope in his early altarpiece of *Jacopo Pesaro presented to Saint Peter* (fig. 238).

Later, Titian occasionally spiced the classicism of his costumes by introducing a check kerchief or sash as accessory. A sash, chequered off-white and greyish blue, hangs over a figure in the *Entombment* (fig. 240), recurs in the *Supper at Emmaus* (Louvre, Paris), in the *Assumption* in the cathedral at Verona, and – in a brighter blue – in the *Crowning with Thorns* in the Louvre: the repetition suggests it may have been one of Titian's studio properties. Pictorially, the sash changes the beat. Its linearity is analogous – albeit twisted – to rows of tesserae, and it is also reminiscent of a modelling device occasionally used in mosaic, whereby light and dark tesserae are placed alternately within a single row to induce an intermediate tone by optical mixture.[18] An example of this serration can be seen in the *Hospitality of Abraham* in the atrium of San Marco, on the neck of the figure of Sarah (fig. 241).

240 Titian, detail of fig. 46.

241 Detail of fig. 64.

Architecture and contre-jour

Expanses of mosaic on walls, both curved and flat, developed Titian's feel for colour as the luminous interface between surface and space.[19] On a big scale, mosaic introduced him to the architectonics of colour; on a small scale, prints offered lessons in the division of the pictorial format into juxtaposed tonal areas. From the first Pesaro altarpiece of *Jacopo Pesaro presented to Saint Peter* (fig. 242) of *circa* 1506 through to the

Entombment of Christ of 1559, in the Prado, the paintings of Titian are commonly bisected by a wall or hanging that provides a dark backdrop to half the picture, while the other side is lighter, often dominated by sky. The symmetry may be slightly less rigorous and the scheme may be varied by the introduction of an arch, as in the *Salome* in the Doria-Pamphili Gallery, Rome, or by the use of trees a backdrop, as in *Sacred and Profane Love* (fig. 243): what recurs time and again is clear-cut division between darkness and light. Typi-

242 Titian, *Jacopo Pesaro presented to Saint Peter by Pope Alexander VI* (*c.*1506). Canvas, 145 × 184 cm. Antwerp, Koninklijk Museum voor Schone Kunsten.

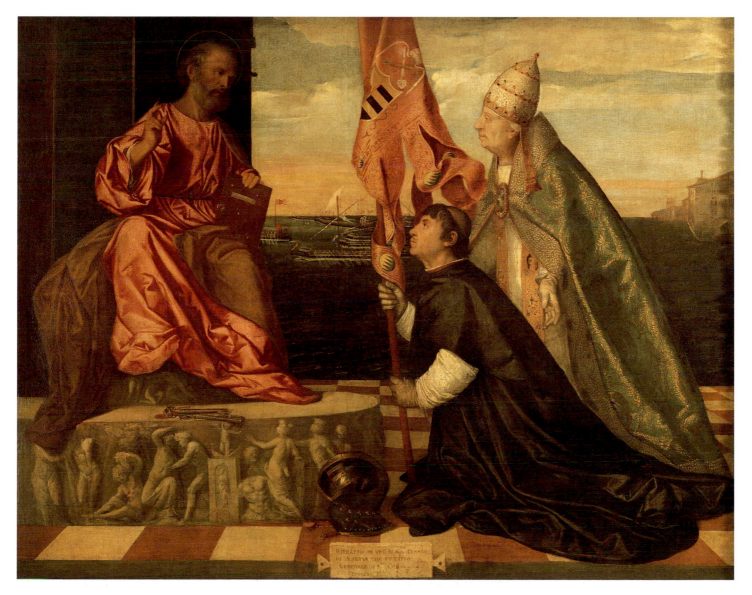

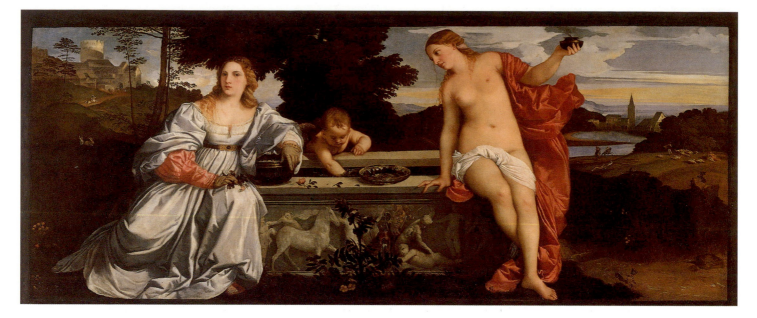

243 Titian, *Sacred and Profane Love* (1515). Canvas, 118 × 279 cm. Rome, Galleria Borghese.

cally, the darkness of these backdrops is not something that can readily be identified with their local colour, for it derives equally from the dazzled eye's inability to penetrate the dark silhouette seen adjacent to the light. In origin this contrast is provoked by situations such as standing in the depths of a Venetian palace, such as the Ca' d'Oro, and looking toward the tracery of the loggia, at the brightness of the canal light (see chapter 3), but this inherently unstable situation, so dependent upon the vantage of the spectator, is transfigured by Titian from subjective effect into architectonic principle. If Leonardo's High Renaissance art was founded upon conscious mastery of chiaroscuro, Titian's stemmed from daily experience of *contre-jour*. It may be that when Dolce chose to describe the essential element of colouring as a *contendimento* between light and dark, he was intuitively picking up on the dynamic of Venetian *contre-jour* by choosing a word that implies contest more than contrast.

The lighting that Titian employed in his paintings had wide-reaching consequences for his colour. Florentines of the fifteenth century, following Masaccio's example as well as the precepts of Alberti's *Della pittura*, favoured a lateral light that divided forms into lit and shaded halves. From the 1470s onwards Leonardo modified this by choosing a steeper and more generalized fall of light from above. This top-lighting, because it provided relief while preserving symmetry of tone, became the ideal for the central Italian tradition, and in Rome it could be observed to perfection in the Pantheon, under the light of the oculus at the centre of the dome. By contrast, even distribution of light from above was a feature neither of ecclesiastical nor of domestic architecture in Venice. The principal rooms in Venetian palaces – the *portego* or *salone* – were long and low, and the windows, concentrated on the canal façades, funnelled a blaze of light horizontally into the room, which then faded into darkness in the remote recesses; their dark walls and beamed ceilings absorbed the light rather than reflecting it as a secondary source.[20] In Venetian churches illumination from above was limited: the thermal windows that occur at clerestory level, in Santo Stefano for instance, are post-Palladian insertions which became necessary when tall altarpieces increasingly blocked nave windows from the late quattrocento onwards. In San Marco although there are windows around the base of the nave cupolas, their light is overwhelmed by the bigger windows inserted in the south transept and west end, and, as mentioned in chapter 2, the reflective gold background of the

mosaics confounds any consistent top-lighting. Titian responded to the lighting situations in the palaces and in San Marco.

In his portraits and smaller paintings for domestic settings he chose a frontal rather than strongly lateral light. Rarely as steep in its angle as Leonardo's, and normally brighter, less diffused, it is as though Titian's light originated from windows of bottle-glass rather than ones in cloth or oiled paper, or temporarily screened as Leonardo recommended.[21] Even more than Giovanni Bellini before him, Titian underplayed reflected lights, preferring to let forms disappear into shadow. The light in these easel paintings is conditioned by cumulative experience of Venetian interior illumination rather than a literal description of a single instance. His settings are, in accord with the practice of the time, abstracted. His lighting is boldly inconsistent: although light may fall brightly on a figure, cast shadow is either eliminated or generalized to become a relieving shade; the light in the sky and light on the foreground may, as in *Sacred and Profane Love*, tell slightly different stories – sweeping from the side in the landscape, more frontal on the figures. Such manipulation of lighting was part of the new-found sovereign power of the painter, a power which sculptors could only envy. To point up this *paragone*, or rivalry between plastic and pictorial art, Titian often included fictive sculptures in his paintings. He loaded the dice in favour of painting as an art of living colour by generalizing the surfaces of these fictive sculptures, as if they were in a slightly more muted, duller light than the polychrome figures (see figs 242 and 244).

244 Titian, detail of fig. 243.

Paragone *and the colours of the body*

Residents of the Venetian lagoon had long been exposed to diversity of peoples from three continents and as a result were attentive to the colour of the body as marker of difference. In San Marco – as noted in chapter 1 – in the Pentecost dome, and again in a cupola of the Baptistery, the peoples to whom the Apostles preached were figured in thirteenth- and fourteenth-century mosaics: oddly, Egyptians were shown as black, perhaps confusing them with Ethiopians. In the Renaissance the darker the colour of a slave's skin, the higher the price they could fetch.[22] Black slaves were evidently considered decorative, dressed in splendid livery and sometimes employed as gondoliers, as can be seen from the view of the Rialto in Carpaccio's *Healing of the Possessed Man* (fig. 245). When Beatrice d'Este, Duchess of Milan, visited Venice in 1493 she described in a letter how she was entertained with stage shows, including a representation with 'four animals in the shape of Chimeras ridden by four naked Moors, sounding tambourines and cymbals or clapping their hands'.[23]

If such accounts imply indiscriminate association of dark skin with exoticism, Venetian paintings indicate more nuanced differences. The flesh modelling of Venetian tempera painters in the fourteenth century is markedly hotter than was the norm in Central Italian painting, surely as a direct result of Byzantine influence. Venetians never employed the base of green earth, *verdaccio*, used by the Tuscans, preferring a foundation of ochre and white;[24] in Paolo Veneziano's paintings, as in fourteenth-century Venetian mosaics, there is more red and less green in the shadows of flesh than in contemporary Sienese painting. In the following century – as noted in the discussion of the Brera *Pietà* (fig. 187) in chapter 7 – Giovanni Bellini contrasted and varied skin tones with devotional purpose. The nuancing of flesh tints was one of the most advanced features of Bellini's later paintings.

According to the standard medieval decorum governing complexion, women and children had paler skin than adults, peasants more tanned skin than nobles; saints known for a rugged out-of-doors existence, such as John the Baptist, were painted as swarthier than gentler, more studious ones. These distinctions, while having some basis in experience, nevertheless privileged whiteness. In the sixteenth century they remained broadly in place but admitted greater variety, particularly with regard to the paleness of the female complexion. Increasingly it was argued that pallor needed to be warmed to avoid the coldness of marble. Mario Equicola, in his *Libro di natura d'amore* published in 1526, advised that flesh should not be so white as 'to tend towards pallor, but should be mixed with blood colour: and if it is brown that is not ugly, for Venus was of that colour, which was not displeasing to Ovid'.[25] Marcantonio Michiel, an amateur of painting and cataloguer of collections, noted, on a visit to Zuanantonio Venier's house in 1528, that a Saint Margaret he believed to be by Raphael had the brown flesh that 'was peculiar to that painter'.[26] Commentators have suggested he mistook a Giulio Romano for a Raphael, but what is pertinent here is that Marcantonio could accept brown flesh in a female saint as a characteristic of the Divine Raphael. By the time Titian's friend and supporter Ludovico Dolce began to write about painting in the 1540s the shift in ideals regarding female skin-colour was under way. In his dialogue the *Aretino*, Dolce argued that many artists paint flesh too white or too red: 'I for my part would wish for a brown hue rather than one that was white in an unseemly way, and would generally banish from my painting those vermilion cheeks with lips of coral, because faces treated in this fashion look like masks. One reads that brown was what Apelles liked to use.'[27] Again, in a letter to Gasparo Ballini he argued that, 'an extreme intensity of white is always displeasing, whereas a certain just proportion intermediate between white and brown embodies every range of loveliness, as one sees in the St Catherine of our great Titian'.[28]

In Titian's *La Schiavona*, whose clothing and kerchiefs were examined in chapter 8, the woman's flesh, contrasting with her dark hair and eyes is pale, yet close up a slight blush rising in her cheek can be detected (fig. 246). Given that the turn of her head and its slight inclination suggest the gentle acknowledgement of the intrusion of another person, the viewer's surrogate, I believe the hint of a blush may also be interpreted as another indication of her reaction to an approach.[29] If so, the flesh tints in Titian's portrait are essential sign that the woman is alive and changing before our eyes.

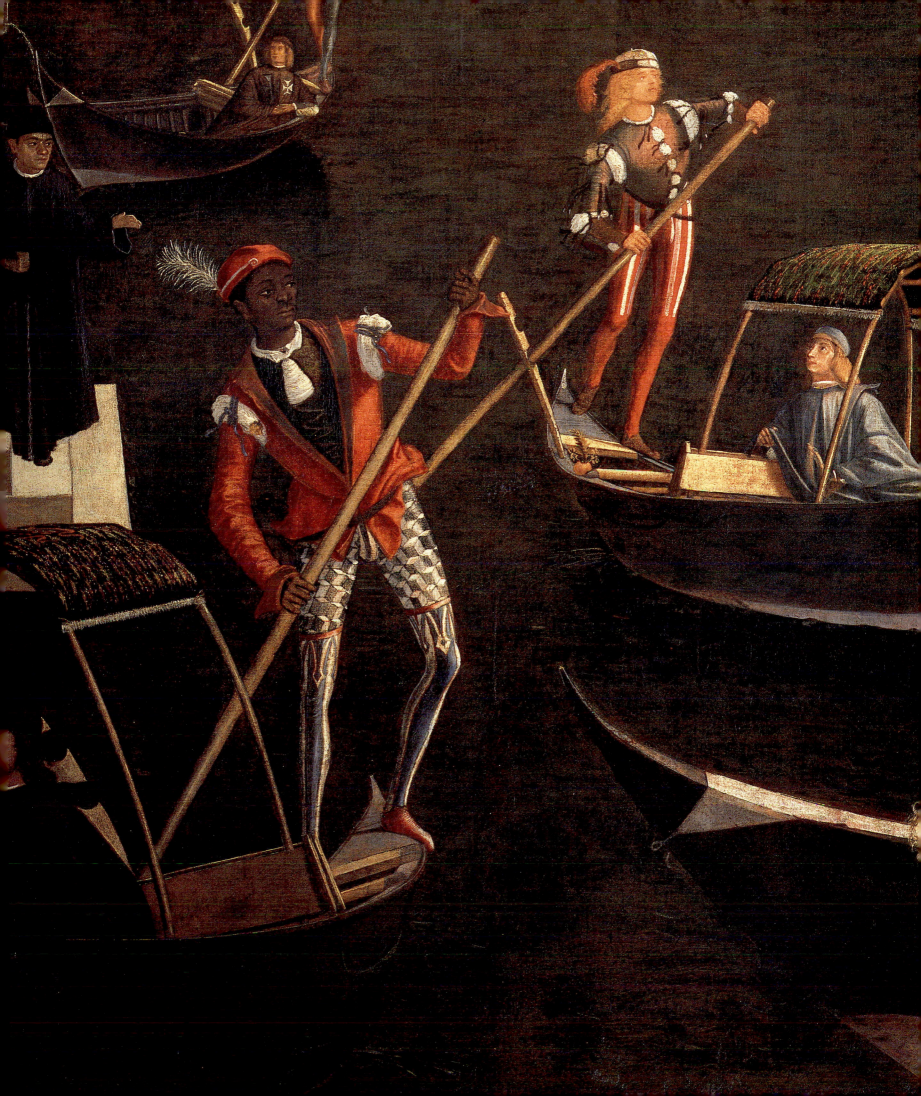

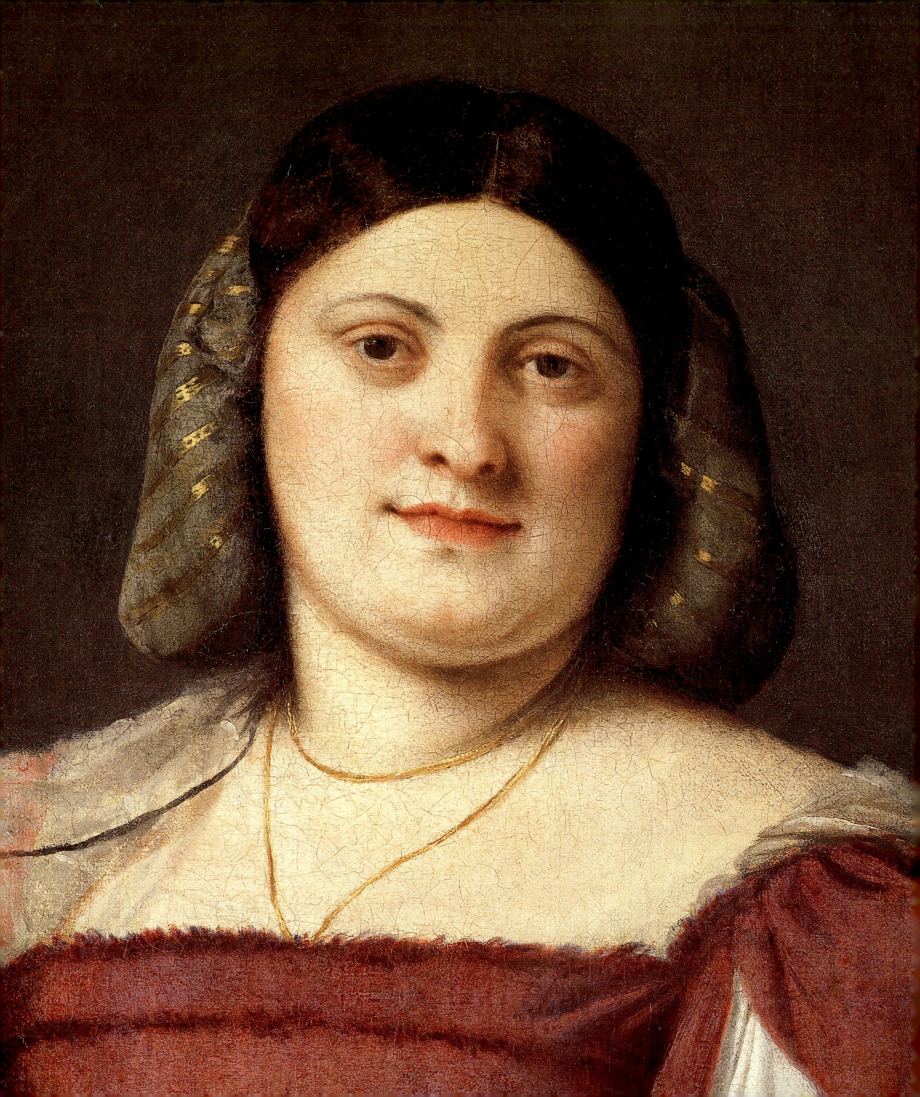

247 Titian, detail of fig. 221.

La Schiavona's blush is a personal instance, as yet barely discernible, of what will in late Titian become a general rule, that colour in all its modulations is a sign of relation between the viewer and what is viewed. The marble bust figured upon the parapet serves to heighten this engagement by its aversion of gaze and monochrome neutrality (fig. 247). Titian artfully suggests by this *paragone* or comparison that sculpture, in lacking the changeful tints of life, is no match for painting.[30]

★ ★ ★

246 Titian, detail of fig. 221.

Giorgione: appearance and time

La Schiavona must have been painted within a year or two of the death of Giorgione in 1510. As the painter who completed several of Giorgione's unfinished works – perhaps the *Concert Champêtre*, certainly the *Sleeping Venus* – Titian would have absorbed how that master's works invite reflection on appearance and transience. Nothing could be more temporary than the flash of lightning in Giorgione's *Tempest* (fig. 248) – yet the painting captures it for ever. A frieze painted around 1500 in the Casa Marta-Pellizzari in Giorgione's birthplace Castelfranco Veneto, possibly by Giorgione himself, teases out with learned imagery themes of shadow and light, time and eternity: one inscription reads, 'Our time is only the passing of a shadow', another 'Only virtue is held to be luminous and eternal'.[31] In many Giorgionesque works the passage of time is evoked by sunset (*tramonto*) or sunrise, but the appearance or disappearance of the sun is just one of the ways in which Giorgione's art comments upon the world as phenomenon, and therefore painting as pictorial, enacting appearance. The three philosophers in the painting in Vienna wait for an appearance of the star, or – according Marcantonio Michiel's account of 1525 – contemplate the rays of the sun. Interchange of light and dark, the visible and obscure, initiates narratives more pictorial than literary: caves or gloomy recesses impenetrable to sight are juxtaposed with lightening skies or window apertures. What is figured engages sight and tests its limits.

Colours in the *Tempest* are modulated by atmosphere, the enveloping air. Transitions from light to deep pockets of umbrage are vibrant. Partially reversing the tradition of working from white gesso ground towards deeper colours, lights float over pools of dark, and darks in turn are relieved against mid-tones – a layering that is not fixed, but wavelike suggests a lapping or sway in foliage and clouds as well as the water of the river. Within this layering of light and dark, colour modulation assumes the force of natural life, of ripening or fading, a pulse of slow and sensuous change not limited to individual forms but coursing through the entire scene. Through the handling of oil paint – so much slower drying than egg tempera – the painter engaged with flux.

One source of this sensibility can be traced back to Giovanni Bellini. He set the devotional image – Saint Francis, the Pietà, the Madonna of the Meadow – within the natural world and its seasonal-cum-liturgical cycle. The ripening from the green of spring to the gold of harvest, pictorially recapitulated in the colour transitions of Bellini's landscapes, matures in Giorgione's paintings into something more internal. The pale gold of the body's flesh tints, in the *Tempest* and in the *Venus* in Dresden, becomes the balance to green, as though the whole colouristic equation was now at root founded upon the world's absorption in the body, and the body's in the world.[32] To the equation of blondness and greenness is added the complement of green, red. Red is linked to flesh tints, to passion, to blushing, to blood. The nudes that Giorgione painted in fresco on the exterior of the Fondaco dei Tedeschi were, as Vasari testified and the surviving figure confirms, famously fiery in their flesh tint.[33] Red mantles in the flesh, it incarnadines the world. These commonplaces of poetic discourse now infiltrate pictorial practice and inform response. Overturning the Aristotelian categorization that held sway in the fifteenth century (see chapter 4), colour in north Italian circles around 1500 was no longer stigmatized as the stuff of dull matter but valued as the essential sign of life, of animation.

The denigration of colour as inferior to form was challenged on a number of fronts. Luca Pacioli (as noted in the last section of chapter 7) shifted attention from colour as pigment, therefore merely material, to the judgement of the painter in tempering his colours to adjust their relative strength: the tones of colours, the mathematician argued, must be governed by proportion. Francesco Colonna in the *Hypnerotomachia Poliphili* also laid stress on the judgement of the eye in registering proportion and the colouring together.[34] Colouring in the *Hypnerotomachia*, whether in veined marbles or in flesh warmed by the veins of blood, engages perception and arouses response.

★ ★ ★

Colorito *and likeness*

Alberti and Leonardo maintained that to animate a figure it was essential to endow it with indications of movement, whereas the Venetians, surrounded by the ebb and flow of water, were less inclined to view movement as privileged sign of sentient life. Rather – as discussed with reference to Giovanni Bellini in chapter 7 – in representations of being they valued stillness and permanence. Even Titian, who on occasion emulated the dynamic figure-style of Michelangelo, took care to endow his portraits with stability and poise: La Schiavona turns only ever so slightly towards the viewer and certainly will not lose her balance. Not the muscular energy or movement of the figure, then, but colouring – *colorito* – in all its variety and its blending is source of animation, of the pulse of life and likeness, in Venetian eyes.

A number of well-known North Italian sources indicate the re-evaluation in the early sixteenth century of colour as sign of life and of nature's variety. In his *De sculptura*, written in Venice and Padua between 1501 and 1504, Pomponius Gauricus included – surprisingly in a treatise on sculpture – a section on physiognomics which categorized differences between northerners and southerners in pigmentation and colour of hair and eyes.[35] A comparable concern with likeness and individual difference, particularly in portraiture, can be found at the same period in the letters of Isabella d'Este.[36]

Titian's princely patrons, such as Isabella's brother, Alfonso d'Este the Duke of Ferrara, were turning to the *Imagines* of Philostratus for ideas when commissioning subjects from classical mythology. On the very first page the Greek author defined painting as 'imitation by the use of colours'.[37] Painting achieves more by the employment of colour alone, Philostratus proposed, than do the plastic arts of carving, modelling and gem-cutting with all their variety of materials and techniques. Far from being supplementary or a mere skin, colour is essential and the deployment and blending of tints requires great skill. Describing a painted still life of lusciously ripe fruits, Philostratus remarked of the apples 'that their redness has not been put on from the outside, but has bloomed from within'.[38] It is intriguing to note that one respected

248 Giorgione, *Tempest* (*c*.1505–6). Canvas, 68 × 59 cm. Venice, Accademia.

249 Titian, *Worship of Venus* (1518–19). Canvas, 172 × 175 cm. Madrid, Prado.

recent investigator of the psychophysical aspects of vision has laid stress on the evolution of both colour and vision as interlinked by such primary needs as judging the ripeness of fruit. 'With only a little exaggeration', wrote John Mollon, 'one could say that our trichromatic colour vision – if not the entire primate lineage – is a device invented by certain fruiting trees in order to propagate themselves.'[39] Certainly ripeness was all for Philostratus and for Titian too when, following a text by Philostratus, he painted the *Worship of Venus* (Prado, Madrid) with its delightful antics of apple-gathering cupids (figs 249 and 250).[40]

250 Titian, detail of fig. 249.

Such appetite for colour in all its bountiful variety and its material sensuousness lies behind the response to Titian's colouring by a man who was as fond of food as of painting, Pietro Aretino. In a number of letters, starting in the 1530s, the Tuscan writer who had adopted Venice as his home, eulogized Titian's colour as the decisive element animating his art. At root Aretino's responses to the material of painting – to Venetian *colorito* – are remarkably physical. His criticism celebrates overlapping sensations of taste, texture and touch: Gabriel in a (now lost) Annunciation by Titian has 'heavenly majesty in his countenance and his cheeks tremble under the flesh-tints of milk and blood which your colouring has rendered so true to nature'.[41] Of course, as a Tuscan, Aretino was aware of the need to justify such a direct response to the material of colour and the counterfeiting of textures of flesh, fur, velvet or armour by allying it to higher, spiritual purposes. Thus of Titian's portrait of Eleonora Gonzaga (fig. 251), which is such a varied feast of textures, he averred that 'the harmony of colours, which Titian's brush has spread, renders visible from without the concord which in Eleonora, the handmaids of the noble spirit govern'.[42] Doubtless such an intellectual gloss should be viewed as very much a *post-facto* justification by a literary man – of some interest regarding the reception of Titian's art, but offering rather less insight into the painter's creative endeavour. As Giorgio Padoan remarked, by the 1530s writers felt threatened by the spontaneous delight that their princely patrons could take in secular painting, particularly portraits and nudes, therefore it was they who felt a pressing need to insinuate themselves as encomiasts of painting.[43] In short, the *literati*, envious of the painter's ability to please the prince, needed to cover their backs by inventing a role for themselves as commentators on painting. Like Aretino's appetite, pleasure in colour came first, theoretical justification second. Reading Philostratus was liberating because he dwelt upon the pleasure of colour in painting.

If, by the mid-sixteenth century, literature was reacting to painting, rather than vice versa, texts on *disegno* and *colorito* probably reveal more about the topoi of literary debate than the practice of the painter with his brushes. Nevertheless it is appropriate to close this consideration of how colouring emerges from

its denigration as merely material to be praised as an essential force of nature, with a few words about Ludovico Dolce's defence of colour. Given that his dialogue on art is entitled the *Aretino*, and Pietro Aretino the spokesman in it who champions Venetian *colorito*, it is hardly surprising that Dolce, like Aretino himself, equated *colorito* both with nature's variety and its power to communicate life and the changefulness integral to life. Dolce followed precedent by dividing painting into three parts, 'invention, design and colouring' (*inventione, disegno e colorito*). Invention concerns the fable or history, design concerns the form, and 'colouring takes it cue from the tints with which nature paints (for one can say as much) animate and inanimate things in variegation'.[44] Notice that this is an active concept of colouring as recreating a process in nature. This dynamism is underlined when Dolce, as noted above, defined the principal part of *colorito* as the *contendimento* (contest/contrast) between light and dark. But then he moves away from the notion of contest to assert that, 'the principal difficulty of *colorito* resides in the imitation of flesh and involves diversifying the tones [*tinte*] and in achieving softness'. Flesh here is in the plural, *carni*, underlining the critical importance of variety of types of flesh – feminine and masculine, youthful and rugged – and of change within carnation.

Extolling variety and softness confirms the superiority of painting over sculpture. Like Paolo Pino (see chapter 8), Dolce praised the ability to convey the textures and touch of fabrics, gold and armour. The description of materials is one thing, the use of them another: skill is more valuable than material, 'let no one think' – Dolce cautioned – 'that what gives colour its effectiveness is the choice of beautiful colours, such as beautiful lakes, beautiful blues, beautiful greens and so on . . . rather it comes from knowing how to handle them fittingly'. Noticing the repetition here of the word beautiful – *bei colori, belle lache*, etc. – it should be recalled that *bellezza* was associated with the bright, unmitigated colour of pure pigment. To handle colours pictorially it is necessary to understand their relationships, their *convenevolezza*, and how to blend them to achieve harmony, or *unione*. Here we reach the heart of the critical distinction between *colori*, colours, and *colorito*, colouring. The painter who understands the power of colouring (*la forza del colorito*) is far superior

to those who 'do not know how to reproduce the variety of tones one gets in clothing, but merely lay on the colours at full strength, just as they are'.[45] Even skill in mixing and tempering pigments might be regarded as purely mechanical: the thrust of Dolce's argument is that effective colouring works to fulfil the highest purposes of painting, to 'stir the actions and passions of the mind, as good poets and public speakers do, in such a way that spectators experience either joy or agitation, according to the character of the subject matter'.[46] Colouring, handled by a master such as Titian, is first and foremost an affective rather than a purely descriptive instrument. Nevertheless, when painting the figure, true colouring establishes convincing likeness which in turn quickens the affective power of the representation. Flesh colouring, on which Dolce seems to lay inordinate stress, is important precisely because it offers a mirror or index of the emotive charge exchanged between viewer and viewed.

Grounds and technique

The common theme that runs through the unsystematic comments on colour by Luca Pacioli, Francesco Colonna, Paolo Pino, Pietro Aretino and Ludovico Dolce is its direct appeal to the judgement of the eye. Their views reflect more than they direct trends in painting. I have pointed to the significance of the rise of the pictorial in the paintings of Giovanni Bellini, and explored how this was diversified by the printmakers' orchestration of the contest between light and shadow, and how it was developed in a self-reflexive direction by Giorgione's painterly engagement with appearance and transience. Titian completed this turn towards an optical mode and at the same time endowed his paintings with classic breadth and stability. In Titian's paintings, in Venetian fashion, colouring combined luminosity and texture to create a world. It is this optical mode that, from Titian to Veronese to Velázquez to Manet, will be so fruitful in the history of European painting.

★ ★ ★

It is time to draw together the threads of this inquiry by turning to the ground of Venetian colour. Conservation and analysis of Titian's paintings in the

251 Titian, *Eleonora Gonzaga* (*c.*1537–8). Canvas, 114 × 103 cm. Florence, Uffizi.

252 Titian, *Presentation of the Virgin in the Temple* (1534–8). Canvas, 345 × 775 cm. Venice, Accademia.

last quarter of a century has led to a revision of received ideas about the grounds on which he built up his *colorito*.[47] Whereas previously it was believed that in his later years he worked on dark, often reddish grounds, it now appears that this is an illusion. The vast majority of his paintings are on canvas, and those examined in conservation laboratories reveal that, in common with other Venetian painters, Titian and his workshop prepared their canvases with a very thin preparation of gesso mixed with animal glue, which in most cases barely covered the weave, leaving a slightly textured surface to paint on. In some cases a film of animal glue has been detected lying over the gesso, to seal its absorbent surface from the paint layers above.[48]

The next layer, the first in paint, is the most intriguing. Given that the evidence for each painting is drawn from a small number of cross-sections examined under the microscope, it is difficult to be certain whether a particular cross-section is picking up local underpainting or underdrawing with the brush in dilute pigment or a general imprimatura over the entire gesso ground of the canvas. In many cases Titian applied a layer of lead white. As an imprimatura it was never so thick as to present a brilliant white, rather it was slightly

greyed by the underlying texture of the canvas weave breaking through the thin gesso ground. Already by the 1510s Titian was, occasionally, accentuating this optical greying: for instance, the lead-white imprimatura of *Sacred and Profane Love* (fig. 243) is greyed by addition of fine particles of lamp black or charcoal.[49] Lorenzo Lazzarini reports 'whiteish *local* imprimatura' underlying the Averoldi polyptych, and 'greyish imprimatura' beneath the Pesaro Madonna in the Frari. By the 1530s this was becoming Titian's frequent practice: the *Supper at Emmaus*, in the Louvre, and the *Presentation of the Virgin*, in the Accademia (fig. 252), both have a thin greyish imprimatura. In all cases the greyish tinge is never dark – usually achieved by a scattering of fine particles of carbon black amongst the lead white – but sufficient, allied to slight roughness of texture, to induce an off-white tone. This off-whiteness is peculiarly responsive, in terms of light and dark, cool and warm, to what is laid over it, particularly – as would become increasingly common in Titian's canvases – where this tone was left visible between the interstices of the loose brush-stokes of the subsequent layers.[50]

In the late works of Titian, when execution often proceeded by fits and starts over a period of years, and when participation by the workshop was extensive,

extrapolating a standard procedure becomes hazardous. What is clear, though, is that a dark imprimatura remains the exception rather than the rule: one exception being the 'brown imprimatura of burnt ochre and carbon black' for the night scene of the *Martyrdom of Saint Lawrence* in the Gesuiti in Venice.[51] The conservator of *Perseus and Andromeda* (Wallace Collection, London) – now a sadly darkened canvas – reported that the gesso ground is so thin that the threads of the canvas showing through it induce 'a pale white, slightly mauve effect'.[52] In the *Madonna and Child* (National Gallery, London) from Titian's last years, what appears to be a reddish-brown imprimatura turns out, on inspection under the microscope, to be induced by spots of bare canvas showing through where paint and ground have been worn away.[53]

Grey, berettino *and* maiolica

In discussing the floor of San Marco (chapter 2) it was noted how the veined grey and white marbles when adjacent to yellows or browns take on by complementary contrast some faint tinge of blue or violet. As strong blues became less frequent in architectural polychromy in the later fifteenth century, the greys and whites of veined marbles came into their own again. In the early sixteenth century the value of mid-tones or half-tints, and how they interact chromatically, was being realized. Tones in prints, whether hatched or laid in by a tonal block, have been examined. As for critical vocabulary, it is striking that Marcantonio Michiel, who in his catalogue of paintings in private collections rarely indulged in more than a bare inventory, criticized Vincenzo Catena's completion of a Madonna by Giovanni Bellini because his painting of strong reflected lights was poorly blended with the half-tints – *meze tente*.[54] By 1532, when Michiel made this comment, failure to blend – failure to achieve what Vasari will term *unione* – was to be deficient in the most refined skill of colouring. The rise of chromatic grey is part of the refinement of half-tints as relatively desaturated areas of tone.[55]

A common word designating either a grey or a tone lacking a pure tint was *berettino*, or *berettin* (see chapter 8). Leonardo described *berettino* as the colour of bare plants in winter, presumably meaning the grey-green of twigs.[56] In Venice – as noted at the end of chapter 6 – the Franciscan house of the Frari was known as the *berettin convento*, and historians of dress coming across *berettin* in inventories of wardrobes have presumed it to be the brownish or indeterminate colour of undyed wool. Lorenzo Lotto in his account book listed a 'berettin fustian'.[57] So what was the tint of four canvases inventoried in Palma Vecchio's studio, at his death in 1528, as having been given 'gesso berettin'?[58] Clearly it must have been noticeably different from a number of other canvases in stock inventoried as having 'white gesso', but exactly whether it meant a brownish or a bluish grey is initially hard to tell.

At this point it is illuminating to turn to another medium – growing in importance in Venice around the time Palma died – maiolica painting. Maiolica production had probably been introduced into the lagoon from Faenza during the brief Venetian occupation of that city between 1504 and 1509.[59] From the start Venetian maiolica was characterized by preference for a bluish ground colour.[60] Towards the middle of the century *fondo berettino* had become the term associated with the tin glazes stained blue, or more commonly greyish blue, typical of Venetian and – later in the century – of Paduan production. A beautiful example of a *berettino* ground can be seen in plate in the Ashmolean (fig. 253), dated 1540 on the reverse, which shows the very Venetian subject of a siren with mirror in a lagoon setting.[61] Painted in blue with white highlights, the decorative and figurative elements are gently relieved against the pale, bluish grey of the *berettino*.

The major source for an understanding of Renaissance maiolica is Cipriano Piccolpasso's *I tre libri dell'arte del vasaio*, written around 1557.[62] Piccolpasso, who came from Castel Durante but had stayed in Venice, included a chapter entitled 'Colori alla veneziana', in which he discussed how maiolica painting on the lagoon differed from that in terra firma cities in that, 'they tint the colours [*loro macchiano i colori*] whereas we leave them plain white as they are'.[63] In this context *colori* refers specifically to the grounds on which the decoration, whether floral or figurative, would be applied, rather than to the entire maiolica palette. *Berettino* (specifically *bertino*) is Piccolpasso's

253 *Siren with a Mirror and Horn* (1540). Venetian maiolica plate, diameter 37.2 cm. Oxford, Ashmolean Museum.

term for this Venetian tinted ground, and he explained that it is made by adding a small amount of *zaffera* (cobalt blue) to 'milled white'.[64]

In the light of Piccolpasso's explanation of a *berettino* ground as containing some cobalt blue, it is likely that Palma Vecchio's canvases prepared with 'gesso berettin' were pale grey with a hint of blue. Titian's greyish *imprimatura*, although it may not actually contain blue, created a similarly silvery ground; it may be that Palma in the 1520s was attempting to emulate Titian's example.

Pittura di macchia

When Piccolpasso wrote that the Venetians 'macchiano i colori', he was using a term for mixture initially more common in the craft rather than literary tradition. We have encountered it in a description of mottled flesh tints in a fifteenth-century treatise on mosaic technique (see chapter 5). In the *Aretino*, Ludovico Dolce praised a manner of painting flesh and suggesting anatomy by hints and spots, 'accennamenti e macature'.[65] By

the mid-sixteenth century, when Dolce was writing, Titian had perfected his optical mode of painting by suggestive hints and *macchie* that, at the right distance, come alive and kindle response in the viewer's eye.

The development of technique away from literal description towards optical suggestion cannot be separated from the metaphorical turn discussed at the close of the last chapter in connection with the *Hypnerotomachia Poliphili*. By the middle of the sixteenth century, when Titian was sending his mythologies or *poesie*, to the future Emperor of Spain, Philip II, Ovidian themes of metamorphosis had become central to Titian's international art. In Ovid's fables gods are made flesh or beast, and nymphs transformed into constellations. Titian's painterly technique is extended to realize states of becoming and their attendant terrors and exhilarations. The inside is turned outwards, flesh is flayed or the blush of Europa turns the sky to flame. The energy of colouring is a metaphor for life, its quickenings and extinctions.

Natural scientists increasingly attempted to track the dynamism of life. There was a new awareness of the instability of matter, of the explosive power of gases and volatile substances. Under the influence of Lucretius, an atomistic view of nature was gaining credence. The inner heat of the body and the outer heat of the world were linked: the anatomist Vesalius likened the heart at the centre of the body to the sun at the centre of the universe.[66] Fire and heat were investigated as the agency of creation capable of transmuting matter and breaking down elemental distinctions.[67] Venetians were masters of pyrotechnics.[68] The industrial potential of fire continued to be harnessed spectacularly in the glass-furnaces at Murano.

Fire, or the semblance of fire, runs wild through the late works of Titian. At root, Titian's *colorito* realizes changing apprehensions of the body and the world, matter and spirit. This can be sensed in the version of *Danaë* painted for Philip of Spain (fig. 254). The story tells how the god Jupiter transformed himself into a shower of gold to make love to the beautiful daughter of King Theseus, so the fable involves an act of creation, it celebrates gold as material and as divine aura, and it involves the sensual abandon of a body to the enveloping air and the explosion of light. On Titian's canvas bounded form and unbounded space

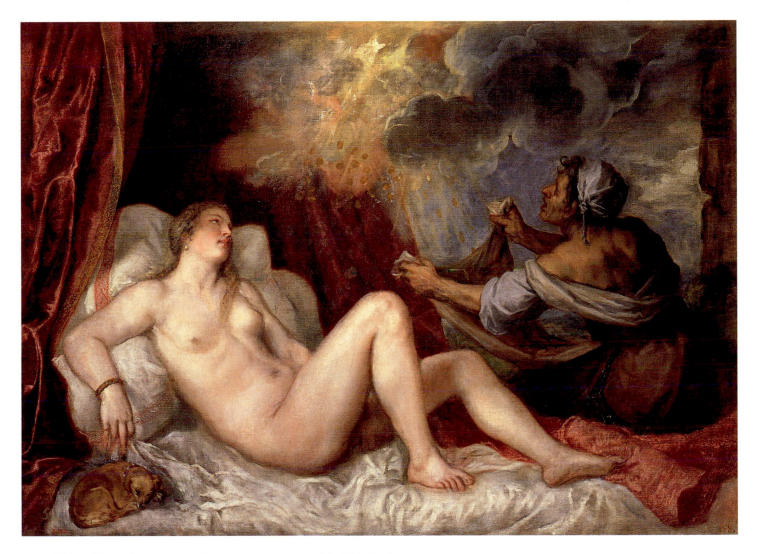

254 Titian, *Danaë* (*c.*1549–50). Canvas, 129 × 217 cm. Madrid, Prado.

connect, lap one another. The essential traditions of Venetian colour are intensified in a cosmic drama. Dolce's notion of colouring as contest, or *contendimento*, in *Danaë* becomes event and subject. The contest of *contre-jour* – bright cloud behind dark cloud – is dispersed throughout the picture in a dynamic play of shifting antitheses.

In technical terms the drama of Titian's painting depends upon the interaction of layers and of the gaps between. In some areas, where paint is thin, an oatmeal tone marked by canvas weave shows through.[69] The canvas provides, as so often in Titian, a generalizing and unifying undertone of texture. This roughness is crucially reinforced by the paint itself. Titian did not work wet-into-wet, but over an extended timescale of many months, and sometimes years, allowed each layer of oil paint to dry. Where he applied stiff lead white with a bristle brush it dried and hardened to reveal the minute ridges and furrows made by the brush-stroke. On the crimson curtains lake has been floated over the previously applied highlights in lead white: the visible texture therefore derives not from the surface glaze but from the rougher, selective impasto beneath it. Titian teases the senses of sight and touch by moving between surface and depth, with the most tactile, the most textural paint lying *below* the surface. As noted in the

last chapter, in the accessories of dress he improvised veils and kerchiefs by means of *velature*; here the naked Danaë holds a kerchief loosely between her fingers, which floats over the bed-sheet, white over white, yet shaded in the mid-tones of its folds with the oatmeal of the ground.

Titian's *colorito*, as at once texture and tone, is a substantial weft uniting the entire canvas, rather as the veins of marbles, running on and on, unite the lower walls of San Marco. Or again, in the linear accents of the brushmarks it is like the lines of mosaic tesserae on the vaults of San Marco. The drapes of the rough figure of the maid, whose ugliness provides a foil to the radiance of the princess, are modelled so that the shifting hues of grey blue, putty and brown add vibrancy to the changes of tone in manner that is analogous to modelling in medieval mosaic.

Unlike a central Italian artist working from a precise cartoon, Titian seems generally to have sketched some underdrawing with the brush, then laid in patches of underpaint, but moved towards resolution of form, focus and colour only in the later application of brush-strokes and glazes. The new manner of colouring essentially involves the total expanse of the picture as an entity rather than its separate descriptive particulars. As Jill Dunkerton has observed, 'since a glaze was no longer tied to a specific colour area – a red glaze did not necessarily have to be painted over a red underpaint – the painter was free to move about the whole surface of the painting while his brush was loaded with the same paint'.[70] In this mode of painting the painter's attention had to hold the whole visual field of the picture in view, and in turn the finished canvas provoked a similar mode of attention in the viewer. As I have attempted to show, the city of Venice itself – the flecks of colour in its marbles, the sheen of its velvets and satins, the mobile play of its reflections on water, the hard-to-focus interchanges of light and darkness – nurtured this peculiar distribution of attention, this *pittura di macchia*.

NOTES

CHAPTER 1

1 Norwich 1990, p. 71.
2 Ibid., p. 71.
3 Ibid., p. 69.
4 *Evagatorium in Terrae Sanctae, Arabiae et Egypti Peregrinationem*, ed. C. D. Hassler, 3 vols., Stuttgart 1843, p. 400.
5 See the discussion of this topos in King 1986.
6 Quoted from Huse and Wolters 1990, pp. 8–9.
7 Translation from Chambers and Pullan 1992, p. 25, from Sansovino 1663, p. 384, 'Et alle finestre si costumano i poggiuoli che sportano in fuori, colonnati all'intorno: alti poco più su della cinta, molto commodi de tempi della State per ricevere il fresco.'
8 For film, surface and volume colour see Katz 1935, pp. 11, 15, and *passim*. I discuss surface and film colour in relation to mosaic in Hills 1987, pp. 29–31.
9 Gibson 1979; for a summary of Gibson's views see Gordon 1989, chap. 7.
10 For a philosophical discussion of how perception of the visible entails and is pre-ordained by the invisible see Merleau-Ponty 1964.
11 On the relation between products, works of art, and social space see Lefebvre 1991, pp. 76–7.
12 For the period before 1300 see Schulz 1991, pp. 419–66.
13 Norwich 1990, p. 141.
14 Burckhardt 1960, pp. 78–9.
15 Cf. Lacan 1977, esp. pp. 67–104, and Merleau-Ponty 1962.
16 Norwich 1990, p. 142, exerpted from Mrs Dobson, *The Life of Petrarch*, 2 vols., London 1805.

17 On the promise in the beauty of nature, see Adorno 1984, esp. pp. 91–116.
18 Gaeta 1981, p. 574.
19 Demus 1988, p. 56.
20 Favaretto 1990, pp. 35–6; Gargan 1992, pp. 503–17.
21 Lefebvre 1991, p. 76.
22 Hahnloser 1971, vol. II, p. 131, and *idem*, 1955.

CHAPTER 2

1 Harrison 1989, p. 100, for the loot taken to Venice after 1204.
2 Translated in Chambers and Pullan 1992, p. 8, from Marin Sanudo, *Laus urbis Venetae*. For the treasury see Hahnloser 1971, vol. II: *Il Tesoro e il Museo*.
3 Ellis 1851, p. 7.
4 For the descriptions by Constantine Rhodios and Nicholas Mesarites of the lost church of the Holy Apostles see James 1996, pp. 111–26. James points out that these texts (Rhodios' written between 931 and 944 and Messarites' between 1198 and 1203) dwell on the brilliance and light-bearing quality of stones and metals, and the 'multi-coloured' quality of the marbles.
5 On the origin and identification of some of these marbles, Lazzarini 1978.
6 Cited by Unrau 1984, p. 59.
7 I depend upon Lazzarini 1995a. See also Tigler 1995, p. 24, for regilding of 1493; p. 43 for painting in red and blue.
8 The names of marbles are confusing because of changes of nomenclature from country to country. Green marbles, often used as exterior revetment in Venice, are especially tricky

because of inconsistent usage of the terms *serpentine* and *verde antico*. Lazzarini distinguishes between a porphyry *verde antico*, called in Venice *serpentino della stella*, and a non-porphyry *verde antico* or *verde di tessaglia*. A useful catalogue of the main quarries and decorative stones in the Roman world, with a listing of ancient, Renaissance and modern names for marbles, is included in Ward-Perkins 1992, appendix 1, pp. 53–60.
9 Cook and Wedderburn 1903–12, vol. X, pp. 88–9.
10 Barral I. Altet 1985.
11 For a discussion of marble floors in relation to Chevreul's harmonies of analogy and of contrast, Blagrove 1888, pp. 14–16.
12 Ibid., p. 14.
13 Sansovino 1663, p. 98.
14 G. E. Street, *Brick and Marble in the Middle Ages*, 2nd ed., London 1874; quoted in Blagrove 1888, p. 27.
15 Mango 1972, p. 75. For comments on the shifting vision of the spectator in a Byzantine church see Gage 1993, p. 46.
16 Connell 1988.
17 In Norwich 1990, p. 135, from *Italian Hours*.
18 My comments on architecture and the body, surface and depth, owe much to the writings of Adrian Stokes.
19 Blagrove 1888, p. 51.
20 Seipp 1911, p. 37, n. 1.
21 Unrau 1984, p. 168.
22 Connell 1988, p. 110. On the interpretation of colours in Byzantium see James 1996, chap. 6 and *passim*.
23 Connell 1988, p. 109.
24 Ibid.
25 Gage 1993, p. 46.

26 On gems and marbles in the imagery of heaven, McDannell and Lang 1988.

27 Gage 1993, p. 46.

28 For a wide-ranging discussion of the theological significance of marble see Didi-Huberman 1990; for column, cloud and fire, p. 155.

29 Gage 1993, p. 57.

30 Albertus Magnus 1967, p. 128. The passage is discussed in Connell 1988, pp. 112–13. Albertus's book would have been known in Venice; a copy is mentioned in the will of Luca Sesto in 1458, see Connell 1972, p. 175.

31 Connell 1988, p. 112.

32 See Demus 1948.

33 Proust 1987, p. 53.

34 For colour in mosaic tesserae see James 1996, pp. 19–26. Harding 1989, pp. 73–102, cites archival evidence for the colours of glass tesserae imported from Venice.

35 Demus 1984, vol. 1, p. 25.

36 The most detailed account of mosaic materials used in the Venetian lagoon that I have found is in Andrescu 1984. For fifteenth-century developments in the enamelling of glass see Saccardo 1896.

37 Saccardo 1896, p. 190.

38 The best discussions of mosaic in relation to later pictorial practices are to be found in the writings of Theodor Hetzer, particularly Hetzer 1935.

39 For recent research on light, visual perception and machine vision see comments and bibliography in Baxandall 1995.

40 On Aristotelian theory, the question of colour-scales and Newton's contribution see Gage 1993, esp. chap. 9.

41 Saccardo 1896, p. 199 and *passim*.

42 I was alerted to this by an observation made by Edmund Fairfax-Lucy.

CHAPTER 3

1 Seipp 1911, p. 57. For the sculpture of the iconostasis see Wolters 1976, cat. no. 146; he points out that there are traces of polychromy on the hems of the draperies.

2 Connell 1988, p. 122, describes the inlay as pieces of blue glass, but Seipp 1911,

p. 57, describes them as lapis lazuli: the former appears more probable.

3 Humfrey 1993, p. 51.

4 Fogolari 1924, pp. 78–9; Connell 1988, p. 171.

5 Wolters 1976, cat. no. 32.

6 Sansovino 1663, p. 575.

7 Concina 1995, p. 95. For the contract see Wolters 1976, cat. no. 143.

8 Goy 1992, p. 211.

9 Vasari's comments on Istrian stone are in Vasari 1878–85, vol. 1, pp. 124–5. See Rodolico 1965, pp. 198–208.

10 Boni 1887, p. 126. In documents of 1372 relating to Andriolo de Santi's architecture of the Capella San Felice in San Antonio in Padua (in Sartori 1976) Verona marble is called *pietra vermiglia* (p. 8), and for the polychromy of the façade 'le quale pietre bianche deno essere bene bianche e le vermiglie bene vermiglie e bene polite e lustrate e bene congiunte' (p. 9).

11 Concina 1995, p. 90.

12 Arslan 1971, pp. 151–2, surveys the literature, but an exact source has not been suggested.

13 Howard 1980, p. 83.

14 Blagrove 1888, pp. 38–9.

15 Ruskin describes and illustrates this spandrel in *The Stones of Venice*, vol. 1, chap. 26 and appendix 20, and pl. 14.

16 Concina 1995, pp. 106–7, argues that the gilding is also a deliberate attempt to identify with the golden buildings of the patrician government.

17 Goy 1992, p. 287; for commentary see Boni 1887, p. 126.

18 Pointed out in Connell 1988, p. 151.

19 A suggestion of Paoletti's referred to in Connell 1988, p. 151.

20 Goy 1992, p. 288.

21 Rigoni 1970, p. 56.

22 'Che lavorar debbi de oro fino, azuro oltramarino, de el piu fino si trovi, et cusi de lache fine verdi laccurei et altri necesssarij tuti fini', Rigoni 1970, p. 55.

23 Tafur 1926, p. 166.

24 Frescobaldi 1944, p. 14: 'Fecevi grande onore, e la sua casa pareva una casa d'oro, ed havvi più camere che poco vi si vede altro che oro e azzurro fine; e costogli dodici mila fiorini . . .'

25 Translated in Norwich 1990, p. 377.

26 For an overview of the history and economics of brick production see

Goldthwaite 1980, pp. 171–212; for the Venetian guild see Monticolo 1896–1914, vol. 1, pp. 79–93 and 213–33.

27 Michler 1989 and Michler 1990. For painting fictive brick over brickwork see also Cristinelli 1992, p. 179. Thomas Tuohy argues that in fifteenth-century Ferrara covering of brickwork with rendering was 'almost certainly universal': Tuohy 1996, p. 197.

28 Huse and Wolters 1990, p. 11. Other canvases in the Cycle of the True Cross from San Giovanni Evangelista show walls with lozenge patterns: there are glimpses of two in Lazzaro Bastiani's *Donation of the Relic*, and a more obvious diaper in pink and white in Giovanni Mansueti's *Miracle of the the Bridge at San Lio*. A couple of varieties of diaper graphically rendered in an early sixteenth-century print of the *bucintoro* passing down a canal further indicate that such patterns had left their stamp on many walls of the Renaissance city.

29 Goy 1992, appendices 1 and 2, pp. 276–8.

30 Connell 1988, p. 171; the documents are printed in Fogolari 1924, pp. 93–118.

31 Crovato 1989, p. 17.

32 Ibid., p. 18.

33 Goy 1992, p. 196.

34 Sansovino 1663, p. 383.

35 Barbaro 1556, pp. 283–4.

36 Cf. Dellwing 1990, pp. 117–23.

37 Hempel 1980, p. 37.

38 Lorenzi 1868, doc. 159, pp. 68–9.

39 See the *mariegola* of the *tagliapietra* guild in the Biblioteca del Museo Civico Correr, Venice (Mariegole, 150), f.26r. xxxvii, 'Chel non si possa messe dar piere de una natura cume piere de altra natura in un medesimo lavorier'.

40 Gentilini 1992. It is noticeable that the reluctance of Venetians to use moulded terracotta in *all'antica* architecture was not shared by the Ferrarese around 1500, although there too marble and stone was more prestigious, see Tuohy 1996, p. 188. Given the importance of Lombard masons in quattrocento Venice, it is noteworthy that in 1387 a decision had been made to change the material of the new cathedral of Milan from brick to marble: on the repercussion of this see Welch 1995, pp. 71–6.

CHAPTER 4

1 Baxandall 1971, p. 62, with Latin text in n. 24. Comments in Gage 1993, p. 117.

2 Baxandall 1971, p. 62, translates *pigmentorum*, 'of colour'; I have changed this to the more literal 'of pigments', although in Latin usage *pigmentum* may refer more widely to colour as material.

3 For austere versus florid see Gage 1981; and Gage 1993, chap. 2; for Decembrio, Baxandall 1963.

4 Baxandall 1963, p. 316.

5 Gage 1993, p. 15.

6 Hills 1987, esp. chaps. 1–4.

7 Baxandall 1971, p. 156.

8 Ibid., p. 11.

9 My understanding of holding-apart in the mental act of reflection owes much to Benjamin 1991. It is intriguing to notice that *distantia* as difference/distance implies, like Derrida's term *différance*, that difference, like distance, is produced through relation rather than pre-existing as given.

10 Translated in Gilbert 1980, pp. 174–5; see also Eisler 1989, pp. 447–8; Mariani Canova 1972; for an account of Fontana's interests see Thorndike 1934, chap. 45; Maccagni 1981, pp. 145–7.

11 Gombrich 1976, pp. 5–6.

12 *On the Sublime*, XVII. 2; translation by Dorsch 1965, p. 127.

13 For an acute account see Baxandall 1995, appendix pp. 146–51; also Hills 1987, pp. 93–4 and *passim*.

14 Hills 1987, pp. 69–70.

15 *De pictura*, bk. I, para. 7; Alberti 1972, p. 40.

16 Fra Mauro's *Mappamondo* is in the Biblioteca Marciana; see Bevilacqua 1980, esp. p. 360; for the 'Venetocentric' limitations of curiosity about distance and difference see Tucci 1980.

17 Recent contributions to the literature on Mantegna's intellectual formation include Lippincott 1993, and Chambers, Martineau and Signorini 1992.

18 Alexander 1977, pp. 54–9.

19 Alexander 1994, cat. 29, pp. 87–90.

20 Wollheim 1980.

21 Ames-Lewis 1984, pp. 351–2.

22 For commentary and colour plate, Alexander 1994, cat. 71, pp. 152–4.

23 Cf. Pächt 1986, p. 152 and chap. 7.

24 Meiss 1957.

25 Mitchell 1969. For Feliciano's links with Mantegna and Bellini see Chambers, Martineau and Signorini 1992, pp. 16–17.

26 Attributed to Michele Savonarola in Ferrara, Biblioteca Comunale Ariostea, MS Cl. II, 147; see Torresi 1992. The text uses Tuscan, Ferrarese and Venetian words. Recipies for 'oro liquido all moresca', f.179v.; for 'verde de' Saracinj', f.81r.; for inks 'polito e lucente' f.142v.; for writing over varnish, f.169v.

27 See Torresi 1992, p. 27, for commentary.

28 Ackerman 1980.

29 For a recent overview see Jay 1993, chap. 1.

30 Stumpel 1988. I am grateful for conversations with Helmut Wohl who is writing a book on ornament in Renaissance art.

31 Robertson 1968, p. 12; Robertson also lists other references to Bellini by contemporary humanists, pp. 12–13.

32 For this turn from a symbolic order to one that is open to instinctual drives see two essays by Julia Kristeva, 'Giotto's Joy', and 'Motherhood According to Giovanni Bellini', both reprinted in Kristeva 1981, pp. 210–70.

CHAPTER 5

1 The complexity of this development is well brought out in Gage 1982; revised as chap. 4 of Gage 1993.

2 Benazzi 1991, the text is on pp. 55–69; yellows pp. 56–7; cobalt blue and aquamarine, p. 62; see also the commentary on technique by M. Verità, pp. 87–103.

3 Benazzi 1991, p. 56; cf. Gage 1993, p. 69.

4 The main exception is the window in the right transept of SS. Giovanni e Paolo, see Castelnuovo 1982.

5 Noted by Gage 1993, p. 41.

6 Saccardo 1896, esp. pp. 186–204.

7 Mariani Canova 1984, esp. p. 735.

8 Collareta 1984, p. 759, citing *Castigationes plinianae*, ed. G. Pozzi, Padua 1974–9, III.1120.

9 Reali 1858.

10 Ibid.: painting mortar, pp. 12–13; cleaning with linseed oil, p. 10; *machie di colore*, p. 12.

11 Zecchin 1987–1990, vol. III, 'Vetri da finestra nelle scritture italiane dal 1288 al 1447', pp. 169–72.

12 For Saint Bernard's simile of the Immaculate Conception as analogous to a ray of light passing through glass without breaking it, see Meiss 1945.

13 Sanudo 1980, p. 21.

14 Sansovino 1663, p. 384.

15 My account of Murano glass is indebted to Tait 1979, which is summarized and revised in Tait 1991, pp. 148–77. Rich documentation is to be found in the three volumes of Luigi Zecchin's collected papers, Zecchin 1987–90. Dreier 1989 is a valuable catalogue of the Kunstgewerbemuseum.

16 On materials see Jacoby 1993 and Toninato 1982.

17 Zecchin 1987–90, 'Veriselli e gioie false', vol. III, pp. 153–7.

18 Reino Liefkes, who has supervised tests on glass at the Victoria and Albert Museum, has recently argued that owing to the lack of stabilizer in true Venetian *cristallo* it decomposes with time, therefore the pieces that survive may in fact be *vetrum blanchum*: since this was a somewhat less clear colourless glass, it may be that today we cannot witness the original clarity of *cristallo*. See Liefkes 1997, pp. 43–4.

19 Spallanzani 1978, p. 165.

20 Neri 1980, bk. II, chap. 37, p. 34.

21 Adorno 1984, chap. 4.

22 Cited in Tait 1979, p. 94.

23 Sanudo 1980 lists amongst the sights to be shown 'signori', the Arsenal and 'Muran, dove si fa veri'; Zecchin 1987–90, vol. II, pp. 233–4, collects the references to distiguished foreigners who visited Murano.

24 Robertson 1968, p. 2.

25 Caution is needed in discussing the colour of this painting because 'the sky is extensively worn and restored' and 'Titian's use of copper resinate in much of the foliage has resulted in its changing colour from green to brown', Gould 1975, p. 275; also Gould 1958, but Gould's interpretations of the X-rays have been revised by Dunkerton and Penny 1995.

26 Dreier 1989, cat. 26, pp. 54–6.

27 According to Zecchin 1987–90, vol. I, p. 49, the first use of the term *zaffera* in connection with the blue tinting of Murano glass was in 1446.

28 Zecchin 1987–90, vol. II, p. 212.

229

29 Zecchin 1987–90, vol. III, p. 84; see also the glossary in Neri 1980, pp. xciii–xciv, *rosichiero* (*sic*).

30 Reino Liefkes tells me that he knows of no surviving examples of *rosechiero*; for ruby glass see Liefkes 1997, p. 72.

31 Verità 1995, esp. p. 96.

32 Carboni 1989, p. 150. The technique of firing enamel colours on glass is described in the fifteenth-century Bolognese *Segreti per colori*, printed in Merrifield 1849, vol. II, pp. 527–9, no. 270; see also L. Zecchin, 'Cristallini dorati e smaltati', *Vetri e Silicati*, 68 (1968), pp. 22–5, reprinted in Zecchin 1987–90, vol. III, pp. 109–13. For earlier techniques and their survival see Verità 1995.

33 Brown 1982, p. 214. Isabella's turn against gold contrasts with Ferrarese quattrocento taste, particulary of her uncle Borso d'Este; for gilding architectural ornament and the Camere Dorate of the 1470s in the Ducal Palace at Ferrara, see Tuohy 1996, pp. 75–9.

34 Brown 1982, p. 213, p. 219 n. 27.

35 Clarke 1974; Tait 1979, pp. 95–6.

36 Colonna 1980, p. 311.

37 Tait 1979, p. 95.

38 Zecchin 1987–90, vol. III, pp. 83–4, and 'Chi inventò gli specchi veneziani?', pp. 368–71. It is noteworthy that steel plate mirrors continued to be bought alongside crystal glass mirrors by Isabella d'Este as late as the 1530s, see Brown 1982, pp. 240–41. In the sixteenth century, the steel mirrors *specchio de azal* were common in modest houses, whereas Murano mirrors were only for the better off; Palumbo Fosati 1984, p. 41.

39 Ludwig 1911; Fletcher 1990. The luxury – and vanity – of *restelli* aroused anxiety: in 1488 'i rastelli et chasse dorate' were banned, Bistort 1912, p. 369.

40 Ilardi 1976, esp. p. 351.

41 *De pictura*, II, para. 46; Alberti 1972, p. 88.

42 Marcello 1508, f.149 (Cap. Xli).

43 See the classic discussion of the differences between Italian and Netherlandish attitudes to lustre in Gombrich 1976, 'Light, Form and Texture in Fifteenth-Century Painting North and South of the Alps', pp. 19–35.

CHAPTER 6

1 For a summary (with references to more detailed publication of technical findings in the *National Gallery Technical Bulletin*) see Dunkerton et al. 1991, pp. 197–200.

2 MS Sloane 416, see Eastlake 1847, pp. 74–7, and note on pp. 90–93.

3 Tosatti 1991, p. 28.

4 Dunkerton 1987.

5 Dorigato 1993, p. 222.

6 Plesters 1978a, p. 22.

7 The technical information which follows is from Valazzi 1988; sections on technique and conservation by M. Cordaro, C. Bertorello and Giovanni Martelloti, and M. L. Tabacco.

8 Valazzi 1988, p. 135. For the composition and history of smalt see Roy 1993, pp. 113–30.

9 Aragnina 1996.

10 See Van Eikema Hommes 1998, esp. p. 97.

11 Cf. Gage 1978, p. 110. For changes in the use of blue see Brusatin 1993.

12 I am indebted to Jeongmu Yang, who showed me his graduate paper 'Giovanni Bellini: Canvas in the Making' (1994); see now Yang 1999 (which has not been taken into account here). For the early history of canvas see Dunkerton et al. 1991, pp. 161–2. The 'Venetian manuscript', Sloane 416, contains 56 recipes for mostly cheaper colours in *acque gommate* for applying to canvas, Tosatti 1991, p. 28.

13 I owe this information to Jill Dunkerton.

14 For the documentation of these lost *tele*, see Brown 1988, pp. 266–8.

15 'depenzerlo . . . nel modo che lavorano al presente li do fratellj Bellinj', Brown 1988, p. 274.

16 For the concept of ambient light see the books by J. J. Gibson, esp. Gibson 1968, chap. 10.

17 For the ship's-keel roof see Lorenzi 1868, doc. no. 842.

18 *Libro dell'arte*, chap. CLXII; Thompson 1932, pp. 103–4.

19 The term 'glue-size' used by Dunkerton 1993 is preferable to 'distemper' used in Martineau 1992 by K. Christiansen, 'Some Observations on Mantegna's Painting Technique', pp. 68–79 (esp. p. 69), and A. Rothe, 'Mantegna's Paintings in Distemper', pp. 80–88.

20 The information on the technique of the Barbarigo canvas is indebted to Lazzarini 1983.

21 Cf. Merleau-Ponty 1962, p. 255, commenting on Berkeley's idea of perception, 'depth is tacitly equated with *breadth seen from the side*, and this is what makes it invisible.' The pictorial conversion of depth into breadth is discussed in Marin 1995, pp. 60–63. Hetzer 1935, p. 37, makes a related formalist point about the Venetian tendency to conceive of light and shadow as coloured planes: 'Licht und schatten sehen die Venezianer als Farbflächen.'

22 H. Kühn, 'Lead-Tin Yellow', in Roy 1993, pp. 83–112.

23 'Ad voler fare colori che tu adoperarai sopra el vetro . . . pilglia de quelli paternostri piccolini de vetro giallo, cioè de quelli venentiani fini che sonno a modo de ambre çalle e pistali bene . . .', Benazzi 1991, p. 56. The reference to amber is a reminder of its importance in Venetian trade; see Heyd 1885–6, p. 274. Venetian goldsmiths were barred from selling inferior gold and silver, but allowed to sell little balls of amber: Monticolo 1896–1914, vol. I, p. 126 (xxxi).

24 'Ad fare colore çallo, pilglia de la limatura dell'argento fino, cioè venetiano . . .', Benazzi 1991, p. 57.

25 Zecchin 1987–90, vol. III, pp. 308–11 (ff. LII–LX of Il Ricettario Darduin).

26 Mancini 1996, esp. doc. 6, p. 176, and doc. 8, p. 178.

27 Dorigato 1993, pp. 224–6.

28 Davanzo Poli 1984, reports that *lionato* is much used of Florentine woollen cloths of the fourteenth century, whereas according to Ericani and Frattaroli 1993, p. 18, it is a common colour word in dress from the mid-sixteenth century.

29 I owe this point to discussion with Jill Dunkerton; cf. her comment in Dunkerton 1994, p. 66. On red lakes in body-colour as well as glazes see Valazzi 1988, p. 136.

30 For the pigments in these paintings see the essential article, Lazzarini 1987.

31 For a summary account of yellow's relation to the trichromacy of human vision see Gordon 1989, pp. 98–9.

32 Cf. Bercken 1914, p. 181.

33 Cf. Antonio da Pisa: 'Note that St Peter is always dressed in a yellow mantle . . .', Benazzi 1991, p. 56.

34 Chatzidakis 1993, pp. 2 and 18–20. On the wider significance of these icons see Cormack 1997, chap. 5.

35 Frodl-Kraft 1970 ('Licht und Farbe' pp. 77–86) argues that in stained glass violet stands in for grey and purple for brown; I have not found it quite as clear cut as this. For *biffo*, Hills 1987, pp. 84–5; for *biffo* in Antonio da Pisa, Benazzi 1991, p. 55; *biffa* was one of the colours of glass bought in Venice to use for mosaic in Orvieto in 1359, Harding 1989, p. 93, document 17.

36 McKenzie 1912; Barbina 1969.

37 Thompson 1926, p. 296.

38 Gage 1993, pp. 117–19.

39 Although superseded by laboratory findings in some technical details, the best analysis of the warm/cool contrasts achieved by glaze over light ground and scumble over dark remains Eastlake 1847, esp. vol. II, chap. 6 and 'Professional Essays', pp. 219–413.

40 Hardin 1988, pp. 140–41; Westphal 1991, pp. 51–68.

41 Walsh and Kulikowski 1995, p. 271.

42 For the occurrence of orpiment and realgar in Venetian painting see Lazzarini 1987.

43 Lazzarini 1987, table on p. 133. Seeing the painting in 1997, after recent cleaning, Jill Dunkerton told me she thinks that in spite of the identification of orpiment and realgar it looks as though the principal pigment is lead-tin yellow. The 'orange' is indeed suspiciously yellow.

44 Rosetti 1969, nos. 68 and 69. Vitali 1992, p. 455, 'Tabella dei colori più in uso'; another useful glossary of colour terms in textiles is in Davanzo Poli and Moronato 1994, pp. 177–80.

45 Letter to Domenico Bollani: 'io vagheggio da un lato gli aranci che indorano i piedi al palazzo de i Camerlinghi', Aretino 1960, p. 117; trans. Bull 1976, p. 118.

46 I follow the detailed analysis of pigments in Dunkerton and Roy 1986.

47 For the colour since cleaning and Michelangelo's use of *cangiantismo* see Hall 1992, pp. 123–9.

48 Lazzarini 1987, p. 122.

49 Bercken 1914, p. 14. The vulnerability of violet may explain the puzzling assertion in Hetzer 1935, p. 37, that it is rare in the Venetian palette: certainly, the sometimes crude purples found in Florentine painting are absent in Venetian.

50 See Kirby and White 1996.

51 Alberti, *De re aedificatoria*, bk. VII, ch. x. Equicola: 'Il candido essere proprio de dèi scrive Cicerone e però seguendo Platone li templi candidi disidera', in Barocchi 1971–7, vol. II, p. 2154.

52 In conversation Jill Dunkerton suggested that some of the greys in Bellini are due to the fading of glazes, particularly in red lake; see comment in Dunkerton 1994, p. 66.

CHAPTER 7

1 On this topic I am indebted to Brown 1996.

2 Alpers 1983, esp. pp. xx–xxi.

3 Hetzer 1935, p. 37.

4 For Renaissance pictorial realization of liminal space, of transaction between viewer and viewed, see Shearman 1992, esp. chaps. 1 and 2.

5 For the closely related term *aria* see Summers 1989.

6 Robertson 1968, p. 55.

7 Belting 1985, p. 30.

8 For *enargeia* see Mack 1992, esp. p. 171; Shearman 1992, pp. 208–9. For inscriptions drawing attention to the role of the artist Humfrey 1995, p. 211 (following Eisler 1989), who points out that Jacopo Bellini inscribed a Madonna and Child of 1448 with the words 'HAS DEDIT INGENUA BELLINUS MENTE FIGURAS'.

9 See comments on pallor and blood in Bennett 1982, pp. 39–41.

10 Cf. Saint Bernard, sermon XLVIII: 'For it is certain that our life, as it was then (living according to the flesh), has

drawn as near to death as the shadow is near the body which casts it . . . But now we have passed from the shadow of death to the shadow of life, . . . and are living by the shadow of Christ. Through the flesh He is the shadow of faith, through the spirit He is the light of knowledge.' Mabillon 1896, p. 296. For this topos in its antique formulation and later transformations see Stoichita 1997.

11 I am indebted to conversations with Jacques Darras on clouds and with David Wood on shadows. See also Damisch 1972. On the necessity of concealment or 'dissemblance' and its theological underpinning in the Pseudo-Dionysius the Areopagite, see Didi-Huberman 1990.

12 Gadamer 1979, 'The ontology of the work of art and its hermeneutical significance', pp. 91–150, esp. p. 123. Gadamer on p. 120 cites Theodor Hetzer for the 'sovereignty of the picture'. See also Belting 1994.

13 Gadamer 1979, p. 126.

14 See Lowry 1991.

15 For 'holding apart' I am indebted to Benjamin 1991.

16 I follow Hobson 1989a, especially pp. 122–13; see also Hobson 1989b.

17 Pointed out by Schlosser 1924, p. 117.

18 Lepori 1980, esp. p. 601.

19 As Rudolph Agricola put it in his *De inventione dialectica* (begun in Ferrara after a ten-year stay in Italy, and completed in Augsburg in 1479): '*copia* of invention is sometimes given to ungoverned and almost mad intelligences, but beauty of disposition and order are formed by skill and judgement. Of these, as the former is a sign of a happier nature so the latter indicates a more cultivated discipline. Both are to be wished for, but the latter is more praiseworthy.' Translation and Latin text in Mack 1993, pp. 224–5.

20 For what follows I am indebted to Landau and Parshall 1994, esp. pp. 65ff, 'The Development of a Tonal System'.

21 See Lowry 1991, pp. 239–54, for list of editions. For comments on Pliny's importance in late fifteenth-century Venice see Goffen 1989, p. 54, with further bibliography.

22 *Natural History* xxxv. v.16, and xi.29; commentary, with slightly divergent interpretations, in Gage 1993, p. 227 and p. 297 n. 10; Thornton 1990; Barasch 1978, p. 107 and p. 130 n. 70. Wright 1984 argues that Alberti's division of painting into three parts, 'circumscriptio, compositio et luminum receptio', is indebted to Pliny's account of the evolution of art from line-drawing through to polychrome painting governed by *tonos* and *harmoge*.

23 *Natural History* xxxv.145.

24 See Gage 1993, pp. 117–19.

25 Connell 1988, p. 150; Meyer zur Capellen 1985, p. 108, doc. 13. For the value of marbles see Strupp 1993.

26 Luchs 1995, pp. 53–4 and p. 148 n. 8.

27 See Hind 1935, vol. ii, pp. 458–505.

28 Plato 1965, p. 95 (36.e) [p. 68 of Stephanus, 1578 edn.].

29 I follow Lichtenstein 1993, pp. 52–3.

30 Lichtenstein 1993, p. 54.

31 For what follows in this paragraph and the importance of luminosity in Plato, see Fóti 1990. For a philosophical meditation on shining and appearance see Sallis 1994.

32 Translated in Chambers and Pullan 1992, pp. 6–7.

33 Plato 1954, pp. 173–4 (*Phaedo* 110).

34 Kristeller 1983; also Melczer 1994. Ficino's translations of the complete works of Plato were published in Venice in 1491.

35 Gosselin 1991. The sun and its radiance became an increasingly important symbol in Christian art from the late Middle Ages: see the survey by Negri Arnoldi 1965.

36 Brown 1996, pp. 164–76, 'A New Golden Age'.

37 Da Mosto n. d., p. 192.

38 King 1986, p. 147.

39 *L'Argoa volgar*, Venice c.1542, opening of bk. ii, 'El Principe con faza serenata sin vien vestito de restagno d'oro porta seco un splendor chel par un Deo . . .'

40 Pacioli 1494, p. 68b (v.vi.); cited in Baxandall 1985, p. 146, with translation on p. 113. The importance of geometry in Venetian art is still underestimated; for Luca Pacioli's teaching in Venice see Lepori 1980, pp. 597–600, and Maccagni 1981, pp. 161–3; for networks between Leonardo, Pacioli and Venetian artists and patrons see also Padoan 1992.

41 Humfrey 1993, pp. 248, 351.

42 Most textbooks on colour describe the difference between these modes; for a summary see Hardin 1988, pp. 82–8. In the absence of assertive clues to orientation, perceptually we tend to assume that a patch of colour lies parallel to the picture-plane, at right angles to the line of sight: see Gombrich 1974, esp. p. 91.

43 Lefebvre 1991, pp. 27–8.

44 Brown 1982, doc. 92, p. 84.

CHAPTER 8

1 Sansovino 1663, p. 493. For comments on Venetian dress, with archival references to legislation governing the colours of office-holders' garb see Casini 1996, pp. 289–90.

2 'Habito certo pieno de fede e de gravità'; Newett 1907, p. 143.

3 Lacan 1977, pp. 99–100, makes suggestive remarks on animal and insect colour as travesty, camouflage and intimidation.

4 Giorgio Dolfin recorded that in 1428 two hundred and fifty women in cloth of gold or just in silk were paraded for the visit of the Duke of Portugal: BMV MS Italiano vii, 794 (8503), f.231r. Many examples of women paraded on official receptions are cited in Bistort 1912, pp. 34–5 and *passim*.

5 Newton 1988, p. 8. More generally see Kovesi Killerby 1994, pp. 99–120.

6 Monticolo 1896–1914, vol. i, p. 142 (viii).

7 Rebora 1970. For cost of kermes see Brunello 1968, p. 141. On the importance of alum that was used for silk and wool dyeing in combination with kermes see Heyd 1885–6, vol. ii, p. 565–71. See also Cardon 1989; Schweppe and Roosen-Runge 1986. Tucci 1998 points out that the Venetians did not use the true purple dye from the *murex* mollusc.

8 For trade in dyestuffs see Heyd 1885–6, vol. ii: for *grana* pp. 607–9, for brazilwood pp. 587–90, for madder p. 618. The best introduction to kermes and its problematic nomenclature is Kirby and White 1996.

9 *Trattato dell'arte della seta*, in Gargiolli 1868.

10 For lac as dyestuff originating from India, see Schweppe and Roosen-Runge 1986, p. 258. The same authors point out, on p. 261, that St John's Blood, *Johannisblut*, was a name given to kermes in medieval Germany. *Margarodes polonicus*, 'Polish kermes', was much used for dyeing in central and eastern Europe.

11 Cozzi, Knapton and Scarabello 1992, p. 236.

12 An observation made by Griffo 1988, p. 261.

13 Sansovino 1663, p. 409, 'un panno d'oro intessuto d'argento'.

14 Cecchetti 1886, p. 43; Davanzo Poli 1984, p. 61. This was common throughout Europe; see Piponnier and Mane 1997, p. 35.

15 Butazzi 1997. Also on tailors, Newton 1988, chap. 7.

16 Davanzo Poli 1993, p. 25, and again in Davanzo Poli and Moronato 1994, pp. 35–6.

17 Davanzo Poli and Moronato 1994, pp. 49–50.

18 Newton 1988, p. 18.

19 Davanzo Poli and Moronato 1994, p. 32.

20 Sanudo 1980, p. 58. *Cremisino* in Venetian texts is often spelt *cremesin*, *cremexin* or *cremizin*.

21 E.g. in a decree of the Maggior Consiglio of 1265: Davanzo Poli and Moronato 1994, p. 22.

22 When the Doge and Signoria received Anne de Foix, Queen of Hungary, it was reported that the gentlemen and ladies were 'tous vestuz de drap d'or, veloux, damas et satin cramoisy; le moindre habillement fut escarlate': Casini 1996, p. 290.

23 Newton 1988, p. 29.

24 Ibid., p. 30, citing Sanudo, *I diarii*, vol. xxxvii, col. 456.

25 Sicily was herald to Alfonso I of Aragon, King of Naples; his treatise, *Le Blason des couleurs en armes, livres et divises*, was published in France at the end of the fifteenth century and reprinted in 1860 ed. H. Cocheris; it appeared in Italian as *Trattato de i colori nelle arme, nelle livree et nelle divise di Sicillo Araldo del Rè Alfonso d'Aragona*, Venice 1545, reprinted Venice 1599, reference to *rosa seccha* p. 7v.

Whereas in the French edition (f.40r.), following the retelling of Pliny's praise of the dignity of painting with colours, Jean Fouquet and 'Maître Jean de Paris' are singled out, in the Venetian edition (f.28r.) the 'divino Titiano' is singled out.

26 Venturi 1983, catalogues Sanudo's references. Some *compagnie* were ephemeral; many had new costumes for each major festival.

27 The magistracy only reached its definitive form in 1514, see Bistort 1912, p. 54.

28 Venturi 1983, p. 95.

29 Sanudo, *I diarii*, vol. XLI, 167; cited in Venturi 1983, p. 91.

30 Sanudo, *I diarii*, vol. L, 431; cited in Venturi 1983, p. 97. For *becheti* see Newton 1988, pp. 12–16.

31 Mantua 1545; in Zonta 1912, p. 173. This passage was brought to my attention by Dr Jane Bridgeman; for matching rank to quality of fabric see Bridgeman 1998.

32 E.g. Sanudo 1980, p. 37, 'il bucintoro . . . è coverto di raso cremisino'.

33 Sanudo, *I diarii*, vol. L, 436–7; cited in Venturi 1983, p. 93.

34 The *Capitulum de Beretarius* is published by Monticolo 1896–1914, vol. III, pp. 69–83.

35 Venturi 1983, p. 105, 'una bareta di veludo negro alla Spagnola bassa con uno bel zoiello sopra'.

36 For a recent account by a neurobiologist see Zeki 1993. For a recent challenge to the scholarly consensus that privileges cultural explanations see Onians 1998.

37 Cf. Hills 1987, chap. 6.

38 Bistort 1912, pp. 118–19 n. 1.

39 Vitali 1992, p. 403.

40 Monticolo 1896–1914, vol. II, p. 36 (xxvi).

41 Darrah 1998.

42 Rosand 1982, p. 10. For the statutes of the *arte* see Favaro 1975.

43 'E nel finger le cose artificiali noi faremo conoscer un'armatura, un panno di seta, di lino, cremisino separato da un verde, e simil cose, e se voleste dire che questi sono effetti de'colori, dico che non, per ch' il verde farà ben tutte le cose verdi, ma non darà la propria differenzia del veluto o dil panno di lana,

e però i colori non possono far tal effetti da sé, se non vi aggiugnie il maestro il suo artificio.' Dialogo di pittura di messer Paolo Pino, printed in Barocchi 1960, vol. I, p. 128.

44 Davanzo Poli and Moronato 1994, p. 52.

45 Translation in Chambers and Pullan 1992, p. 7.

46 Vespasiano da Bisticci tells how King Alfonso of Naples who 'usually dressed in black, with just a buckle in his cap and a gold chain around his neck' playfully instigated the roughing up of a Sienese ambassador who was excessively partial to gold brocade: Vespasiano 1951, p. 60; translated by Baxandall 1972, p. 15, who comments on the reasons for a shift away from 'gilt splendour'. Ercole d'Este, who lived at King Alfonso's court from the age of fourteen to thirty, was more given to wearing black than this elder brother Borso, who was inordinately fond of cloth of gold. Ercole succeeded Borso as Duke of Ferrara in 1471; see Tuohy 1996, p. 9. Piponnier and Mane 1997, pp. 71–3, imply a start to the fashion for black as early as the end of the fourteenth century and relate it to the rise of black silks available in Italy. Philip the Good, Duke of Burgundy in the early fifteenth century, chose to be shown in black. For an overview see Harvey 1995, esp. chap. 2.

47 Brunello 1968, p. 154 on the Low Countries, p. 155 on Venetian *arte*.

48 Davanzo Poli 1997, p. 22. See particularly, Berveglieri 1988.

49 Davanzo Poli 1984, p. 60 (citing Mariegola no. 48 in Museo Correr).

50 For cultural categorization of purity and dirt see Douglas 1966.

51 For its later manifestation see Harvey 1995.

52 Frimmel 1888, pp. 92, 100 and *passim*. For the meaning of *al* or *dal naturale* see L. Syson, 'Introduction', in Mann and Syson 1998, p. 9.

53 Frimmel 1888, p. 96.

54 The border around *Sacred and Profane Love* has recently been certified as original by Lazzarini 1995b, p. 345. Dunkerton 1993, p. 30, points out that Mantegna's *Virgin and Child with the Magdalen and Saint John the Baptist*, in the National Gallery, London, has a 'painted border of black, flecked and

spattered with red'. In the move from the marmoreal hardness of fictive frame to yielding visual periphery, Raphael's example must have been crucial for Titian: the portrait of *Castiglione* (Paris, Louvre), a symphony of blacks, bears the blurred trace of a black painted margin along the bottom edge of the canvas.

55 Black borders may have been first introduced in Netherlandish painting on canvas: traces of one surround the *Crucifixion* sometimes attributed to Dieric Bouts in Brussels, Musées Royaux des Beaux-Arts, cat. no. 7, see Wolfthal 1989, pp. 43–4.

56 Lazzarini 1991, discussion of sample 21 on p. 176. It should be noted that Lazzarini describes the findings as 'preliminary'; there is some imprecision in the identification of the lakes.

57 On the optical production of warm and cool as consequence of transparency and opacity the comments in Eastlake 1847, still cannot be bettered; see esp. the 'Professional Essays' at the end of vol. II.

58 Sanudo 1903, vol. XXIV, col. 341; cited by Bistort 1912, p. 38.

59 See Levey 1983, and Levey and Payne 1983; a facsimile of the Venetian pattern-book with brief introduction and technical notes.

60 *De pictura*, bk. II, para. 47, Alberti 1972, pp. 90–91; see discussion of Alberti and Leonardo in Hall 1992, pp. 47–123.

61 Palumbo Fosati 1984, esp. pp. 14 and 31.

62 For gloves in portraits see Campbell 1990, p. 134.

63 Molmenti 1907, pt. II, vol., II, chap. 12, 'Fashions, Costume, and Head-Dress – Sumptuary Laws', is wide ranging on this topic.

64 Published in the influential pattern-book Pagan 1558; see also Levey 1983 and Urbani de Ghelthof 1882 (no pagination).

65 For an overview of the debate concerning Colonna's identity, particularly the controversial claims that he might be a Roman nobleman, see Brown 1996, appendix 1, pp. 287–90.

66 For literary sources see Fumagalli 1984.

67 A point made in the chapter on Colonna in Onians 1988, p. 12.

68 *Convivio*, ix. 13. According to the

Chadwyk-Healey CD-Rom, *Art Theorists of the Italian Renaissance*, which includes the best-known fifteenth- and sixteenth-century texts, in the *Hypnerotomachia* 'coloramento' occurs 34 times and 'coloratione' 23 times, while neither are used in any of the other texts.

69 Lib. I, cap. vii.

70 E.g. Lib. I, cap. vii, 'Et indi et quindi cum mensurata et digesta distantia et intervallo, cum gratiosi spatii compositamente . . .'

71 Davanzo Poli 1990. Texts in bk. I, chap. x, p. 119.

72 Pointed out by G. Pozzi in Colonna 1980, vol. II, p. 122, citing *Trattato di Architettura*, I.II, Venice 1551, 30r.

73 Davanzo Poli 1984, vol. I, glossary under *Zardin*.

CHAPTER 9

1 Cf. Dionisotti 1978, p. 268; Gage 1993, p. 95.

2 Pliny, *Natural History*, XXXV.XXXVI.91; see Gage 1993, chap. 2, 'The Fortunes of Apelles', esp. pp. 33–4. Gage observes that although Pietro Aretino, Anton Francesco Doni and Ludovico Dolce were aware of Pliny's account of Apelles, and although they compared Titian to Apelles, they did not imply that Titian adopted the four-colour palette that Pliny attributes to Apelles.

3 Landau and Parshall 1994, p. 88. Also a succinct account in Landau 1983.

4 Proem to bk. I, Philostratus 1929, p. 5. A copy of the *Imagines* was in Venice by 1415, see M. Baxandall in *Journal of the Warburg and Courtauld Institutes*, 27 (1964), p. 92. For an account of 'The Elder Philostratus's Response to Art' see Land 1994, chap. 2.

5 I follow Landau and Parshall 1994, pp. 261–4. For the attributions of drawings to Giorgione and Giulio Campagnola see Oberhuber 1993; for the influence of Dürer's prints on Titian see Oberhuber 1995.

6 Landau and Parshall 1994, p. 262.

7 Rosand and Muraro 1976, cat. no. 4, pp. 70–87.

8 For Tuscan use of *biacca* to create *rilievo* see Baxandall 1995, appendix on pp. 149–51.

9 Landau and Parshall 1994, p. 180.

10 Landau and Parshall 1994, pp. 180–202.

11 Rosand and Muraro 1976, print the text of Ugo's petition on p. 36 n.14; for *Saint Jerome* see cat. no. 6, pp. 92–3, also Landau and Parshall 1994, p. 150.

12 Aretino 1957, vol. II, pp. 16–18.

13 For *contrapposto* as a pervasive principle of antithesis see Summers 1977.

14 'Del lume, ultima parte et anima del colorire . . .' *Dialogo di pittura di messer Paolo Pino*, printed in Barocchi 1960, vol. I, p. 118.

15 'É la principal parte del colorito il contendimento, che fa il lume con l'ombra', Roskill 1968, p. 142. Dolce was a friend of Titian; his *Aretino* was published in Venice in 1557.

16 According to Dolce, see Roskill 1968, p. 184.

17 Reali 1858, p. 12.

18 For optical mixture in mosaic see Gage 1993, p. 42.

19 For the relationship between Titian and mosaic see Hetzer 1935, and the summary in Demus 1984, vol. I, pp. 227–8.

20 For fabrics on the walls, even in the houses of artisans, see Palumbo Fosati 1984, p. 34.

21 Kemp 1989, p. 214.

22 Dennis Romano made this point at the University of Warwick's Symposium in Venice, 1993.

23 Cartwright 1905, p. 202.

24 M. Simonetti, 'Tecniche della pittura veneta', in Lucco 1989, vol. I, p. 247.

25 Barocchi 1971–7, vol. II, p. 1619: 'il colore non bianco tanto che tenda al pallore, ma misto con sangue; se è bruna, non è deforme: di questo colore era Venere et ad Ovidio non dispiacque.' Barocchi cites other sixteenth-century texts affirming the necessity of some red or brown in flesh, p. 1619 n.2.

26 Frimmel 1888, p. 96.

27 Translation from Roskill 1968, p. 153, with Italian on p. 152. Gage 1993, p. 34, points out that reference to Apelles would have come via Dolce's reading of Pliny as well as his familiarity with the *Libellus de Coloribus* by Anthonius Thylesius, Venice 1528.

28 Translation from Roskill 1968, p. 209, with Italian on p. 208.

29 For wider consideration of how painters acknowledged the presence of an observer see Shearman 1992, especially chaps. 1, 2 and 3.

30 For a fuller, slightly different, discussion see Freedman 1989.

31 I use the translations of Brown 1996, p. 254, and am indebted to her commentary. The Latin texts read 'Umbre transitus est tempus nostrum', and 'Sola virtus clara aeterna que habetur'.

32 See Wollheim 1987, chap. 7, 'Painting, Metaphor and the Body: Titian, Bellini, De Kooning, etc.'

33 Vasari 1878–95, vol. IV, p. 97, 'colorite vivacissimamente'. For recent findings on Giorgione's technique see Anderson 1997.

34 As Onians 1988, p. 209, has pointed out, Colonna, as well as deploying a comparison between the Orders and musical modes, argues that the way an architect modulates and divides up a building is analogous to the way a musician chooses the key (*intonatione*), the tempo, and chromatic divisions (*chromatice minute*).

35 Gauricus 1969, pt. III, *De Physiognomia*, pp. 129–63.

36 Land 1994, chap. 5.

37 Philostratus 1929, p. 3.

38 Philostratus 1929, pp. 123–5.

39 'Seeing Colour' in Lamb and Bourriau 1995, p. 134.

40 Philostratus describes the scene in bk. 1.6, 'Cupids', where he dwells on the variety of tints in apples ('golden and red and yellow') and in the wings of cupids, in embroidered mantles and jewels.

41 Bull 1976, p. 124; Aretino 1957, vol. I, pp. 78–9.

42 Freedman 1995, p. 88. I am indebted to Freedman's account, and to the lucid discussion of 'Pietro Aretino's Art Criticism' in chap. 6 of Land 1994.

43 Padoan 1990.

44 Roskill 1968, pp. 116–17 (p. 17 of the 1557 edition).

45 Roskill 1968, pp. 154–5 (p. 36 of the 1557 edition): 'Altri in contrario non sanno imitar la diversità delle tinte de' panni, ma pongono solamente i colori pieni, come essi stanno . . .'

46 From the letter to Gasparo Ballini, first published in 1559; Roskill 1968, pp. 208–9.

47 My principle sources for conservation findings on Titian's technique are: Plesters 1978b; Lank 1982; Jaffé and Groen 1987; Lazzarini 1987; Cordaro, Giantomassi and Zavi, 1988; Nepi Scirè 1990; Spezzani 1990; Lazzarini 1991; Volle 1993; Dunkerton 1994; Lazzarini 1995b.

48 Glue layers have been reported on the *Assumption of the Virgin* in the Frari, the Averoldi Polyptych in Brescia and the *Presentation of the Virgin* in the Accademia in Venice.

49 Lazzarini 1995b, p. 345.

50 For a wide-ranging discussion see Hout 1998.

51 Lazzarini 1987, table on p. 135.

52 Lank 1982, p. 405.

53 Plesters 1978b, p. 38.

54 Frimmel 1888, p. 80: 'Sono molti anni che la fece et è contornata aparentemente cun li reflexi fieri mal uniti cun le meze tente.'

55 It is noteworthy that Lorenzo Lotto adopted a grey imprimatura for his *Saint Nicholas* altarpiece in the Carmini in Venice (1527–9): Lazzarini 1987, p. 134.

56 I have adopted the spelling of *berettino* preferred by historians of maiolica, however in the sources it often appears as *beretino* or *beretin*.

57 Lotto 1969, p. 232.

58 Rylands 1991, p. 350: 'Un quaro de ca. q. 7 dato de zesso beretin' (and three similar entries).

59 Alverà Bortolotto 1981, pp. 51–4; Ericani and Marini 1990; Wilson 1987, pp. 108–111.

60 An early example may be the tiled floor of the Cappella Lando in San Sebastiano, which is dated 1510, but whether these tiles were executed locally or imported from Faenza is uncertain. Alverà Bortolotto 1981, p. 51, argues that the floor is probably Venetian, 'di lavoro policromo con il fondo eseguito in quel venezianissimo color azzurognolo'. For colour plates and commentary see Quinterio n.d., pp. 108–13.

61 See Wilson 1989, cat. no. 25, pp. 58–9.

62 The manuscript, dating from 1556–9, is in the library of the Victoria and Albert Museum, London. The most recent edition is Piccolpasso 1980.

63 F.46r.

64 F.42r.; translation in Piccolpasso 1980, p. 81; the 'milled white' is made from a mixture of *marzacotto* with a smaller quantity of tin (*stagnio*).

65 Roskill 1968, p. 142. Paolo Pino tells how a mother, whose daughter he is painting, complains to him that 'my daughter doesn't have a spot [*macchia*] beneath her nose', to which he replies that it is not a spot but a shadow. The mother's conviction that the painter has laid a blemish upon her daughter encapsulates the difference between the uninformed view of the painter's marks and spots as literal and the informed view of them as pictorial. Barocchi 1960, vol. 1, p. 134. For the later history of *macchia* and brushstroke see Sohm 1991.

66 For an overview see Mendelsohn 1964; p. 26 for Vesalius, referring to the *Fabrica*, bk. VI.

67 Girolamo Cardano's account of the agency of fire and heat is notable: for an introduction see A. Ingegno, 'The New Philosophy of Nature', in Schmitt 1988, pp. 236–63.

68 Pre-eminent amongst Venetian publications on gunpowder and pyrotechnics is Biringuccio 1540.

69 I am not aware that any cross-sections of the painting have been published, therefore it would be rash to suggest that this oatmeal tint is a general imprimatura.

70 Dunkerton 1994, p. 73

BIBLIOGRAPHY

Ackerman, J. 1980. 'On Early Renaissance Color Theory and Practice', *Studies in Italian Art and Architecture: Fifteenth through Eighteenth Centuries*, Memoirs of the British Academy in Rome, XXV, ed. H. A. Millon, Rome, pp. 11–44 (repr. with postscript in J. S. Ackerman, *Distance Points*, Cambridge, Mass., 1994. pp. 151–84).

Adorno, T. 1984. *Aesthetic Theory*, trans. L. Lenhardt, London and New York.

Alberti, L. B. 1972. *On Painting*, ed. C. Grayson, Oxford.

Albertus Magnus 1967. *Book of Minerals*, trans. Dorothy Wyckoff, Oxford.

Alexander, J. J. G. 1977. *Italian Renaissance Illuminations*, London.

Alexander, J. J. G., ed. 1994. *The Painted Page: Italian Renaissance Book Illumination 1450–1550*, London (catalogue of exhibition at the Royal Academy of Arts).

Alpers, S. 1983. *The Art of Describing*, Chicago.

Alverà Bortolotto, A. 1981. *Storia della Ceramica a Venezia*, Florence.

Ames-Lewis, F. 1984. 'Matteo de' Pasti and the Use of Powdered Gold', *Mitteilungen des Kunsthistorischen Institutes in Florenz*, XXVIII, pp. 351–64.

Ames-Lewis, F., and Rogers, M., eds. 1998. *Concepts of Beauty in Renaissance Art*, Aldershot.

Anderson, J. 1997. *Giorgione: The Painter of 'Poetic Brevity'*, Paris and New York.

Andrescu, I. 1984. 'Torcello IV. Cappella Sud, mosaici: cronologia relativa, cronologia assoluta e analisi delle paste vitree', in *III Colloquio internazionale sul mosaico antico* (Ravenna, 6–10 September 1980), pp. 542–50.

Aragnina, M. E. 1996. 'La tecnica pittorica di Pisanello attraverso le fonti e l'analisi delle opere veronesi', in *Pisanello*, Verona, pp. 465–76 (catalogue of an exhibition at Castelvecchio).

Aretino, P. 1957. *Lettere sull'arte di Pietro Aretino*, ed. E. Camesasca, 2 vols., Milan.

Aretino, P. 1960. *Lettere*, ed. F. Flora, Milan.

Arnaldi, G., and Stocchi, M. P., eds. 1980–81, *Storia della cultura veneta*, pt. 3, vols. I–III, *Dal primo quattrocento al Concilio di Trento*, Vicenza.

Arslan, E. 1971. *Gothic Architecture in Venice*, London.

Barasch, M. 1978. *Light and Color in the Italian Renaissance Theory of Art*, New York.

Barbaro, D., ed. 1556, *I dieci libri della Architettura di Vitruvio . . .*, Venice.

Barbina, A. 1969. *Concordanze del 'Decameron'*, Florence.

Barocchi, P., ed. 1960. *Trattati d'arte del Cinquecento*, 3 vols., Bari.

Barocchi, P., ed. 1971–7, *Scritti d'arte del Cinquecento*, 3 vols., Milan and Naples.

Barral I Altet, X. 1985. *Les Mosaïques de pavement medievales de Venise, Murano, Torcello*, Paris.

Baxandall, M. 1963. 'A Dialogue on Art from the Court of Leonello d'Este: Angelo Decembrio's *De politia literaria* Pars LXVIII', *Journal of the Warburg and Courtauld Institutes*, 26, pp. 304–26.

Baxandall, M. 1971. *Giotto and the Orators*, Oxford.

Baxandall, M. 1972. *Painting and Experience in Fifteenth-Century Italy*, Oxford.

Baxandall, M. 1985. *Patterns of Intention*, New Haven and London.

Baxandall, M. 1995. *Shadows and Enlightenment*, New Haven and London.

Belting, H. 1985. *Giovanni Bellini Pietà: Ikone und Bilderzählung in der venezianischen Malerei*, Frankfurt.

Belting, H. 1994. *Likeness and Presence: A History of the Image before the Era of Art*, Chicago.

Benazzi, G., et al. 1991. *Vetrate: arte e restauro. Dal trattato di Antonio da Pisa alle nuove tecnologie di restauro*, Milan.

Benjamin, A. 1991. 'Spacing and Distancing', in *Art, Mimesis and the Avant-Garde*, London, pp. 43–59.

Bennett, J. A. W. 1982. *Poetry of the Passion: Studies in Twelve Centuries of English Verse*, Oxford.

Bercken, E. von der. 1914. *Untersuchungen zur Geschichte der Farbengebung in der venezianischen Malerei*, Parchim.

Berveglieri, R. 1988. 'L'arte dei tintori e il nero di Venezia', in Davanzo Poli 1988, pp. 55–61.

Bevilacqua, E. 1980. 'Geografi e Cosmografi', in Arnaldi and Stocchi 1980–81, 3/II, pp. 355–74.

Biringuccio, V. 1540, *De la pirotechnia*, Venice.

Bistort, G. 1912. *Il Magistrato alle Pompe nella Republica di Venezia*, Venice.

Blagrove, G. H. 1888, *Marble Decoration*, London.

Boni, G. 1883, 'Il colore sui monumenti', *Archivio Veneto*, 25, pp. 344–60.

Boni, G. 1887. 'La Ca d'Oro e le sue decorazioni policrome', *Archivio Veneto*, 34, pp. 115–32.

Bridgeman, J. 1998. '"Condecenti et netti": Beauty, Dress and Gender in Italian Renaissance Art', in Ames-Lewis and Rogers 1998, pp. 44–51.

Brown, C. M. 1982. *Isabella d'Este and Lorenzo da Pavia*, Travaux d'Humanisme et Renaissance, CLXXXIX, Geneva.

Brown, P. F. 1988. *Venetian Narrative Painting in the Age of Carpaccio*, New Haven and London.

Brown, P. F. 1996. *Venice and Antiquity: The Venetian Sense of the Past*, New Haven and London.

Brunello, F. 1968. *L'arte della tintura nella storia dell'umanità*, Vicenza.

Brusatin, M. 1993. 'Pierre et ligne d'azur', in *Azur*, preface by H. Chandès, Paris, pp. 70–80 (catalogue of exhibition at Fondation Cartier).

Bull, G. trans. 1976. *Aretino: Selected Letters*, Harmondsworth.

Burckhardt, J. 1960. *The Civilization of the Renaissance in Italy*, trans. S. G. C. Middlemore, New York.

Butazzi, G. 1997. 'Considerations on the Profession of Tailor in the Republic of Venice', in Davanzo Poli 1997, pp. 46–9.

Campbell, L. 1990. *Renaissance Portraits*, New Haven and London.

Caniato, G., and dal Borgo, M. 1990. *Le arti edili a Venezia*, Rome.

Carboni, S. 1989. 'Oggetti decorati a smalto di influsso islamico nella vetraria muranese: tecnica e forma', in *Arte Veneziana e Arte Islamica*, ed. E. J. Grube Venice, pp. 147–66.

Cardon, D. 1989. 'Mediterranean Kermes and Kermes-Dyeing', in *Dyes in History and Archaeology*, Acts of 7th meeting (York 1988), pp. 508ff.

Cartwright, J. 1905. *Beatrice d'Este, Duchess of Milan, 1475–1497*, London.

Casini, M. 1996. *I gesti del principe: la festa politica a Firenze e Venezia in età rinascimentale*, Venice.

Castelnuovo, E. 1982. *La grande vetrata di SS. Giovanni e Paolo*, Venice.

Cecchetti, B. 1886, 'La donna nel medioevo a Venezia', *Archivio Veneto*, 31, pp. 38–69, 307–45.

Chambers, D., Martineau. J., and Signorini, R. 1992. 'Mantegna and the Men of Letters', in *Andrea Mantegna*, ed. J. Martineau, London, pp. 8–31 (catalogue of exhibition at the Royal Academy of Arts).

Chambers, D., and Pullan, B. 1992. *Venice: A Documentary History, 1450–1630*, Oxford.

Chatzidakis, N. 1993. *From Candia to Venice: Greek Icons in Italy, Fifteenth–Sixteenth Centuries*, Athens.

Clarke, T. H. 1974. 'Lattimo: A Group of Venetian Glass Enamelled on an Opaque-White Ground', *Journal of Glass Studies*, XVI, pp. 22–56.

Collareta, M. 1984. '"Encaustum vulgo smaltum": note sulla percezione umanistica delle tecniche figurative', in *Annali della Scuola Normale Superiore di Pisa*, ser. 3, XIV/2, pp. 759–69.

Colonna, F. 1980. *Hypnerotomachia Poliphili*, ed. G. Pozzi and L. C. Ciapponi, 2 vols. Medioevo e Umanesimo, 38–9, Padua (reissue of edition of 1968 in smaller format).

Concina, E. 1995. *Storia dell'architettura di Venezia*, Milan.

Connell, S. 1972. 'Books and Their Owners in Venice, 1345–1480', *Journal of the Warburg and Courtauld Institutes*, 35, pp. 163–86.

Connell, S. 1988. *The Employment of Sculptors and Stone-Masons in Venice in the Fifteenth Century*, New York.

Cook, E. T., and Wedderburn A., eds., 1903–12, *The Works of John Ruskin*, 39 vols., London.

Cordaro, M., Giantomassi, C., and Zavi, D. 1988. 'La pala Gozzi di Tiziano', *Critica d'Arte*, 53, ser. 5, no. 17, pp. 63–71.

Cormack, R. 1997. *Painting the Soul: Icons, Death Masks and Shrouds*, London.

Cozzi, G., Knapton, M., and Scarabello, G. 1992. *La Repubblica di Venezia nell'età moderna: dal 1517 alla fine della Repubblica*, Turin.

Cristinelli, G., ed. 1992. *Restauro e techniche: saggi e ricerche sulla costruzione dell'architettura a Venezia*, Venice.

Crovato, A. 1989. *I pavimenti alla Veneziana*, Venice.

Damisch, H. 1972. *Théorie du nuage*, Paris.

Da Mosto, A. n.d. *I dogi di Venezia nella vita pubblica e privata*, Milan (repr. Florence 1983).

Darrah, J. A. 1998. 'White and Golden Tin Foil in Applied Relief Decoration, 1240–1530', in Hermens 1998, pp. 49–80.

Davanzo Poli, D. 1984. *I mestieri della moda a Venezia nei secoli XIII–XVIII: Documenti*, 2 vols., Venice.

Davanzo Poli, D. 1988. *I mestieri della moda a Venezia*, Venice.

Davanzo Poli, D. 1990. 'Tessuti e ricami nel giardino di seta di Polifilo', in *Le vie della seta a Venezia*, ed. G. Curatola, Rome, pp. 79–86.

Davanzo Poli, D. 1993. 'La produzione serica a Venezia', in *Tessuti nel Veneto, Venezia e la Terraferma*, eds. G. Ericani and P. Fruttaroli, Verona.

Davanzo Poli, D., ed. 1997. *The Arts and Crafts of Fashion in Venice, from the Thirteenth to the Eighteenth Century*, London 1997 (the Italian edition, Davanzo Poli 1988, is fuller and more reliable for terminology).

Davanzo Poli, D., and Moronato, S. 1994. *Le stoffe dei veneziani*, Venice.

Dellwing, H. 1990. *Die Kirchenbaukunst des späten Mittelalters in Venetien*, Worms.

Demus, O. 1948. *Byzantine Mosaic Decoration*, London.

Demus, O. 1984. *The Mosaic Decoration of San Marco, Venice*, 4 vols., Chicago and London.

Demus, O. 1988. *The Mosaic Decoration of San Marco, Venice*, ed. H. Kessler, Chicago and London.

Didi-Huberman, G. 1990. *Fra Angelico: dissemblance et figuration*, Paris.

Dionisotti, C. 1978. 'Tiziano e la letteratura', in *Tiziano e il manierismo europeo*, ed. R. Pallucchini, Florence.

Dorigato, A., ed. 1993. *Carpaccio, Bellini, Tura, Antonello e altri restauri quattrocenteschi della Pinacoteca del Museo Correr*, Milan.

Dorsch, T. S. 1965. *Classical Literary Criticism*, Harmondsworth.

Douglas, M. 1966. *Purity and Danger*, London.

Dreier, F. A. 1989. *Venezianische Gläser*, Berlin.

Dunkerton, J. 1987. 'The Unmasking of Tura's *Allegorical Figure*: A Painting and its Concealed Image', *National Gallery Technical Bulletin*, 11, pp. 5–35.

Dunkerton, J. 1993. 'Mantegna's Painting Techniques', in *Mantegna and Fifteenth-Century Court Culture*, ed. F. Ames-Lewis and A. Bednarek, London, pp. 26–38.

Dunkerton, J. 1994. 'Developments in Colour and Texture in Venetian Painting of the Sixteenth Century' in *New Interpretations of Venetian Painting*, ed. F. Ames-Lewis, London, pp. 63–76.

Dunkerton, J., Foister, S., Gordon, D., and Penny, N. 1991. *Giotto to Dürer: Early Renaissance Painting in the National Gallery*, London.

Dunkerton, J., and Penny, N. 1995. 'Noli me tangere', in *Tiziano: Amor Sacro e Amor Profano*, Milan, pp. 364–7 (exhibition catalogue).

Dunkerton, J., and Roy, A. 1986. 'The Technique and Restoration of Cima's *Incredulity of Saint Thomas*', *National Gallery Technical Bulletin*, 10, pp. 4–27.

Eastlake, C. L. 1847, *Materials for a History of Oil Painting*, London (reissued as *Methods and Materials of the Great Schools and Masters*, New York 1960).

Eisler, C. 1989. *The Genius of Jacopo Bellini,* New York.

Ellis, H., ed. 1851, *The Pylgrymage of Syr R. Guylforde, Knyght, to the Holy Land, A.D. 1506*, The Camden Society, no. 51, London.

Ericani, G., and Marini, P., eds. 1990. *La ceramica nel Veneto: La Terraferma dal XIII al XVIII secolo*, Verona.

Ericani, G., and Frattaroli, P. 1993. *Tessuti nel Veneto*, Verona.

Favaretto, I. 1990. *Arte antica e cultura antiquaria nelle collezione venete al tempo della Serenissima*, Rome.

Favaro, E. 1975. *L'arte dei pittori in Venezia e i suoi statuti*, Florence.

Feller, R. L., ed. 1986. *Artists' Pigments: A Handbook of their History and Characteristics* vol. 1, Cambridge.

Fletcher, J. 1990. 'Harpies, Venus and Giovanni Bellini's Classical Mirror: Some Fifteenth-Century Venetian Painters' Responses to the Antique', in *Venezia e l'archeologia* ed. G. Traversari (*Rivista di Archeologia*, suppl. 7) Rome, pp. 170–76.

Fogolari, G. 1924. 'La Chiesa della Carità', *Archivio veneto-tridentino*, v, pp. 57–118.

Fóti, V. M. 1990. 'The Dimension of Colour', *International Studies in Philosophy*, XXII/3, pp. 13–28 (repr. in G. A. Johnson, ed., *The Merleau-Ponty Aesthetics Reader*, Evanston 1993, pp. 293–308).

Freedman, L. 1989. '*The Schiavona*: Titian's Response to the Paragone between Painting and Sculpture', *Arte Veneta*, 41, pp. 31–40.

Freedman, L. 1995. *Titian's Portraits through Aretino's Lens*, University Park, Pa.

Frescobaldi, L. 1944. *Viaggio in Terrasanta*, ed. C. Angelini, Florence.

Frimmel, T., ed. 1888, *Der Anonimo Morelliano*, Vienna.

Frodl-Kraft, E. 1970. *Die Glasmalerei*, Vienna and Munich.

Fumagalli, E. 1984. 'Francesco Colonna lettore di Apuleio e il problema della datazione dell' Hypnerotomachia Poliphili', *Italia Medioevale e Umanistica*, XXVII, pp. 233–66.

Gadamer, H. 1979. *Truth and Method*, 2nd English edn., London.

Gaeta F. 1981. 'L'idea di Venezia', in Arnaldi and Stocchi 1980–81, 3/III, pp. 565–641.

Gage, J. 1978. 'Colour in History: Relative and Absolute', *Art History*, I, pp. 104–30.

Gage, J. 1981. 'A *Locus Classicus* of Colour Theory: The Fortunes of Apelles', *Journal of the Warburg and Courtauld Institutes*, 44, pp. 1–26.

Gage, J. 1982. 'Gothic Glass: Two Aspects of a Dionysian Aesthetic', *Art History*, 5, pp. 36–58.

Gage, J. 1993. *Colour and Culture: Practice and Meaning from Antiquity to Abstraction*, London.

Gargan, L. 1992. 'Oliviero Forzetta e la nascita del collezionismo nel veneto', in *La pittura nel veneto: il Trecento*, ed. M. Lucco, Milan.

Gargiolli, G. 1868. *L'arte della seta in Firenze*, Florence.

Gauricus, Pomponius, 1969. *De sculptura*, ed. A. Chastel and R. Klein, Geneva.

Gentilini, G. 1992. *I Della Robbia: la scultura invetriata del rinascimento*, Florence.

Gibson, J. J. 1968. *The Senses Considered as Perceptual Systems*, London.

Gibson, J. J. 1979. *The Ecological Approach to Visual Perception*, Boston, Mass.

Gilbert, C. 1980. *Italian Art, 1400–1500*, Englewood Cliffs, NJ.

Goffen, R. 1989. *Giovanni Bellini*, New Haven and London.

Goldthwaite, R. A. 1980. *The Building of Renaissance Florence*, Baltimore and London.

Gombrich, E. H. 1974. 'The Sky Is the Limit: The Vault of Heaven and Pictorial Vision', in *Perception: Essays in Honor of J. J. Gibson*, Ithaca, pp. 84–94; (repr. in E. H. Gombrich, *The Image and the Eye*, Oxford 1982, pp. 162–71).

Gombrich, E. H. 1976. *The Heritage of Apelles*, Oxford.

Gordon, I. E. 1989. *Theories of Visual Perception*, New York.

Gosselin, E. A. 1991. 'The "Lord God's" Sun in Pico and Newton', in *Renaissance Society and Culture*, ed. J. Monfasani and R. G. Musto, New York, pp. 51–8.

Gould, C. 1958. 'A Famous Titian Restored', *Burlington Magazine*, C, pp. 44–8.

Gould, C. 1975. *The Sixteenth-Century Italian Schools* (National Gallery Catalogues), London.

Goy, R. J. 1992. *The House of Gold: Building a Palace in Renaissance Venice*, Cambridge.

Griffo, G. C. D. 1988. 'Cronache di moda illustri: Marin Sanudo e le vesti veneziane tra Quattro e Cinquecento', in *Il costume dell'età del Rinascimento*, ed. D. L. Bemporad, Florence, pp. 259–72.

Hahnloser, H. R. 1956. 'Scola et artes cristellariorum de Veneciis, 1284–1319. Opus venetum ad filum', in *Venezia e l'Europa*, Atti del XVIII Congresso Internazionale di Storia dell'Arte, 1955, Venice, pp. 157–65.

Hahnloser, H. R. 1971. *Il Tesoro di San Marco*, 2 vols., Florence.

Hall, M. 1992. *Color and Meaning: Practice and Theory in Renaissance Painting*, Cambridge.

Hardin, C. L. 1988. *Color for Philosophers: Unweaving the Rainbow*, Indianapolis.

Harding, C. 1989. 'The Production of Medieval Mosaics: The Orvieto Evidence', *Dumbarton Oaks Papers*, 43, pp. 73–102.

Harrison, M. 1989. *A Temple for Byzantium: The Discovery and Excavation of Anicia Juliana's Palace Church in Istanbul*, Austin, Tex.

Harvey, J. 1995. *Men in Black*, London.

Hempel, K., and G. 1980. 'A Technical Report on the Condition of the Porta della Carta and its Restoration by the Venice in Peril Fund', in *The Restoration of the Porta della Carta*, ed. S. Romano, Venice.

Hermens, E., ed. 1998. *Looking Through Paintings* (*Leids Kunsthistorisch Jaarboek*, XI), Baarn and London.

Hetzer, T. 1935. *Tizian, Geschichte seiner Farbe*, Frankfurt.

Heyd, W. 1885–6, *Histoire du commerce du Levant au Moyen-Age*, 2 vols., Leipzig.

Hills, P. 1987. *The Light of Early Italian Painting*, New Haven and London.

Hind, A. M. 1935. *An Introduction to a History of Woodcut*, 2 vols., New York.

Hobson, A. 1989a, 'Islamic Influence on Venetian Renaissance Bookbinding', in *Arte Veneziana e Arte Islamica*, ed. J. Grube, Venice, pp. 111–24.

Hobson, A. 1989b, *Humanists and Bookbinders: The Origin and Diffusion of the Humanistic Bookbinding, 1459–1559*, Cambridge.

Hout, N. van. 1998. 'Meaning and Development of the Ground Layer in Seventeenth-Century Painting', in Hermens 1999, pp. 199–225.

Howard, D. 1980. *The Architectural History of Venice*, London.

Humfrey, P. 1993. *The Altarpiece in Renaissance Venice*, New Haven and London.

Humfrey, P. 1995. *Painting in Renaissance Venice*, New Haven and London.

Huse, N., and Wolters, W. 1990. *The Art of Renaissance Venice: Architecture, Sculpture, and Painting, 1460–1590*, Chicago.

Ilardi, V. 1976. 'Eyeglasses and Concave Lenses in Fifteenth-Century Florence and Milan: New Documents', *Renaissance Quarterly*, XXIX, pp. 341–59.

Jacoby, D. 1993. 'Raw Materials for the Glass Industries of Venice and the Terraferma, c.1370–c.1460', *Journal of Glass Studies*, 35, pp. 65–90.

Jaffé, M., and Groen, K. 1987. 'Titian's *Tarquin and Lucretia* in the Fitzwilliam', *Burlington Magazine*, 129, pp. 162–72.

James, L. 1996. *Light and Colour in Byzantine Art*, Oxford.

Jay, M. 1993. *Downcast Eyes: The Denigration of Vision in Twentieth-Century French Thought*, Berkeley and Los Angeles.

Katz, D. 1935. *The World of Colour*, London.

Kemp, M., ed. 1989. *Leonardo on Painting*, New Haven and London.

King, M. 1986. *Venetian Humanism in an Age of Patrician Dominance*, Princeton.

Kirby, J., and White, R. 1996. 'The Identification of Red Lake Pigment Dyestuffs and a Discussion of their Use', *National Gallery Technical Bulletin*, 17, pp. 56–80.

Kovesi Killerby, C. 1994. 'Practical Problems in the Enforcement of Italian Sumptuary Law, 1200–1500', in *Crime, Society and the Law*, ed., T. Dean, Cambridge, pp. 99–120

Kristeller, K. O. 1983. 'Marsilio Ficino e Venezia', in *Miscellanea di studi in onore di Vittore Branca*, Biblioteca dell' Archivum Romanicum, ser. 1, CLXXXI), III/2, Florence, pp. 475–92.

Kristeva, J. 1981. *Desire in Language*, Oxford.

Lacan, J. 1977. *The Four Fundamental Concepts of Psycho-Analysis*, trans. A. Sheridan, London.

Lamb, T., and Bourriau, J. 1995. *Colour: Art and Science*, Cambridge.

Land, N. 1994. *The Viewer as Poet: The Renaissance Response to Art*, University Park, Pa.

Landau, D. 1983. 'Printmaking in Venice and the Veneto', in *The Genius of Venice*, ed. C. Hope and J. Martineau, London, pp. 303–5 (catalogue of exhibition at the Royal Academy of Arts).

Landau, D., and Parshall, P. 1994. *The Renaissance Print, 1470–1550*, New Haven and London.

Lank, H. 1982. 'Titian's *Perseus and Andromeda*: Restoration and Technique', *Burlington Magazine*, 124, pp. 400–406.

Lazzarini, L. 1978. 'La frequenza, le cause e forme di degrado dei marmi e delle pietre di origine greca a Venezia', *Quaderni della Soprintendenza ai Beni Artistici e Storici di Venezia*, 7, pp. 139–50.

Lazzarini, L. 1983. 'Le analisi di laboratorio', in *Quaderni della Soprintendenza ai Beni Artistici e Storici di Venezia*, 3, pp. 23–7.

Lazzarini, L. 1987. 'The Use of Color by Venetian Painters, 1480–1580: Materials and Techniques', in *Color and Technique in Renaissance Painting: Italy and the North*, ed. M. B. Hall, New York, pp. 115–36.

Lazzarini, L. 1991. 'Indagini preliminari di laboratorio', in *Il polittico Averoldi di Tiziano restaurato*, ed. E. L. Ragni and G. Agosti, Brescia, pp. 173–77.

Lazzarini, L. 1995a, 'Nuovi studi tecnico-scinetifico sui rilievi degli arconi della Basilica Marciana', in *Le sculture esterne di San Marco*, ed. O. Demus, Milan, pp. 228–34.

Lazzarini, L. 1995b. 'Indagini scientifiche sui materiali e la tecnica pittorica dell' *Amor Sacro e Profano* di Tiziano', in *Tiziano: Amor Sacro e Amor Profano*, Milan, pp. 21–33.

Lefebvre, H. 1991. *The Production of Space*, trans. by D. Nicholson Smith, Oxford.

Lepori, F. 1980. 'La Scuola di Rialto dalla fondazione alla metà del cinquecento', in Arnaldi and Stocchi 1980–81, 3/II, pp. 539–605.

Levey, S. M. 1983. *Lace: A History*, Leeds.

Levey, S. M., and Payne, P. C. 1983. *Le pompe, 1559. Patterns for Venetian Bobbin Lace*, Bedford.

Lichtenstein, J. 1993. *The Eloquence of Color: Rhetoric and Painting in the French Classical Age*, Los Angeles.

Liefkes, R., ed. 1997. *Glass*, London.

Lippincott, K. 1993. 'Mantegna and the *scientia* of Painting', in *Mantegna and Fifteenth-Century Court Culture*, ed. F. Ames-Lewis and A. Bednarek, Birkbeck College, London, pp. 45–55.

Longo, O., ed. 1998. *La porpora: realtà e immaginario di un colore simbolico*, Atti del Convegno di Studi, Istituto Veneto, 1996, Venice.

Lorenzi, G. 1868, *Monumenti per servire alla storia del Palazzo Ducale di Venezia*, Venice.

Lotto, Lorenzo 1969. *Libro di spese diverse (1538–1556)*, ed. P. Zampetti, Civiltà Veneziana, Fonti e Testi, IX, ser. i, 6, Venice and Rome.

Lowry, M. 1991. *Nicholas Jenson*, Oxford.

Lucco, M., ed. 1989. *La pittura nel Veneto: il Quattrocento*, 2 vols., Milan.

Luchs, A. 1995. *Tullio Lombardo and Ideal Portrait Sculpture in Renaissance Venice, 1490–1530*, Cambridge.

Ludwig, G. 1911. 'Restello, Spiegel und Toilettenutensilien in Venedig zur Zeit der Renaissance', *Italienische Forschungen*, 4, pp. 185–361.

Mabillon, J. 1896. *Life and Works of St Bernard*, vol. IV, London.

Maccagni, C. 1981. 'Le scienze nello Studio di Padova e nel Veneto', in Arnaldi Stocchi 1980–81, 3/II, pp. 135–71.

Mack, P. 1992. 'Agricola's Use of the Comparison between Writing and the Visual Arts', *Journal of the Warburg and Courtauld Institutes*, 55, pp. 169–79.

Mack, P. 1993. *Renaissance Argument: Valla and Agricola in the Traditions of Rhetoric and Dialectic*, Leiden.

Mancini, M. 1996. 'I colori della bottega: sui commerci di Tiziano e Orazio Vecellio con la corte di Spagna', *Venezia Cinquecento*, VI, pp. 163–79

Mango, C., 1972. *The Art of the Byzantine Era, 312–1453*, Englewood Cliffs, NJ.

Mann, N., and Syson, L., eds. 1998. *The Image of the Individual: Portraits in the Renaissance*, London.

Marcello, C. 1508, *De anima*, Venice (repr. Farnborough 1969).

Mariani Canova, G. 1972. 'Riflessioni su Jacopo Bellini e sul libro dei disegni del Louvre', *Arte Veneta*, 36, pp. 9–30.

Mariani Canova, G. 1984. 'Presenza dello smalto traslucido nel Veneto durante la prima metà del Trecento', in *Annali della Scuola Normale Superiore di Pisa*, ser. 3, XIV/2, pp. 733–56.

Marin, L. 1995. *To Destroy Painting*, Chicago and London.

Martineau, J., ed. 1992. *Andrea Mantegna*, London (catalogue of an exhibition at the Royal Academy of Arts).

McDannell, C., and Lang, B. 1988. *Heaven: A History*, New Haven and London.

McKenzie, A. K. 1912. *Concordanza delle rime di Francesco Petrarca*, Oxford.

Meiss, M. 1945 'Light as Form and Symbol in Some Fifteenth-Century Paintings', *Art Bulletin*, XXVII, pp. 175–81, (repr. in *The Painter's Choice: Problems in the Interpretation of Renaissance Art*, New York 1976. pp. 3–18).

Meiss, M. 1957. *Andrea Mantegna as Illuminator*, New York.

Melczer, W. 1994. 'Il Neoplatonismo nel Veneto nell'epoca di Giorgione (1490–1510)', in *I tempi di Giorgione*, ed. Ruggero Maschio, Rome, pp. 64–72.

Mendelsohn, E. 1964. *Heat and Life: The Development of the Theory of Animal Heat*, Cambridge, Mass.

Merleau-Ponty, M. 1962. *Phenomenology of Perception*, trans. Colin Smith, London.

Merleau-Ponty, M. 1964. *Le Visible e l'invisible*, Paris.

Merrifield, M. P. 1849, *Original Treatises on the Arts of Painting*, 2 vols., London.

Meyer zur Capellen, J. 1985. *Gentile Bellini*, Stuttgart.

Michler, J. 1989. 'La Cathédrale Notre Dame de Chartres: reconstitution de la polychromie originale de l'intérieur', *Bulletin Monumental*, 147/1, pp. 117–31.

Michler, J. 1990. 'Grundlagen zur Gotischen Wandmalerei', *Jahrbuch der Berliner Museen*, 32, pp. 85–136.

Mitchell, C. 1969. 'Archaeology and Romance in Renaissance Italy', *Italian Renaissance Studies*, ed. E. F. Jacob, London, pp. 455–84.

Molmenti, P. 1907. *Venice*, trans. Horatio Brown, pt. II, vol. II, London.

Monticolo, G. 1896–1914. *I Capitolari delle arti veneziane*, 3 vols., Rome.

Negri Arnoldi, F. 1965. 'L'iconographie du soleil dans la Renaissance italienne', in *Le Soleil à la Renaissance: science et mythes*, Travaux de l'Institut pour l'Etude de la Renaissance et de l'Humanisme, II, Brussels and Paris, pp. 522–38.

Nepi Scirè, G. 1990. 'Recenti restauri di opere di Tiziano a Venezia', in *Tiziano*, Venice, pp. 109–31 (catalogue of an exhibition at Palazzo Ducale, Venice, and National Gallery of Art, Washington).

Neri, A. 1980. *L'arte vetraria*, ed. R. Barovier Mentasti, Milan.

Newett, M. 1907. *Canon Pietro Casola's Pilgrimage to Jerusalem in the Year 1494*, Manchester (trans. of *Viaggio di Pietro Casola a Gerusalemme*, ed. G. Porro, Milan 1855).

Newton, S. 1988. *The Dress of the Venetians, 1495–1525*, Aldershot.

Norwich, J. J. 1990. *Venice: A Traveller's Companion*, London.

Oberhuber, K. 1993. 'Le Message de Giorgione et du jeune Titien dessinateurs', in *Le Siècle de Titien*, Paris, pp. 431–78 (catalogue of an exhibition at the Grand Palais).

Oberhuber, K. 1995. 'L'Amor Sacro e Profano di Tiziano e la grafica', in *Tiziano: Amor Sacro e Amor Profano*, Milan, pp. 133–40.

Onians, J. 1988. *Bearers of Meaning*, Cambridge.

Onians, J. 1998. 'The Biological Basis of Renaissance Aesthetics', in Ames-Lewis and Rogers 1998, pp. 12–23.

Pächt, O. 1986. *Book Illumination in the Middle Ages*, London.

Pacioli, L., 1494. *Summa de arithmetica, geometria, proportioni, et proportionalità*, Venice.

Padoan, G. 1990. 'Titian's Letters', in *Titian Prince of Painters*, Venice, pp. 43–52 (catalogue of exhibition at Palazzo Ducale, Venice, and National Gallery of Art, Washington).

Padoan, G. 1992. 'Leonardo and Venetian Humanism', in *Leonardo and Venice*, ed. P. Parlavecchia, Milan, pp. 97–110.

Pagan, M. 1558, *La gloria e l'onore dei ponti tagliati et ponti in aere*, Venice.

Palumbo Fosati, I. 1984. 'L'interno della casa dell'artigiano e dell'artista nella Venezia del cinquecento', *Studi Veneziani*, n.s. VIII, pp. 1–45.

Philostratus. 1929. *Imagines*, trans. A. Fairbanks, London.

Piccolpasso, C. 1980. *The Three Books of the Potter's Art*, ed. R. Lightbown and A. Caiger-Smith, London.

Piponnier, F., and Mane, P. 1997. *Dress in the Middle Ages*, trans. C. Beamish, New Haven and London.

Plato. 1954. *The Last Days of Socrates*, trans. H. Tredennick, Harmondsworth.

Plato. 1965. *Timaeus*, trans. E. Lee, Harmondsworth.

Plesters, J. 1978a. 'Giovanni Bellini's *Blood of the Redeemer*', *National Gallery Technical Bulletin*, 2, pp. 11–24.

Plesters, J. 1978b. 'Titian's *Bacchus and Ariadne*: The Materials and Technique', *National Gallery Technical Bulletin*, 2, pp. 37–47.

Proust, M. 1987. *On Reading Ruskin*, ed. J. Autret, W. Burford and P. J. Wolfe, New Haven and London.

Quinterio, F. n.d. *Maiolica nel l'architettura del Rinascimento italiano, 1440–1520*, Florence.

Reali G., ed. 1858, *Sul modo di tagliare ed applicare il musaico*, Venice.

Rebora, G. 1970. *Un manuale di tintoria del quattrocento*, Milan.

Rigoni, E. 1970. *L'arte Rinascimentale in Padova: studi e documenti*, Padua.

Robertson, G. 1968. *Giovanni Bellini*, Oxford.

Rodolico, F. 1965. *Le pietre delle città d'Italia*, 2nd edn., Florence.

Rosand, D., and Muraro, M. 1976. *Titian and the Venetian Woodcut*, Washington (catalogue of an exhibition at the National Gallery of Art).

Rosand, D. 1982. *Painting in Cinquecento Venice: Titian, Veronese, Tintoretto*, New Haven and London.

Rosetti, G. 1969. *The Plictho of Gioanventura Rosetti*, ed., and trans. S. M. Edelstein and H. C. Borghetty, Cambridge, Mass.

Roskill, M. W., ed. 1968. *Dolce's 'Aretino' and Venetian Art Theory of the Cinquecento*, New York.

Roy, A., ed. 1993. *Artists' Pigments: A Handbook of their History and Characteristics*, vol. II, New York and Oxford.

Rylands, P. 1991. *Palma Vecchio*, Cambridge.

Saccardo, P. 1896, *Les Mosaïques de Saint Marc à Venise*, Venice.

Sallis, J. 1994. *Stone*, Bloomington and Indianapolis.

Sansovino, F. 1663, *Venezia città nobilissima et singolare* (1581), ed. G. Martinioni, Venice.

Sanudo, M. 1903. *I diarii*, ed. R. Fulin et al., 58 vols., Venice.

Sanudo, M. 1980. *De origine, situ et magistratibus urbis Venetae*, ed. A. C. Aricò, Milan.

Sartori, A. 1976. *Documenti per la storia dell'arte a Padova*, Vicenza.

Schlosser, J. von. 1924. *Die Kunstliteratur*, Vienna.

Schmitt, C. G., ed. 1988. *The Cambridge History of Philosophy*, Cambridge.

Schulz, J. 1991. 'Urbanism in Medieval Venice', in A. Molho et al., *City States in Classical Antiquity and Medieval Italy*, Stuttgart, pp. 419–66.

Schweppe, H., and Roosen-Runge, H. 1986. 'Carmine: Cochineal Carmine and Kermes Carmine', in Feller 1986, pp. 255–83.

Seipp, H. 1911. *Italienische Materialstudien*, Stuttgart.

Shearman, J. K. G. 1992. *Only Connect: Art and the Spectator in the Italian Renaissance*, Princeton.

Sohm, P. 1991. *Pittoresco: Marco Boschini, his Critics and Their Critiques of Painterly Brushwork in Seventeenth- and Eighteenth-Century Italy*, Cambridge.

Spallanzani, M. 1978. *Ceramiche orientale a Firenze nel Rinascimento*, Florence.

Spezzani, P., et al., 1990. 'La tecnica pittorica di Tiziano', in *Tiziano*, Venice, pp. 377–400 (catalogue of exhibition at Palazzo Ducale, Venice, and National Gallery of Art, Washington).

Stoichita, V. 1997. *A Short History of the Shadow*, London.

Strupp, J. 1993. 'The Colour of Money: Use, Cost and Aesthetic Appreciation of Marble in Venice ca. 1500', *Venezia Cinquecento*, III, no. 5. pp. 7–32.

Stumpel, J. 1988. 'On Grounds and Backgrounds: Some Remarks about Compostion in Renaissance Painting', *Simiolus*, 18, pp. 219–43.

Summers, D. 1977. '"Contrapposto": Style and Meaning in Renaissance Art', *Art Bulletin*, 59, pp. 336–61.

Summers, D. 1989. 'Aria II: The Union of Image and Artist as an Aesthetic Ideal in Renaissance Art', *Artibus et Historiae*, 20, pp. 15–31.

Tafur, P. 1926. *Pero Tafur: Traveller and Adventurer, 1435–39*, ed. M. Letts, London.

Tait, H. 1979. *The Golden Age of Venetian Glass*, London (catalogue of exhibition at the British Museum).

Tait, H., ed. 1991. *Five Thousand Years of Glass*, London.

Thompson, D. V. 1926. 'Liber de coloribus illuminatorum sive pictorum', *Speculum*, 1, pp. 280–307, 448–50.

Thompson, D. V., ed. and trans. 1932. *The Craftsman's Handbook*, New Haven.

Thorndike, L. 1934. *A History of Magic and Experimental Science*, vol. IV, New York.

Thornton, J. 1990. 'Paolo Veronese and the Choice of Colours for a Painting', in *Nuovi Studi su Paolo Veronese*, ed. M. Gemin, Venice.

Tigler, G. 1995. *Il Portale Maggiore di San Marco a Venezia*, Istituto Veneto di Scienze, Lettere ed Arti, Venice.

Toninato, T. 1982. 'La sezione tecnologica', in *Mille anni di arte del vetro a Venezia*, Venice, pp. 9–13.

Torresi, A. P., ed. 1992. *Pseudo-Savonarola: 'A far littere de oro'. Alchimia e tecnica delle miniatura in un ricettario rinascimentale*, Ferrara.

Tosatti, B. S. 1991. *Il Manoscritto Veneziano*, Milan.

Tucci, U. 1980. 'Mercanti, viaggatori, pellegrini nel quattrocento', in Arnaldi and Stocchi 1980–81, 3/II, pp. 317–53.

Tucci, U. 1998. 'Venezia senza porpora', in Longo 1998, pp. 389–99.

Tuohy, T. 1996. *Herculean Ferrara: Ercole d'Este (1471–1505) and the Invention of a Ducal Capital*, Cambridge.

Unrau, J. 1984. *Ruskin and St Mark's*, London.

Urbani de Ghelthof, G. M. 1882. *A Technical History of the Manufacture of Venetian Laces*, trans. Lady Layard, Venice.

Valazzi, M. R., ed. 1988. *La Pala Ricostituita. L'Incoronazione della Vergine e la cimasa Vaticana di Giovanni Bellini: indagini e restauri*, Venice.

Van Eikema Hommes, M. 1998. 'Painter's Methods to Prevent Colour Changes Described in Sixteenth to Early Eighteenth-Century Sources on Oil Painting Techniques', in Hermens 1998, pp. 90–131.

Vasari, G. 1878–85, *Le vite de' più eccellenti pittori, scultori ed architettori* (1568), ed. G. Milanesi, 9 vols., Florence.

Venturi, L. 1983. *Le Compagnie della Calza*, Venice (repr. from *Nuovo Archivio Veneto*, n. s. XVIII (1908) pp. 161–221, and XIX (1909), pp. 140–233).

Verità, M. 1995. 'Analytical Investigation of European Enameled Beakers of the Thirteenth and Fourteenth Centuries', *Journal of Glass Studies*, 37, pp. 83–98.

Vespasiano da Bisticci. 1951. *Vite di uomini illustri*, ed. P. D'Ancona and E. Aeschlimann, Milan.

Vitali, A. 1992. *La moda a Venezia attraverso i secoli: lessico ragionato*, Venice.

Volle, N., et al. 1993. 'La restauration de huit tableaux de Titien du Louvre', *Revue du Louvre*, 43, pp. 58–80.

Walsh, V., and Kulikowski, J. 1995. 'Seeing Colour' in *The Artful Eye*, ed. R. Gregory, J. Harris, P. Heard and D. Rose, Oxford, pp. 268–78.

Ward-Perkins, J. B. 1992. *Marble in Antiquity: Collected Papers of J. B. Ward-Perkins*, Archaeological Monographs of the British School at Rome, 6, ed. H. Dodge and B. Ward-Perkins, London.

Welch, E. 1995. *Art and Authority in Renaissance Milan*, New Haven and London.

Westphal, J. 1991. *Colour: A Philosophical Introduction*, 2nd ed., Oxford.

Wilson, T. 1987. *Ceramic Art of the Italian Renaissance*, London (catalogue of exhibition at the British Museum).

Wilson, T. 1989. *Maiolica: Italian Renaissance Ceramics in the Ashmolean Museum*, Oxford.

Wolfthal, D. 1989. *The Beginnings of Netherlandish Canvas Painting, 1400–1530*, Cambridge.

Wollheim, R. 1980. *Art and Its Objects*, 2nd edn., Cambridge.

Wollheim, R. 1987. *Painting as an Art*, London.

Wolters, W. 1976. *La scultura veneziana gotica, 1300–1460*, 2 vols., Venice.

Wright, D. R. E. 1984. 'Alberti's *De Pictura*: Its Literary Structure and Purpose', *Journal of the Warburg and Courtauld Institutes*, 47, pp. 52–71.

Yang, J. 1999. 'Giovanni Bellini: Experience and Experiment in Venetian Painting, *c*.1460–1516', Ph.D. University College, London.

Zecchin, L. 1987–90. *Vetro e Vetrai di Murano*, 3 vols., Venice.

Zeki, S. 1993. *A Vision of the Brain*, Oxford.

Zonta, G., ed. 1912. *Trattati d'amore del cinquecento*, repr. Bari 1967.

INDEX

Photographic Acknowledgements

AKG London 29, 226, 239; Bildarchiv Preussischer Kulturbesitz, Berlin 126, 150, 230; Osvaldo Böhm 9, 71, 72, 117, 138, 194; Cameraphoto 4, 13, 24, 25, 42, 45, 48, 57, 59, 92, 118, 130, 134, 135, 136, 156, 157, 178, 179, 192, 193, 200, 204, 205, 208, 252; Reproduced by permission of the Duke of Devonshire and the Chatsworth Settlement Trustees 189; Paul Davies 19; Electa 216, 217, 243, 244; The Governing Body, Christ Church, Oxford 235; Courtesy of the Fogg Art Museum, Harvard University Art Museums, Gift of

W. G. Russell Allan 222, 223; Paul Hills 5, 6, 8, 21, 23, 31, 40, 43, 44, 49, 50, 51, 52, 53, 60, 69, 75, 79, 84, 85, 86, 87, 88, 89, 90, 91, 94, 95, 100, 101, 102, 103, 106, 107, 110, 111, 132; Su concessione del Ministerio per i Beni e le Attivita Culturali, Milan 183, 187; Angus Mill frontispiece, 7, 11, 20, 22, 32, 33, 34, 38, 68, 76, 82, 83, 109, 191; Nicolò Orsi Battaglini 173; © Sarah Quill/Archivio Veneziano 14, 78, 80, 98, 99, 139, 190; © Photo RMN 44, 67, 112, 115, 127, 142, 184, 206, 207, 218, 220, 237, 240; Photo W. Ritter,

courtesy of Dumbarton Oaks 26, 62, 63, 64, 65, 66, 241; Guido Rossi/Image Bank 2. Scala 3, 12, 15, 16, 18, 27, 30, 36, 37, 39, 54, 55, 58, 70, 73, 74, 77, 81, 93, 96, 105, 108, 116, 119, 121, 122, 123, 137, 162, 163, 165, 166, 167, 168, 170, 171, 172, 174, 175, 182, 185, 186, 201, 202, 203, 210, 211, 212, 214, 215, 245, 248, 251; John Unrau 28, 41, 56, 61; V&A Picture Library 141, 145, 223.

Comment